UNFAMILIAR STREETS

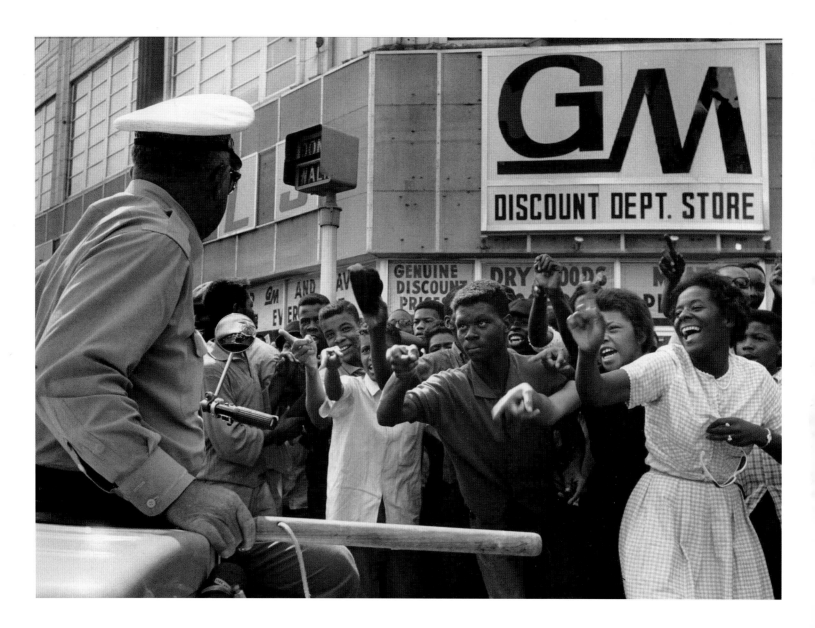

UNFAMILIAR STREETS

THE PHOTOGRAPHS OF RICHARD AVEDON, CHARLES MOORE, MARTHA ROSLER, AND PHILIP-LORCA DICORCIA

Katherine A. Bussard

Yale University Press
New Haven and London

Publication of this book has been aided by grants from the Wyeth Foundation
for American Art Publication Fund of the College Art Association, from the
Graham Foundation for Advanced Studies in the Fine Arts, and from the Minor White
Photography Publications Fund of the Princeton University Art Museum.

yalebooks.com/art

Designed by Rita Jules, Miko McGinty Inc.
Set in Berling Nova and Bau type by Tina Henderson
Printed in China through Oceanic Graphic International, Inc.

Library of Congress Cataloging-in-Publication Data
Unfamiliar streets : the photographs of Richard Avedon, Charles Moore, Martha
Rosler, and Philip-Lorca DiCorcia / Katherine A. Bussard.
 pages cm
 Includes bibliographical references and index.
 ISBN 978-0-300-19226-1 (cloth : alk. paper) 1. Street photography. I. Bussard,
Katherine A. II. Avedon, Richard, photographer. III. Rosler, Martha, 1943– ,
photographer. IV. DiCorcia, Philip-Lorca photographer.
 TR659.8.U54 2014
 778.9'4—dc23 2013023365

A catalogue record for this book is available from the British Library.

This paper meets the requirements of ANSI/NISO z39.48-1992 (Permanence of Paper).

10 9 8 7 6 5 4 3 2 1

Frontispiece: Charles Moore, *Downtown Birmingham, Alabama* (fig. 43)

Jacket illustrations: (*front*) Philip-Lorca diCorcia, *New York* (fig. 78); (*back*) Richard
Avedon, *Renée, The New Look of Dior, Place de la Concorde, Paris, August 1947* (fig. 12),
Martha Rosler, *The Bowery in Two Inadequate Descriptive Systems* (detail 10a) (fig. 61),
and Charles Moore, *Downtown Birmingham, Alabama* (fig. 30).

CONTENTS

For my parents, always

ACKNOWLEDGMENTS

As with any project a decade in the making, this book requires an extensive list of acknowledgments for the many sources of encouragement, assistance, and inspiration during its research and writing. At the City University of New York, I had the good fortune to experience Geoff Batchen's profound support. He has provided a model of critical inquiry, shaping and reshaping my thinking about photography, always reinforcing a commitment to the objects of my art-historical study. As true mentors do, Geoff has challenged as much as encouraged me. I hope his example is manifest in these pages.

I am deeply indebted to Robin Kelsey and Douglas Nickel for making suggestions that substantially improved the text and to Darby English, Katherine Manthorne, and Claire Bishop for their careful and insightful readings of various drafts. The very possibility of a life engaged with the history of photography came to me during a single class with Ralph Lieberman. Several other professors and advisors changed the course of my intellectual development as an art historian: Benjamin Buchloh, Ron Clark, Michael Conforti, Jim Ganz, Jennifer González, Mark Haxthausen, Michael Ann Holly, Caroline Houser, Dana Leibsohn, Patricia Mainardi, Keith Moxey, Carol Ockman, Richard Rand, and Sally Webster.

My research has benefited enormously from the support of the Art Institute of Chicago: David Travis simultaneously championed it and my career; Jim Cuno and Matt Witkovsky facilitated the completion of my dissertation; and Liz Siegel was a constant source of wisdom and encouragement in the office next door. This book was completed following my transition to the Princeton University Art Museum, and I am grateful for the generous and helpful environment fostered especially by James Steward, Bart Thurber, and Peter Bunnell. More broadly, the years spent working on the manuscript taught me the joy of being surrounded by kind and inquisitive colleagues; special thanks go to Mitra Abbaspour, Ken Allan, Naomi Beckwith, Whitney Bradshaw, Huey Copeland, Julian Cox, Lisa Dorin, Tash Egan, Alison Fisher, Greg Foster-Rice, Peter Galassi, Jenny Gheith, Elyse Gonzales, Sophie Hackett, Greg Harris, Virginia Heckert, Lisa Hostetler, Karen Irvine, Judy Keller, Annie Lyden, Sarah Miller, Allison Moore, Weston Naef, Mark Pascale, Dan Quiles, Michal Raz-Russo, Brian Sholis, Joel Snyder, Lisa Sutcliffe, Nat Trotman, Anne Tucker, Kate Ware, Colin Westerbeck, and Sylvia Wolf. I am grateful for the conversations with countless others

who, knowingly or not, provided much-needed insights and provocations in the refining of this project.

My research has led to many fruitful collaborations, some more evidently related than others. Lisa Hostetler and I shared a passion for images made on the street long before working together on the exhibition and publication *Color Rush: American Color Photography from Stieglitz to Sherman.* Conversations with Lydia Yee led to earlier iterations of portions of this project appearing in her catalogue *Street Art, Street Life: From the 1950s to Now,* an opportunity for which I remain grateful. My investigations dovetailed in ways I could never have foreseen with those of Greg Foster-Rice and Alison Fisher, with whom I am curating and writing *The City Dynamic: Representing Crisis and Renewal in New York, Chicago, Los Angeles 1960–1980,* an interdisciplinary consideration of the intersection of photography, architecture, and urban studies.

For their assistance with all manner of research at various points in the past decade, I acknowledge Amy Ballmer, Emma Bee Bernstein, Peter Blank, Ian Bourland, Jack Brown, Grace Deveney, Melanie Emerson, Jenny Gheith, Greg Harris, Jim Iska, Jacob Lewis, Lauren Makholm, Autumn Mather, Alissa Schapiro, Doug Severson, Newell Smith, and Betsy Stepina Zinn at the Art Institute; Karen Bucky, Michael Conforti, Michael Ann Holly, Valerie Krall, Mark Ledbury, and Susan Roeper at the Clark Art Institute; Sandra Brooke, Jessica Dagci, and Ofra Amihay at Princeton University; Julian Cox at the High Museum; Nova O'Brien from the Avedon Archive at the Center for Creative Photography; Lesley Martin and Christina Wiles at Aperture; Whitney Gaylord, Tasha Lutek, and Sarah Meister at the Museum of Modern Art; Whitney Rugg at the Bronx Museum; Karen Marks at the Howard Greenberg Gallery; and Lauren Panzo at Pace/MacGill.

This publication was made possible through grants from the Wyeth Foundation for American Art Publication Fund of the College Art Association, from the Graham Foundation for Advanced Studies in the Fine Arts, and from the Minor White Photography Publications Fund of the Princeton University Art Museum. Additional support was provided by the Richard Avedon Foundation. None of that support, however, would have been possible without Yale University Press. I am grateful to Patricia Fidler for conversations early on that made the publication process transparent, as well as for her true engagement with the topic. Katherine Boller, Heidi Downey, and Mary Mayer at Yale demonstrated their commitment to this project time and time again. This book is all the better for their assistance. I also acknowledge the judicious copyediting of Duke Johns, the fastidious indexing by Karla Knight, and the elegant design by Miko McGinty and Rita Jules.

Betsy Stepina Zinn worked tirelessly to ensure the careful, thoughtful, and timely editing of many versions of the manuscript. I continue to be grateful for her mix of professionalism and flexibility, and I alone am responsible for any faults or

oversights that lie within these pages. Lauren Makholm ably coordinated all the images that appear in the book, including relentlessly tracking down images with no apparent creator or rights holder. For their assistance with rights and reproductions, this project is indebted to Eugenia Bell at the Richard Avedon Foundation, Steve Kasher at Steven Kasher Gallery, Mamie Tinkler at Mitchell-Innes & Nash, and Hope Dickens at David Zwirner Gallery.

I remain grateful to Scott Allan, Annie Burns, Betsy Bussard, Megan Dennis, Lisa Dorin, Des FitzGerald, Emily Mark FitzGerald, Maria Franzon, Myra Greene, Molly Herron, Mary Larson, Jane MacAvock, Hannah Nudell, Michal Raz-Russo, Seth Richardson, Josh Shamsi, Larry Smallwood, Sarah Szwajkos, and Molly Wilson. "Thankful" is not a big enough word to encompass the effect of all your phone calls, e-mails, packages, advice, and home-cooked meals. The safety net woven by my extended family never ceases to amaze me. Betty English and Loraine DeYampert were especially encouraging. My grandparents, Phyllis and Richard Little and Doris and Sherman Lucas, spurred me on for years with the question "Can we call you doctor yet?" and it was a welcome and humbling reminder of the value they placed on an education they were never able themselves to experience. Sandy and David Ekberg's inquiry about when they might read this book has been an affectionate prompt for me to remember that the themes covered by this project can expand and engage far beyond the field of art history. My sisters, Molly Wilson, Betsy Bussard, and Annie Burns, have offered constant and accommodating assurances that we will always be there for each other when it counts the most. My partner, Adam Ekberg, has cheered me on throughout many revisions, always demonstrating the unequivocal support and kind heart he brings to our life together. Finally, I thank my parents, Ellen and David Bussard and Elaine and Greg Lucas. Their deep, abiding belief in me is the foundation for this and any other accomplishment I have ever enjoyed, and so it is to them I dedicate this book.

INTRODUCTION

City streets have appeared in photographs since the inception of the medium in the early nineteenth century. It took an active and widespread practice of making photographs in city streets, however, before street photography was referred to as a genre. Street photography emerged as a category—albeit one still uncertainly discrete from others—around the beginning of the twentieth century. Photographer Osborne Yellott appears to have been the first person to deploy the term "street photography," as the title of an essay he wrote in 1900 for one of the many technical and advice manuals that proliferated in the decades after Kodak championed photography's mass accessibility.[1] In his text Yellott considered broadly the technical craft of photographing out of doors, acknowledging up front that for a growing number of amateurs, the "humor and pathos" of the "everyday life of the streets of [the] city" offered subjects "far more interesting than deserted mills or rustic bridges."[2] Yellott reinforced the immediacy of the city: "Foremost among the attractions of street photography is the fact that we do not have to travel, or wait for rare opportunity, to find our picture material." Importantly, he then divided the genre into two strains of photographic meaning, delineating street photographs based on attention to the specifics of location from those rooted in the scene the photographer discovers there. For the first category, the "pictorial treatment of locality," he argued that "an intimate acquaintance with the locality is essential to success." For the second category, the "record of scene or incident which may possess sentiment or merely human interest," the specific location of a photograph bears little importance.[3] What is remarkable about Yellott's text is not only that it gives first articulation to "street photography" but also that it illuminates two very different considerations of the genre: one in which urban context is key, the other stressing poetic or fortuitous happenstance.

Over the ensuing decades, street photography has come to be identified with Yellott's second category.[4] Records "of scene or incident" unattached to specific locations have come to epitomize the entire genre. Codified by Henri Cartier-Bresson's 1952 publication *The Decisive Moment* and exemplified in the work of Garry Winogrand, this practice of street photography emphasizes mobility, speed, stealth, intuition, spontaneity, instantaneity, and singularity.[5] The process can be generally described as follows: the street photographer surreptitiously snaps a wealth of pictures with his handheld camera, later editing to find the single frame, "the decisive moment" uniting visual contrasts,

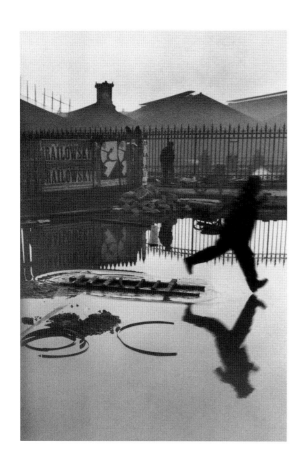

FIG. 1. Henri Cartier-Bresson,
Place de l'Europe, Paris, 1932.

ironic juxtapositions, and lively vantage points (figs. 1 and 2).[6] A series of unmediated reactions to the experience of the city street is thus eventually suppressed in favor of one perfectly tuned picture.

This book acknowledges the importance of such street photography, as well as the codes and literature surrounding it to date. At the same time, it revives the forgotten strain, those photographs Yellott deemed "pictorial treatment[s] of locality."[7] As such, I advocate for an analysis of street photographs firmly grounded in the locations of their making. Shifting the conversation to the depicted streets themselves, my analysis addresses the significance of the street as both site and subject.[8] I attend to the specifics of the urban locations of street photographs and consider how those specifics inform what meanings audiences may attach to such pictures.

Other articulations of the street beyond art history—those derived from the disciplines of urban studies, comparative literature, and sociology—tip the balance in the opposite direction: they advance the understanding of streets as specific sites, but they do so without sustained attention to visual representations of streets, photographic or otherwise. Distancing the city as subject from the city as represented experience only fosters or reinforces restrictive explanations of both the city and related art. If there is no single, fixed city, how can there be a single or comprehensive understanding of art's relationship to the city?[9] Accordingly, I accept the proposition that because streets, like the cities in which they are located, have no single, fixed identity or meaning, we should think of photographs taken in and of these streets as correspondingly variegated.

In my approach, "street photography" should not be limited to those images taken in or of any street seeking the "scene or incident" of Yellott's second category. Rather, my framework, aligned with Yellott's first category, contends that street photographs necessarily involve an engagement with their sites as particular cultural, political, economic, and social environments.[10] Moving beyond formally fortuitous glimpses snatched from urban life, this book embraces how the construction and production of street photographs corresponds—or fails to correspond—to the ways in which the street both frames and determines urban experience.[11] To emphasize this departure, I will use the term "street photograph" to delineate Yellott's first category from the "street photography" of Yellott's second category, with which the genre has for too long been exclusively equated. If we understand street photographs as efforts to represent in photographic form the complex, alternately shared and contested experiences of city streets as informed by gender, commerce, race, politics, class, economics, desire, and spectacle, a different and intrepidly social mode of historical analysis is warranted. (Indeed, historically, street photographs were commercial

FIG. 2. Garry Winogrand, *New York City*, 1968.

endeavors, made available for sale through a practice that required careful attention to urban pedestrian patterns within metropolises.)[12] Moreover, since the artists' creation of these images not only embraced but also inscribed these various aspects of city streets into the images themselves, the corresponding historical analysis should address how these images came to be known. My four case studies—discussing photographs by Richard Avedon (1923–2004), Charles Moore (1931–2010), Martha Rosler (b. 1943), and Philip-Lorca diCorcia (b. 1953)—exemplify such an incorporation of the original viewing context for street photographs. As such, they invite an art-historical approach to the dynamics that animate and complicate the specific city streets they depict.

This book offers an idiosyncratic set of otherwise disparate practitioners who are more quickly, and not incorrectly, labeled a fashion photographer, a photojournalist, a conceptual artist, and a contemporary art photographer, respectively, and for whom city streets are but one theme in their individual careers. The four case studies are thus vignettes of a social history of street photographs in the United States since the 1940s. Published during the heyday of postwar consumerism, Avedon's late 1940s photographs for *Harper's Bazaar* employ Parisian streets as deliberate locations of material desire, trading on a nostalgic image of that city. Moore's *Life* magazine photographs of civil rights demonstrations in Birmingham, Alabama, in the spring of 1963 capitalize on widespread awareness of the street as a site of political protest at the outset of a decade that would make the two virtually synonymous. Rosler's removal of human subjects in the street photographs of her seminal work, *The Bowery in Two Inadequate Descriptive Systems* (1974–75), prompts the viewer's negotiation and reevaluation of urban poverty and homelessness. Finally, diCorcia's sustained explorations of the individual and communal experience of Times Square have yielded street photographs that unite the social and architectural space of urban change in America's most iconic public square. Among their contemporaries, Avedon, Moore, Rosler, and diCorcia offer the most salient examples of how street photographs can engage the specifics of the streets on which they were made, as well as how that specificity informs their appearance before viewers. These four photographers also offer a complex range of practices that defamiliarize prevailing street photography. From unacknowledged to shunned, from contentious to embraced, my case studies thus present various "unfamiliar streets."

Offering an alternate conception of and approach to the genre does not require inserting a history of street photography into a social history of postwar America.

Instead, social history is always and already inherent in street photographs. Attending to the *streets* in street photographs is therefore one and the same as attending to the cultural, political, economic, and social specifics of urban contexts.

There are several instances where other approaches—including literary, sociological, anthropological, and urban studies—have informed my thinking.[13] Given that cities have long represented cultural achievement, economic centers, condensed human interaction, technical innovations, political nexuses, and social dynamics, it should not be surprising that city streets have stimulated so many different disciplines. Using key ideas from these sources illuminates other possible analyses of street photographs. This book is deeply indebted to Rosalyn Deutsche's scholarship, which advocates the more integrated, cross-disciplinary approach afforded by urban studies. Her essay for the anthology *If You Lived Here ... The City in Art, Theory, and Social Activism* takes art history to task for its categorical conventions regarding the city and art.[14] She elaborates on the interpretive and intellectual straitjacketing that has resulted from categorical understandings: "All connections between art and the city drawn by aestheticist tendencies within art history are, in the end, articulated as a single relationship: timeless and spaceless works of art ultimately transcend the very urban conditions that purportedly 'influenced' them, or that are 'expressed,' 'reflected,' or 'transparently' depicted in them."[15] Contrary to this, I contend that an aesthetic, art-historical consideration can and should be attentive to the time and space of the work's creation in an urban location. Moreover, in demonstrating that street photographs always and already anticipate their own appearance to and circulation among viewers, I suggest a social function for this genre of art. Rather than obscuring the city, which has been standard procedure in so many art-historical efforts, I propose a function for street photographs that begins in the city and continues to exist *because of* the constructions and experiences of street photographs.

To the extent that this approach can be characterized as social art history, it is not one necessarily welcomed by Deutsche:

> Social art history departs from such accounts of "city painting" by emphasizing art's reliance on, rather than independence from, the urban "context." However, social art history merely replaces the model of autonomy with one of "interaction" between art and the city, maintaining an essential division between the two. Traditional Marxist interpretations, sometimes called "the new social art history," often introduce political categories—such as class—into aesthetic debates. But they, too, posit a fundamental origin and determinate of all meaning, both urban and aesthetic, locating "the political" in a single governing sphere—the economic. Marxist art history thus substitutes an *a priori* separation of art from the city with a predetermined reduction of both to the level of economic relations.[16]

I question the assumption that "interaction" between art and city necessarily maintains an essentializing distance between the two, and my four case studies are intended to purposefully suggest an open-ended approach that does not, in fact, reduce "the political" to the economic sphere. At the same time, I remain committed to the detailed formal analysis of street photographs, an analysis that I contend should be possible without subscribing to the "aestheticist tendencies" identified by Deutsche. In contrast to Deutsche's New York City–centric writings, I hope for a more open model, one that benefits from grappling with the specifics of multiple cities.[17] I agree wholeheartedly that one separation of art and city should not be substituted for another. I nevertheless argue—from a position deeply committed to photo history—for the productive and illuminating possibilities of multiply and differently oriented considerations of the interaction between art and city.

To explore street photography as more than merely a moment's interaction in the process of making pictures, Yellott's early writing is again instructive. Yellott made a related but crucial aside that, faced with the selection of a single apparatus for making photographs on city streets while traveling, he would choose his stereoscopic camera, as it was "preeminently suitable" to street photography. "When we see a picture of a person through the stereoscope, we can almost feel that he is standing before us. That is the feeling which we wish to produce in the minds of our friends when we bring home our pictures."[18] What seems a nod to the armchair travels made possible for many bourgeois people by the stereoscope is in fact a remarkable advocacy for the experiential photographic representation of the street. Yellott celebrated the distance, both geographic and interpersonal, that a street photograph could collapse. Yet he also privileged the circulation of street photographs. Whether intentionally or not, Yellott's conception powerfully endorses street photographs' ability to represent the experiences of metropolitan streets as well as their encounter-producing function for viewers.

Taking Yellott's insistence on the experiential nature of street photographs to heart, *Unfamiliar Streets* asks, How did particular street photographs come to be known and what was their impact? The four photographers featured in this book were chosen because they intended to make affective pictures, capitalizing on their photographs' circulation, reproduction in magazines, relationship to text, and publication context or physical scale in relation to viewers. Their audiences were decidedly widespread. And although mass circulation was possible before World War II, more people had access to photographic images—including those considered here—because of the postwar rise and expansion of the middle class, a shift that engendered new and multiple modes of photographic circulation, display, and publication. Avedon, Moore, Rosler, and diCorcia inscribed roles for viewers contemplating their choreographed representations of historical urban experience.

Accompanying Yellott's early prescription that the most successful photographs taken on the street enable their viewers to sense that the subject "is standing before us" is his conviction that such experiential, shared vision was fitting for representations of city streets. In addition to addressing the particular circumstances of viewing the works of Avedon, Moore, Rosler, and diCorcia, I maintain that street photographs are best understood when the potentially shared nature of both streets and viewers is taken into account.

Each case study in this book follows a roughly similar trajectory, beginning with a consideration of a set of generative precedents in order to illuminate the relationship between the work and other distinct but related engagements with the street. These considerations of precedent not only reengage a range of historical practices but also acknowledge the preconditions productively elaborated or exploited in the work of these four photographers and their audiences at the time of the photographs' production and initial appearance. Each chapter then offers a process-oriented description of how the photographs were made in the city. This is followed by a careful analysis of the specifics of the streets that constitute the photographs' site and subject, as well as relevant broader historical context. Each chapter concludes with an exploration of how the street photographs originally appeared to viewers, from choices in editing, scale, captioning, or display to reactions encouraged in viewers through a work's appearance and circulation. More generally, the case-study structure implies a widespread application of my approach beyond these four unexpected examples to other photographers, cities, and eras. It is my intent that the four case studies can serve as both a demonstration of and an invitation to a new approach to street photographs.

In choosing to focus on the "unfamiliar streets" of Avedon, Moore, Rosler, and diCorcia, I intentionally sought photographers who translate urban experiences through a variety of strategies including interventionist, constructed, and documentary. An artistic construction of the streets may take viewers much closer to such experiences than a documentary photograph; likewise, the appearance of a documentary photograph in a magazine or alongside text may complicate urban experience more than an interventionist photograph of the streets. Such photographic confrontations must, of course, remain open to multiple readings, whether those readings are situated in the past, present, or future.[19] It is my hope that the selection of these four photographers provides a survey of types and meanings of street photographs within the context of American postwar urban culture, a survey that diversifies, expands, and complicates the existing discourse.

Each of these artists was born in a different decade but came of age in postwar America, and the photographs addressed in this book were made at intervals ranging from twelve to twenty years; the cumulative effect of these choices is a generational

span across postwar American street photography. While Avedon, Moore, Rosler, and diCorcia have been accorded monographs and significant exhibitions as individual practitioners, only diCorcia has been included in the discourse surrounding street photography.[20] Avedon, Moore, Rosler, and diCorcia understood, to the point of anticipating or controlling, their work's appearance and circulation. Far from being merely isolated art objects, these street photographs engage their own reproducibility, audience, criticality, and reflexivity. Avedon, Moore, Rosler, and diCorcia explored photography's potential for shared cultural connotations, as evidenced by their photographs' aesthetic processes, choices, and appearance. My case-study treatment of the work of these four photographers, each of whom considers the street with particular motivations, allows for a culturally and historically specific demonstration of new approaches to the street and its photographic representation.

Although Richard Avedon has become widely known for his work as a studio portrait and fashion photographer, it is his late 1940s work for *Harper's Bazaar* that broke new ground in the practice of photography. With these pictures, Avedon daringly located fashion photography on the streets of Paris, making explicit the association of the urban environment with gendered material desire.[21] Nevertheless, these images have been discounted as having little if any significance in the surrounding discourse beyond their ability to sell skirts, hats, and shoes. Published in *Harper's Bazaar* as part of a conscious push for overseas postwar consumerism among American women, Avedon's photographs mine the viewer's familiarity with urban experience, successfully eliciting an identificatory desire for the product on display and the Parisian modernity and nostalgia on which it traded.[22]

When Avedon began making photographs, American picture magazines offered tremendous employment opportunities to many photographers, to say nothing of the audience afforded by *Life*'s several million readers. But as a new generation came of age in the early 1960s, it questioned the assumptions of the previous generation, which had been shaped so dramatically by depression and war. The problems facing America undermined the prevailing postwar emphasis on suburban life, material possessions, and family stability. Among those problems, perhaps the most pressing were America's legacy of racism and national policies of racial discrimination, both of which would increasingly be challenged publicly, in force, by the civil rights demonstrations of the 1960s. As Jane Jacobs noted in "The Use of Sidewalks: Contact," a section of her 1961 study *The Death and Life of Great American Cities*, "Sidewalk public contact and sidewalk public safety, taken together, bear directly on our country's most serious social problem—segregation and racial discrimination."[23] Given that the centrality of the street for 1960s social revolutions is now almost a cliché, it is time for a history that grapples with the centrality of street photographs in establishing and disseminating that aspect of the decade's reputation.

Demonstration photographs from the 1960s record the street in the decade when it was inseparably linked with political struggle. Working for *Life* magazine, Charles Moore photographed the occupation of Birmingham's streets, sidewalks, and other urban spaces with deep connotations of governmental power. Street photographs documenting protests such as the one staged in Birmingham enjoyed ever-increasing circulation in newspapers and picture magazines as well as through the rising medium of television.[24] Although there would soon be photo coverage of women's liberation marches, demonstrations following the Stonewall riots, and widespread protests against the Vietnam War, it was the civil rights movement that gained steady front-page prominence in the early 1960s. Some of these photographs are among the best-known street photographs ever made, so familiar to many of us that they can be conjured with the briefest descriptions: a black man careening between two attacking police dogs; people knocked over by the water from fire hoses; marchers with picket signs reading "I *am* a man." Others, while less iconic, filled the daily visual landscape of any sentient US citizen.

Like Avedon, Moore capitalized on his viewers' ability to recognize the city streets. Unlike Avedon's photographs, however, Moore's images appeared only and always with detailed news accounts of the events on the ground. Of course, photojournalists are aware of and reference certain aesthetic standards in their photographs, and such standardization, as Cartier-Bresson wrote in *The Decisive Moment*, "gives the viewer a sense of familiarity—we know these pictures—as well as creating the impress of evidence."[25] Accordingly, Moore formally inscribed his 1963 images for *Life* with an identificatory power, such that viewers have no choice but to find themselves situated, for example, alongside the firefighters ordered to hose protestors off the streets of Birmingham. Moore's photojournalistic practice anticipated its exclusive context on the pages of *Life*, which required viewers to engage editorial text as well as photographic layout. In the original appearance of his Birmingham photographs, a tension or disconnect emerges in the photo essay; nevertheless, the identificatory power of Moore's photographs manages to render the accompanying text perfunctory.

In November 1963 civil rights leader A. Philip Randolph spoke at the American Federation of Labor and Congress of Industrial Organizations convention, declaring, "The Negro's protest today is but the first rumbling of the '*under-class.*' As the Negro has taken to the streets, so will the unemployed of all races take to the streets."[26] Randolph's statement reflected the kind of democratic spatial politics about which Deutsche has written extensively: "When space is pictured as a closed entity, conflicts—and social groups associated with conflict—appear as disturbances that enter space from the outside and must be expelled to restore harmony. . . . We cannot recover what we never had. Social space is produced and structured by conflicts."[27] Nevertheless, from the 1960s to the 1970s, a rhetoric grounded in identifying and expelling disturbances thrived,

such that Stanford Anderson could remark in his 1978 preface to the anthology *On Streets*: "Familiar are the numerous entrenched expressions where 'street' bears a negative connotation: 'on the street,' 'streetwalker,' 'street crime.' Streets then, present problems, and 'street' is used as a metaphor for what is aberrant and fearful in the light of social norms."[28] Large-scale urban homelessness and poverty developed in the 1960s, and Barbara Ehrenreich has noted that the 1964 declaration of a "War on Poverty" in the United States cannot be understood apart from the civil rights movement's demonstrations in the years immediately preceding that announcement. Civil rights demonstrators were not "passively selected by news photographers, like the exemplars of poverty featured in magazine stories," whereas the poor were ultimately "less threatening to white, middle-class sensibilities than the swelling black movement." Thus, the War on Poverty was "a way, almost, of changing the subject."[29] Those picture magazines that had featured the silent urban poor declined rapidly in the late 1960s, a difficult turn for photographers such as Moore. But the simultaneous explosion of art world interest in photography also affected the conceptualization of street photographs. As art institutions such as the Museum of Modern Art established a canon, postmodern artists such as Martha Rosler exposed and challenged restrictions of the genre.

In Rosler's *The Bowery in Two Inadequate Descriptive Systems* (1974–75), photographs of empty streets accompanied by equally pivotal text posit the physical and critical removal of the human subject from street photographs. *The Bowery* does not picture its rhetorical subjects: destitute New York City drunks. Instead, purposefully echoing the style of canonical documentary photographer Walker Evans, Rosler photographed abandoned stoops, desolate storefronts, and emptied bottles, representing her subjects and their habits through artifact alone. Each photograph is paired with words related to drunkenness or drunks, providing an evocative exercise in language. Rosler's project forces the viewer to negotiate and reevaluate the complicated messages street photographs had delivered and could deliver about homelessness and urban poverty in the context of art institutions. As Rosler has acknowledged, "'The street' suggests metropolitan locales with deeply divided class structures and conflict, and perhaps where the impoverished and excluded are also ethnically different."[30]

At the time of *The Bowery*'s making, moreover, New York was experiencing large-scale homelessness and, convinced of its ability to control public space, was embarking on the kind of urban planning so aptly critiqued by Deutsche. The city mixed high-rise culture and street culture at a time when the downtown areas of many other American cities succumbed to depopulation. Given these factors, representations of urban homeless populations took on new connotations that, as Florian Ebner wrote in the *Street and Studio* catalogue, were reinforced by street photographs: "The recumbent body not only dominates the picture's horizontal axis, but also *signifies* it: the horizontal line alludes to the existential condition of all those who are

out of sync with the city's operating system."[31] Photography's complicit articulation of this position went hand in glove with the conceptual art practices and postmodernist theories of the day, which sought to complicate art's social possibilities and overturn the tradition of decontextualized art objects.[32] Much postmodern art demonstrates the fluidity of representations, meanings, and institutions. Working from this premise, many artists used language, multiple images, and the active interpellation of or accounting for the viewer and context to expand photography's possibilities. It is in this respect that Rosler's empty Bowery streets remain exemplary among street photographs for insistently shifting responsibility from photographer to viewer.

Of the four artists considered in this book, only Philip-Lorca diCorcia has previously been discussed within the rubric of street photography. As early as diCorcia's first monograph, published in 1995 by the Museum of Modern Art, Peter Galassi wrote of the "untended legacy" of street photography, suggesting diCorcia's importance to the canonical version of that genre's history.[33] The body of work that Galassi's catalogue debuted, *Streetwork* (1993–99), was made on the streets of metropolises around the world, including New York City. DiCorcia's next body of work, *Heads* (1999–2001), was made exclusively in Times Square, the dominant location of the New York photographs in *Streetwork*. Times Square is a place rife with symbolism and history. Central to the city's identity, the square is a locus of spectacle and consumerism, social and sexual desire, individual and communal experience. It is also an indicator of the increasing presence of isolation, surveillance, and global genericism in American urban life. From a site-oriented perspective, *Streetwork* and *Heads* forcefully present a challenging contribution to the history of street photographs, beyond their elaborate lighting and theatricality, as the literature consistently suggests. When diCorcia transformed the commercial pedestrian spectacle of Times Square through a process indebted to but distinct from photographers such as Winogrand, what do the resulting images tell viewers about urban experience? Moreover, how do the shifts in appearance from the aesthetics of *Streetwork* to those of *Heads* correlate to the shifts in Times Square from 1993 to 2001? The viewer must confront the fact that diCorcia's street photographs unite the social and architectural space of urban change that defines Times Square. Thus, Times Square itself is of inescapable importance to diCorcia's *Streetwork* and *Heads*; but the events of September 11, 2001, because of the effect they continue to have on the reading of *Heads*, bear heavily on the images, both despite and in addition to diCorcia's original intentions. As with those by Avedon, Moore, and Rosler, each of diCorcia's street photographs is a visual nexus of the particular location of its making, the historical context of its moment, and its ongoing presentation to the audience.

The selection of these four photographers does not aim to reflect the entire range or complexity of street photographs; taken together, however, they embody cross-currents in the discourse surrounding the genre. Moreover, the case studies devoted to

each artist exemplify a new historical approach to the street and its photographic representation. The meaning of street photographs—in tandem with the meaning of city streets—should be investigated archaeologically (to recover and preserve its past), memorially (to recall subjects who might otherwise be forgotten), and dialectically (to recognize and illuminate simultaneously past and present).[34] Following these models, each case study does not assume a definitive or linear account of either the street photographs considered or the urban experiences they depict; instead, each approaches the images and the specifics of their streets from those social-historical perspectives that seem most illuminating. Thus, as detailed in the first chapter, Avedon's work engages with the gendered commercialism of postwar couture, offering a fresh, young, newly initiated vision of Paris that was undeterred by the aftermath of World War II. The second chapter explores Moore's photojournalism as indictments of the actions of racist authorities and restorative of widely reproduced street photographs' role during the decade in American history most synonymous with the streets. Rosler contended with urban economic dispossession in *The Bowery*, a work that the third chapter explains was purposefully contrary toward art history and the art market but was also, if less consciously, defiant of the tradition of street photography. The fourth chapter considers diCorcia's sustained engagement with a single, iconic urban location, yielding street photographs that map sexuality and spectacle against urban change and "revitalization." Each of the four chapters reflects an opportunity, via a practice exemplary of each photographer's generational moment, to think of street photographs differently, by considering streets as specific sites.

Cities are large, densely inhabited areas with residences, businesses, municipal governments, public transportation, community spaces, and more. The streets and sidewalks of these cities are sites of commerce, display, demonstration, inequality, dispossession, power, desire, and spectacle. They are the main public spaces of cities and are thus pivotal to understanding urban experience, both as lived and as depicted. An observation of Deutsche's is especially apt with respect to city streets and sidewalks: "No space, insofar as it is social, is a simply given, secure, self-contained entity that precedes representation; its identity as a space, its appearance of closure, is constituted and maintained through discursive relationships that are themselves material and spatial—differentiations, repressions, subordinations, domestications, attempted exclusions."[35] *Unfamiliar Streets* posits a new approach to street photographs in which the specifics of city streets are made photographic, products of the cultures that simultaneously shape and are shaped by cities. Articulated long ago by Osborne Yellott, this understanding of street photographs addresses itself to the particular economic, political, social, and psychological dynamics that energize city streets. Through the work of Avedon, Moore, Rosler, and diCorcia, *Unfamiliar Streets* offers vignettes of a model of analysis that is appropriate to its historical subjects.

RICHARD AVEDON
BETTER THAN REAL

This is a very different city from the Paris I saw a year ago. There are cars on the streets and a few buses. And the fashions are wonderful. . . . [The fashions pictured here] take you to Paris, not to the newsreel Paris of disillusion and political unrest, but to the Paris of the designer's dreams.
—CARMEL SNOW

The [Paris] street scenes, where these women sometimes encounter "regular" people (an acrobat, a bicyclist), have a strange dissonance: they contrast quasi-documentary backgrounds with the sharp, darting stiffness of the models in their Dior abstractions—geometric skirts . . . rigidly belled out.
—ROBERTA SMITH

In a magazine picture, a woman stands on a sun-drenched sidewalk, across the street from a building with elaborate wrought-iron balconies, holding up a copy of the French newspaper *Le Figaro* high in front of her (fig. 3). The paper obscures the woman's face, but her pose suggests she is actively looking for something, giving the photograph a narrative quality. The lifted paper accomplishes other visual feats. First, it allows for the unimpeded consideration of her fashionable ensemble: checked dress, matching jacket, and dramatically belted waistline. Second, although the paper hides some of the architecture behind her, its height privileges a full view of the street on which the woman stands—the gray stretch of paving contrasting with her busy dress, a passing car, and a fellow pedestrian. The car is legible but blurred, as is the pedestrian's silhouette on the sidewalk opposite her, though a knee cocked in midstride is clearly discernible.

This is one example of more than a dozen photographs by Richard Avedon published in the October 1948 issue of a leading fashion-and-culture magazine of the era, *Harper's Bazaar*. Certainly, like most fashion photographs, this picture illustrates particular items of clothing, in this case an ensemble designed by Balenciaga. Against the grain of its time, however, it insistently places fashion—and the models who wore its latest creations—in the city, on its streets, and among fellow pedestrians and

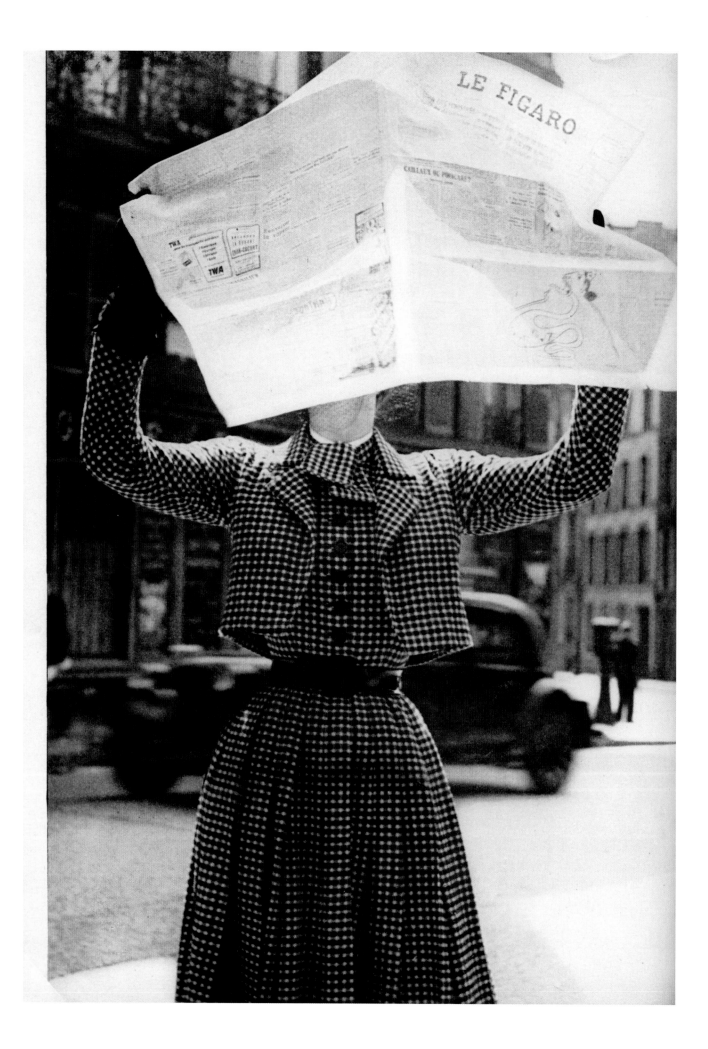

spectators. As such, this picture exemplifies the inventive claims Avedon staked in postwar fashion photography from 1947 to 1949, and the effective impact of staging street photographs.[1] In creating street photographs in service to the fashion industry, Avedon infused his images with romantic, nostalgic yet modern suggestions of daily urban life in Paris, exponentially heightening the relatability of his photographs and the viewer's identification with and desire for the products they represented in the pages of *Harper's Bazaar*. Rosalind Krauss has identified the double-page magazine spread as "the most opulent of the typographic theaters of mass advertising." Furthermore, "the very determination to fill both facing pages with a single image and to close the visual space of the magazine against any intrusion from outside this image/ screen is part of this strategy to create the reality effect, to open up the world of the simulacrum."[2] Avedon's process for his street photographs intended this exact "reality effect." More so than any of his predecessors or contemporaries, he dramatically transplanted the site of modern fashion's representation from the studio to the street, a move that was both timely and astute, given the economic and cultural effects of World War II and the American nostalgia and desire for Paris in the immediate postwar years.

FASHION PHOTOGRAPHY IN THE STREETS: PRECEDENTS

The decisive nature of the change initiated by Avedon's street photographs can be understood best by way of comparison with the types of images that preceded them. Fashion photography—that group of photographs whose chief purpose is the display or selling of clothing or accessories—came into popular use in Europe and the United States during the 1880s, flourishing alongside and because of the technological developments that enabled pictures to be easily, efficiently, and inexpensively reproduced in pattern books and periodicals.[3] One enterprising photography firm, Ed. Cordonnier, even began to record the latest fashions worn by society women to such outdoor events as the races. This formula of photographing women from the upper echelons of society—the supposed embodiment of refined elegance and "good breeding"—modeling their own clothes would continue well into the 1940s, made most famous by Baron Adolf de Meyer and Edward Steichen in the leading American fashion magazines, *Vogue* and *Harper's Bazaar*.[4] These photographs were not intended to capture the exact detail of the clothing as revealed by direct, even lighting; rather, they were created to evoke the mood and character of the garments, often through elaborate backdrops and dramatic lighting inspired by the modernist aesthetic of the day. The names of the socialite models in these photographs were printed in the accompanying captions. Most important for my purposes, photographs such as those by Steichen created and maintained a clear disinterest in such representations' ability to conjure real experiences or daily life. As Susan Kismaric and Eva Respini have written of this historical

FIG. 3. *Harper's Bazaar*, October 1948, p. 178 (detail). Photograph by Richard Avedon, Paris. Dress and jackets by Balenciaga. Modeled by Capucine.

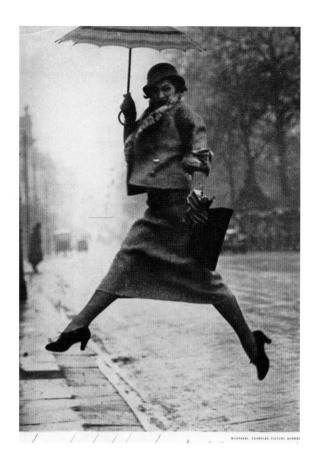

FIG. 4. *Harper's Bazaar*, April 1934, p. 92. Photograph by Martin Munkacsi. Model unknown.

moment, "Their primary function was to describe clothes as they appeared on the model conceived as mannequin, the human incarnation of the seamstress's dress form on which clothes are fitted. . . . Encoded in such hierarchical values is an implied system of power, morality, good behavior, stability and propriety, and even aesthetic and beauty, to which larger segments of earlier generations automatically aspired, or so it was thought. In these earlier pictures, the power of privilege is understood as absolute, as are the crisp and elegant standards of beauty that are integrated with it."[5] Fashion photographs by Steichen and the many who emulated his style throughout the 1920s and 1930s aimed strictly "to depict a supremely desirable garment worn by an archetypically desirable individual."[6] Even by the 1940s, this raison d'être had shifted little.

One outstanding exception was the Hungarian photographer Martin Munkacsi, who upended the convention of stiff poses, studio settings, and reliance on lighting effects during his first assignment for *Harper's Bazaar* in 1933. Munkacsi's signature style draws on the informality and spontaneity of snapshots: his photographs are animated, set outdoors, and often lighthearted (fig. 4).[7] Munkacsi was the first fashion photographer to consistently abandon the studio, favoring beaches, train stations, and a handful of other natural and architectural settings. He was also the first to ask his models to run, jump, and move during a shoot. Together, these innovations allowed his photographs for *Harper's Bazaar* to represent fashion in a manner so convincing and realistic as to make it look like something viewers might expect to see in their own snapshots. Editor-in-chief Carmel Snow recalled Munkacsi's first and most famous fashion photograph, made when he had not yet moved to the United States, spoke little English, and relied on gestures to convey his wishes to the socialite model Lucille Brokaw (fig. 5): "It seemed that what Munkacsi wanted was for the model to run toward him. Such a 'pose' had never been attempted before for fashion (even 'sailing' features were posed in a studio on a fake boat), but Lucille was certainly game, and so was I. The resulting picture of a typical American girl in action, with her cape billowing out behind her, made photographic history."[8] Munkacsi brought to fashion a style honed during the 1920s as he photographed sporting events on assignment, first for *Az Est* in his native Hungary and then for the *Berliner illustrirte Zeitung*.[9] The Brokaw photograph is exemplary of this style. She is depicted in midmotion, which accomplishes two effects simultaneously: it conveys that the subject was full of energy (an exuberant woman full of vitality), and it suggests that there was a reason for or a story behind the motion (her daily exercise routine).

Munkacsi effectively introduced both a modern momentum and a sense of narrative to an entire category of pictures—fashion photography—that had been lacking both of those qualities. He wanted to make images that would "respect the visual and emotional facts of life" as it was lived in the present.[10] Drawing on distinctly modern experience, Munkacsi emphasized movement and realistic nonstudio settings, opening the door for a more widespread audience to engage with fashion photography. Yet Munkacsi's style, in combination with the fashions it portrayed, proved resistant to formulaic application. As historian Nancy Hall-Duncan notes, "The realistic fashion photograph appeared in the thirties in Europe as well as America. The effects, which worked so well for American sportswear, however, looked somewhat lackluster when applied to Parisian haute couture, and the results are disappointing."[11] The "disappointing" European results lacked the animation that Munkacsi brought to his pictures as well as his sense of their engagement with a particular site.

That would change with Avedon's work in Paris, as evidenced by comparing two photographs taken at the Place du Trocadéro, one by Avedon and the other by his contemporary Jean Moral (figs. 6 and 7). Where Avedon used and occupied the site, Moral merely treated it as a set. While unquestionably depicting his model outdoors and walking through the plaza in the mode of Munkacsi's realism, Moral's photograph maintains conventions that hark back to a time before Munkacsi's innovations. The picture offers an uncomplicated view of the garment, giving attention to its every detail and to the accessories recommended to complete the outfit. Moreover, as a backdrop, the plaza is emptied of all other pedestrians and, quite significantly, of any information that would situate it in Paris. If Moral cared to locate his photograph there, he relied entirely on the efforts of the editors and designers at *Harper's Bazaar*, who would place the photograph just above the name of the coat's famous French designer, Dior, and discuss the innovations of its design in the accompanying column. Avedon's photograph, by contrast, centers on the Eiffel Tower, which he rendered out of focus, though not to such an extent that its signature silhouette is unrecognizable. Pedestrians,

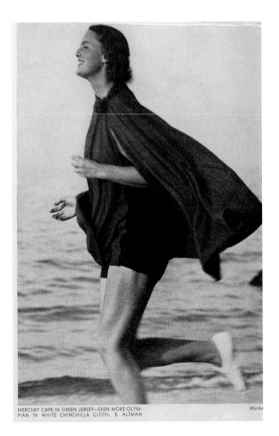

FIG. 5. *Harper's Bazaar*, December 1933, pp. 46–47. Photograph by Martin Munkacsi. Modeled by Lucille Brokaw.

MERCURY CAPE IN GREEN JERSEY—EVEN MORE OLYMPIAN IN WHITE CHINCHILLA CLOTH. B. ALTMAN

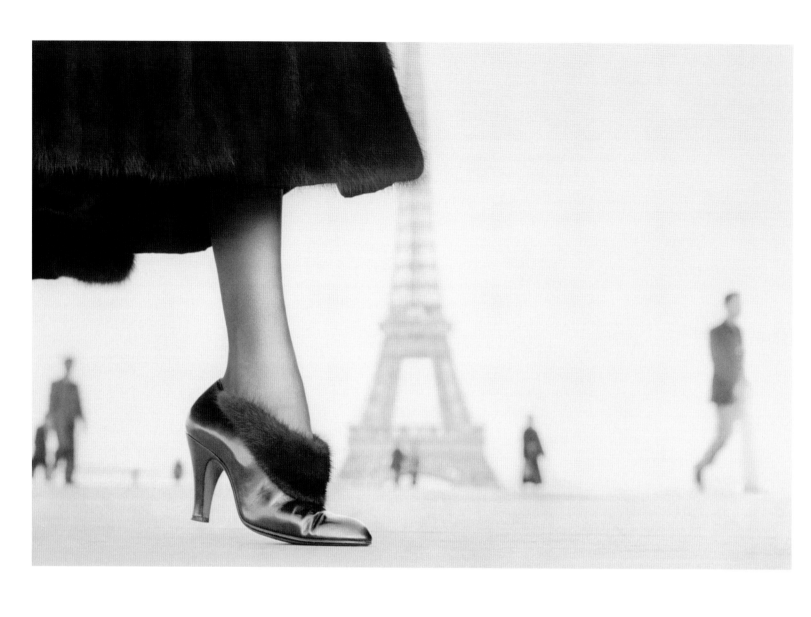

FIG. 6. Richard Avedon, *Shoe, designed by Perugia, Place du Trocadéro, Paris, August 1948.*

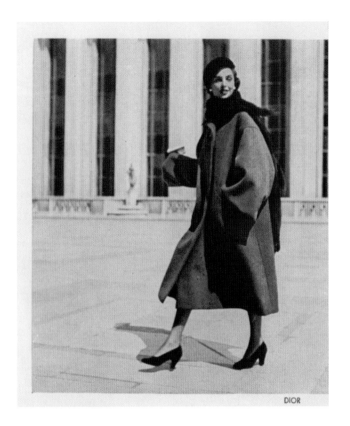

DIOR

FIG. 7. *Harper's Bazaar*, October 1949, p. 135 (detail). Photograph by Jean Moral, Place du Trocadéro, Paris. Coat by Dior. Model unknown.

also out of focus, traverse the plaza. The low vantage point indicates that Avedon set the camera down on the Place du Trocadéro in order to capture the step of another pedestrian, a woman wearing a fur-lined pump and voluminous skirt. The extreme close-up shot of the woman's foot and lower leg is in keeping with Munkacsi's unconventional views. Thanks to the photographic rendering and flattening of perspective, the shoe has become architecture—it is more prominent than the Eiffel Tower, even as it replicates its structure. In Avedon's photograph, a cultural and national landmark effectively transfers its status as *the* symbol of Paris to the shoe being modeled, which becomes an axis for modern urban lives full of motion. We can read the variously bent legs in the stilled strides of the pedestrians on the plaza, making it all the more significant that the shoe creases from the flexing momentum of the model's step. Avedon's representation of these fashions may not attend to the entire outfit, but it deploys a Paris icon and the momentum of the city to new and remarkable effect, transforming the street from a relatively generic and meaningless pictorial backdrop into a timely and desirable representation of modern urban life.

Avedon readily and repeatedly acknowledged that his street photographs were built on the foundation laid by Munkacsi. Avedon paid photographic tribute to him in 1957 (fig. 8) and penned a memorial tribute in August 1963, in which he recalled the impact of his childhood initiation to Munkacsi's pictures: "Because my family

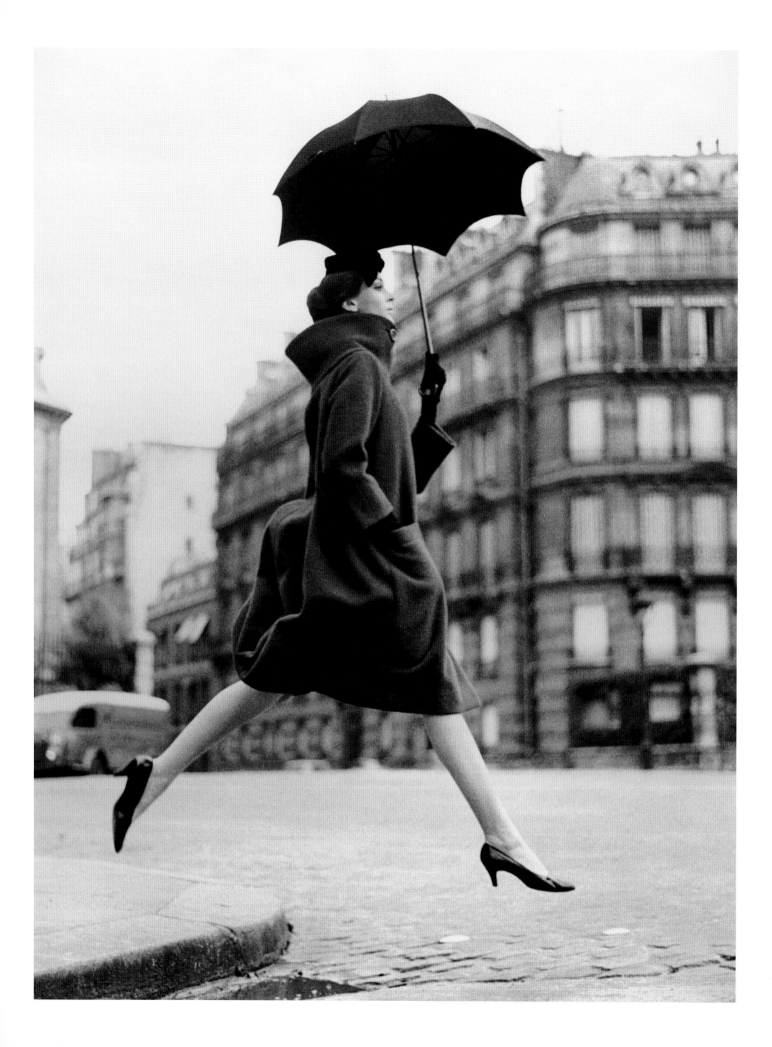

subscribed to *Harper's Bazaar*, it became my window and Munkacsi's photographs my view. There were over twenty of his pictures on the wall, buckling from humidity and home-made paste, . . . including *his women*, striding parallel to the sea, unconcerned with his camera, freed by his dream of them, leaping straight kneed across my bed."[12] Avedon's recollection conveys a sense of how surprising and inventive Munkacsi's photographs were to his 1930s audience. Like Munkacsi, Avedon rejected the model-as-statue fashion photograph and took real experience as his inspiration, as described by Hall-Duncan: "Comparing Munkacsi's famous photographs of girls running down a beach with Avedon's early work, we find a similar improvised and almost accidental quality achieved through blurred motion. Avedon's spontaneity is more orchestrated than Munkacsi's; it is a more complicated and sophisticated version of Munkacsi's innovations. Both share a mood of relaxed spontaneity, but while Munkacsi's origins as a sports photographer are always evident, for his women always remain sports-women, Avedon's models are in motion in quite a different way. They are filled with carefree exuberance and joyous abandon, with a love of life."[13] Hall-Duncan rightly points to a difference in their use of models, particularly the degree to which Munkacsi's models invoked the 1930s culture of health and fitness. Beyond models, however, Avedon distinguished his photographs by situating them *in* Paris—not against a backdrop of it. The viewer's familiarity with urban experience counteracted the unusual sight of a model in this setting, signaling a much-desired version of the city, without chaos or difficulties or, perhaps most tellingly, without any sign of the recent war and its effects.

Making photographs in the street to capture something of everyday urban experience was an approach that Avedon had appreciated even before *Harper's Bazaar* launched his career. He recalled seeing Helen Levitt's photographs at the Museum of Modern Art as early as 1943.[14] Jane Livingston, a preeminent historian of midcentury photography in New York, has written, "It is easy to see how Levitt's approach to photographing life in city streets—making each composition a self-contained piece of original choreography, [and] finding the unexpected in the ordinary . . . —would have struck a chord in Avedon."[15] In 1958 Avedon explained his relationship to street photography: "The trouble was that when I got out into the street, I just couldn't do it. I didn't like invading the privacy of perfect strangers. It seemed such an aggressive thing to do. Also, I have to control what I shoot, and I found that I couldn't control Times Square. . . . I began trying to create an out-of-focus world—a heightened reality, better than real, that suggests, rather than tells you."[16] In contrast to an increasingly codified street photography—Henri Cartier-Bresson's *Decisive Moment* would appear within a few years—Avedon's Paris photographs from the late 1940s emphasize the inspiration city streets afforded the young American photographer and are an unapologetic demonstration of street photographs as a controlled art, one that necessarily requires us to reconceive the work's process and eventual context.

FIG. 8. Richard Avedon, *Carmen (Homage to Munkacsi), coat by Cardin, Place François Premier, Paris, August 1957.*

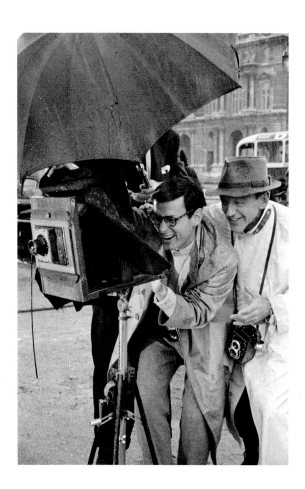

FIG. 9. David Seymour/
MAGNUM, *Richard Avedon and
Fred Astaire (as Dick Avery)*,
Tuileries, Paris, April 1956.

AVEDON'S PROCESS IN THE CITY

This or any assertion about Avedon's Paris street photographs relies on an understanding of how he planned, staged, and eventually photographed the models and locations involved. An effective point of reference is the classic 1957 Paramount film *Funny Face*, for which Avedon served as a special visual consultant (fig. 9).[17] Starring Fred Astaire as the fashion photographer Dick Avery and Audrey Hepburn as his newly "discovered" and reluctant model, Jo Stockton, *Funny Face* is in fact based on Avedon's early career in Paris. Some aspects of the film depart dramatically from historical and biographical facts: Paris is not a recently war-torn city; the French fashion houses are not desperate for renewed international support; Avery is not portrayed as a contemporary of Stockton's but is twenty-odd years older than Avedon was in 1957. Nevertheless, the film's portrayal of Avery at work in Paris matches written descriptions of Avedon's own method of making such photographs.[18] When Avery has a handful of days to photograph Stockton in Paris, we see him encouraging her with exclamations of praise, verbally creating narratives for her along the lines of "Your love has just kissed you goodbye," and instructing her to "Run!" across the Tuileries Garden.[19] Avery and Stockton act out photographic shoots in eight different locations. Most of them are unmistakably Parisian sites (the Tuileries, the Louvre, the Seine, and the Palais Garnier opera house) that Avedon had used for his *Harper's Bazaar* photo shoots in the late 1940s. To reinforce the viewer's possible familiarity with Avedon's photographs and to mimic the photographer's process from shoot to published image, each time Avery completes a shoot with Stockton, the screen becomes a sequence of photographic stills simulating the scene just shot in the film. (In contrast to the majority of Avedon's published photographs, those "by" Avery are shown in color.)[20] In these moments of *Funny Face*, Avery's/Avedon's photographic process is emphasized as one that begins in the street and finishes with imagining an eventual viewer.

New to Paris in the summer of 1947, Avedon was determined to represent French fashions as though casually observed on the streets of an iconic city. He elaborately researched, made detailed plans for, and even rehearsed his shoots of the major French couturiers' semiannual collections. (Assignment to the fall and spring Paris collections was intensely guarded and coveted, and Avedon would cover at least one, and sometimes both, for *Harper's Bazaar*.)[21] Avedon sought out potential locations, sometimes based on reading about their cultural significance, and he would often make sketches or take preliminary photos of them.[22] "Most of the pictures had a historical subtext," he later recalled, ". . . and I spent weeks before a sitting

documenting it with research and snapshots. Maybe the Marquis had raised a guillo-tine in a courtyard where I assembled a troupe of acrobats, scattered a bale of hay, and posed a model in a New Look suit."[23]

Once Avedon had selected his locations, he would pair them with the fashions chosen by Carmel Snow.[24] On site with his model(s), the featured fashions, and other subjects as the photograph's narrative premise required, Avedon's photo shoots risked—in ways that studio photography never did—revealing the designs to the public. While on assignment in locations throughout Paris, model Dorian Leigh recalled that "to protect the designers, we were wrapped in sheets wherever we went until we were in front of the camera."[25] That camera was most often a 2¼-inch Rollei-flex, such as the one Avery often has around his neck in *Funny Face*. (In the 1950s, Avedon increasingly adopted the stationary 8 × 10 view camera, also visible on the movie set [see fig. 9].)[26] Portable and most often held at chest or waist level so the photographer could look down into the viewfinder, the Rolleiflex allowed Avedon to move with his subjects during fairly animated shoots. Its 2¼-inch negatives retained more visual information than a 35 mm negative.[27] This was crucial, since Avedon frequently cropped his prints to achieve more rectangular proportions, closer to those of a vertical full page or horizontal double-page spread in *Harper's Bazaar*. He struck a balance between the quickness needed on the shoot and the quality of information desired during printing. His exceptional planning of details—from his conscientious location selection to camera choice and from the eventual photograph's imagined narrative to its presentation of the latest fashion designs—also extended to his choice of model.

Adam Gopnik has used the verb "cast" to describe the portraits that Avedon would become famous for in the 1960s.[28] Considering the process of Avedon's Paris street photographs of the late 1940s, I suggest these were also cast, since that verb implies both the sense that a sculpture is cast from an already prepared form (akin to his carefully selected locations) and that a model is chosen for a particular role in a performance (for his camera). Although an anonymous and unrecognizable model seems almost impossible to imagine today, it was the norm when Avedon began working with his models. Beginning in 1947, he repeatedly singled out particular women who spurred his creativity and with whom he worked almost exclusively (this is, more or less, the entire premise of *Funny Face*). Dorian Leigh, the first of Avedon's models to be widely celebrated, captured his attention for two or three years starting in 1948. She recalled that "Dick wanted his models to look like real people wearing real clothes; he wanted real expressions on their faces and genuine reactions to their surroundings. Of course, the girls were more beautiful and the settings more idyllic than most real-life situations, but that was the point. An Avedon fashion photograph was just real enough to make a fashion-minded woman feel she *could* look the way

the model did."[29] Along with Leigh, Elise Daniels was another preferred subject from about 1948 to the early 1950s, followed by Dovima.[30]

As photographed by Avedon, these women represented a startling revolution on the pages of *Harper's Bazaar* and for fashion photography in general, the apex of which for an early critic was a single photograph featuring Leigh (fig. 10): "Dorian Leigh was shown bursting into laughter while throwing her arms around the winner of a French bicycle race. The picture created a sensation in the profession, since embracing sports heroes and laughing had not previously been thought suitable activities for fashion models."[31] Avedon wanted his model to seem realistically engaged with the situation depicted, and he ensured that his lively exchange with the model during the shoot would create the spontaneous reactions he desired. To encourage their interaction with the location and narrative premise of the shoot, Avedon mimed desired poses to the models or urged them to run, laugh, then run *and* laugh, often while steadily chatting to keep their expressions from being static. The resulting photographs established a relatable model, what the critic had called "human," while never distracting from the couture she wore.

Reviewing these early fashion photographs, over fifty of which were included in the Metropolitan Museum of Art's 1978 Avedon retrospective, Roberta Smith wrote, "It's actually in his early work . . . that Avedon shows fashion photography at its most powerful, and brings it closest to art. These images, taken in Paris almost entirely in the seven years between 1948 and 1955, center on a race of emaciated, extravagantly beautiful women as they move through that city's streets, casinos, and cafes, elegant escorts often in tow. The street scenes, where these women sometimes encounter 'regular' people (an acrobat, a bicyclist), have a strange dissonance: they contrast quasi-documentary backgrounds with the sharp, darting stiffness of the models in their Dior abstractions—geometric skirts . . . rigidly belled out."[32] Smith rightly pointed to the disparity between the models and the other people in Avedon's photographs. By not fully exploring that disparity, however, she failed to extrapolate its likely effect on the readers of *Harper's Bazaar.* More important, in locating another incongruity between the "sharp" or "rigid" shapes of the models' garments and the depiction of the city's spaces, Smith reduced Parisian streets to backdrops like any other that Avedon could have deployed in his studio or that did not vitally represent Paris.

On his first assignment in Paris in August 1947, Avedon made photographs that matched the "New Look" fashions Dior was debuting. As Carol Squiers has noted in her essay on Avedon's years at *Harper's Bazaar,* the magazine had "not yet produced a drawing or a photograph that adequately conveyed what all the fuss was about."[33] To showcase the full cut of Dior's New Look skirts, Avedon photographed one such garment midtwirl to draw attention to its shape. One of these photographs (fig. 11) appeared in *Harper's Bazaar* in October 1947 with the model cropped above the waist,

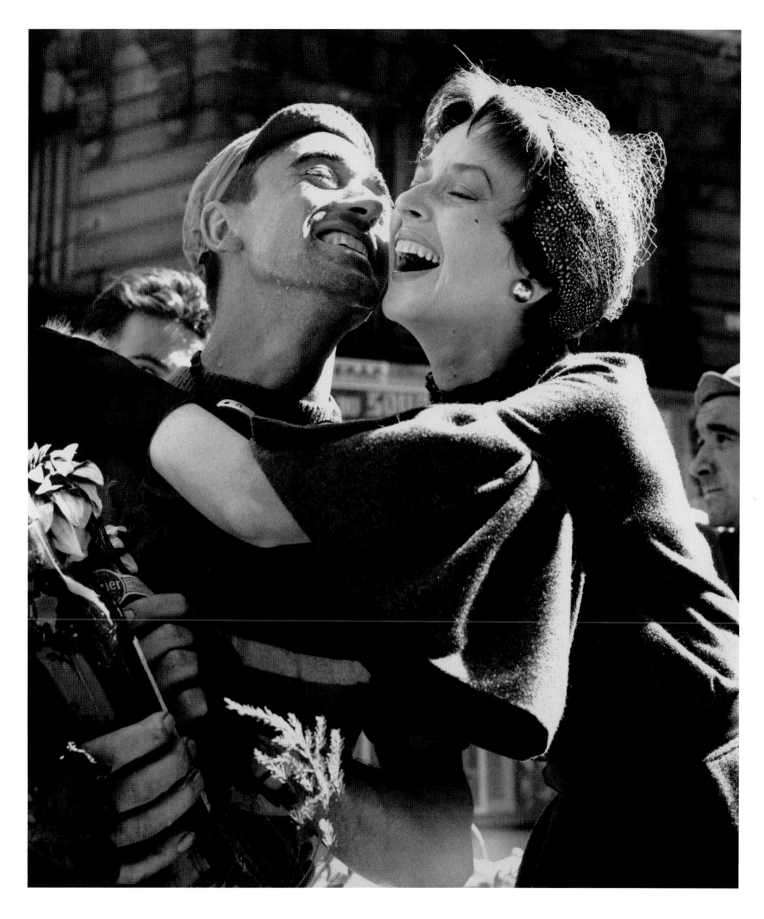

FIG. 10. Richard Avedon, *Dorian Leigh with bicycle racer, dress by Dior, Champs-Élysées, Paris, August 1949.*

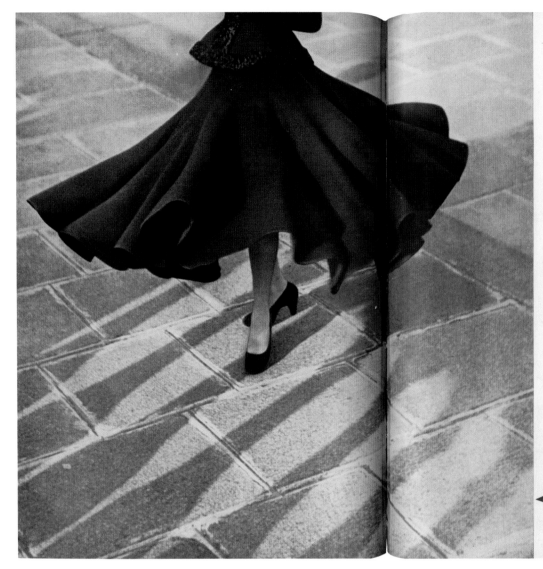

PARIS:
The New Fashion Is Traveling Fast

• Swirling skirts. Pleats and pleats. Models pirouetting in skirts twenty-five yards wide. Dior makes a skirt forty-five yards wide. Suits, day dresses, evening dresses—all swirling. • At most of the houses day skirts are twelve inches from the floor, sometimes even longer. There are several silhouettes. • You can be the Currier and Ives Skating Girl in a short fitted peplum jacket and an enormously full, swirling skirt. Or you can wear a Victorian combing jacket in bright plaid, with a pleatéd skirt. Or you can be a stringbean in a jacket with a tightly fitted peplum and a skirt so narrow it has to be slit eight inches for walking. Or you can acquire a sloppy elegance in a short, unfastened dolman jacket lined with fur or velvet, a little narrower at the bottom, always with fullness in back. These have straight skirts. • Three important coats: The lovely, romantic Cossack coat, tremendously full and longer in back, invariably collarless, with a border of fur all around and sometimes a lining of fur as well. The redingote, belted or fitted snug under the bust and cut in a princess line which exaggerates the fullness of the skirt. And the straight, ample long coat, without fastening. It is made in a two-faced wool in contrasting colors or plain and plaid. • Fur edges everything. Squirrel and mole are used for trimming and lining. There are charming fur tippets, little separate fur capelets to wear with dresses or suits. The revival of silver fox is fantastic. Leopard is divine with black or with green. • Green is the color of the season. All shades. Green velvets, jerseys, wools, taffetas. Every (Continued on page 293)

← • Opposite: Swirling enormously, the wide-open-umbrella skirt of Dior's brown wool suit, "Palais de Glace." Above it a tightly fitted basque jacket, with a little collar and a short peplum edged in a margin of brown Persian lamb. I. Magnin; Marshall Field.

RICHARD AVEDON

FIG. 11. *Harper's Bazaar,* October 1947, pp. 190–91. Photograph by Richard Avedon, Place de la Concorde, Paris. Skirt by Dior. Modeled by Renée.

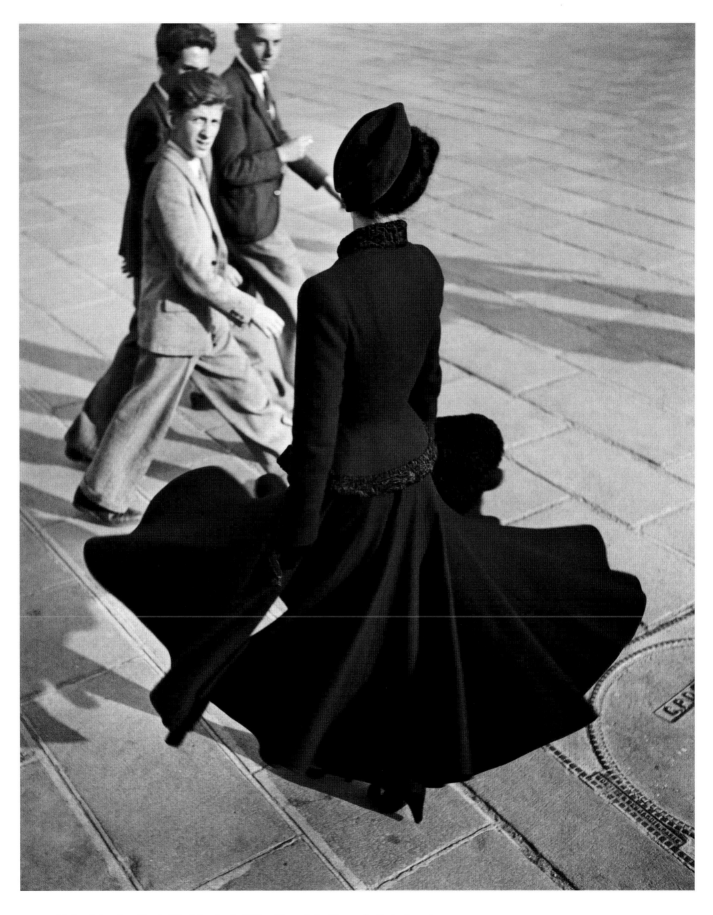

FIG. 12. Richard Avedon, *Renée, The New Look of Dior, Place de la Concorde, Paris, August 1947.*

thereby placing all emphasis on the sumptuous extravagance of the New Look skirt as it swirls aloft over squares of pavement. Another view of the same Dior ensemble (fig. 12), however, was Avedon's favorite; he included it in his 1978 *Paris* portfolio and in many other publications and exhibitions for the rest of his career.[34] Importantly, Avedon's preferred shot depicts the entire outfit, and it also grounds the model in a public space (the Place de la Concorde), where the stasis of a colonnade's shadow has been replaced by the animated diagonals of at least five other pedestrians, three of whom—young men in suits—turn midstride to observe the model. In a photograph published just one month later, the model wears a dark jacket that is tightly fitted to her waist above a flounce of gathered fabric and a full-cut skirt, also dark in tone (fig. 13). The ensemble's repetition of excess fabric, its contrast with the pale gray tones of the cityscape, and its depiction from behind all greatly emphasize its highly feminine silhouette. Avedon's photograph depends on his carefully selected dense urban surrounding, both in terms of tonality and content: the street-corner column for the display of posters known as a *colonne Morris*, the Parisian cobblestone, the cars, and city buildings.[35]

Avedon took his models to a variety of purposeful sites throughout central Paris: the Marais, the *quai* along the Seine, Montmartre, the Place du Trocadéro, the Place de la Concorde, the Champs-Élysées, Avenue Montaigne, rue François Premier, the Café de Flore, Pont Alexandre III, the Gare du Nord, and the Eiffel Tower. An exhaustive list of the public spaces Avedon used for his shoots would cover nearly every central arrondissement of the city (as well as a few of the outlying ones) and would represent an assortment of cultural, historical, and classed spaces rich with connotations.[36] Between the two world wars, Montmartre had been surpassed by Montparnasse as the city's artistic heartbeat; nevertheless, Montmartre retained some of the bohemian character it was renowned for in the 1880s and 1890s (see fig. 13). The Place de la Concorde, the site of Louis XVI's beheading during the aftermath of the French Revolution, remains the city's point of convergence during national celebrations or citywide public protests (see figs. 11 and 12). The Champs-Élysées represents a gem among Paris's many *grands boulevards*, the wide, open streets that were the result of the city's modernization by Baron Georges-Eugène Haussmann in the mid-1800s. Many of the major haute couture houses, including Dior, were located among the decidedly high-end shops, auto showrooms, and restaurants along the Champs-Élysées (see fig. 10). The Café de Flore was the meeting point for "writers and publishers and poets and philosophers and film people . . . evening after evening," as Carmel Snow declared in her first postwar report from Paris.[37] The Pont Alexandre III was built for the Universal Exposition of 1900, along with Paris's iconic Grand and Petit Palais (see fig. 24). And the Eiffel Tower was quite simply *the* symbol for Paris, so identifiable that Avedon could render it entirely out of focus and still capitalize on its meaning (see fig. 6).

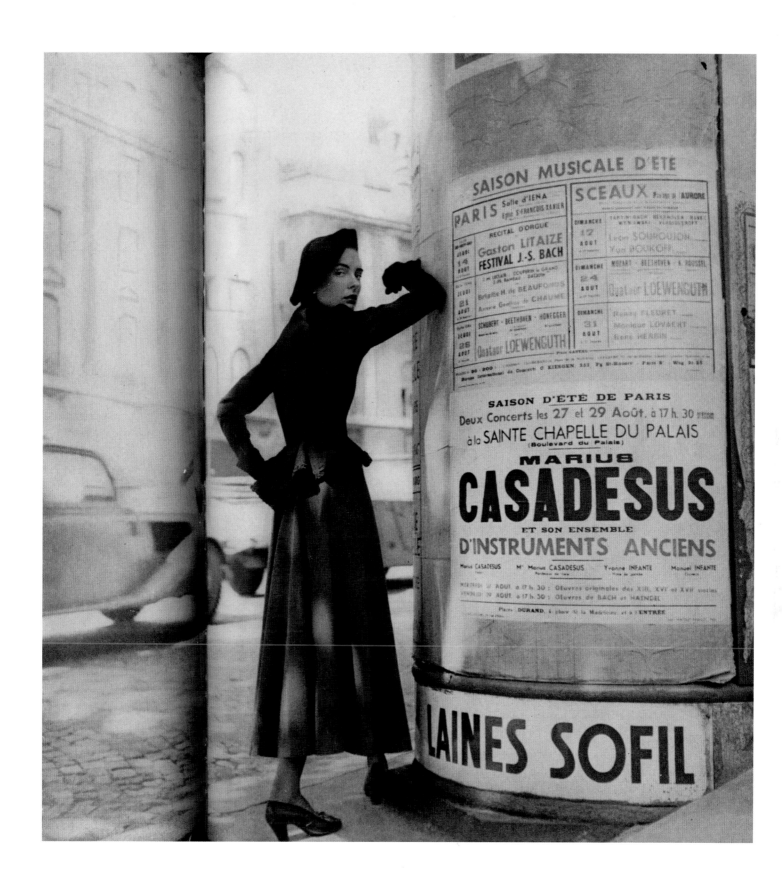

FIG. 13. *Harper's Bazaar*, November 1947, pp. 168–69 (detail). Photograph by Richard Avedon, Paris. Suit by Jacques Fath and beret by Maud Roser. Modeled by Doe Avedon.

Rosamond Bernier affirmed Avedon's attentiveness to his locations: "These photographs reflect his romance with Paris: the loving side-look at uneven paving stones, the worn surface of a wall, the curve of a café chair, the watery lights on a bridge, the siphon of soda water on a bistro table, the old-fashioned lettering on a shop front, the art nouveau arabesques over a doorway."[38] Once selected, these locations were often altered, enhanced, or manipulated for their eventual photographic representation: lights would be set up alongside a generator truck if need be, including the klieg lights most commonly used for cinematic sets and strong enough to create the effect of daylight even at night; cobblestones might be moistened to provide glistening atmospheric reflections; and, when necessary, the crowds were kept at bay by the French police.[39]

Avedon even chose to return to some locations such as the Marais, photographing within its intimate courtyards and historic streets in both 1947 and 1948.[40] In 1947 he created an interaction between the artist Christian Bérard and the model Renée on one of the Marais's cobblestone streets (see fig. 20). Bérard's perch on the gleaming front fender of a parked car underscores their presence on the street. Apart from Bérard's identity as an artist, another signifier of bohemian Paris is the *caves du vin* behind them, as indicated by the lettering just above Renée's left shoulder. (Not coincidentally, Jo Stockton ducks into a *cave* in *Funny Face*, searching for her favorite bohemian philosopher.) For Avedon's 1948 shoot, a courtyard in the Marais was transformed into an arena for a street performance by acrobats (see fig. 23). The intimacy of the space is created by a more or less rectangular arrangement of buildings, which Avedon conveyed by shifting the vantage point so that both lengths of the courtyard are shown between the two pictures. Yet he was careful to keep several stories of windows within the frame, ensuring the viewer's sense of a densely inhabited space and the admixture of centuries of urban planning and building that created the distinctive, complexly layered nature of Paris's most historical arrondissement.

Avedon's ingenuity with regard to his Paris locations has been attributed to a rather practical desire to "give a novel twist to what, owing to the coverage by the daily press, will be a familiar story by the time his photographs appear."[41] The French fashion houses debuted their designs at the beginning of August, when Avedon also photographed them. His pictures would then be worked into layouts that could appear in the September issue but more consistently appeared in the October issue, making for a standard two-month delay from shoot to publication. These practicalities worked against any immediate impact of the photographs' explicit subject: new fashions. So one may wonder why Avedon photographed the collections in Paris instead of having the clothes sent to the New York offices. Likewise, he could have easily shot the collections in his Paris studio rather than on location in the city.

Clearly, then, the in situ character of Avedon's Paris street photographs held value for both *Harper's Bazaar* and their photographer. Controlling his process, models,

and locations, he used the streets of Paris to create that "reality, better than real" in his photographs. This enterprise was facilitated by a city desperate to support his endeavors—lights, generators, wet cobblestones, police, and more—and their positive implications for French fashion. The site (and sight) of the city of Paris was also deemed significant by *Harper's Bazaar*, as part of its message to its readers. Avedon's undoubtedly Parisian photographs helped elicit the attention postwar Paris needed from the magazine's prosperous American readers. His street photographs were inextricably linked to the revitalization of French fashion and, by extension, of France itself. They conjured and relied on a postwar desire for Paris's particular combination of modernity, fashion, and nostalgia.

FASHION AND NOSTALGIA IN POSTWAR PARIS

In *How New York Stole the Idea of Modern Art*, Serge Guilbaut offers a succinct account of Paris's wartime occupation that vividly conveys the American reaction to the city's taking by German troops, the aftermath of its occupation, and the dismaying notion that such a cultural center could not or would not defend itself:

> When the lights went out in Paris, panic reached as far as New York and beyond into the American hinterland. The American press without exception lamented the abandonment of Paris to the Germans. Lost without a battle, Paris now suffered under the jackboots of the Nazis, but at least it had been saved from destruction. The city of light may have been protected by its culture, but this made it no less painful for American editorial writers to see the symbol of Western civilization calmly abandoned to "barbarism." Paris was occupied by German troops on June 14, 1940. For five years life came to a standstill, or rather it soon took another form, hushed, incomplete, half-hidden. Seen from abroad Paris was a ghost town. Americans saw in the fall of Paris the death of a certain idea of democracy. For them Paris stood for the triumph of individualism, for a free way of life made popular by the artists of Montparnasse.[42]

What had been lost was not simply one country's capital but the symbolic cultural center of Western society.

Postwar Paris exemplified a modernity that was, in many respects, no more than its wished-for representations. During the war and especially the occupation, Paris had been accessible to Americans only through its photographic depictions in newspapers, magazines, and newsreels.[43] Some of the most dramatic examples portrayed the liberation of the city in August 1944 (fig. 14). These signal images indicate an increased blurring of reality and representation, one that Guy Debord described in the opening sequence of his landmark 1967 book *The Society of the Spectacle*: "The whole life of

FIG. 14. Henri Cartier-Bresson, *Liberation of Paris*, August 22–25, 1944.

those societies in which modern conditions of production prevail presents itself as an immense accumulation of *spectacles*. All that was once directly lived has become mere representation."[44] In Debord's account, the spectacle not only characterizes modern society but also shapes it, being ever present and sought out during society's so-called leisure time.[45] The spectacle's almost always urban context supports and encourages its very forms: news, propaganda, advertising, and other modes of consumable entertainment. To the extent that fashion constitutes consumable entertainment, *Harper's Bazaar* employed all forms mentioned by Debord in its efforts to report, persuade, and promote various fashionable products to its readers. In this way, Avedon's Paris street photographs served as a kind of spectacle, superbly filling American longings for immediacy, romanticism, and a Paris where the war had taken no visible toll.

While many scholars have equated photography with modern vision, sociologist and visual culture historian Don Slater has particularly detailed photography's relationship to the modern spectacle, and his analysis is relevant to the discussion of Avedon's postwar *Harper's Bazaar* photographs:

> Ironically, if modernity is based on restricting "believing" to "seeing," on the idea that seeing is the only valid basis for believing, then it must constantly generate visual spectacles which inspire belief. . . . The modern injunction to believe only what one sees, then, confusingly coexists with awesome technical powers to produce convincing spectacles: the ability to transform appearances both in remaking the material world industrially and commercially, and in organizing technologies of representation which duplicate the world in realistic exactitude. . . . A realist film or novel articulates a representational world which

we can treat as plausible, as real, because the representations are internally consistent, coherent and the means of constructing the reality effect are hidden from view: we can treat the representation as a reality because it obscures all those elements which point to it being a representation.[46]

While photography has always been viewed as a "more than plausible" representation of the world, I contend that Avedon's street photographs create the reality effect Slater describes. Avedon made convincing but nostalgic representations of Paris that readers of *Harper's Bazaar* could believe in; he "obscur[ed] all those elements" that might have revealed their construction.[47] His spectacular and constructed street photographs were intended to induce viewers to believe in their depictions and to experience their reality effect. Of course, Avedon's presentation of "reality, better than real" in these photographs was also a representational denial of the war's effects on Paris. The implications of this broader social-historical context are borne out when we consider the more specific cultural and economic context within and against which Avedon made his street photographs: the postwar French fashion industry.

Haute couture, according to art historian Nancy Troy, was "one of the modern period's most important innovations in the production and social meaning of clothing."[48] In France, fashion generally and haute couture in particular had long been a major cultural export, earning Paris its reputation as "the international capital of style."[49] It rightly claimed the best designers of luxury garments, and the city maintained a commitment to the system necessary to support haute couture's production and sales. True haute couture is a distinct category of designs produced by fashion houses accredited by the Chambre syndicale de la couture parisienne. The most prestigious houses were required to produce no fewer than twenty-five designs every spring and fall; the largest houses often exceeded 150 designs in each collection, and Dior was certainly the most prolific, accounting for more than half of the total French haute-couture exports by 1955.[50] Naturally, World War II curtailed or shut down much of this activity.[51] Wartime clothing demanded inexpensive production, functional design, and adherence to restrictions that often limited everything from buttons to pockets to pleats.

Cutbacks in supplies and labor also affected fashion photography and the magazines it appeared in. The availability and expense of film, lights, props, models, and studio space quickly dictated new practices. For example, Condé Nast allowed his photographers to abandon the previously mandatory 8 × 10 view cameras that ensured infinite detail, and to instead use Rolleiflex cameras that were cheaper to buy and required smaller supplies of film.[52] And *Vogue* simply closed the doors to its Paris studio in 1940. More generally (in a context now flooded with daily reports of the latest casualties, battles, and air raids), fashion had to conform to wartime realities by

FIG. 15. *Harper's Bazaar*, June 1946, pp. 82–83 (detail). Photograph by Ronny Jaques.

addressing women's roles on the home front and featuring more frugal garments.

Keenly aware of the near-total absence of Parisian couture in important publications such as *Harper's Bazaar* since 1940, the Chambre syndicale de la couture parisienne conceived plans for an exhibition near the war's end. *Le théâtre de la mode* would display 230 exquisitely dressed dolls in elaborate sets, and its international tour was intended as a demonstration of the vitality of the French couture industry to its overseas consumers.[53] The fashions were created by designers at the major houses such as Lanvin, Schiaparelli, Balmain, and Lelong, and the sets were designed by artists such as Jean Cocteau and Christian Bérard. Significantly, a number of the sets represented Parisian street scenes or other iconic locations within the city (fig. 15). The catalogue for the exhibition declared that "France has suffered greatly from the war and the Occupation. . . . She has great difficulty in reconstituting her stocks, even for her personal requirements. But her creative genius is intact."[54] The exhibition opened in Paris just months prior to the city's liberation; immediately following, the Chambre syndicale toured it to major European cities such as Barcelona, London, and Stockholm, knowing that foreign support of French haute couture was an absolute necessity if the weakened industry were to survive. The exhibition's 1946 appearance in New York—where Avedon would probably have seen it—was in fact partially underwritten by American relief organizations.[55] The displays were photographed at the New York venue and subsequently featured in the June 1946 issue of *Harper's Bazaar*. Despite such publicity in 1946 and the first postwar collections by the major houses that spring, Parisian haute couture would not arrive in consistent, regular seasonal quantities until 1947, the year that Avedon first took his street photographs for *Harper's Bazaar*. Nevertheless, *Le théâtre de la mode*, in tandem with American magazine coverage by the likes of *Harper's Bazaar*, undeniably helped relaunch the French fashion houses.[56]

By August 1947, when Avedon traveled to Paris for the first time to cover the fall collections on assignment for *Harper's Bazaar*, the newly created house of Dior had debuted a bold set of designs, its New Look.[57] First appearing in February of that year, the New Look silhouette took full advantage of the design and material restrictions that had been relaxed or lifted following the war's end. During the war, trousers had become acceptable attire for women, as had boxy jackets, designs of military simplicity, and skirts falling just below the knee.[58] In contrast, New Look skirts for daytime wear often measured fifteen inches from the ground, and even less for afternoon or

evening wear.[59] Of the New Look's lush and lavish feminine designs, Dior commented, "We were emerging from a period of war, of uniforms, of women-soldiers built like boxers. I drew women-flowers, soft shoulders, flowering busts, fine waists like liana and wide skirts like corolla."[60] Soft shoulders were accomplished by dropping seams down the arm, while hips were emphasized not only by cinched waists and full skirts but also by padding placed under hip pockets.[61] Dior explained these changes as consumer driven: "It was because women longed to look like women again that they adopted the New Look."[62] A social and cultural explanation, however, is that the enhanced femininity of Dior's designs matched a demand for women to return to more traditional roles than those fostered by wartime activities.

Regardless of motivation, soon most Parisian designers were showing flowing capes, cloaks, and coats above tightly cinched waists and full, voluminous skirts with longer hemlines. This new turn in fashion, however, did not come without some controversy: "The 'New Look' was more than just a fashion," Hall-Duncan writes. "The yards and yards of cloth required for Dior's silhouette, following the enforced poverty of the war years, prompted street riots in Paris. The implications were so controversial that models wearing the new style actually had the gowns ripped from their bodies."[63] In addition to blatantly rejecting material restrictions, these new fashions emphasized femininity and refinement, two less tangible qualities that the practicalities of wartime had logically ignored or overwhelmed.

Writing on the first postwar Paris collections in 1946, Carmel Snow captured the general mood in a trademark string of verbal snapshots that soon became a recurring feature entitled "Notes from Paris" (fig. 16):

> These are the first spring showings since the end of the war and the designers have made a tremendous effort. I love France, and I must say that I was a little anxious for them. Everything is so difficult—the shops aren't heated, the workers are undernourished, the political situation is very tense. Nevertheless, this is a very different city from the Paris I saw a year ago. There are cars on the streets and a few buses. And the fashions are wonderful.
>
> [The fashions pictured here] take you to Paris, not to the newsreel Paris of disillusion and political unrest, but to the Paris of the designer's dreams. . . . One can no longer say, "French fashion for the French and American fashion for the Americans." Fashion is fashion. In spite of the fact that they have been cut off for six years and that very few American films are playing in France today, the French designers have got the feel of America. . . . It seems inevitable that we, on our side, will again feel a strong French influence in our American fashions.
>
> Naturally, very few Frenchwomen can afford such prices [$250 was the average price for a dress from a major house that year]. In fact, there are very

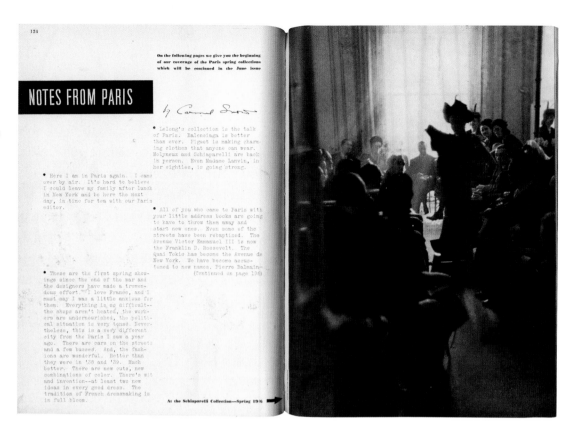

FIG. 16. *Harper's Bazaar*, May 1946, pp. 124–25. Photograph by Henri Cartier-Bresson, Schiaparelli Collection, Paris.

few places in France where the naked evening gowns can be worn. But France needs machine tools and farm implements and tractors. In order to buy abroad she must export, and fashion is one of her greatest export products. The success of these spring collections is important to France. Even government people ask me anxiously what I think of the collections. If you've been wondering why luxurious fashions are made in a city where almost everyone is hungry more of the time, that is the answer.[64]

While Snow offered her reader images of a rebounding Paris (represented by activity in the streets) despite difficult conditions (lack of food and heat), she also made absolutely plain the stakes of the fashion showings by directly linking them to France's ability to maintain its newly bustling streets and to farm its land in order to feed a hungry nation. This language of hunger and satiation recurred throughout accounts of postwar France, because it described a physical condition of so many as well as an appetite for consumer goods from hosiery to automobiles, a product of the country's restricted and recovering market.[65] Snow's notes explain why she, and thus *Harper's Bazaar*, was there to cover the fashion collections, what these fashions could offer American designers and consumers, and what, in exchange for pursuing and purchasing those fashions, would be provided to the French economy and spirit.[66] Snow's "Notes from Paris" did more than describe a new cut to sleeves or skirts; it made those sleeves and skirts seem not only desirable but also necessary.

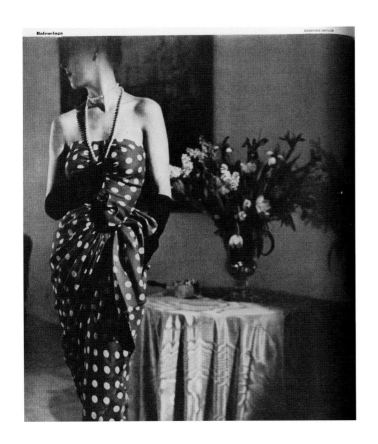

Balenciaga

FIG. 17. *Harper's Bazaar*, May 1946, p. 128 (detail). Photograph by Genevieve Naylor, Paris. Dress by Balenciaga. Model unknown.

The year between Snow's first postwar report and Avedon's arrival in Paris had not lessened the cultural and economic stakes. Daily conditions for the average Parisian were not much improved by the summer of 1947. Nevertheless, Avedon instigated a new approach to the photographic coverage of the collections, one that would contrast sharply with the stiff, old-fashioned, backlit studio photographs by Genevieve Naylor that had appeared alongside Snow's column in the May 1946 issue (fig. 17). Whether taking a cue from Snow's descriptions of the activity on Paris's streets, from his longstanding admiration of Munkacsi and Levitt, or simply from his own awe at experiencing the city for the first time, Avedon began to make photographs that resounded with urban energy and heralded a New Look of their own. Never explicitly political but also aware that "fashion photography does not exist in a political vacuum,"[67] he created images that project a carefree and charming life, counter to the war-weary existences of most Parisians, if not most Americans. His street photographs for *Harper's Bazaar* identifiably situate this blithe lifestyle in the city that had defined modernity and fashion for Americans, answering the questions that the war and occupation had posed about Paris's current and future standing as an international cultural capital. Avedon's pictures anticipate a more full-blown affection for all things French in 1950s America.[68]

Before seeing Paris for the first time in 1947, Avedon had known it only through its photographic and filmic representations, an "accumulation of spectacles," in Debord's terms.[69] Avedon himself recalled being struck by the discrepancy between, on one hand, the women and the vision of Paris presented in his photographs and, on the other hand, the different realities of the two: "Well, of course, nobody was dressed like that in Paris and nobody looked like that in Paris, and I had no idea what people who dressed like that looked like. So I made it all up out of my own imagination which had been influenced by early films, pre-war films. And these pictures are really a fantasy on the part of a very young photographer who was seeing Paris for the first time and trying to fill it with what everyone's dreams were and his own dreams were."[70] There is no question that he understood how this "fantasy on the part of a very young photographer" served the task of his pictures made on the streets of Paris. His willingness and desire to render Paris nostalgically went hand in glove with the larger goal of *Harper's Bazaar* in those specific years. Avedon made this plain in a 1995 transcript, when he recalled that there was a "mandate from Carmel Snow to help the French economy by bringing back the glamour of pre-war Paris. . . . It was my job to do it."[71]

These recollections illuminate Avedon's awareness of not only the mandate from *Harper's Bazaar* but also the real incongruities between what he was seeing in Paris and what he wanted and needed to picture there. I believe his photographs contain a similar ambiguity in his choice to portray women in New Look fashions—with all their social and cultural connotations of traditional femininity—as active occupants of urban spaces, occasionally interacting with other pedestrians. On the other hand, such complexities in the pictures may be best explained by Avedon's photographic suppression of the war's effects on Paris. Avedon's street photographs for *Harper's Bazaar* place the New Look in a Paris that is prewar—or, more accurately, *non*war, in the sense that Paris appears as though the war and its resulting hardships never happened. Both locations and fashions are thus nostalgic, grounded in the past but presented as both timely (the New Look) and urgent (as detailed by Snow's mandate). Avedon, the young American photographer seeing Paris simultaneously with romantic nostalgia and for the first time amid postwar deprivations, had his finger on the pulse of American desire. His photographs respond to the complex demands of those years, particularly when their appearance within the context of the magazine is fully considered.

THE PHOTOGRAPHS' APPEARANCE IN *HARPER'S BAZAAR*

Throughout the middle of the twentieth century, *Harper's Bazaar* and *Vogue* reigned as the leading magazines of the fashion business. The "trinity" at *Harper's Bazaar*, as Avedon affectionately dubbed it, comprised editor-in-chief Snow, fashion editor Diana Vreeland, and art director Alexey Brodovitch.[72] All three of them contributed to revolutionizing and modernizing the magazine's look and content until it was considered the most sophisticated and original fashion-and-culture magazine of its day.[73] Snow's early conviction about Munkacsi's animated photographs and Brodovitch's complete overhaul of the magazine's layout, typography, and use of photographs were further enhanced by Vreeland's belief that fashion was about desire, not need: "One cannot live by bread alone. One needs *élan*, chinchillas, jewels, and the touch of a master designer, to whom a woman is not just a woman but an illusion."[74] Vreeland believed strongly in fashion photography's role as a visual catalyst for that desire: it "has the basic necessity of showing every line, seam, and hemstitch in a dress. Avedon managed to infuse that kind of photograph with a sense of motion, life, and mood."[75] In turn, Avedon credited her with the magazine's inspired fashion coverage. Nevertheless, for many, Brodovitch's art direction was the most conspicuous and prominent feature of *Harper's Bazaar*.[76] He replaced stiff and boxy layouts with designs that stretched and careened across double-page spreads. He employed bold typography and photographs that bled off the page or ran across the gutter, were startlingly cropped, or arranged on the page in unexpected ways. A spread from October 1934 (fig. 18), reporting on the winter 1935 collections, includes elements of his distinctive graphic

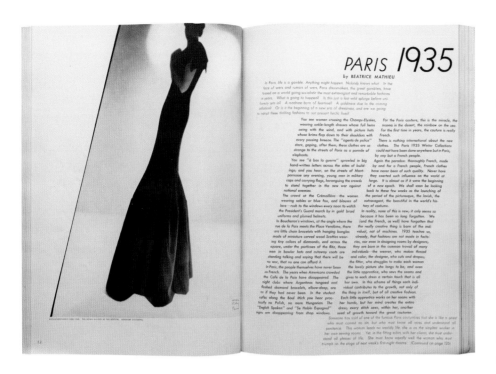

FIG. 18. *Harper's Bazaar*, October 1934, pp. 52–53. Photograph by Man Ray. Model unknown.

design: the photograph has been cropped in a trapezoidal shape; the typeface's angularity and the "tilted" text column itself mirror the lines of the image; and the negative space on the pages adds visual balance and relief.

A spread published in *Harper's Bazaar* represented the culmination of an entire process. Consider the appearance of Avedon's photograph of the Perugia shoe (fig. 19). First Vreeland selected the shoe, among other fashions, and then Avedon went about creating his desired shoot. The resulting photographs were sent to Brodovitch, who chose which ones to publish, often in conversation with the photographer. The selected images would then be cropped (if necessary), printed to scale, and arranged within a layout, in this case a full bleed across two pages, which served as the opening spread to the issue's coverage of the French fall collections. The display text—"PERUGIA'S BRONZE KID SHOE / EDGED WITH MINK / Shown in the Dior Collection. / Custom-made, I. Miller."—announces the topic as boldly as the shoe dominates the spread, but it never interferes with or encroaches on Avedon's photographic effects of blurred pedestrians and low vantage point. Brodovitch believed that the best graphic design always responded to and worked from the images; his stimulating, supportive, and collaborative presence at the magazine initiated and sustained an era of unsurpassed photographic quality.[77] With photographers such as Avedon, whom he hired in 1945, Brodovitch negotiated the transformation of the original image into the visual anchor of a magazine layout.[78]

As Brodovitch's most avid protégé, Avedon made photographs always attentive to their eventual appearance on the magazine page. Willing to experiment with proportion, cropping, and size, he appreciated the malleability of a photograph's meaning depending on the surrounding information or the choices made in taking, printing, and presenting it: "The minute you pick up the camera you begin to lie—or to tell your own truth. You make subjective judgments every step of the way—in how you light the subject, in choosing the moment of exposure, in cropping the print. It's just a matter of how far you choose to go."[79] His subjective judgments made throughout his process responded to the eventual published magazine spread. To ensure that the tonality of the fashions pictured would be legible, he considered how the tonality of a chosen location would appear in a final layout as either more white (sky or open spaces), gray (most architecture or foliage), or black (night or certain

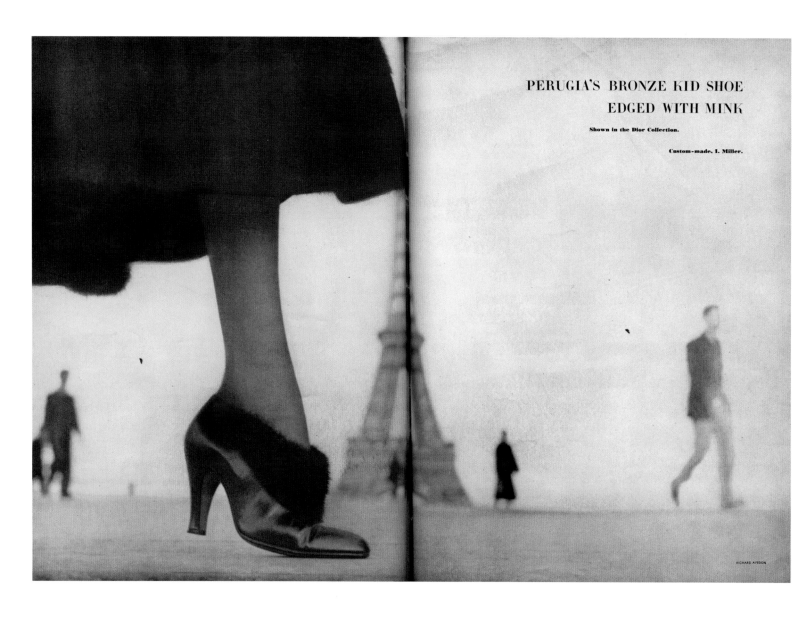

PERUGIA'S BRONZE KID SHOE
EDGED WITH MINK

Shown in the Dior Collection.

Custom-made, I. Miller.

FIG. 19. *Harper's Bazaar*, October 1948, pp. 160–61. Photograph by Richard Avedon, Place du Trocadéro, Paris. Shoe by Perugia. Model unknown.

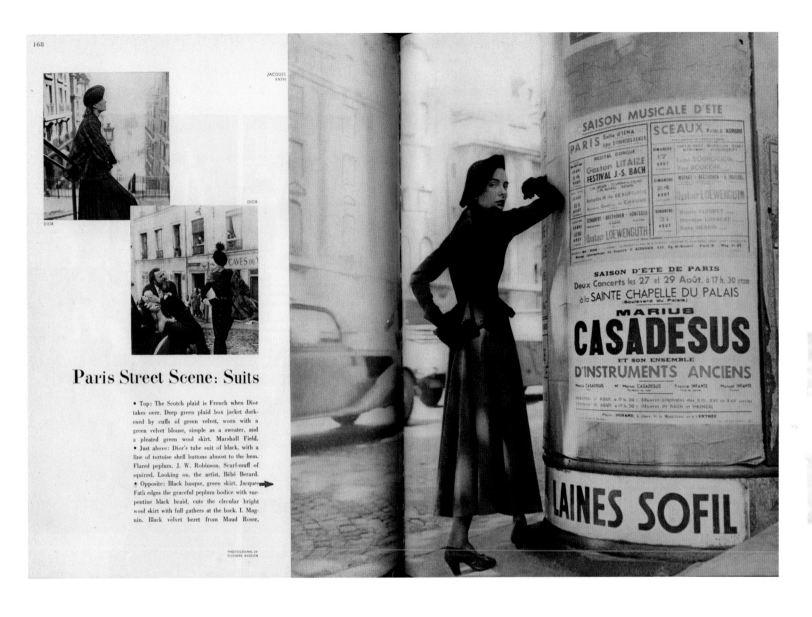

FIG. 20. *Harper's Bazaar*, November 1947, p. 168–69. Photographs by Richard Avedon. Suits by Dior and Jacques Fath. Modeled by Doe Avedon and Renée.

interiors). For almost all his early Paris photographs, his preferred background tonality was either gray or black.[80] Before releasing the shutter, Avedon knew the cut of a dark-toned suit would stand out sufficiently against the grays of a Parisian *colonne Morris* (fig. 20). He used a shallow focal plane to call attention to the fashions on display and to formally emphasize the urban movement behind them (see figs. 3 and 6). These decisions in anticipation of the final published appearance contributed immensely to Avedon's goal of "heightened reality, better than real." For similar reasons, he skillfully managed and adjusted his Paris street photographs, ensuring that the model would always be noticed—not in spite of the other elements in the picture, but rather because of them.

The success of Avedon's *Harper's Bazaar* photographs always required that the viewer be able to distinguish those wearing the objects of desire. The model's appearance, or legibility, depended not only on her surroundings but also, when applicable, on the representation of other figures present in the frame with her. One example, appearing on the page facing the photograph of the woman holding *Le Figaro*, uses tonal disparities, blurred background, and accompanying figures to draw the viewer's attention to the model and her garments (fig. 21). The dark shapes of the outfit on the model at the far right of the spread, complete with a sleek, gloved hand, seem silhouetted against the ranges of gray around it. Similar tonal impact purposefully directs attention to the model seated on the left, in spite of her turn away from the camera and her outfit's obstruction by elements in the foreground. Facing her, looking directly at her in fact, a third woman is caught midstride. Avedon's blurring of her features and clothing indicates that she is not a model but rather a part of the life of this street or courtyard; her presence is echoed and intensified by another figure in the distance who leans against a doorway. Another, perhaps the most banal, example of Avedon's effort to make his model recognizable is his inclusion of men in the frame, as in the *Harper's Bazaar* spread featuring Dorian Leigh congratulating the victorious French Tour de France team (fig. 22). As a group, the men enthusiastically turn their attention to her, thereby subtly suggesting and echoing the direction of the viewer's own gaze.

Avedon's negotiation of a model's relationship to a crowd sometimes offers a more visually complicated example, as when he photographed two models watching acrobats perform along with a crowd of onlookers (fig. 23). Smiling in the direction of the strong man with his barbell hoisted high, the woman in the larger of the spread's two images is positioned near the center of the performance, set off from the shoulder-to-shoulder line of people behind her. She leans on the table placed between members of the troupe, her dark-gloved hand contrasting with the tabletop, as do her dark pumps against the paving stones. The line and elegance of her outfit and hat are all the more striking when compared with the other female onlookers. In the image on the left of the spread, a model stands near the center of the performance area,

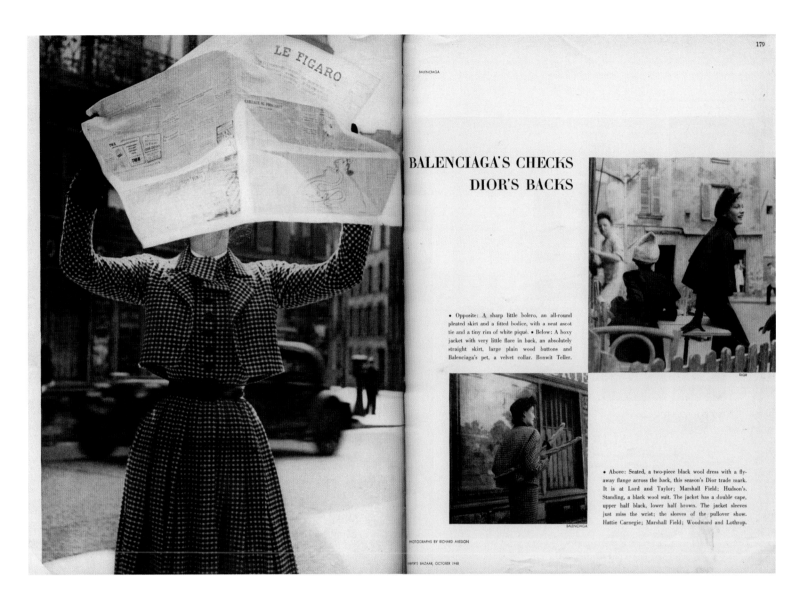

FIG. 21. *Harper's Bazaar*, October 1948, pp. 178–79. Photographs by Richard Avedon, Paris. Dresses, jackets, and skirts by Balenciaga and Dior. Modeled by Capucine.

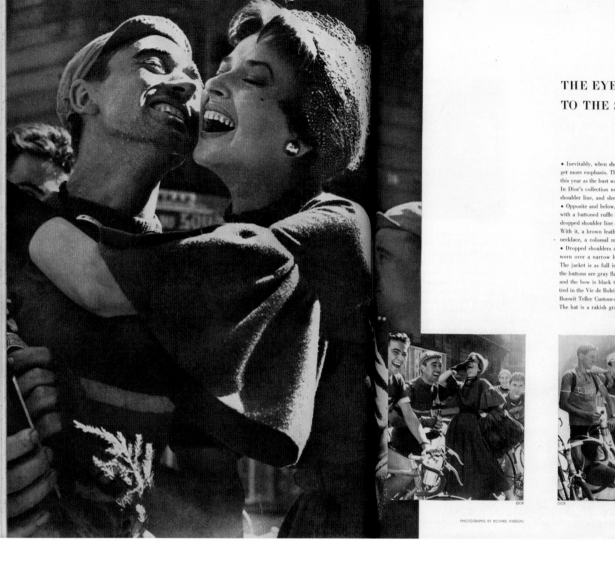

THE EYE TRAVELS
TO THE SLEEVE

• Inevitably, when shoulders are dropped the sleeves
get more emphasis. The sleeve is as important
this year as the bust was a year ago.
In Dior's collection not a single dress has a normal
shoulder line, and sleeves are very important indeed.
• Opposite and below, left, Dior's gray flannel dress
with a buttoned ruffle below the
dropped shoulder line and a skirt that is almost all flounce.
With it, a brown leather belt, an ebony
necklace, a colossal muff. Hattie Carnegie.
• Dropped shoulders again on a Dior gray flannel jacket
worn over a narrow black skirt.
The jacket is as full in back as in front,
the buttons are gray flannel with metal rims
and the bow is black taffeta.
tied in the Vie de Bohème manner.
Bonwit Teller Custom-made Salon.
The hat is a rakish gray velvet jockey cap.

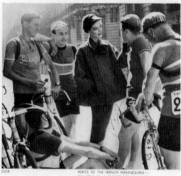

PHOTOGRAPHS BY RICHARD AVEDON

FIG. 22. *Harper's Bazaar*, October 1949, pp. 136–37. Photographs by Richard Avedon, Champs-Élysées, Paris.
Dress and coat by Dior. Modeled by Dorian Leigh.

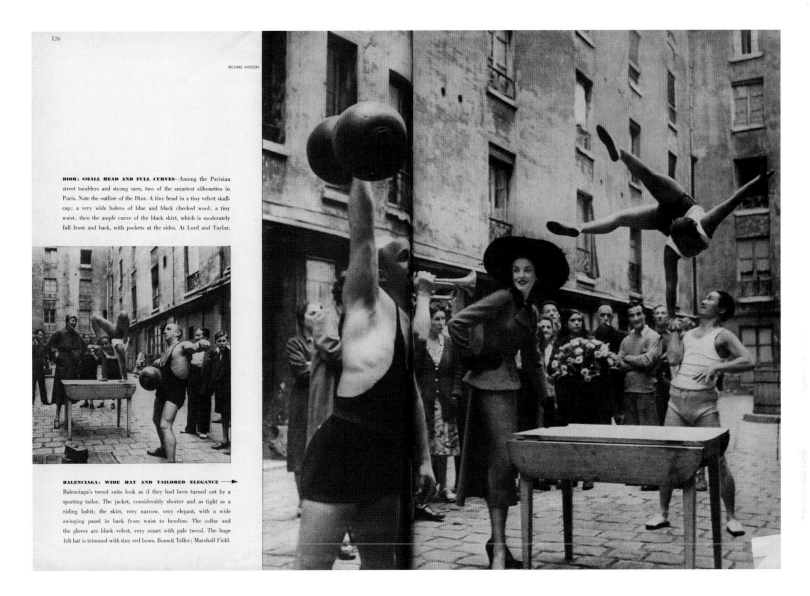

FIG. 23. *Harper's Bazaar,* October 1948, pp. 176–77. Photographs by Richard Avedon, Le Marais, Paris. Fashions by Balenciaga and Dior. Modeled by Elise Daniels and an unknown model.

physically apart from the loose semicircle of people behind her. In the larger image, Avedon positioned Elise Daniels near the acrobats, set off from the fairly orchestrated linearity of the shoulder-to-shoulder gathering. The clothing of one female onlooker, placed just in the gap between Daniels and the strongman, offers a striking visual point of comparison, her long cardigan and barely gathered skirt differing substantially from the fitted shape and distinct line of the Balenciaga suit. One writer characterized it as the contrast between "earthy" and "ethereal," "plebian" and "aristocratic," but this is too simple and polarized.[81] Instead of a model-as-goddess presentation (or its earlier incarnation, the socialite model), Avedon offered up models who, though still glamorous, are more believable and relatable. In part he accomplished this by situating them on the streets of Paris, but he was also careful to attend to, and even emphasize, such distinctions as the woman in the cardigan.[82]

A version of this same distinction existed within the machinations of the fashion industry itself. Haute couture involved creating the most exclusive and expensive women's clothing, available to department stores as made-to-order fashions, particularly as a means of reaching the foreign consumer base that supported this important national export. In fact this information was part and parcel of what *Harper's Bazaar* conveyed to its readers; on pages 176 and 177 of the October 1948 issue, captions indicate that the Balenciaga and Dior suits featured were available domestically at Lord and Taylor, Bonwit Teller, and Marshall Field's (see fig. 23). (Notably, North American commercial buyers such as these were the first and most privileged viewers of the spring and fall postwar collections, ahead of European commercial buyers, who were themselves ahead of most private clientele.)[83] At their core, the photographic representations of distinctions in fashion relied on a viewer's subtle recognition of class differences, as played out in publicly accessible urban spaces of Paris. Avedon clearly preferred fewer removes between the imaginary life of the women in his photographs and the identification with that life on the part of *Harper's Bazaar* readers. Accordingly, at this time he most often chose to shoot a glamorous model on the city's streets, in its plazas, and enjoying its courtyards and sidewalk cafés, helping achieve that sought-after "heightened reality." His pairing of the model's outfit—the very reason for the photograph—with the location continually anticipated the eventual visual appearance of both his subject and site before the readers of *Harper's Bazaar*.

Both at the level of Avedon's making of the photographs and of Brodovitch's later arrangement of them within the magazine, the engagement of the magazine's readers hinged on the narrative qualities these images inspired. Avedon, for his part, created and told stories during the shoot and often directed the model's gaze and gestures. His stories might have encouraged her to look over her shoulder or up as if she had suddenly become aware of something (see fig. 13), or she might smile in acknowledgment of another person (fig. 24). In this latter image, the model's pose—

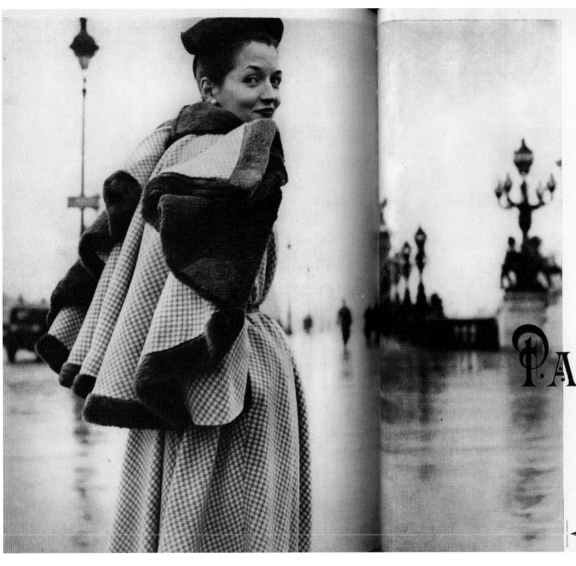

• There is really no new silhouette—rather there is a new interpretation of the silhouette launched a year ago. To launch the new shape Paris had to exaggerate; now that it is accepted, clothes are less "cocotte," infinitely more wearable and distinguished.

Skirt lengths have not changed. For simple day dresses, about 12 inches off the floor; for later afternoon, 10 inches; for short dinner dresses, 8 inches. Ninety per cent of the evening dresses clear the floor in front but dip and sweep toward the back.

Waistlines are usually at *the natural waist,* but at Balenciaga's, they tend to mount in front almost to an Empire line, dropping in back to normal.

The main changes: *No more padded hips* though the roundness of hip-line continues. More pleats than we have ever seen. At Dior's, *a complete redistribution of fullness.* In the evening he holds the fullness flat over the stomach, releasing it low in front, lower in back; or he makes a straight skirt caught up at both sides, or catches the fullness up in front, or pulls the fullness tightly to one side. *The straight line* is surely coming back, but a skirt is seldom straight all round. When a Schiaparelli suit walks toward you the skirt seems straight; when it turns its back, through pleats or a bias swing, it has motion and interest. *Emphasis is always at the back,* never over the stomach. *Bows, bustles,* and *sashes* draw the eye backwards. The most wearable: A large Manet bow placed at the back of a windblown evening skirt, about fifteen inches below the waist. The most preposterous: Fath's huge pouf, plumb center back, just below the jacket of a tailored suit.

COATS: *Balenciaga's high-waisted coat* is the newest coat in Paris (see next page). It seems straight in front, but in back it has a Kate Greenaway effect due to three deep pleats that release fullness well above the waist.

(Continued on page 212)

← Fath's Palatine—Checked wool with a patent leather belt and a detachable nutria-lined cape

FIG. 24. *Harper's Bazaar,* April 1948, pp. 124–25. Photograph by Richard Avedon. Dress and cape by Jacques Fath. Modeled by Maxime de la Falaise.

hands in her skirt's pockets, elbows cocked out to her sides, her head turned over her right shoulder—accentuates the voluminous, fur-trimmed folds of her cape; the sculpting of the cape also mirrors the architectural embellishments of the fixtures on the Pont Alexandre III. Avedon's structuring of narrative and his building room for its elaboration and continuation created images that allowed for engagement and projection. As Roland Barthes noted in his book *The Fashion System*, clothing is essentially a form of signification, and fashion is a cultural language through which meaning is constructed. Thus, "*Doing the shopping* is no longer impossible, or costly, or tiring, or troublesome, or disappointing; the episode is reduced to a pure, precious sensation, simultaneously tenuous and strong, which combines unlimited buying power, the promise of beauty, the thrill of the city."[84]

Avedon's on-shoot decisions, anticipating the eventual audience for his photographs, were reinforced by the magazine layouts and sequences devised by Brodovitch. The art director often used two photographs recognizably made in the same location—where a change in the model or the outfit depicted constitutes the significant difference—suggesting that either time or pedestrians had passed between the taking of the two pictures. The spread featuring two photographs of the street circus performers in the Marais (see fig. 23) accomplishes this effect. To different ends, so does Brodovitch's arrangement of a double-page spread reproducing photographs Avedon took in front of some *affiches* (posters) on Paris streets (fig. 25). An intervening image appears between two shots of a model posed in front of the same backdrop. The effect suggests not only that time has passed but also that the models themselves are passersby, pedestrians we would expect to pass before the street posters. Brodovitch also used multiple photographs of a single model that were sequenced to suggest a series of moments from the same event, as in the three photographs of Dorian Leigh and the Tour de France team (see fig. 22). On the left spread, Leigh is shown close-up, ecstatically embracing a single rider. The next photograph, moving left to right across the spread, depicts her still laughing but from a greater distance, in order to encompass three more riders perched on their bicycles. In the final image the euphoria has passed, and the riders have dismounted to converse with her on the sidewalk of the Champs-Élysées. The overall effect suggests a time-based shift from the immediacy of a first encounter to a stilled gathering for polite conversation; a narrative unfolds across the layout of the pictures. In all these ways, Avedon's photographic allowances for narrative anticipated Brodovitch's decisions as art director that would reinforce the narrative, thus giving viewers the strong sense that something had happened just before, just after, or in between the moments presented on the printed page.

Photography's indexical relationship to the actual world and widespread faith in its unerring referentiality has ensured that, whenever a photograph is viewed, that

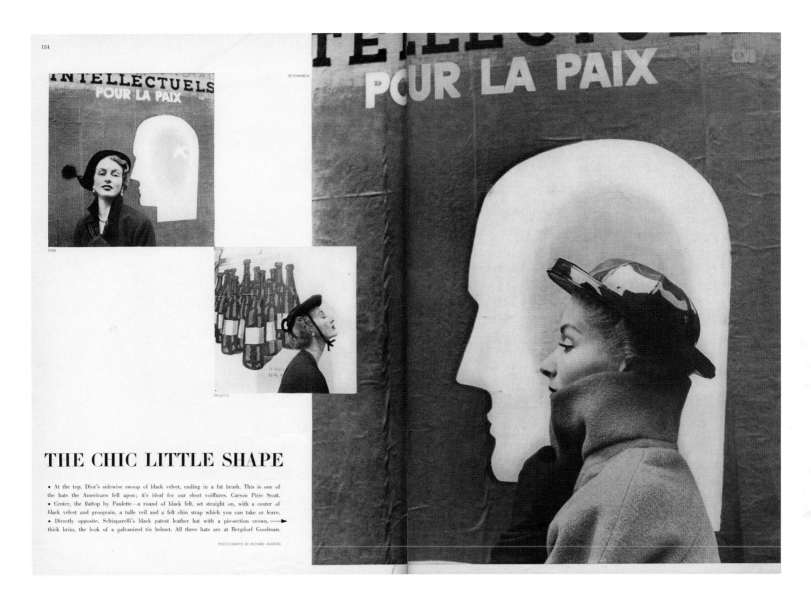

THE CHIC LITTLE SHAPE

• At the top, Dior's sidewise swoop of black velvet, ending in a fat brush. This is one of the hats the Americans fell upon; it's ideal for our short coiffures. Carson Pirie Scott.
• Center, the flattop by Paulette—a round of black felt, set straight on, with a center of black velvet and grosgrain, a tulle veil and a felt chin strap which you can take or leave.
• Directly opposite, Schiaparelli's black patent leather hat with a pie-section crown, →→ thick brim, the look of a galvanized tin helmet. All three hats are at Bergdorf Goodman.

PHOTOGRAPHS BY RICHARD AVEDON.

FIG. 25. *Harper's Bazaar*, October 1948, pp. 184–85. Photographs by Richard Avedon, Paris. Hats by Dior, Paulette, and Schiaparelli. Models unknown.

world—not its particular depiction—is perceived. Barthes summarized this brilliantly by pointing to the consistency with which we say "Look, this is my brother," as opposed to saying "Look, this is a photograph of my brother."[85] Photographs have constantly engaged their viewers, through evocation, imagination, and projection. Driven by the desire to see a photograph's content as a reality to be experienced, a viewer's involvement is only reinforced when looking at a photograph whose meaning is bound up in the encouragement of both a product and its purchase. An advertising image does just this, and in her critical study charting some historical changes to that category, Maud Lavin notes that the hallmark of postwar era advertising was consumer identification with the product: "That product looks like something I would buy."[86] A fashion photograph relies on the same operations as those of an advertisement, its goal being to *so* stimulate desire for the fashions pictured that a purchase will ensue. As Hall-Duncan summarizes, "The success of a fashion photograph depends not only on the desirability of the clothing but on our willingness to believe in and identify with the subject . . . [such that] the reality of the photograph will be ours."[87] Even Hall-Duncan falls into the trap she articulates when she fails to qualify the "reality of the photograph" as one likely to have been constructed to *appear* real. Nevertheless, she rightly points out the extent to which fashion photographs rely on identifications with the models, the clothes they wear, and the lifestyles they seem to enhance; their intent is absolutely to effect recognition and familiarity. Avedon relied on that familiarity to intensify his audience's identification with both the French fashions on display and the life that seemed to accompany them.

John Berger's book *Ways of Seeing* contains a useful introductory analysis of the function of what he termed "publicity" images, which closely relate to the fashion photographs considered in this chapter. Berger illuminated publicity images' complicated relationship to time and, by extension, to the real. They belong to but never address the present moment because "they must be continually renewed and made up-to-date."[88] "Publicity is, in essence, nostalgic. . . . It remains credible because the truthfulness of publicity is judged, not by the real fulfillment of its promises, but by the relevance of its fantasies to those of the spectator-buyer. Its essential application is not to reality but to day dreams."[89] Approaching Avedon's postwar Paris street photographs with this in mind, the complicated coexistence in his pictures of the shirking of all present tense (save the fashions themselves), the nostalgia for a past-tense Paris in which the war has wrought no consequences, and the implications of future fulfillment (for both the readers and for France) become clear. As a rhetorical and visual device, publicity intentionally manufactures desire and envy in a viewer, whom it suggests lacks the very thing on offer. In the case of certain Avedon photographs, that status is given representational form in a woman in the background wearing out-of-date clothes (see fig. 23).

Fashion is a cultural system that conveys and constructs meanings through both language and image. Fashion institutes, then affirms and perpetuates, social roles and hierarchies. Barthes analyzed this system, specifically its 1958–59 season, as a linguistic code of what he called "written clothing" in *The Fashion System.*[90] Barthes's study intentionally focuses on the descriptive language surrounding the fashion system. He admitted that this limit prevented an analysis of "the rich resources of photography," and, in his appendix on the matter, he noted that "in Fashion photography, the world is usually photographed as a décor, a background or a scene, in short, as a theater. The theater of Fashion is always thematic: an idea (or, more precisely, a word) is varied through a series of examples or analogies. . . . Fashion dissolves the myth of innocent signifieds, at the very moment it produces them; . . . it does not suppress meaning; it points to it with its finger."[91] Nevertheless, some of Barthes's general observations about fashion's descriptive language maintain their aptness when applied to fashion photographs. For example, he remarked on the rhetoric's need to "construct a genuine vision of the world: *evening, weekend, promenade*" and the resulting narrative's ability to simultaneously confirm the existence of the promenade and abstract the promenade's value into an "appearance of *the experience.*"[92] Another important aspect of the fashion system's function is the placing of the reader in relation to locality, where the clothing proposes a utopian answer to the question: where?[93] Perhaps most important, Barthes distinguished between a "real elsewhere" and a "utopian elsewhere."[94] I believe that, in Avedon's *Harper's Bazaar* photographs, there is substantial elision between Barthes's two categories of locality, where Paris exists simultaneously in two factions: a real elsewhere, encountered for the first time and avidly explored by a young photographer following the wartime scarcity of Paris's depiction in fashion magazines; and a utopian elsewhere, imagined and constructed by that same man with a romantic nostalgia for prewar visions of Paris.

During the postwar era, that elision between a real and utopian elsewhere was made increasingly plausible as fashion itself, like the photographs it relied on, became more democratic. Although total magazine readership is difficult to ascertain, because each issue is likely read by more than one individual (the "pass-along" factor), there is no question that circulation and sales increased dramatically in the postwar years.[95] The ideal reader of a magazine such as *Harper's Bazaar* was between twenty-five and thirty-five years old, "tired of wartime deprivation, [and] in need of frivolity."[96] This was a logical response to America's postwar economic boom and its burgeoning middle class, whose culture encouraged a generation of women to shop as a part of the "postwar prosperity, conformism in the interest of business and country" and providing for their families.[97] Women's fashion-and-culture magazines regularly demonstrated to their readers how best to shop and what to shop for, disseminating new cultural

and social ideals to their boosted postwar readership.[98] Kristin Ross has noted that postwar women were "the subjects of everydayness and as those most subjected to it, as the class of people most responsible for consumption."[99] Nevertheless, even for a magazine with the prestige of *Harper's Bazaar*, the likely readership, by Snow's own admission, was not able to afford the luxurious goods pictured on its pages: "Thousands of women [buy] *Harper's Bazaar* not because they can afford the most expensive fashions we show but because they are fascinated by the new (in styles, in photography, in art, in writing), because they are eager to train their taste, and because they depend on the editors to present *the best* in every field."[100] Accordingly, the fashion photographs in *Harper's Bazaar* began to focus on the kind of life supposedly enjoyed by a person who wore particular clothes. This is not to suggest that the clothes were downplayed or became less important, but that an effort was made to describe visually (through photographs) and verbally (through captions) the emulation- or aspiration-worthy lifestyle that such clothes suggested.

Captions began to take a more casual tone postwar, familiarly addressing the reader as in Snow's "Notes from Paris" or carefully mentioning the location of a particular shoot, suggesting that the reader—were she to come to this place—could look and live just as beautifully as the model. In fashion photographs, the shift in models played a crucial role, as Susan Kismaric and Eva Respini observe: "For readers of fashion magazines or viewers of fashion pictures, the relationship to the subject was being changed from that of observer to that of implicit participant. As fashion photographers changed the models from objects into active humans in realistic situations, they began to make the viewer an extension of these situations."[101] Whether described as situations or lifestyles, what the fashion photograph depicted became more identifiable to a broadening audience.

Avedon's planning and construction of his photographs, as well as his collaboration with Brodovitch for their final appearance in *Harper's Bazaar*, reveal the depth of his understanding of the implications for his audience, particularly during a time of the democratization of fashion photography's subjects and of fashion itself. His photographs undertook and accomplished the creation of that perfect balance between reality and fantasy. Even his constructions of a romantic and nostalgic nonwar Paris relied on the viewer's conviction of the reality of their specifics (the locations were not sets, the models' movements seemed natural, the suggested narratives seemed mundane, and so on). He achieved his "better than real" effect by creating street photographs that could be "treated as a piece of the world, then as a substitute for it," because he recognized that each element in his nostalgic Paris street photographs furthered the *Harper's Bazaar* reader's desire to relate to the image, the desire to imagine the photograph's representation as a possible reality.[102]

Avedon decided that to take photographs of a "heightened reality, better than real, that suggests, rather than tells you" was to take them on Paris streets, aligning them with the city as a site of vision, spectacle, and experience. It was this choice to select iconic Parisian streets as his setting that defines the purpose of these photographs. Identifiably situating these photographs in Paris, particularly postwar Paris, Avedon created images that drew vitality from (and indirectly helped bring vitality to) a city that had defined modernity and fashion for Americans, encouraging viewers to admire, desire, and even purchase the featured fashions as much as they wanted to believe in the spectacle of a Paris that appeared both nostalgically prewar and newly revitalized. Through their elision of a real and utopian elsewhere, as well as readers' ability to identify with them, Avedon's street photographs established a longing for the urban experiences of Paris as much as for the fashions they depicted.

CHARLES MOORE
TO BE INVOLVED

The events in Birmingham and elsewhere have so increased the cries
for equality that no city or state legislative body can prudently ignore
them. The fires of frustration and discord are burning in every city,
North and South.
—JOHN F. KENNEDY

As one of the most prominent sources of visual news, *Life* magazine was
instrumental in showing white Americans these [civil rights] struggles
and defining the terms of debate.
—WENDY KOZOL

Early in the summer of 1963, Andy Warhol created a series of screen paintings based
on photographs from a civil rights demonstration that had occurred just weeks earlier
in Birmingham, Alabama. In the series, the screened images are presented in various
repetitions and densities, and each canvas is a different color, from mauve to mustard
to red. The works contain the phrase "race riot" in their titles, such as *Red Race Riot*
(fig. 26), and Warhol casually referred to them as "the dogs in Birmingham" pictures.[1]
Assessing the importance of the photographic source imagery for these paintings,
art historian Anne Wagner has written:

> For a start, *any* picture of black protest was in 1963 emphatically topical, given that
> black activism had reached a new urgency and visibility under the John F. Kennedy
> administration and the leadership of the Reverend Martin Luther King Jr. . . .
> But Warhol's subject was not just generally topical; the specific image he chose
> for his *Race Riots* were also familiar. They were lifted from *Life*, that mainstay of
> American photojournalism and prime source for white middle-class impressions
> of the week's *actualités*. . . . The three screens Warhol used in the *Race Riots* came
> from the *Life* exclusive 'They Fight a Fire That Won't Go Out,' a photo essay
> by . . . Charles Moore, a civil rights veteran as dedicated as he was skilled.[2]

FIG. 26. Andy Warhol,
Red Race Riot, 1963.

Charles Moore's street photographs were first published in *Life* magazine on May 17, 1963. Millions came to know his images of the Birmingham demonstrations, most especially the narrative sequence showing a black man being attacked—and bitten—by German shepherd police dogs under the supervision of officers (figs. 27–29). *Life*'s readers also came to know another photograph depicting firemen turning their powerful and painful hose on demonstrators huddled defensively on a sidewalk (fig. 30).[3] Moore's photographs would become part of the quintessential record of racial violence in the United States in the aftermath of the Birmingham demonstrations. Although any photograph of these demonstrations might have sufficed for Warhol, so long as it had been widely disseminated at the time, Moore's images were particularly appealing because of his proximity to the events. Indeed, an unknown photographer for the *Birmingham News* caught Moore in the process of shooting the dog attack (fig. 31). Yet even without this representation of Moore's mode of picture making, his close proximity is evidenced in his own photographs, as when a dog turned its attention to Moore in the third photograph of the sequence (see fig. 29). Moore's Birmingham street photographs conveyed to *Life* magazine's readers the intensity and brutality of a single, specific public demonstration for civil rights, an event as remarkable for its utilization of city streets as it was for the catalyzing effect its representation in the press had in rallying white middle-class support for those rights.

No era of US history is more closely associated with the street in its actual events and popular recollection than the era known as "the sixties."[4] The characterization of that decade—then and now—through its political protests, acts of civil disobedience, and public unrest originated in the struggle for civil rights, in what would come to be known as the civil rights movement or simply "the movement."[5] The popular stereotype of 1950s prosperity and plenty was tested, and eventually replaced, by media representations of 1960s turbulence and public action. Historian Matthias Reiss has characterized such public actions: "All protest marches share certain basic features, most notably the involvement of crowds, the occupation of space, navigation of—

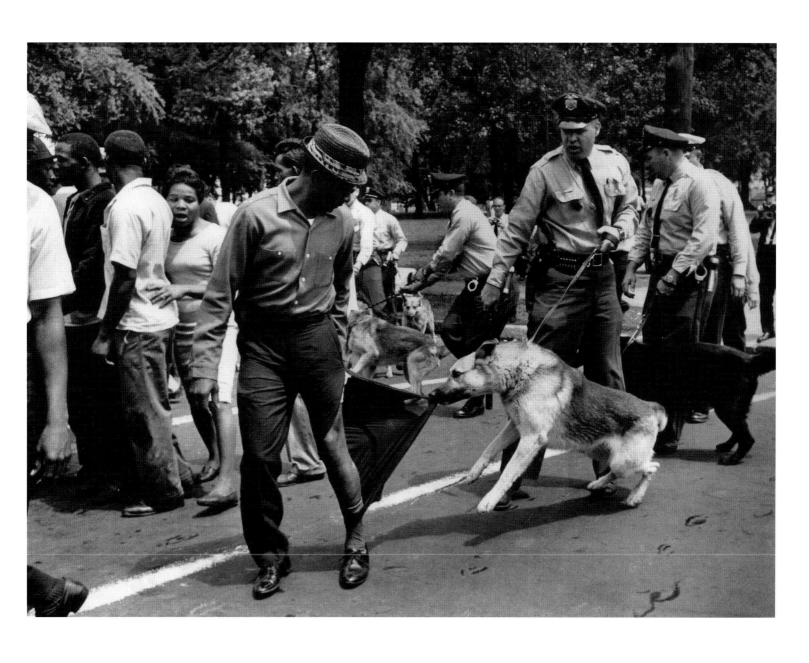

FIG. 27. Charles Moore, *Intersection near Kelly Ingram Park, Downtown Birmingham, Alabama*, May 3, 1963.

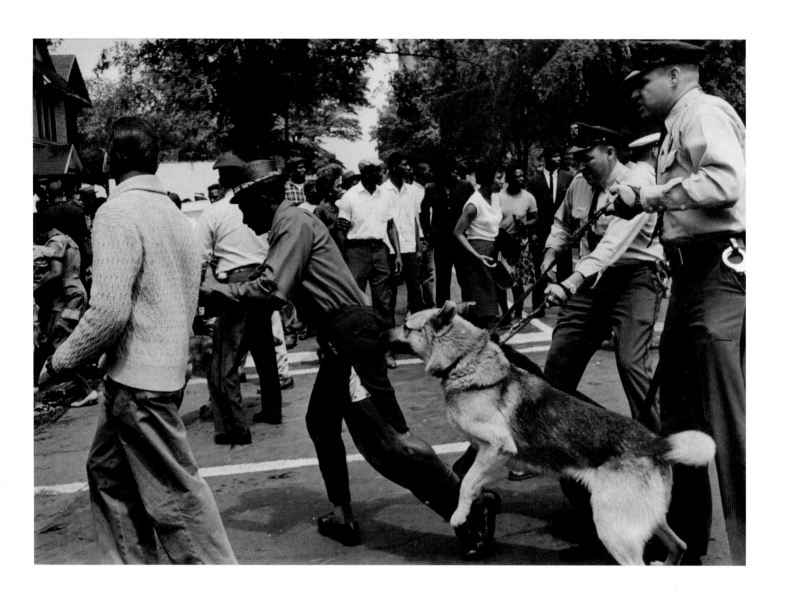

FIG. 28. Charles Moore, *Intersection near Kelly Ingram Park, Downtown Birmingham, Alabama*, May 3, 1963.

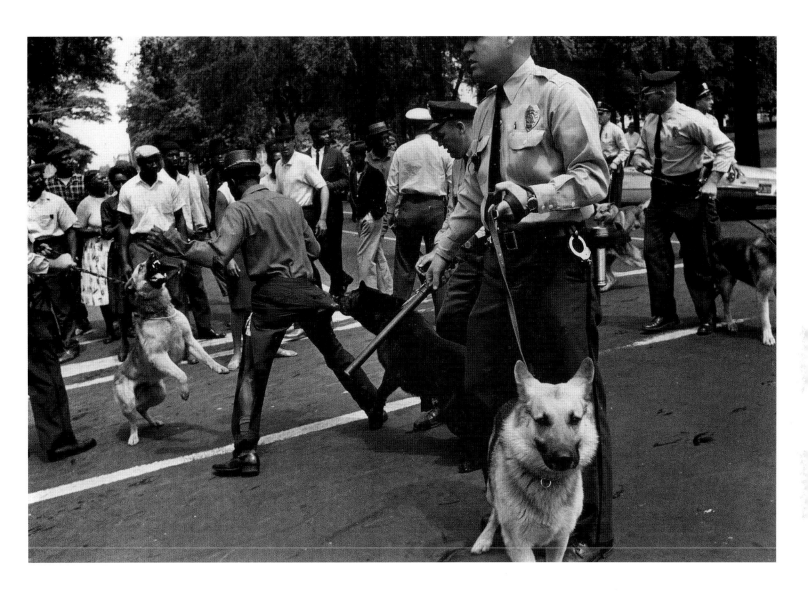

FIG. 29. Charles Moore, *Intersection near Kelly Ingram Park, Downtown Birmingham, Alabama*, May 3, 1963.

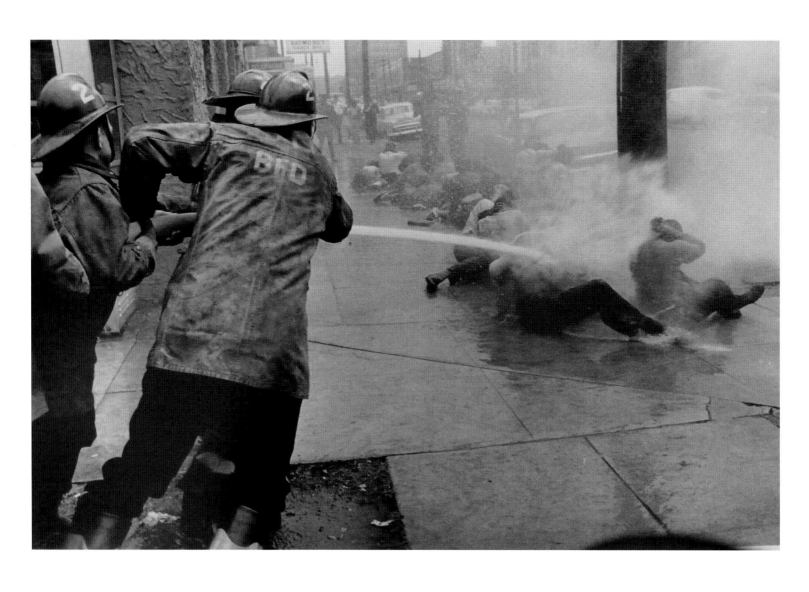

FIG. 30. Charles Moore, *Downtown Birmingham, Alabama*, May 3, 1963.

usually urban—landscapes, and, as events in the public sphere, interaction with society."[6] The demonstrations of the 1960s were not the first time Americans had used city streets to seek political and social change, but they were the first sustained, nationwide demonstrations to capitalize on a well-established, widely circulating picture magazine press, as well as on burgeoning mainstream television coverage. Photo dealer and civil rights historian Steven Kasher has said that these years marked the first time that images of black Americans' struggle for equality, whether published or televised, entered many white homes. In the mid-1950s the movement's earliest demonstrations coincided with television's boom, and those of the early 1960s benefited from television's radically expanded capability to broadcast events live around the globe.[7] *Life* magazine gave prominent photographic coverage to civil rights events in the late 1950s and 1960s, at a time when its weekly issue was, by all accounts, one of the—or *the*—"single most important media organ, seen by more than half the adult population of the US and reaching more people than any television program."[8] Photographic images, and especially street photographs, played a different role than ever before in depicting and disseminating these demonstrations' ongoing political utilization of city streets. Remarkably, histories of photography have rarely reckoned with these pictures.[9] The literature on street photography has done so even more minimally.[10] Through the example of Charles Moore's Birmingham street photographs for *Life*, this chapter offers an example of the rich dialogue between what would become the defining site of 1960s demonstrations and the political use of streets as a photographic subject with wide circulation and impact.

FIG. 31. Photographer unknown, *Police-Dog Attacks and Photographers* (detail), May 3, 1963.

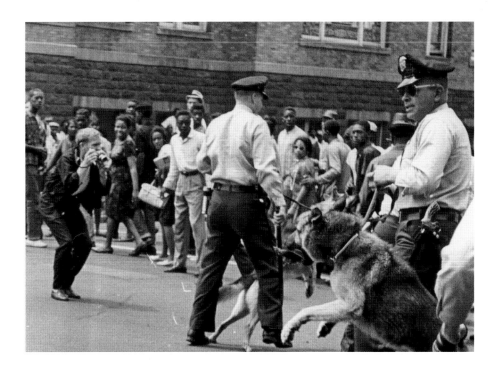

Demonstrations transformed streets into political occupations and, more often than not, local authorities turned them into sites of violence. During an evening march in Alabama in 1965, for example, police shot out the streetlights so that reporters and photographers could not capture the beatings they inflicted on the demonstrators.[11] More generally, Kasher's impassioned summary of the photographs of the movement's early demonstrations locates both the movement and the photographs in urban spaces charged with power struggle: "These photographs are about participation, collaboration, struggle, and jubilation. Utopian visions become real here. As if they were allowed, the courageous participants in the movement rode and walked the highways together, sat down where they were not invited, danced in the parks and streets, sang on the stairs of power. They were not allowed, but they did it anyway, making the future happen. Fists and guns were thrust in their faces; clubs, fangs, and jet-streams tore at their bodies; but they did not stop, they went on. These people stood up to power and took some of that power for themselves. As always, power did not concede willingly."[12]

If this is how urban streets were being used, the relationship between photography and the streets must be rethought. I contend that the corresponding photographs, particularly those taken by Moore in Alabama in 1963, offer a crucial opportunity to embrace the historical and political contextualization of street photographs. As much as it has become commonplace to suggest that the history of the civil rights movement—indeed the 1960s in general—cannot be understood without the photographs that documented and disseminated it, this chapter posits that the history of street photographs cannot be understood without those same images of demonstration.

PHOTOJOURNALISM, *LIFE* MAGAZINE, AND PRECEDENTS

Dating back to the 1840s, illustrated journalism steadily expanded in popularity in the United States until the 1920s, when the technology of handheld cameras, faster film processing, halftone and color printing, and the rotary press made the widespread use of photographic reproductions viable. Modern photo reportage, or what I will call photojournalism, enjoyed a welcome and ever-prominent place in newly founded weekly magazines such as *Time* (1923), *Newsweek* (1933), *Life* (1936), and *Look* (1937). Although *Time* mostly published photographic portraits in its first decade, Michael Carlebach has noted that the prominence and bold use of photographic illustration in early and successful issues of *Newsweek* undoubtedly prompted *Time*, the nation's premier news magazine, to reexamine its use of pictures.[13] This created an increased demand for photographers, as curator John Szarkowski has observed: "The picture magazines were at the height of their success and confidence, and magazines that had traditionally depended on the written word had come to devote a substantial number of their pages to photo-stories. The greatly expanded market of the postwar years made room for scores of new photojournalists."[14] Still, newsweeklies such as

Time and *Newsweek* generally continued to use photographs as supplements to their articles. Picture magazines like *Life* and *Look* proposed the reverse: the text supported the photographs.

Picture magazines were undoubtedly a more enjoyable, creative way of "telling" the news, though the longstanding debates about content and legibility continued.[15] For the purposes of this chapter, I will restrict discussion of image legibility to the reinforcing process that enables viewers to approach new images with an understanding of previously experienced pictures, those which necessarily inform their understanding of subsequent ones. Conversely, the codes of legibility are often self-reinforcing, so that previously experienced pictures affect the taking and publishing of new, subsequent photographs. Notions of camera-based truth and documentary realism bear heavily on this process. Art historian and philosopher Yves Michaud has offered a definition of photojournalism—"all photographic or filmic images that appear to reproduce or resemble reality with a particularly high degree of accuracy"—that hinges on such notions in order to call them into question as "constructed objects that exist in a complex relation to reality" and to remind us that they are "a series of signs, generated technologically and controlled by humans, that exist in problematic relation to reality."[16] Given the likely irresolvable difference between a belief in the objectivity of the photographic record and an acknowledgment of the photographer's ability to construct, restrict, or manipulate that same record, Michaud concluded that images are "always a sample of reality, a part that stands for the whole."[17] And however helpful this argument may be to a book concerning nonspontaneous engagements with the street as both site and subject, it must be said that the media itself has little need for such nuance, preferring as it does to reinforce and uphold the belief in objective reporting. Howard Chapnick, founder of the photo agency Black Star and a champion of Moore, is but one example. The preface to his autobiography, evocatively titled *Truth Needs No Ally*, offers a particularly decisive statement: "To ignore photojournalism is to ignore history."[18] If Chapnick's outlook epitomizes the media's stake in photographs, it also serves as a welcome admonishment to the literature on street photography for its near-total exclusion of photojournalistic street photographs.[19] Moore's photographs from Birmingham are exemplary in this regard; reproduced and circulated in *Life* magazine, they represent the photographic catalyst of city streets depicted as politically mobilized sites.

When Henry Luce, the head of Time Inc., penned his goals for *Life* magazine, he also outlined its distinction from his company's flagship magazine: "To see life; to see the world; to eyewitness great events; . . . to see and be amazed; to see and be instructed. . . . To see, and to show, is the mission now undertaken by a new kind of publication, The Show-Book of the World."[20] *Life*'s editors, many of them from *Time*, understood that by the 1930s news had become "fundamentally visual."[21] *Life*

therefore strove to represent news in visually appealing and creative ways, such as the photo essay, which relied on high-quality photographic reproductions. Another aspect of *Life*'s popularity was its conviction that a better way of life, and therefore a better America, could result simply from the magazine's embodiment of optimism and confidence. *Life* set out to disseminate news and ideas to what art and cultural historian Erika Doss has called "an ever increasing body of consumers fluent in the language of pictorial communication."[22] The magazine's debut issue hit newsstands on November 23, 1936.

Life quickly became one of the most widely consumed magazines in the country. Within just two years of publication, it had reached a circulation of two million and enjoyed a "pass-along" factor that was sometimes as high as 17.3 nonsubscribers per issue.[23] As a testament to its popularity with the burgeoning middle class, *Life* received nearly one-fifth of all magazine advertising dollars spent in the United States during the postwar years. Despite increased competition from television, *Life* enjoyed a healthy circulation of six million in 1960.[24] Though at no point in its history did *Life* reach a majority of the US population,[25] as James Baughman's research makes clear, "*Life* undoubtedly shaped the political and cultural values of many Americans."[26] Doss emphasized photography's role in the process: "Each week, *Life* presented itself to its mainly middle-class readership as the visual theater of postwar national identity."[27]

In order to do this, *Life* hired dozens of talented photographers for whom landing the magazine's cover was, according to Doss, the "pinnacle of postwar [professional] success."[28] The magazine's masthead listed photographers above reporters, indicating the value placed on their contributions. *Life* also employed nonstaff photographers. For example, the Black Star agency often hired out its photographers to the magazine, splitting fees with the photographer, an arrangement that accounted for some 30 to 40 percent of the agency's business.[29] For those interested in photography, *Life* also proved a pivotal source of published images in its early years. Despite photography's primacy within *Life*'s mission, its editors considered pictures a straightforward and appealing means of communication; thus, in their desire to foster the image of a homogeneous postwar American middle class, *Life*'s editors simultaneously assumed that the magazine's readers would absorb the messages of nationalism, capitalism, and optimism that the photographs (and their captions) presented. This tension between photographs and their context can be found on *Life*'s pages.[30]

Life's struggle to represent a homogeneous postwar American middle class was embodied by its coverage of the civil rights movement. Considered in relation to Moore's photographs of the 1963 Birmingham demonstrations, the work of fellow *Life* photographer Gordon Parks reveals a telling discrepancy in how *Life* represented the movement. Parks, twenty years Moore's senior, was *Life*'s first black staff photographer. His tenure at the magazine began in 1948 and continued throughout the height of

FIG. 32. "'The White Devil's Day Is Almost Over,'" *Life*, May 31, 1963, pp. 22–23. Photographs by Gordon Parks.

its popularity over the next two decades. During the early 1960s—the years in which Moore's civil rights images were just beginning to appear—Parks enjoyed a newly prominent photographic *and* authorial byline in the magazine. In ways it did not do with Moore, *Life* celebrated Parks's personal-as-already-political outlook. Parks was drawn or restricted (or both) to intimate, interior portrayals of black experiences during the civil rights movement. In contrast, Moore's status as a Southern white man afforded him proximities that resulted in strikingly different photographs.

Beginning in the 1960s, Parks photographed and penned a group of autobiographical articles that offered his personal assessment of racism, accompanied by photographs that mirrored the circumstances of their making and context. Collectively, these articles helped shape—through both Parks's words and his pictures—the magazine's advocacy for racial equality, and they presented white readers with a more familiar and intimate representation of blacks and civil rights than other contemporary magazines afforded.[31] The May 31, 1963, issue of *Life*, for example, includes Parks's photo essay on Elijah Muhammad and the Nation of Islam, "'The White Devil's Day Is Almost Over'" (figs. 32–34), followed by Parks's own written reaction to black Muslims, "'What Their Cry Means to Me'—A Negro's Own Evaluation," which includes more of his photographs from the assignment.[32] Another pair of articles appeared in the August 16, 1963, issue: a semifictional photo essay "How It Feels to Be Black," featuring excerpts from Parks's autobiographical novel *The Learning Tree*, and a documentary photo essay and text entitled "The Long Search for Pride" (fig. 35).[33] As a black photographer, Parks had access to certain people and situations that a white

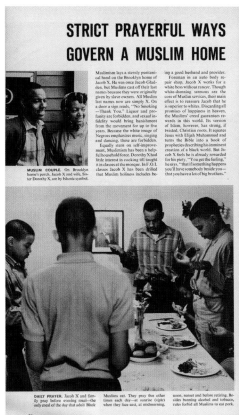

STRICT PRAYERFUL WAYS GOVERN A MUSLIM HOME

Muslimism lays a sternly puritanical hand on the Brooklyn home of Jacob X. He was once Jacob Gladden, but Muslims cast off their last names because they were originally given by slave owners. All Muslim last names now are simply X. On a door a sign reads, "No Smoking —Thank You." Liquor and profanity are forbidden, and sexual infidelity would bring banishment from the movement for up to five years. Because the white image of Negroes emphasizes music, singing and dancing, these are forbidden.

Equally stern on self-improvement, Muslimism has been a helpful household force. Dorothy X had little interest in cooking till taught it in classes at the mosque. In F.O.I. classes Jacob X has been drilled that Muslim holiness includes being a good husband and provider.

Foreman in an auto body repair shop, Jacob X works for a white boss without rancor. Though white-damning sermons are the core of Muslim services, their main effect is to reassure Jacob that he is superior to whites. Discarding all promises of happiness in heaven, the Muslims' creed guarantees rewards in this world. Its version of Islam, however, has strong, if twisted, Christian roots. It equates Jesus with Elijah Muhammad and turns the Bible into a book of prophecies describing his imminent creation of a black world. But Jacob X feels he is already rewarded for his piety. "You get the feeling," he says, "that if something happens you'll have somebody beside you— that you have a lot of big brothers."

MUSLIM COUPLE. On Brooklyn home's porch, Jacob X and wife, Sister Dorothy X, are by Islamic symbol.

DAILY PRAYER. Jacob X and family pray before evening meal—the only meal of the day that adult Black Muslims eat. They pray five other times each day—at sunrise (*right*) when they face east, at midmorning, noon, sunset and before retiring. Besides banning alcohol and tobacco, rules forbid all Muslims to eat pork.

WORKING FOR ISLAM. Neatly dressed, sons Orlando, 12 (*front*), Arnold, 14, sell Muslim biweekly newspaper *Muhammad Speaks* on streets.

FIGS. 33 AND 34. "'The White Devil's Day Is Almost Over,'" *Life*, May 31, 1963, 28–29 (details). Photographs by Gordon Parks.

photographer would likely have been denied, the most obvious example being the inner sanctum of the Nation of Islam, including Muhammad's home as well as that of a devout follower, prayer in the temple, and the men's self-defense courses and women's sewing lessons (see figs. 32 and 33).

The photographs Parks made on this assignment demonstrate a different kind of photojournalism than that of Moore, particularly in terms of formal composition. Parks eliminated much of the surrounding context from the frame to the point that it is difficult to discern where Elijah Muhammad is situated (see fig. 32), nor can one see more than a framed portrait of Muhammad in the image that captures a family in a moment of prayers (see fig. 33). This compositional tendency results in images easily categorized as portraits; the same is true of the instances when Parks photographed out of doors on city streets. His tightly framed subjects remain the focus, whether they are sidewalk sellers of Muslim newspapers (see fig. 34) or a crowd of Harlem demonstrators (see fig. 35). There is notably little action in these pictures, and there is also an absence of white authority figures such as policemen, who are so common in much of the journalistic coverage of civil rights struggles. One might be tempted to explain this by demographics alone, but at the demonstration in Harlem, Parks could have easily turned away from the interior of the crowd to its periphery, in order to photograph the policemen present "sometimes 50 to a single block" by his own description in the accompanying text.[34] Instead Parks remained intent on creating intimate pictures that exist almost apart from the streets on which they were made.

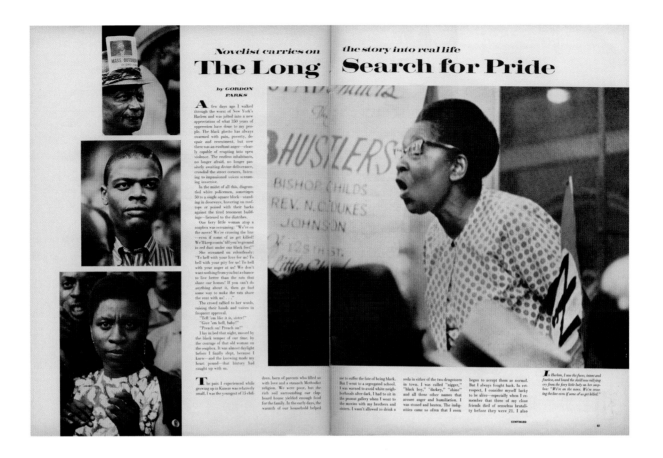

CONTINUED

FIG. 35. "The Long Search
for Pride," *Life*, August 16, 1963,
pp. 80–81. Photographs by
Gordon Parks.

The same sense of intimacy and proximity also characterizes Parks's written
contributions to *Life*. He began "The Long Search for Pride" in a diaristic mode:

A few days ago I walked through the worst of New York's Harlem and was
jolted into a new appreciation of what 350 years of oppression have done to my
people. The black ghetto has always swarmed with pain, poverty, despair and
resentment, but now there was an exultant anger—clearly capable of erupting
into open violence. The restless inhabitants, no longer afraid, no longer pas-
sively awaiting divine deliverance, crowded the street corners, listening to
impassioned voices screaming invective. . . . I lay in bed that night, moved by
the black temper of our time. . . . It was almost daylight before I finally slept,
because I knew—and the knowing made my heart pound—that history had
caught up with us.[35]

Focusing on his personal, even physical, reaction to the crowd in the street (the jolt,
the sleeplessness, the pounding heart), Parks successfully avoided the agency that one
might ascribe to his seemingly accidental presence at the demonstration. The personal
tone also downplayed the specific social and political reasons for the condition of life
in Harlem (poverty, despair, anger) or the demands that might rectify them (anger
and violence trump calls for equality in housing, voting, and employment). Parks used
a similarly casual, confiding tone to characterize the full sweep of black activism:

"With the passiveness of King and the extremism of Muhammad, the Negro rebellion has come alive. Fire hoses, police dogs, mobs or guns can't put it down. The Muslims, the NAACP, the Urban League, Black Nationalist groups, the sit-inners, sit-downers, Freedom Riders and what-have-you are all compelled into a vortex of common protest."[36] This excerpt from "'What Their Cry Means to Me'" served, as Doss articulates, as "a personal warning to *Life*'s readers about the strong appeal of black nationalism if integration failed."[37] Considering the sum of these early 1960s civil rights stories by Parks, Doss further concluded: "Whether or not Parks actually intended to pacify *Life*'s [primarily white] audiences in this manner is unknown. What is clear is the degree to which his ambivalence about social and political activism segued with that of *Life* magazine. While visualizing and speaking on behalf of black America, Parks sidestepped direct political engagement."[38] There was, however, another side to *Life*'s depiction of the civil rights movement: the more active and varied representation offered by Moore's photographs, which in turn exemplify "direct political engagement."

MOORE'S PROCESS IN THE CITY

In September 1958, within a year of beginning his career as the staff photographer for the *Montgomery Advertiser*, Moore took a series of photographs of Martin Luther King Jr., which focus on his arrest for loitering outside the Montgomery court building. These images culminate in a widely published portrait of the burgeoning civil rights leader being booked inside the police station (figs. 36–38). Moore's interest in capturing a sequence that conveys the event's narrative—rather than emphasizing the single image of King's booking, as *Life* did in its September 15, 1958, issue—would become the hallmark of his famous series of photographs of the dog attacks in Birmingham (see figs. 27–29).[39] Moreover, his photographs of King make plain what the single published image cannot: the movement would occupy the streets and, in particular, those public locations holding deep connotations of power such as courthouses, state capitol steps, and the spaces outside police headquarters. New visions, nearly all of them photographic or filmic, of these public sites of power would come to populate the press and, therefore, the popular imagination. The same also held true for photographs taken in the seemingly less loaded public spaces of downtown shopping and business districts.

Recalling another of his early street photographs (fig. 39), Moore explained that "the editor of the [*Montgomery Advertiser*–owned] afternoon paper, *The Alabama Journal*, told me he heard that there was some trouble downtown a few blocks away. When I arrived, I saw a man pulling a baseball bat out of a bag so I ran as fast as I could to get there just as he swung the bat at a black woman. I made the photograph so hurriedly that it is askew, but that seems to accentuate the violence portrayed."[40] Although taken quickly in response to the unfolding action, the photograph is sharply

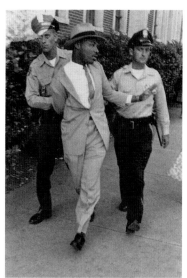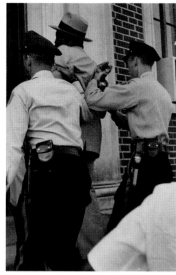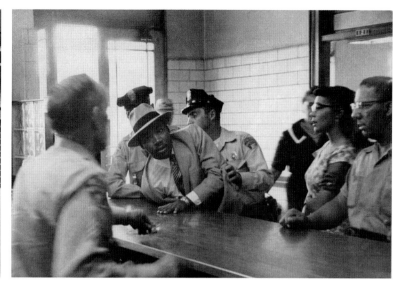

FIGS. 36–38. Charles Moore,
Police Headquarters, Montgomery,
September 3, 1958.

focused, capturing both the instant of imminent attack by the white man and the anticipated attack by the black woman in the center of the picture. It also shows a different white man about to punch another black woman, as scores of black and white pedestrians react to the scene. The picture ran on the front page of the next day's *Advertiser* and in other national papers.[41] Moore has argued that the *Advertiser* was more liberal than most papers: "The newspaper tried very hard to portray everything fairly. It could have ignored the civil rights story; a very conservative paper would have said 'We're giving this troublemaker King too much publicity. Let's ignore him. Maybe it will die down.' Well, the Montgomery paper didn't do that."[42] Strikingly, in the case of the photograph of the attack on downtown Montgomery shoppers, the paper chose to publish the name of the vigilante alongside the picture.[43] As a result, Moore received death threats, and police commissioner L. B. Sullivan openly reprimanded the *Advertiser.* Nevertheless, as the author of Moore's monograph, Michael S. Durham, has noted, "the paper's editor, Grover Hall, eccentric, fair-minded, and outspoken, managed to put the situation in perspective. 'Sullivan's problem is not a photographer with a camera,' he wrote. 'Sullivan's problem is a white man with a baseball bat.'"[44] Moore claimed that this photograph, and the subsequent experience of its publication, was the impetus for his decision to be "where the violence was happening, no matter where it was."[45] His passion for photojournalism merged with his anger about the injustice he witnessed in his home state; in June 1962 he quit the *Montgomery Advertiser,* began working at Chapnick's Black Star agency, and made photographs, often appearing in *Life,* that earned him a reputation as one of the most daring and impassioned civil rights photographers.

Steven Kasher has emphasized the presence of varying photographers capturing the civil rights movement, as well as their multiple motivations and commitments. Categorically speaking, there were employed journalists (Moore and Parks shooting for *Life*), agency photographers (Moore for Black Star), movement photographers (Danny Lyon), and artists interested in photographing the events for less immediate

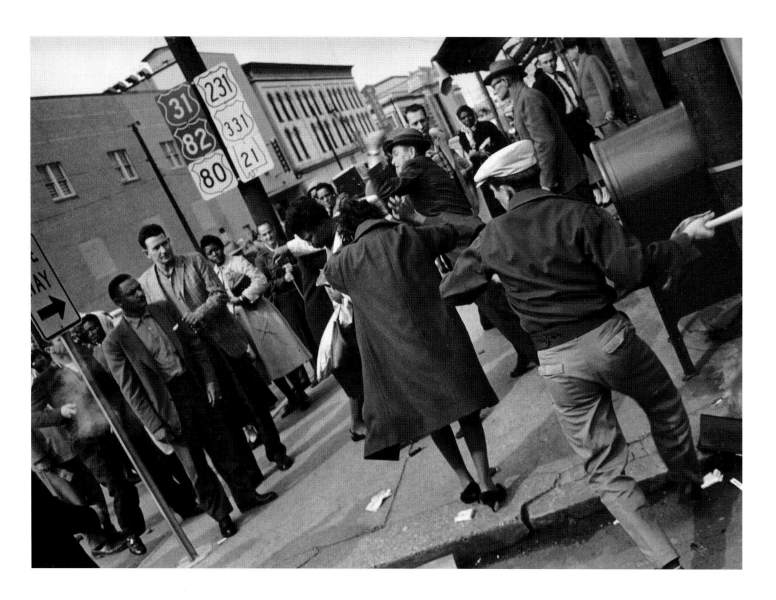

FIG. 39. Charles Moore, *Dexter Avenue, Downtown Montgomery*, February 27, 1960.

or more personal reasons (Richard Avedon). More broadly, there were those operating either within or outside the struggle. Kasher notes that the latter—whether labeled photojournalists or documentary photographers for their commitment to recording events—took the majority of the era's photographs, but that both outside photographers and those working for civil rights organizations "knew that they were recording crucial moments for a transforming nation. They rarely set out merely to make an 'objective' record of historical events; rather, they felt a need to hasten the transformations, to choose a side."[46] Capturing events that might otherwise have been claimed not to officially exist often imparted urgency and strong points of view to their photographs. Moore, for example, recalled that Southern police were "ready to fly into any member of the press" and put him or her in jail. Like others, Moore realized that if enough photographers were jailed, there would cease to be thorough or appropriate photographic coverage, making it crucial for every photographer "to avoid trouble" in order to "keep shooting."[47] Clearly, what civil rights photographers could depict depended on their ability to be on location, to avoid arrest, to take risks in covering dangerous events, and, most especially, to find access to events.

Danny Lyon's civil rights photographs exemplify the benefits of access. As the first official photographer for the Student Nonviolent Coordinating Committee (SNCC), Lyon spent much of his time in SNCC offices, accompanying members to work the back roads of the South and participating in SNCC demonstrations. As such, he frequently crossed cultural and political boundaries between whites and blacks. Not compelled by a publication deadline or an editor's demands, he often pursued a more personal, expansive, and relaxed mode of picture making. (As with Parks, this accounts for the preponderance of photographs taken indoors, in more intimate spaces, and of more private moments.) Lyon roguishly identified himself as a SNCC photographer and was able, on occasion, to refute the identification entirely to gain access to the situation at hand. Lyon's transcript of his June 1963 conversation with members of the state highway patrol from Gadsen, Alabama, reflects one such occasion. He introduced himself as a photographer working for a fictional, quasi-fascist Chicago news agency:

> The police spoke a great deal about what we would call police brutality. The more intelligent ones, or honest might be better, seemed troubled and offered elaborate explanations: [electric] prod poles [for cattle] were more humane than sticks. A local citizen put it this way—they hurt but do not harm. . . . A larger force could less painfully subdue a demonstrator. . . . (I noticed that an officer, sitting behind the wheel of his car was going through a pile of 8/10 [sic] photos.) That one's a Black Muslem [sic] I think. See (pointing to a black and white print of the front row in a Gadsen Mass Meeting), red socks and red tie—that's what they wore in Birmingham. (He said a Birmingham news man was sending them shots. Maybe I could send shots of Danville leaders to check against those in Gadsen?)[48]

Lyon's stunt indicates a dramatic shift in the kind and degree of information he had access to. Reassured by the fact that Lyon purportedly worked for a news agency sympathetic to their racist outlook, the patrolmen were at pains to explain the use of electric cattle prods on humans, and they revealed that civil rights photographs—regardless of who had taken them—also served as identifying and incriminating tools for civil rights leaders. Plainly, access to this information, even as part of a ruse, would have been denied to a black photographer such as Parks.[49] These subtle manipulations of white identity responded to the fact that access to information was granted on a racial basis.

Moore's identity as a Southern white photographer increased his degree of access and actively shaped his photographs of the street demonstrations. Recognizing that the frequent and pervasive civil rights demonstrations in the South required Southern photographers, Chapnick offered Moore a retainer in 1962 if he left New York for his

hometown of Montgomery: "I told him I felt one of the great stories in American history was unfolding in the South. He came from the South and understood it. Going back to Alabama to document the events taking place there would provide the chance for Charles to do work he was uniquely qualified for."[50] A small cadre of Southern reporters and photographers shared this qualification, and when they invented a mock press corps dubbed the Southern Correspondents Reporting Equality Wars (SCREW), Moore received the first mock SCREW press badge in honor of his highly risky photographic coverage of the 1962 University of Mississippi desegregation protests.[51] During the "Ole Miss" riots over James Meredith's enrollment—riots that led to a French photojournalist's death—Moore gained access to the besieged university building from which the National Guard defended itself. He was the only photographer, black or white, Northern or Southern, to do so, and he ended up with a *Life* exclusive for his pictures.

Life paired Moore with reporter Michael S. Durham on civil rights assignments because Moore was from the South and Durham was not. When Moore heard Durham speak with a Northern accent, he reportedly quipped, "At least you look like a redneck. But when we're together, don't say anything."[52] This advice was predicated on Moore's knowledge of the volatile situations that would arise if their status as *Life* staffers, always presumed to be Northern and liberal, were revealed. He had learned this lesson while photographing rallying segregationists on the streets of downtown Jackson, Mississippi, following a speech given in conjunction with Meredith's imminent enrollment, in which Governor Ross Barnett had declared: "I love Mississippi! I love her people! I love our customs!":

> I began photographing these three students who were each waving rebel flags. They started waving them at me, which was fine because it made dramatic photographs [fig. 40]. But then they started jabbing . . . first at the camera, then at my face. . . . I knocked one flag on the ground. I could tell from the way they were looking that I had committed an unpardonable sin. . . . [That same evening] the hotel room door banged open and in rushed a phalanx of screaming college students, including this guy with the flag, who came right at me and grabbed me by the collar and began twisting my tie and choking me. I've never been able to re-create [sic] the obscenities, but it was like, "You goddamn *Life* magazine bastards, we found out who you were. You nigger lovers had better go home." . . . I have never seen such hate on anyone's face before. . . . To him I was worse than "a nigger," I was a white nigger . . . and worse than that I was a white *Life* magazine nigger.[53]

Young and white, Moore had enmeshed himself easily among the segregationist Ole Miss students, even while photographing them and their flags, but his aggressive

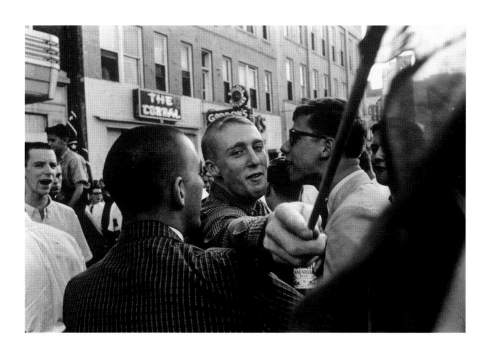

FIG. 40. Charles Moore, *Jackson, Mississippi*, 1962.

act toward the flag revealed his position as a nonsegregationist white Southerner, one affiliated, as the flag bearer discovered, with *Life* magazine. Until Moore's aggression toward the rebel flag, however, his proximity and access put him in an ideal location for covering the event *as a participant* and conveying the location and point of view that accompanied it.

Historians such as Kasher have indicated that such confrontations affected Southern photographers, including those like Moore who had not previously had reason to take a stand on civil rights issues: "Some, even in the South, were angered by the scenes of racist injustice that they witnessed and came to support the cause of civil rights, insinuating that support into their pictures."[54] Moore himself acknowledged that he underwent this transformation as a direct result of the violent acts in Birmingham: "Birmingham was in my own state. These were my people. . . . I'm watching dogs being led into the crowds and the high-pressure hoses knocking people down, and it troubled me, because I love the South. And it opened my eyes to the need for change in the state of Alabama. I saw that we had to become a state for all citizens, that blacks deserved the same kind of chance that I was given."[55] Despite its overtones of naïveté and condescension, Moore's revelation indicates the degree to which what unfolded before his camera in the civil rights movement came to affect the ways he continued shooting and covering those events. He readily admitted that it was only *after* taking some of his first photographs in Birmingham that he realized their import, both personally and historically. Pragmatically, he was most concerned with taking his pictures "without stumbling over something or being hit by the cops," indicating his tendency to fully insert himself in Southern civil rights clashes such as those in Birmingham.[56] Although as a photojournalist Moore did not choose where to make his photographs—as did Lyon and, to some extent, Parks—the answers to questions about Moore's location remain paramount. They reveal nuances about his proximity to newsworthy events, to other positions available for coverage, and to the access he had been granted as a Southerner.

On May 3, 1963, Moore and Durham were on assignment elsewhere, but the radio news coming out of Birmingham became too compelling. Driving into the city in the early afternoon, they arrived at 16th Street Baptist Church just as firemen

prepared to turn their hoses on demonstrators who had been streaming out of the church all day. Within minutes, Moore would take one of his most notorious photographs, placing himself just behind the firefighter's triangular formation as they directed a stream of water with a force of 100 pounds per square inch on demonstrators huddled on the city sidewalk (see fig. 30).[57] Gene Roberts and Hank Klibanoff have aptly summarized Moore's process for this photograph: "He wanted to get as close to the action as he could, as close as the firefighters and demonstrators themselves. . . . He wanted his images to be felt; if the firefighters were going to use hoses, his images had to feel wet. . . . [He] made his way to a position right beside the firefighters, close enough to touch them. Through his lens he saw the straight, white laser line of water drilling into the upper back of a seated man, who pulled a woman close to shield her from the battering."[58] Moore was so close to the firemen that he conversed with them (one of them would later confide to him, "We're supposed to fight fires, not people").[59] His proximity meant that he was not only struck in the leg by a piece of concrete hurled at the attacking firemen but also appeared in other photographers' images of this particular attack.[60] In other fast-breaking situations, he was physically steered by Durham, who gripped either Moore's collar or belt, so that he never had to stop looking through his viewfinder and thus never stopped shooting composed, in-focus photographs. In his recent catalogue on civil rights photography, Julian Cox has noted that this was not the norm: "The blurred forms, harsh contrasts, and grainy quality of many press photographs also directly reveal the conditions under which they were made."[61] Moore avoided blurring and over- or underexposing his negatives by moving only in a controlled manner that allowed all his attention to remain directed to the act of picture making. The absence of graininess in his photographs could also be attributed to this care, but it seems more likely that its presence in other press photographs is the direct result of overenlarging a negative from a handheld 35 mm camera. This enlargement would be necessary for the frames taken by other photographers, because they were standing farther away from the scene.

Such consistent physical engagement with the action on the street was borne out in Moore's choice of equipment:

> There was so much going on at Birmingham, things were happening so fast—crowds would start running off in this or that direction—that the only way I could keep up with it was to run backwards and keep shooting. I wanted to be everywhere. And I didn't want to stand back and shoot it with a long lens. I didn't have much equipment at that time, no lens longer than a 105mm, but even a 105 would have kept me out of the action. No, I wanted to shoot it with a 35mm or a 28mm lens, to be where I could feel it, so I could sense it all around

me and so I could get the depth that you get with a wide-angle lens. I wanted to see foreground, middle ground, and background. I wanted to get a feeling [in my pictures] of what it was like *to be involved*.[62]

By 1960 most photojournalists increasingly used only 35 mm cameras, though it was common to have multiple camera bodies, each outfitted with different lenses to accommodate different distances and/or set to different apertures to respond to varying light levels. Magazine (as opposed to newspaper) photographers enjoyed more flexible deadlines, could anticipate more space on the printed page for their images, and were encouraged by editors to capture events in several frames.[63] Multiple preset camera bodies encouraged this photographic mode. Carrying more than one camera, however, was less than ideal in situations calling for inconspicuous coverage. Moore noted that he had little equipment with him in Birmingham and specifically references only his 28 mm wide-angle lens when discussing the photographs made that day.[64] (As for film, Moore recalled that most of his civil rights pictures were taken on Kodak Tri-X film, whose exposure he guessed and adjusted as necessary, since there was no time for a light reading and his camera had no built-in light meter.)[65] Proximity in relation to the events he watched through his viewfinder remained paramount for Moore: "My emotional connection is when I'm close up, when I am close in there, up there as close as I can be."[66]

On the second day that water hoses failed to stop the continual swell of demonstrators on Birmingham's streets, Public Safety Commissioner Eugene "Bull" Connor ordered in police dogs as brutal reinforcements for his overwhelmed men.[67] At an intersection proximate to both Kelly Ingram Park and 16th Street Baptist Church, where hundreds had confronted the hoses on the previous day, no fewer than five policemen with at least as many dogs occupied the crosswalk. The gathering demonstrators, with their unhurried postures and dry clothes, had the appearance of spectators. Moore captured the moment when one German shepherd announced the division between power and protest (see fig. 27). The photograph, taken at an oblique angle to the crosswalk, depicts a man stopped midstreet, his ripped pant leg pulled back by the attack dog straining against its leash. The policeman controlling the leash looks down, his lips parted perhaps in surprise or command, but seems not to have called off the attack. In Moore's next frame, the man leans forward midstride while the dog is poised to bite his buttocks; just behind, another dog and officer (leash coiled around his wrist to no avail) joins the attack (see fig. 28). Moore has squared himself off perpendicular to the crosswalk, so that those gathered at the left side of the previous frame now appear as a wall of onlookers. By the third frame, the dog under the first policeman's control has turned to face Moore, leaving the attack to the two other dogs, one of which bites the man's right buttock while the other lunges toward him

with bared teeth (see fig. 29). Moore's composition emphasizes the triangle created by the two attacking dogs and the immobilized man, even at the formal expense of the vertiginous horizon line and the foreground interference of the original officer and his dog. As Cox has argued, "Typically, the photographs they produced are valued as historical evidence and for their capacity to effect cultural and political change. That is, their function as social documents is commonly emphasized above their status as critical or aesthetic representations. But occasionally and profoundly, they show us something that we have not seen before—a point of view that prompts us to look at the world, and the subject, with renewed concentration."[68] The formally considered compositions of Moore's Birmingham dog attack photographs do just this. The foreground presence of the dog and the policeman (see fig. 29), for example, makes Moore's proximity to the events absolutely clear. Indeed, as Roberts and Klibanoff have noted, in the first of these three frames (see fig. 27) other photographers shoot from the safety of the far curb, the immediacy of the scene diminished by several feet of distance from the action.[69] Remarkably, Moore seems to be no less threatened by the dogs and officers than those demonstrators who form the backdrop of his second frame.

Many scholars have argued that photojournalists such as Moore knew the potential for influencing their audience when framing their compositions. As Michaud has succinctly stated, "Both parties—makers and viewers—know what the other is up to and how they go about it."[70] In the same catalogue on contemporary photojournalism, Jörg Huber elaborates on the process behind such an outlook, pointing out that phrases such as "emotional impact," "telling a story," or "providing context" reflect our "cultural patterns on which the interpretation of communication and information is based . . . [and also] act as a filter in the mind and the camera of the photographer: pictures are created as the product of ideological programming."[71] Moreover, Huber continues, "actually taking a photograph usually involves acting so quickly that there is rarely time to wait for the 'decisive moment' or consider in advance the details of the situation. The requirements of spontaneity and intuition mean that photographers not only respond to the event they are photographing, but also reproduce images already stored in their mind."[72] Although he refers to Cartier-Bresson's decisive moment—the instant when photographic elements of lighting, subject, point of view, and framing all align to produce a singular and definitive image—Huber also suggests that some of these components may not be attended to in the demands of a timely, even immediate, reaction.[73] Thus, the photographer operates within codes of legibility and accessibility, which, in photojournalism, function as self-reinforcing processes. In images of war or political gatherings—whose iconography and language frequently come to bear on civil rights photographs—the codes of legibility and accessibility are reinforced through visually recognizable villains and

heroes, such as the multiple Birmingham officers and dogs participating in an attack against a single person.

Moore's ability to convey the experience of the Birmingham demonstrations owes a great deal both to his proximity to the events and to his framing of the scene that suggests he was the only photographer present, or at least the only one willing to risk full engagement with the demonstrations. These are both qualities that have been heralded in traditional street photographs. In Moore's case, however, he increasingly used them to insinuate his support of the civil rights movement into his pictures. Moore pinpointed the dog attacks as a definitive and irreparable rupture in his (supposedly) detached and objective journalistic coverage of the demonstrations: "My emotional involvement in the story grew as I saw what was happening. The police dogs were what really did it for me. I knew that those high-pressure hoses hurt people—I saw them ripping off their clothes, knocking them down, and rolling them around—but somehow I didn't see them getting hurt badly. But the sight of snarling dogs, and the possibility of dogs ripping flesh, was revolting to me."[74]

Moore continued to photograph in Birmingham until May 7, despite the injury he suffered from the concrete block on May 3. In the intervening days, newspapers around the world carried pictures from the Birmingham demonstrations—all of which made evident that the civil rights movement was an insurrection against the state by its citizens (indeed, it was called the "Second American Revolution" in some contemporary commentary)—and police commissioner Connor realized the effect of unregulated photographic coverage. He ordered his forces to arrest Moore and Durham at the slightest appearance of probable cause, and both were eventually taken into custody for their refusal to obey a police order to cease taking photographs.[75] Moore's commitment to photographing the violence of his home state certainly earned him a reputation as someone willing and proximate to the movement's events. Following the appearance of his Birmingham photographs as an eleven-page lead story for *Life*, he was seen by colleagues as someone who would always be present when, as Durham recalls, "all hell broke loose. One network television correspondent so admired the way Charles maneuvered in fast-breaking situations that he would tell his crew to watch Moore and to move when he moved."[76] Moore's commitment to his photographic coverage stemmed from his own identity as a Southerner, and it registered in his photographs. "What I saw covering the civil rights movement hurt me beyond just being angry. I loved the South. I didn't want to know these terrible things were happening. But they were, and I was going to photograph everything I could."[77] Moore's engagement as a Southerner and the impact of his Birmingham photographs can be most fully understood by a consideration of the specifics of these demonstrations and of the city streets on which they took place.

BIRMINGHAM'S CIVIL RIGHTS DEMONSTRATIONS

A large, industrial, post–Civil War city of approximately 350,000 residents by 1963, Birmingham epitomized segregation. Among Southern cities, it had a significant black population (40 percent) that was predominantly working class, as was the majority white population. Alabama's largest city was referred to as "the last stop before Johannesburg, South Africa," for its notoriously volatile race relations and fierce enforcement of segregation.[78] It had opted to close all its municipal parks, pools, playgrounds, and golf courses rather than comply with federal orders to desegregate such public facilities. From 1957 to 1963 the city had dozens of unsolved racist bombings in a single black neighborhood (dubbed "Bombingham's Dynamite Hill") and even more numerous cross burnings. In May 1961 a Freedom Rider bus was attacked without any police presence or intervention. Commissioner Connor had overseen the city's police force, known for its brutality, for twenty-three years. For civil rights advocates, he became the emblematic arch-segregationist; for many whites in Birmingham, he reflected their own hatred of those he freely called "niggers," who did not "know their place" in a Jim Crow stronghold.[79] President John F. Kennedy had described Birmingham as "the worst city in the south," and, for that very reason, Martin Luther King Jr. hoped that the Birmingham demonstrations would "break the back of segregation all over the nation."[80]

Devised by King, Fred Shuttlesworth, the pastor of Birmingham's 16th Street Baptist Church, and other King advisors during a secret retreat in January 1963, Project C (short for Project Confrontation) intended to catalyze the support of the local business elite and the (Northern) steel corporations that employed many residents. The project had three phases: persistent economic boycotts and picketing of white downtown businesses, daily marches on city hall, and a final swell of choreographed nonviolent demonstrations involving thousands of local youth. The last of these explicitly aimed not only to fill the city's jails beyond capacity but also to provoke Connor's typical police brutality on participating schoolchildren in the expectation of widespread media—and especially photographic—coverage. The cumulative effect of all three phases would garner adverse publicity for the city, its officials, and its policies. The anticipated arrests of Shuttlesworth and thousands of demonstrators would occur only after the economic effects of the boycotts and picketing had registered with Birmingham's business leaders, and the youth would only participate at the culmination of the project, in order to be present when violence erupted.

Much of what occurred in Birmingham went according to plan; even Connor's injunction against the first march, while it postponed the second phase of the project, was a clear signal of the commissioner's increasing frustration. As Cox has pointed out, it also allowed Connor to prepare: he blocked off the major intersections near both the white and black downtown business areas using patrol cars and motorcycles;

he readied plainclothes officers (often referred to as "posse men" in contemporary accounts), uniformed officers, and police dogs; and he requested the construction of special high-pressure water hoses for use by the fire department.[81] On Wednesday, May 1, when demonstrators descended the steps of 16th Street Baptist Church bound for downtown, Connor had police wagons intercept and arrest eight hundred of them, beginning the filling of the jails.

The following day waves of demonstrators continued to file out of the church and into Kelly Ingram Park, a tree-lined block of Birmingham's black downtown district. They were packed into police wagons, patrol cars, and finally school buses until nearly a thousand were arrested. One group of students, Kasher noted, bypassed the blockades and "carried their picket signs into white downtown, where Connor's harried forces finally caught them."[82] That same day, according to *Time*, firemen deployed the custom-made hoses, whose monitor guns forced the power of two standard fire hoses through a single nozzle, creating a jet that peeled bark from the trees in Kelly Ingram Park from a distance of one hundred feet and broke bones at close range. "Black-booted firemen turned on their hoses," *Time* reported. "The kids fell back from the crushing streams. The water pressure increased. Children fell and lay there bleeding. The march stopped."[83] The hoses would continue being used for the remaining five days of demonstrations. Many in the press arrived in Birmingham that day and the following, May 3. As Roberts and Klibanoff have summarized, "What they saw, what they wrote, what they broadcast, and, most important, what they photographed . . . would have a swift and stunning impact on the American people, all the way to the White House."[84]

By the time Moore arrived in Birmingham in the early afternoon of May 3, the expanded demonstrations, announced by King that morning, had just begun, with over a thousand youth participating, some as young as six years old. The water hoses forced marchers out of Kelly Ingram Park and blasted them off its surrounding streets, dispersing or containing them for arrest before any neared the white downtown and city hall. Others hunkered down against the hoses, as photographed by Moore (see fig. 30). Witnessing the resolve of the demonstrators and aware that others were antagonizing his men, Connor ordered in the police dogs in an effort to further disperse the crowd from the park.[85]

The next morning, newspapers across the nation and around the world published photographs of the dog attacks by Associated Press (AP) and United Press International (UPI) press photographers, and the brutality and immediacy of these images elicited the public moral outrage that King and Shuttlesworth had anticipated. Bill Hudson's picture of a dog attacking a demonstrator named Walter Gadsen ran on the front pages of the *New York Times*, *Washington Post*, *Los Angeles Times*, and *San Francisco Chronicle*, among others (fig. 41).[86] Formally, Hudson's photograph presents a static triangle

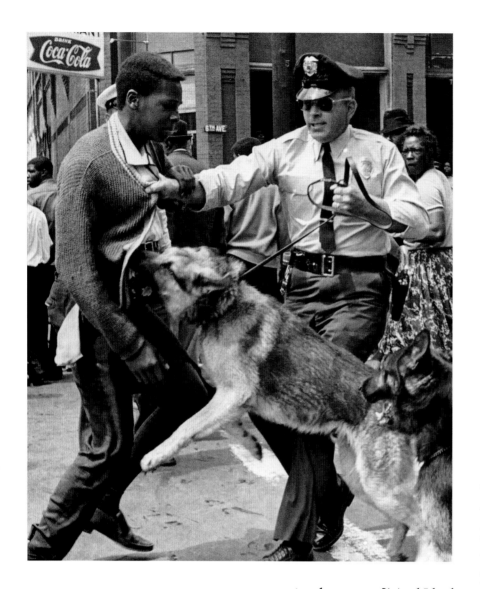

between the black demonstrator, the white policeman, and the German shepherd; the lines of connection are reinforced by the officer's outstretched restraining arm, the taut leash in his other arm, and the dog's upward and forward lunge at Gadsen's stomach. This photograph quickly hit the AP wire after Hudson took it, and was rapidly distributed.[87] Moreover, Hudson's image (and other, lesser-known ones like it) crossed national boundaries; published outside the United States, the dog attack photographs resonated in ways perhaps even Shuttlesworth and King could not have foreseen. Congressman Peter Rodino told a House judiciary subcommittee that he "was attending a conference at Geneva . . . and the incident of the police dog attacking the Negro in Birmingham was printed all over the world. One of the delegates from one of the nations represented at the conference there showed me the front page of the European edition of the *Times* and he was a little more frank than some of the others, and he asked me, 'Is this the way you practice democracy?' And I had no answer."[88] For the United States, so invested in aggressively projecting its Cold War image as *the* model democratic society, this anecdote gives but a small indication of the foreign embarrassment caused by the photographs of the Birmingham demonstrations.

FIG. 41. Bill Hudson, *Walter Gadsen Attacked by K-9 Units outside 16th Street Baptist Church, Birmingham* (detail), May 3, 1963.

While the world reacted to the images, marches continued on downtown Birmingham, city hall, and the overflowing jail. The marches on Monday, May 6, alone resulted in 2,500 arrests, the highest daily total of all the demonstrations. The following day, the same number left 16th Street Baptist in new waves of marches into downtown (fig. 42): "Yelling and singing, they charged in and out of department stores, jostled whites on the streets, paralyzed traffic" (fig. 43).[89] Both this report and Moore's photographs emphasized the demonstrators' physical occupation of the street and their disturbance of its normal protocols ("jostling," "charging," finger wagging) and its smooth functioning ("paralyzed traffic," a sidewalk corner so densely packed no other

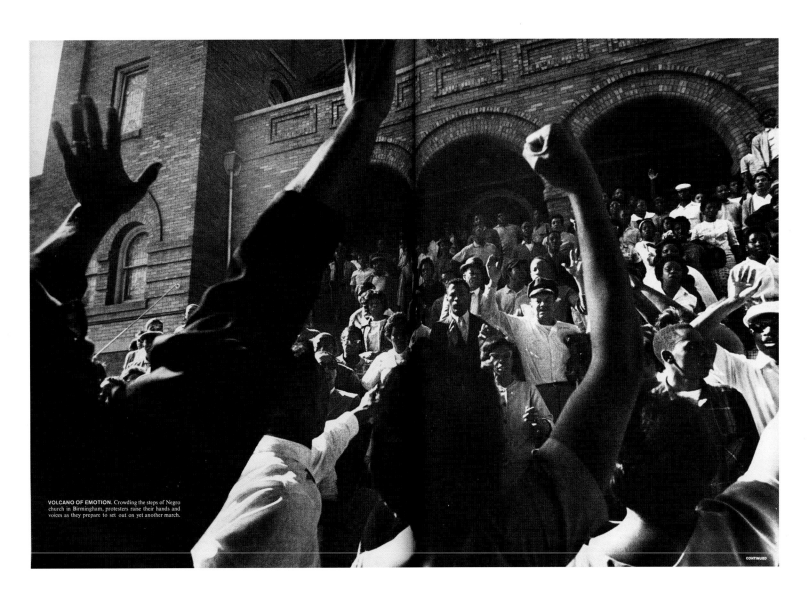

VOLCANO OF EMOTION. Crowding the steps of Negro church in Birmingham, protesters raise their hands and voices as they prepare to set out on yet another march.

CONTINUED

FIG. 42. "They Fight a Fire That Won't Go Out," *Life*, May 17, 1963, pp. 34–35. Photograph by Charles Moore.

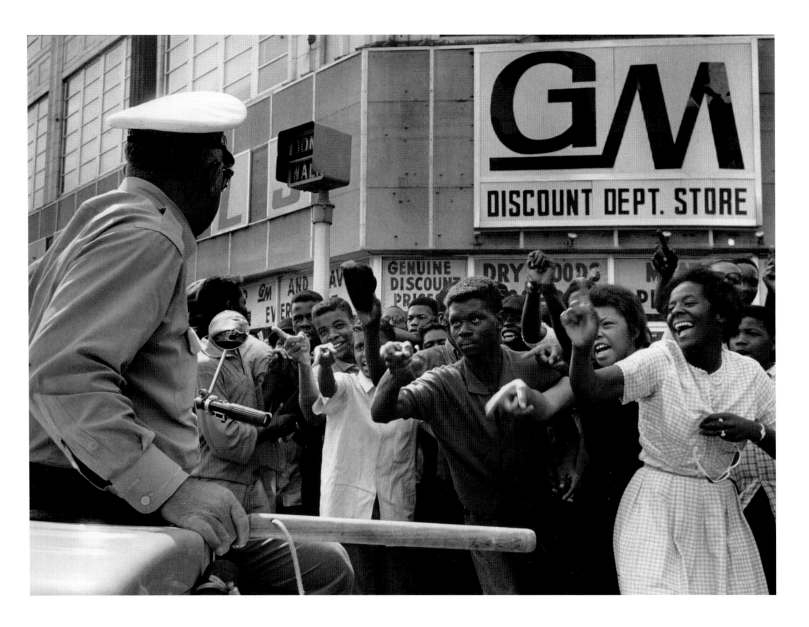

FIG. 43. Charles Moore, *Downtown Birmingham, Alabama,* May 7, 1963.

pedestrian use was possible). Moreover, both implied the economic impact of such occupation of the streets: the article mentions department stores in which such interruptions would have been unwelcome; Moore's photograph (see fig. 43) captures the store's window and door signs behind an impassable sidewalk corner thick with protestors. On other sidewalks downtown, firemen used hoses again in attempts to disperse the marchers, since, by Tuesday, there was no more room in the black section of the jail.[90] As before, demonstrators took cover from the forceful hoses (fig. 44). While taking photographs of these hosings, Moore and Durham were arrested.[91]

Over the next three days, negotiations finally yielded an accord between Birmingham's merchants and civil rights demonstrators. All public spaces and department stores would be desegregated immediately, equal job opportunities would be ensured, a biracial committee would be charged with the reopening of closed public facilities, and no charges would be brought against the arrested demonstrators. In language that revealed an ideological equation between urban downtown areas and

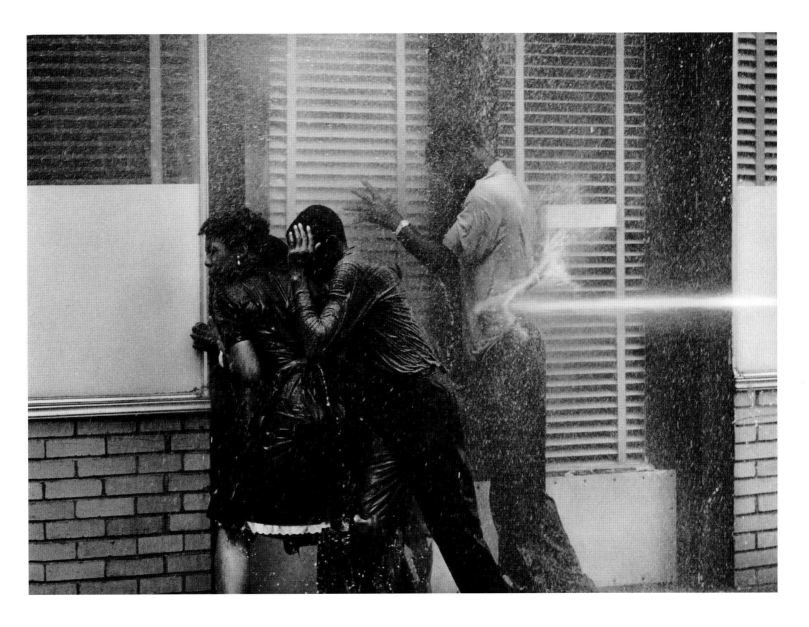

FIG. 44. Charles Moore,
Downtown Birmingham, Alabama,
May 7, 1963.

the white "communities" that controlled them, *Life* triumphantly declared that Project C had "forced white communities to start desegregating their city facilities."[92] It further pointed out that Project C had violated an injunction against the marches, but applauded the result: "Dr. King's demonstrations did take place in violation of Birmingham's parade ordinance. But the technical legal infraction was far outweighed by the broader right of citizens in a free society to assemble peaceably to seek redress of grievances. . . . 'Nonviolent direct action' made the whole community—and nation— hear him."[93] Connor's violence, while abhorred, was cast in physical terms for its visual effect on the printed page: "millions of people—North and South, black and white—felt the fangs of segregation and, at least in spirit, joined the protest movement. The revolution was on—in earnest."[94] But it was the photographs—more than accounts of King's strategies and Connor's retaliations—that continued to resonate and reverberate in the coming months and even years. Among the most telling example is *Time* magazine's January 1964 issue, which named King "Man of the Year." The cover

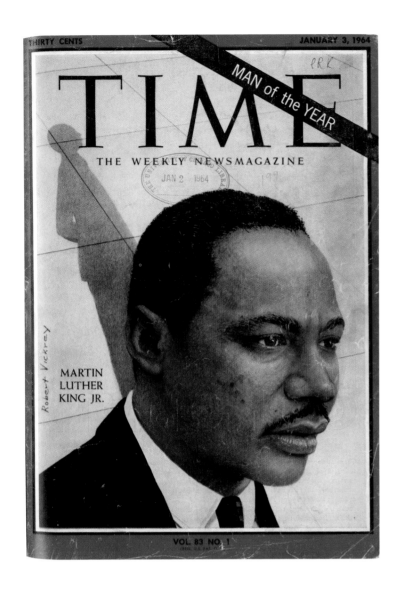

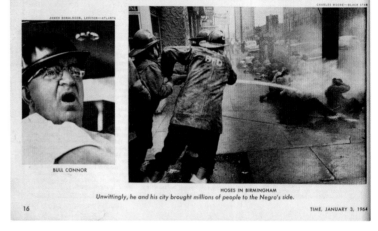

FIGS. 45 AND 46. "Man of the Year: Martin Luther King Jr.," *Time*, January 3, 1964. Illustration by Robert Vickrey. Photographs by James Donaldson (left) and Charles Moore (right).

portrait (fig. 45) depicts King with his shadow cast along an urban stretch of sidewalk—symbolic of the demonstrations that had marked 1963—and the article inside includes a reproduction of Moore's already famous photograph of the firemen (fig. 46).

On a practical level, the events in Birmingham prompted perhaps the most extensive demonstrations ever across the nation; Kasher cites over a thousand such actions and nearly 20,000 resulting arrests in over one hundred cities throughout the South.[95] On a rhetorical and symbolic level, the events in Birmingham were mentioned in President Kennedy's first and most vigorous appeal on the matter of civil rights during his televised national address in June 1963, in which he called for the passage of the Civil Rights Act by Congress:

> We preach freedom around the world, and we mean it. And we cherish our freedom here at home. But are we to say to the world—and much more importantly, to each other—that this is the land of the free except for Negroes? . . .

Now the time has come for this nation to fulfill its promise. The events in Birmingham and elsewhere have so increased the cries for equality that no city or state legislative body can prudently ignore them. The fires of frustration and discord are burning in every city, North and South. . . . We face, therefore, a moral crisis, as a country and a people. It cannot be met by repressive police action. It cannot be left to increased demonstrations in the streets. It cannot be quieted by token moves or talks. It is time to act in the Congress, in your state and local legislative bodies, in all our daily lives.[96]

Kennedy plainly stated the impact of Birmingham, and his crafted language incessantly evoked the cities and streets now so closely associated with demonstrations. More than that, however, the president indicated both his own and his audience's understanding of the street's status as image.

The demonstrations in Birmingham also became a touchstone for illuminating the conceptual schism between militant strategies and nonviolent direct action. In Gordon Parks's photo essay "'What Their Cry Means to Me,'" for example, Elijah Muhammad exemplified this mode of conjuring Birmingham:

There is one thing good about what is happening down there [in the South]. The black man at last can see what the white man is really like, what he really feels about him. Birmingham bears witness to the fact that a white man is a devil and can't do right, what with water hoses stripping dresses from our women and our youth being chased and bitten by vicious dogs. At last the black man realizes he must fight for his rights if he is to attain them. The white man is more vicious than the dogs he sets upon us. He is never satisfied with a black man no matter what his position. You can lie down and let your back be his doormat, but soon he'll get tired of that and start kicking you. "Turn over, nigger! You're laying on the same side too long," he'll say.[97]

Even for those with a less overt agenda, street demonstrations were usefully and frequently evoked, in part because of the highly visual language that would accompany them. Such evocations allowed any informed reader, particularly a *Life* subscriber, to picture recent street photographs from the magazine's pages as they read passages such as, "'Freedom *now!'*—no matter how wonderfully it lends itself to the emotional mood of orator and crowd, no matter how bravely those placards wave above good people softly singing *We Shall Overcome*—is a phrase with explosive potential."[98] Eventually and gradually, the nonviolent direct actions that had characterized the first several years of the civil rights movement did indeed give way to more aggressive and explosive years.[99] Nevertheless, those years—with the Birmingham

demonstrations as their apex—became the model for every subsequent political and social movement in the United States during the next ten years.[100] Street photographs such as Moore's visually inspired the continued struggle. Circulating in *Life* and other international publications as records of timely and era-defining events, Moore's photo essay thereby engaged that magazine's white middle-class readership in ways that no other records could.

THE PHOTOGRAPHS' APPEARANCE IN *LIFE*

One month after the Birmingham demonstrations, public reaction was still strong. *Life* magazine continued to express concern, and its June 14 editorial went so far as to attempt to reorient President Kennedy's domestic and foreign priorities: "The U.S. race problem has changed character . . . recommitting Americans (again in [Civil War historian Bruce] Catton's words) 'for the rest of time to a much broader concept of the quality and meaning of freedom and democracy than anything they [have] yet embraced.' How we handle this challenge is much more important to our stature in the world than any talks Kennedy can possibly have abroad at this time. We strongly support [the] view that the President should cancel his European trip and tend to these compelling matters at home."[101]

There is no question that Moore's photographs of Birmingham gripped the nation; by transcending the local, by compelling sympathetic activism, and by giving photographic form to racist brutality in the United States, they are arguably the most pivotal of all civil rights demonstration photographs. Following the initial burst of widespread daily newspaper photographic coverage on May 4 and several days of demonstrations that followed, the newsweeklies and picture magazines reached newsstands. None chose to feature Birmingham on its cover. Roberts and Klibanoff have attributed this to a miscalculation regarding the major turning point that Birmingham represented in the movement, a view "that changed quickly. *Life* came out with Moore's shocking photos, and the outrage was renewed."[102] The title of the May 17 article, "They Fight a Fire That Won't Go Out," seems to anticipate the pivotal nature of the Birmingham demonstrations, if not the role the ten-page photo essay would play in expanding the circulation of and reaction to the photographs.[103]

The number of photographs, their sequencing, the number of pages allocated to them, and their framing, scale, layout, and captioning all played a role in the way the photo essay appeared to millions of readers and thus affected the perceived meaning of both visual and written content for those readers. Through his photographic process on the city streets and his subsequent involvement with the images' appearance on the printed page, Moore combined journalistic shock with personal accountability and immediacy. Indeed, I believe that Moore's photographs complicate the narrative crafted by the editors at *Life*. Certain images are in tension with the

surrounding text, confounding editorial efforts at clear meaning making through captioning and thus making it possible for viewers to privilege the photographs' immediacy apart from the words that accompany them. Typically, *Life* did not grant bylines either to the writers or photographers responsible for a particular story; when it did, it indicated the stature of a particular writer or photographer or, in the case of a photographer byline, the magazine's privileging of that photographer's vision on the topic.[104] "They Fight a Fire That Won't Go Out" was Moore's first byline, and it seems that he had some oversight in the final layout of the eleven-page lead story.[105] In two of his spreads, a full-bleed photograph stretches across both pages. Two other spreads feature large photographs that dominate over half the layout. *Life*'s paper and oversize format (in comparison with newsweeklies such as *Time*) enhance the photographs' presence in the essay. If there was any doubt that these pages—perhaps with the exception of the last, single page—were driven by Moore's photographs, the chosen headings for each spread never overlap the image or interrupt the picture frame, save for the opening spread (fig. 47), where the article's title and subtitle overlay the image bleed (along with the magazine's logo).

The article's text begins on the second spread; reading from left to right and top to bottom, the text block is encountered only after two dramatic and large photographs of further hosings in Birmingham (fig. 48). The third spread presents Moore's three images of the dog attack, the last of which covers nearly one-and-a-half pages (fig. 49). As Roberts and Klibanoff have summarized, "Dogs that seemed menacing but grainy in newspapers became breathtaking in *Life*, especially when Moore's series of shots showed how impossible it was to get away from them."[106] Most of the following spread's four photographs are portrait-like representations of the demonstrators; the largest of the four images emphasizes the physical occupation of the streets by depicting the equally physical removal of the demonstrators by uniformed policemen (fig. 50). An image of the rally on the steps of 16th Street Baptist Church fills the last spread (see fig. 42), followed by a report on the reactions of Birmingham's white residents to the events pictured on the preceding pages (fig. 51). While the text offers one person who supports the demonstrations (but who cannot have his or her name printed for fear of retribution), most of those quoted voice anger at the demonstrators and support for continued segregation. Here readers are also presented with their first and only visual portrayal of Bull Connor, which appears in the upper-right corner of the page and is contrasted with a photograph of jubilant, taunting demonstrators who have overtaken one of downtown Birmingham's sidewalks. Considered as a whole, these eleven pages reinforce the potency, vividness, and implications of Moore's photographs.

Perhaps nowhere is this more evident than in the first spread of the photo essay (see fig. 47). Moore's framing of the action, already so immediate because of his mode of photographing, now serves to bring the viewer into the action vicariously. The

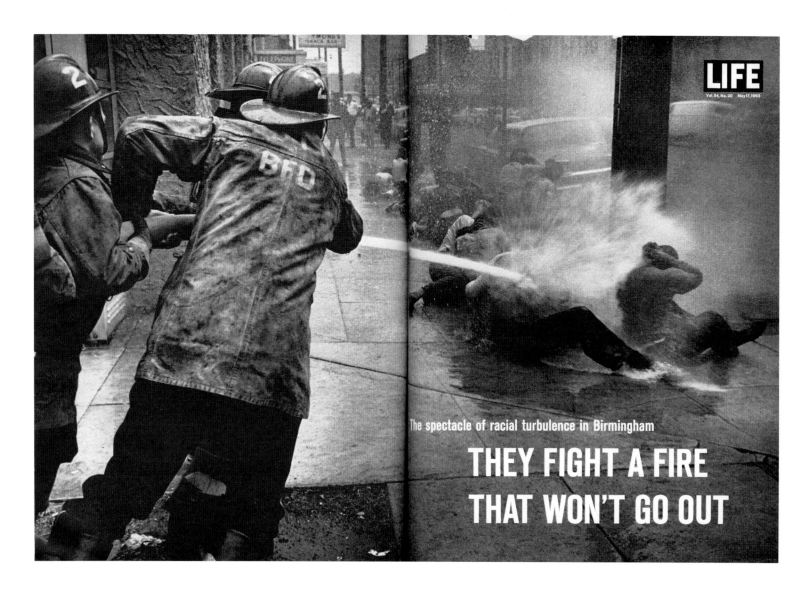

FIG. 47. "They Fight a Fire That Won't Go Out," *Life*, May 17, 1963, pp. 26–27. Photograph by Charles Moore.

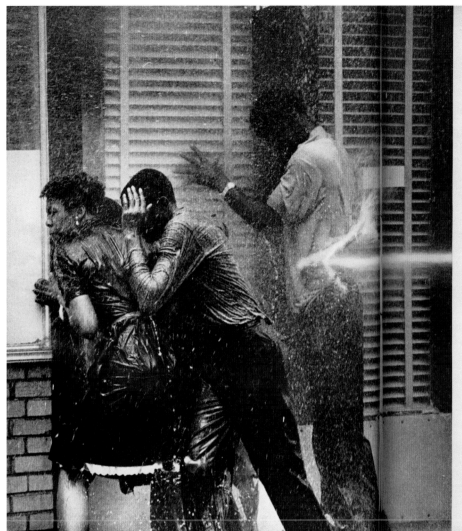

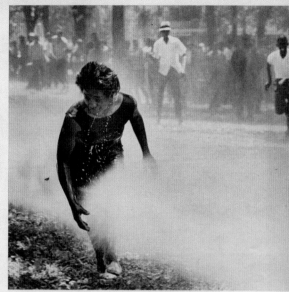

PINNED TO WALL. Pummeled by shaft of water hitting like a battering ram, three demonstrators reel against a building front. Firemen used high-velocity "monitor-gun" nozzle.

CAUGHT IN OPEN. Struck on the knees by hose blast as she ran forward to taunt the police, a Negro girl frantically tries to jump clear. An instant later she was knocked down.

PROVOCATION, REPRISAL
WIDEN THE BITTER GULF

The pictures on these 11 pages are frightening. They are frightening because of the brutal methods being used by white policemen in Birmingham, Ala. against Negro demonstrators. They are frightening because the Negro strategy of "nonviolent direct action" invites that very brutality—and welcomes it as a way to promote the Negroes' cause, which, under the law, is right. And they are especially frightening because the gulf between black and white is here visibly deepened.

For a half century, Birmingham has been known as the "South's toughest city." A large Negro population combined with a dominant class of white industrial workers has made for a climate of simmering racial hatred that has frequently erupted into open conflict.

Personally led by the Reverend Martin Luther King,

the Birmingham campaign is now the *cause célèbre* of the entire American Negro movement. Elsewhere in the South, by such "nonviolent" techniques as sit-ins and "kneel-ins" in white churches, King and his followers have forced white communities to start desegregating their city facilities—and to sit on biracial panels to discuss further desegregation. This is what the Negroes in Birmingham want, and they are prepared to go to jail —or to face hoses and police dogs—to get it.

Up to now, open conflict has erupted only between the "direct action" group and police; at midweek a truce had been agreed on. Still the Negroes—aware they are trying to crack "the toughest city in the South" —and the police, with their dogs and fire hoses, have set an ominous precedent of provocation and reprisal.

Photographed for LIFE by CHARLES MOORE

CONTINUED 29

FIG. 48. "They Fight a Fire That Won't Go Out," *Life*, May 17, 1963, pp. 28–29. Photographs by Charles Moore.

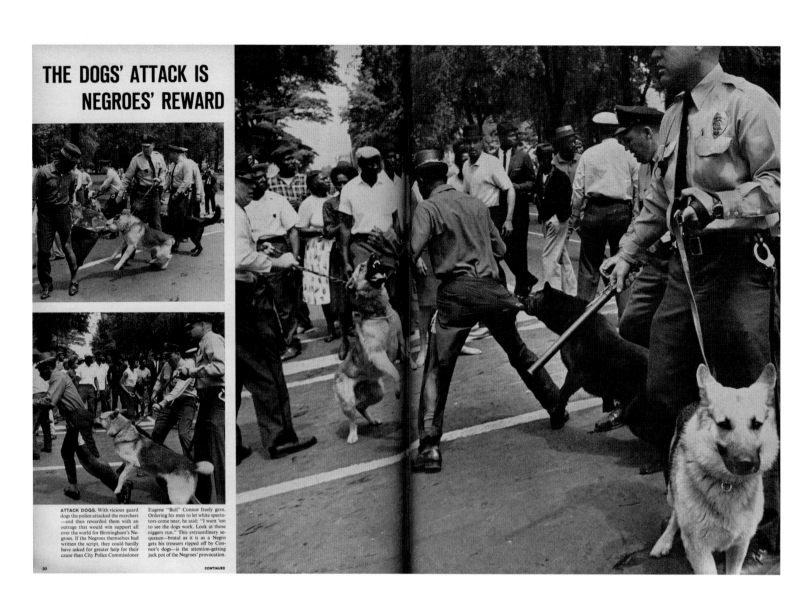

THE DOGS' ATTACK IS NEGROES' REWARD

ATTACK DOGS. With vicious guard dogs the police attacked the marchers —and thus rewarded them with an outrage that would win support all over the world for Birmingham's Negroes. If the Negroes themselves had written the script, they could hardly have asked for greater help for their cause than City Police Commissioner Eugene "Bull" Connor freely gave. Ordering his men to let white spectators come near, he said: "I want 'em to see the dogs work. Look at those niggers run." This extraordinary sequence—brutal as it is as a Negro gets his trousers ripped off by Connor's dogs—is the attention-getting jack pot of the Negroes' provocation.

CONTINUED

30

FIG. 49. "They Fight a Fire That Won't Go Out," *Life*, May 17, 1963, pp. 30–31. Photographs by Charles Moore.

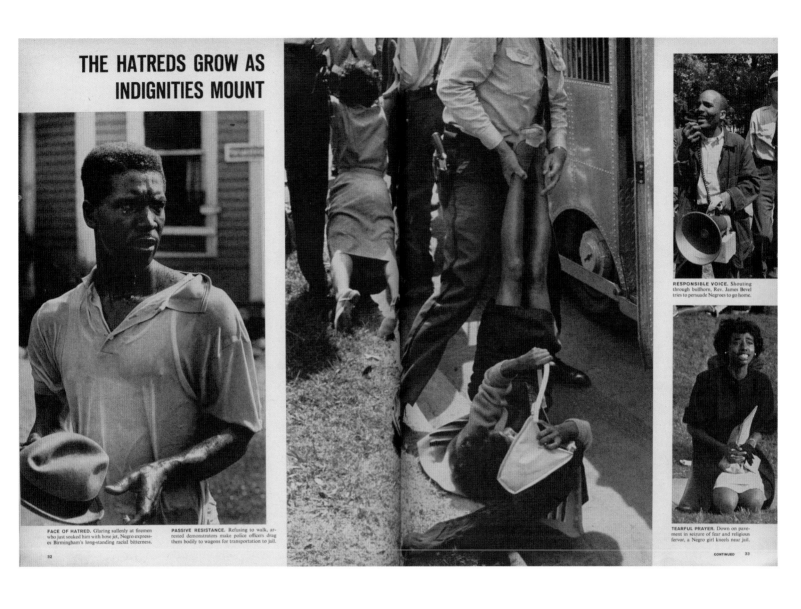

THE HATREDS GROW AS
INDIGNITIES MOUNT

FACE OF HATRED. Glaring sullenly at firemen who just soaked him with hose jet, Negro express-es Birmingham's long-standing racial bitterness.

PASSIVE RESISTANCE. Refusing to walk, ar-rested demonstrators make police officers drag them bodily to wagons for transportation to jail.

RESPONSIBLE VOICE. Shouting through bullhorn, Rev. James Bevel tries to persuade Negroes to go home.

TEARFUL PRAYER. Down on pave-ment in seizure of fear and religious fervor, a Negro girl kneels near jail.

32

33 CONTINUED

FIG. 50. "They Fight a Fire That Won't Go Out," *Life*, May 17, 1963, pp. 32–33. Photographs by Charles Moore.

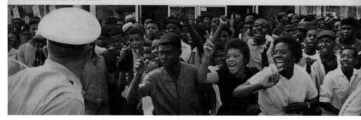

QUERY FOR SOUTHERN WHITES—WHAT NOW?

The Negroes of Birmingham know what they want and how they want to get it. The white people of that city, shaken by recent events, are perplexed about what to do, and some are searching for attitudes and policies to solve the searing problem. LIFE Reporter Bill Wise spoke to a cross section of white Birmingham residents to learn their reactions and hear their suggestions for dealing with the new Negro tactic of nonviolent mass demonstrations.

REVEREND WALLACE W. LOVETT, pastor of Woodlawn Methodist Church: "I think the demonstrations are delaying attainment of the ultimate objectives of the colored people of Birmingham. The solution to the problems we face here will not come out of demonstrations of massive force, but out of sensible negotiations by leaders of both groups."

FRANK PLUMMER, president of the Birmingham Trust National Bank: "I was very concerned with their problems but now I've lost sympathy with this thing. If we could keep the outsiders—both white and black—out of here we could solve the problem."

JACK WILSON, salesman: "They are defeating themselves. They are just causing a lot of anger and resentment. Martin Luther King has told them that after another week or two of this the people of Birmingham will be willing to submit to their demands, but that simply isn't true."

TED HUBBARD, engineer: "A few weeks ago I wouldn't have thought a thing about walking down a street in the colored area alone, but I sure as hell wouldn't do it now. They aren't trying to prevent trouble. They are looking for trouble. If you get 4,000 individuals, white or black, and try to lead them down the street, it only takes one hothead to start a riot."

JOE FERGUSON, barber: "They call these people out here demonstrators. They called those white boys down at Ole Miss a 'rioting mob.'"

MARVIN COX, retired Air Force officer: "I served 20 years in the service of my country and was proud of it, but if I had known that this was what I was fighting for I would have been ashamed."

R.L. BURDETTE, scrap iron broker: "When a man takes small children and purposely puts them where they can get hurt, he is far worse than Bull Connor."

MORGAN KNIGHT, car salesman: "If they keep trying to shove this thing down people's throats there is going to be real trouble. They are just making people mad."

DR. FRANK BUCHANAN, Baptist minister: "This thing has to be solved by a process of evolution. A lot of good intelligent Negroes in this understand this, but they can't speak out for moderation because the Kings and other outsiders call them Uncle Toms and accuse them of selling out their race."

JESSE MADARIS, parking lot attendant: "We've got to accept integration. Not that I want to, but it is here. But this situation now is going to lead to small war between the Negroes and the whites. The white people are finally going to get riled up enough so that we will have real bloodshed."

A WHITE HIGH SCHOOL TEACHER: "All this time we've done nothing to prepare these kids for social change. All these years there should have been some effort to prepare them for this. But we've been forbidden to even mention it. They could have been taught about the worldwide aspirations of all peoples for equality, and there should have been social exchange between colored and white children. . . . The demonstrations are worthwhile if they only focus the attention of right-thinking people on this situation so that eventually something may be done about it. To me the solution is very simple: just treat human beings as human beings. But to many of these people Negroes are not human beings. Please don't use my name with this. I am ashamed to ask you not to. If you do I will lose my job. The fear that prevents people from saying what they want to say is a terrible thing."

ALICE HUMPHRIES, sales clerk: "I'm not in favor of Bull Connor and his dogs. This is true of a great many people of Birmingham, but a lot of people won't speak their thoughts because they are afraid. I think the demonstrations are ill-timed. If they had waited until the new city government was installed, maybe this wouldn't have been necessary."

EDDIE ENTREKIN, college student: "I think this has been coming for a long time. Birmingham has been a sort of radical bastion of the South. Most people here realize the Negroes haven't had the rights they deserve, but they [the whites] have been unwilling to change. At first I was glad to see the demonstrations, but I have begun to question King's motives lately."

TOMMY ARWOOD, auto body and paint man: "You can't blame the Negro for what he is trying to do. Sooner or later they are going to win, but they aren't going to school with my children."

CARDER HIGGINS, management trainee: "I guess if I were in their shoes I might do the same thing. I think maybe we've handled it wrong. If they want to parade and march along and sing and shout we should let them."

GEORGE SEIBELS, city councilman-elect: "It is most unfortunate that all these unlawful, untimely demonstrations took place just following the election of the new city government. They have done everything to upset what hope we had for making progress."

POLICE BOSS. Busily waving a hand, Commissioner "Bull" Connor directs police task force. Many white citizens deplore Connor's ruthless methods but hesitate to say what they think.

JEERING MOB. Waggling their fingers at an officer (left), youthful Negroes taunt police. Provocation like this, to most whites, is a wide-open invitation to full-scale racial warfare.

FIG. 51. "They Fight a Fire That Won't Go Out," *Life*, May 17, 1963, p. 36. Photographs by Charles Moore.

viewer is placed in uneasy proximity to the firemen, and the immediacy of the scene accomplishes Moore's goal (in shooting only with wide-angle lenses) of providing "'a feeling of what it was like to be involved.'"[107] It is important to remember that Moore's photograph appears on this spread in as large a format as was available; it occupies the full span of both pages and cedes little space to *Life*'s requisite text components. Such a choice—whether instigated by *Life*'s editors and approved by Moore or vice versa—is a lucid illustration of the magazine's commitment to enhancing on the printed page the formal photographic strategies that could "align the viewer's gaze with the camera's and/or the subject's gaze."[108] The article's bold title both prompts the reader's identification with the firemen ("they" decidedly does not refer to the huddled demonstrators) and suggests the utter futility of the firemen's actions, hosing "a fire that won't go out" given the demonstrators' commitment. Already, then, in the opening spread of Moore's photo essay, *Life*'s readers were visually and textually engaged.

The heading of the second spread (see fig. 48) announces that "PROVOCATION, REPRISAL WIDEN THE BITTER GULF" in a font only slightly smaller than on the title spread. The story then begins: "The pictures on these eleven pages are frightening. They are frightening because of the brutal methods being used by white policemen in Birmingham, Ala. against Negro demonstrators. They are frightening because the Negro strategy of 'nonviolent direct action' invites that very brutality—and welcomes it as a way to promote the Negroes' cause, which, under the law, is right. And they are especially frightening because the gulf between black and white is here visibly deepened."[109] The first caption, corresponding to the photograph of demonstrators pressed against a building facade, also services the opening spread's photograph by describing the bright white horizontal blast of water so visually dominant in both photographs: "PINNED TO WALL. Pummeled by a shaft of water hitting like a battering ram, three demonstrators reel against a building front. Firemen used high-velocity 'monitor-gun' nozzle."[110] In the facade photograph in particular (see fig. 44), the water takes on a more visceral solidity; viewers can see it indenting the back of the tallest demonstrator, making an arrow-like

shape upon contact, whereas the stream in the first photograph (see fig. 30) dissipates into a seemingly less threatening spray ("seemingly," because the huddled demonstrators bodies appear to bend beneath the water's pressure, thus giving form to the pain it inflicts). The text on the second spread concludes by linking the fire hoses and the police dogs, thereby preparing the reader to turn the page: "[Desegregation] is what the Negroes in Birmingham want, and they are prepared to go to jail—or to face hoses and police dogs—to get it. . . . Still the Negroes—aware that they are trying to crack 'the toughest city in the South'—and the police, with their dogs and fire hoses, have set an ominous precedent of provocation and reprisal."[111] On the next spread (see fig. 49), the heading "THE DOGS' ATTACK IS NEGROES' REWARD" appears above and to the left of the three photographs of the dog attacks, the last of which has been cropped (see figs. 27–29).[112] Bleeding fully across the right page of the spread and onto half of the left page, this photograph's new cropping carefully aligns each element: on the left page of the spread, a lunging German shepherd with bright bared teeth dominates; the black demonstrator being attacked now visually straddles the spread's gutter, mimicking his physically stretched-out stance between the two dogs; and the other policeman and dog are now aligned with the right page's rightmost edge, the dog in particular looking squarely out (at the viewer) from the foreground. In short, the presentation of this photograph refines Moore's initial framing of the scene and draws greater attention to both the aggressors and the victim. The only other element in this spread's layout is a fairly extended caption: "ATTACK DOGS. With vicious guard dogs the police attacked the marchers—and thus rewarded them with an outrage that would win support all over the world for Birmingham Negroes. If the Negroes themselves had written the script, they could hardly have asked for greater help for their cause than City Police Commissioner Eugene 'Bull' Connor freely gave. . . . This extraordinary sequence—brutal as it is as a Negro gets his trousers ripped off by Connor's dogs—is the attention-getting jack pot of the Negroes' provocation."[113] This caption, along with others, reveals a disconnect with the photographs (and their presentation, in some cases) that opens an interesting rift in how viewers can perceive them. Where, for example, did the writer of this caption expect *Life*'s readers to find the visual corollary to the heading "THE DOGS' ATTACK IS NEGROES' REWARD" or the phrases "attention-getting" or "Negroes' provocation"?

To begin to answer such a question about image-caption tensions, it is important to remember how captions function as part of a picture magazine's meaning-making apparatus. Captions (sometimes in tandem with layout headings) ideally function to assist, direct, or anchor a picture's message and, in the context of reporting newsworthy events, aspire to journalistic objectivity. Despite the fact that images rather than text drive picture magazines' content, Kozol asserted that *Life* photographers rarely participated in writing captions for their images.[114] If this was truly the

case for Moore's photo essay—meaning that his most active role was likely oversight of the photographic layout—then it would explain the image-caption tensions in "They Fight a Fire That Won't Go Out." These tensions have prompted a generalized, sweeping debate but little contemplation of their likely impact or result. Kasher is highly critical of the text, even while misstating certain facts: "The article pays lip service to the ideal of equal rights, but its main point is that the violence had been provoked by black movement leaders. The word *nonviolence* is always in skeptical quotes. 'Simmering racial hatred' is attributed to blacks. Not a single black voice is quoted. Instead, the article concludes with a page of sixteen quotes from 'a cross section of Birmingham's white residents,' all of them critical of the demonstrations."[115] Kaplan has noted that descriptions of "the movement as a 'crusade'" and *Life*'s "use of sympathy headlines such as 'The Dogs' Attack Is Negroes' Reward'" complicate any unilateral criticism.[116] Though both writers assessed the captions for their intent and meaning-making function—with readings as varied as promoting cynical terror or sympathetic understanding—neither historian considered the direct relationship between the text and the photographs, a relationship that I find fraught with tension and incongruity. Since Moore had, as Roberts and Klibanoff stated, "respected the point and purpose of photojournalistic objectivity . . . [but] had concluded, through the lens, that there was a right side and a wrong side," I suggest an assessment based on Moore's photographs (and his presumed oversight of their appearance on *Life*'s pages), which may prove more productive.[117]

The final single page (see fig. 51) offers what I consider to be one of the most telling clues to the photo essay's photographically determined intention. This page is the first to depict Bull Connor, despite his mention six pages prior. The choice to reserve his portrayal for a text canvassing the town's white residents seems fairly straightforward, but the picture's discrepancy from the characterization of Connor in the text proposes another explanation. His methods are called "ruthless," and the caption suggests a widespread fear of Connor. Moreover, despite the largely segregationist bent of the white Americans' responses, Connor is the only person quoted using the term "nigger," which appears in the extended caption for the dog attack sequence: "Ordering his men to let white spectators come near, he said: 'I want 'em to see the dogs work. Look at those niggers run.'"[118] The undramatic, nonthreatening photograph of Connor has been relegated to the last page, allowing the policemen and attack dogs—Connor's actions rather than his image—to represent him for most of the photo essay.

The essay's final page is also the first page to offer *Life*'s readers an image of black demonstrators that could be remotely considered illustrative of the "provocation" mentioned in the earlier pages. Taken just moments before or after fig. 43, the published photograph depicts a mass of protestors, the front row of whom have

their hands raised and index fingers extended in midwave. Mouths are open, as if in midchant or midsong, and many wear smiles. The presence of law enforcement is only identifiable by the policeman's cap in the left foreground; this was apparently a connection that *Life* editors thought viewers would not make, thus the accompanying caption: "Jeering mob. Waggling their fingers at an officer (*left*), youthful Negroes taunt police. Provocation like this, to most whites, is a wide-open invitation to full-scale racial warfare."[119] Roberts and Klibanoff's interpretation of the image as it appeared in *Life* suggests an alternate set of assumptions for the magazine's white readers: "The images of masses of well-dressed, determined, smiling Negroes taking to the streets to demonstrate bravely and nonviolently exploded several other myths: . . . [they were not] lazy, unkempt, compliant, or complacent people . . . [and] they were not outsiders. . . . What Americans saw was what Moore's camera found: young, emboldened Negroes openly taunting white police officers, singing and swaying while pointing their fingers sassily in the officers' faces."[120] Irrespective of the differences between the *Life* caption and Roberts and Klibanoff's interpretation, the placement of this photograph at the end of the photo essay more or less asks the (presumably white) readers of *Life* how they would react to the protestors. Did they believe that gestures such as finger wagging could explain the violence presented on the previous pages? Did their reactions to this picture align them with "most whites" as described in the caption? There is, of course, historical difficulty in locating exact answers to these questions. Nevertheless, Moore's final photograph visually invited its viewers to contemplate the proposed textual justifications for any of the events pictured in the preceding ten pages. To fail to reckon with this final photograph and the cumulative visual impact of the photo essay is to unproductively sidestep the images' appearance to *Life*'s readers and others. That rupture is revealed in Moore's photo essay. His photographs overpower and disrupt the accompanying text as well as *Life*'s framework in their presentation to a widespread audience.[121]

To be sure, Moore's photographs of the Birmingham demonstrations—especially those depicting dog attacks and hosings—appeared beyond the pages of *Life*.[122] The pictures were celebrated among photojournalists, and the demonstrations themselves became tied to their photographic representation in popular culture and historical accounts.[123] Many contend that they swayed legislators and thereby aided in the passage of the Civil Rights Act of 1964.[124] Besides their incorporation in Warhol's screen paintings from the summer of 1963 (see fig. 26) and their reproduction in *Time*'s summary of the movement in 1964 (see fig. 46), portions of Moore's Birmingham photographs were included within a set of five commemorative collages, which served as the official memento for the March on Washington for Jobs and Freedom in August 1963 (figs. 52 and 53).[125] In one particular collage, Moore's images of a policeman, Connor, and a lunging dog were reworked into an artistic, even childlike, rendering of

FIGS. 52 AND 53. *March on Washington for Jobs and Freedom, August 28, 1963* (New York: National Urban League, 1963), n.p.

a dog with intense triangular bared teeth. The dog grips the pant leg of the ensnared demonstrator from Moore's first photograph (see fig. 27). Another collage was made from a swastika-shaped cutout of Moore's firemen (see fig. 30). Yet the Birmingham streets have been painted over, and instead of the huddled group of demonstrators visible in Moore's original photograph, a lone protester (whose image was taken by a UPI photographer) appears in the collage as the victim of the fire hoses. This portfolio of five collages demonstrates the primacy of Moore's images, reinforcing Sara Blair's claim that, in the wake of demonstrations, "photographic images acquired new urgencies and intensities. Photo-text and photographic narrative proliferated, from the pages of *Life* and *Time* to the visual artifacts of Robert Rauschenberg and Romare Bearden."[126] That only photographs published in *Life* were used to create collages—which themselves had to be recognizable in their reinterpretation of their source imagery—reinforces the circulation and impact of that magazine.

After all, *Life*'s six million subscribers and potential thirty million weekly readers granted the magazine "iconic presence and cultural prestige" and made it one of the most important sources of news media, reaching "more Americans than any television program."[127] The possibility of having an impact on a "broader audience" was what had lured Moore away from newspapers and to *Life* in the first place, and he was not misguided.[128] There are multiple testimonials from those drawn to the movement and its actions because of their personal interpretation of images they saw in circulation in magazines.[129] Who were these people? Certainly not *all* Americans were affected by

Life's photographic coverage of the civil rights movement. Crucially, *Life*'s readership reflected a group whose opinion would have been far less informed about (and likely less sympathetic toward) the movement's struggles than those demonstrating: white, middle-class Americans. *Life* even referenced this in its own coverage of the Birmingham demonstrations and their aftermath, while exercising its opinion in hopes of affecting a particular position: "Starting with the Birmingham demonstrations, the new impatience of the American Negro (LIFE, May 24) caught President Kennedy and probably a majority of white Americans off guard. This impatience is exacerbated by the Negro's growing conviction that the white man's machinery of justice has failed him. What then is wrong with the machinery of justice and what should we do to fix it? The answers to those questions are the President's most urgent business."[130]

 Life's anticipated reader was, more specifically, thirty to thirty-four years old, from the professional and skilled labor classes, college educated, married, and likely living in a city.[131] Taking this into accord adds new import to the lead spread of Moore's photo essay (see fig. 47). Beyond immediacy, the opening spread aligned *Life*'s audience with the firemen in Birmingham. It was as if they were in Moore's place, close enough to hear the orders to turn on the hose. In the same manner, the final photograph enabled viewers to occupy Moore's place opposite the finger-wagging crowd of demonstrators, giving viewers the possibility to determine whether, after all they had seen and read on the preceding ten pages, such an act constituted "provocation" (see fig. 51). Moore structured these images to allow for such immediacy and proximity; his photo essay amplified those qualities to make possible the engagement and implication of *Life*'s white, middle-class readers. Moreover, as James Baughman has noted, those readers were likely to be city dwellers, giving street photographs of black demonstrators occupying and repurposing urban space the possibility of immense resonance.[132] If *Life*'s readers chose not to identify with the crowds pictured, they could certainly choose to align their sympathy with them, thereby distancing themselves from the white policemen and firemen. Thus, *Life*'s pages—with such depictions appearing consistently throughout the 1960s, Moore's Birmingham photo essay among them—offered a distinct and *visual* challenge to white, middle-class idealism. Moore's street photographs of the Birmingham demonstrations—as well as their appearance in *Life*'s May 17, 1963, issue—functioned as a part of the struggle for civil rights. The demonstrations treated the streets as political sites. Moore's photographs and photo essay did no less. Specifically, they transformed Birmingham's streets into a national symbol for the civil rights movement; more generally, they offer a necessary expansion of the history of street photographs as a history encompassing representations of politicized streets.

MARTHA ROSLER
A WALK DOWN THE BOWERY

A city embodies and enacts a history. In representing the city, in
producing counter-representations, the specificity of a locale and its
histories becomes critical. Documentary, rethought and redeployed,
provides an essential tool, though certainly not the only one.
—MARTHA ROSLER

Art is social in the first instance. With meaning understood to be
geographically, historically, and socially situated, rather than guaranteed
by an underlying and stable reality, art may have lost some of the prestige
it enjoyed under modernism but it has gained a far greater potent: to
participate in the creation of social life. In fact, there was no choice;
art is never really outside the city.
—ROSALYN DEUTSCHE

For an artist committed to a thoroughgoing critique of the function of truth, myth,
and artistic practice in everyday experiences, photography offers both great difficulty
and great potential. As Martha Rosler, one such artist, has noted, "The dual questions
of art's instrumentality and of its truth are particularly naked in relation to photogra-
phy, which can be seen every day outside the gallery in the act of answering to a
utilitarian purpose, in assertions of truth from legal cases to advertising to news reports
to home albums."[1] Rosler also understands that photography, in contrast to other arts,
effects a different relationship with its viewers. Within a medium that appears in art
galleries as well as in news reports, she has isolated a particular kind of photograph
that aims to be both artful and useful: the documentary photograph, particularly its
subsidiary, social documentary, which coalesces around its ability to show people,
conditions, things, and spaces "as they are."[2] Taken at face value, these photographs
operate with remarkable social and ideological power. More precisely, documentary
photography, as defined by Rosler in 1981, represents "the social conscience of liberal
sensibility presented in visual imagery."[3] She continues: "Documentary testifies,
finally, to the bravery or . . . the manipulativeness and savvy of the photographer, who
entered a situation of physical danger, social restrictedness, human decay, or combina-
tions of these and saved us the trouble. . . . W. Eugene Smith, David Douglas Duncan,

Larry Burrows, Diane Arbus, Larry Clark, Danny Lyon, Bruce Davidson, Dorothea Lange, Russell Lee, Walker Evans, Robert Capa . . . are merely the most currently luminous of documentarian stars."[4]

Rosler's eventual critique of photographic history was fueled by her own picture taking, which began in the 1960s. Initially, she photographed nature during escapes from the city, searching for transcendence, not unlike the prevailing raison d'être of the abstractions she painted at the time. As early as 1964, however, she began photographing her walks on the city sidewalks (figs. 54 and 55). Art historian and long-standing Rosler interlocutor Benjamin H. D. Buchloh recently brought up these early urban pictures, asking, "How did the street photography that you practiced fit in?" Rosler answered, "It *was* street photography, but not of people. It was photography of streets and vehicles. . . . I wasn't much interested in making pictures of people, yet I remember one photograph of people sitting on garbage cans on the Lower East Side, signs of poverty. Photography was, the art world told us, of a lesser order, mired in temporality as opposed to the transcendent world of painting. So you could deal with it as a practice less mediated, more immediate, than the one the art world had mulled over so intensively. It was accessible and vernacular, and it was low key . . . as far as I knew then, photography had no critical history."[5]

Rosler's street photographs were no fortuitous accident, as she has made clear in numerous writings and in another recent interview with art historian Molly Nesbit and curator Hans Ulrich Obrist: "Street photography was the ocean in which I swam."[6] Later in that same interview, Rosler elaborates:

> In my urban photographs there was the class romanticism of ruins—always looking for the signs of activity just passed: junkyards, ancient tar wagons, and accumulations of discarded objects.
>
> > *Obrist:* They are street scenes without people?
> >
> > *Rosler:* Yes, street scenes without people, as far as I could manage [see fig. 54]. I was interested in the marginal: things at the edge of the East River, decrepit industrial buildings, giant waterfront gravel heaps. But there are also street scenes with people, in "anonymous" neighborhoods in Brooklyn and the Lower East Side—as long as I am riding past in the car [see fig. 55]. The mediation of the vehicle represents my presence, the walker in the city, in this case, the rider. The passages are actual, not primarily metaphoric. . . . passages through and out of the urban landscape.[7]

In these interviews, as well as in her multiple critical texts, Rosler most consistently locates within the category of "street photography" the practices of the following: Diane Arbus, Walker Evans, Farm Security Administration (FSA) photographers, the

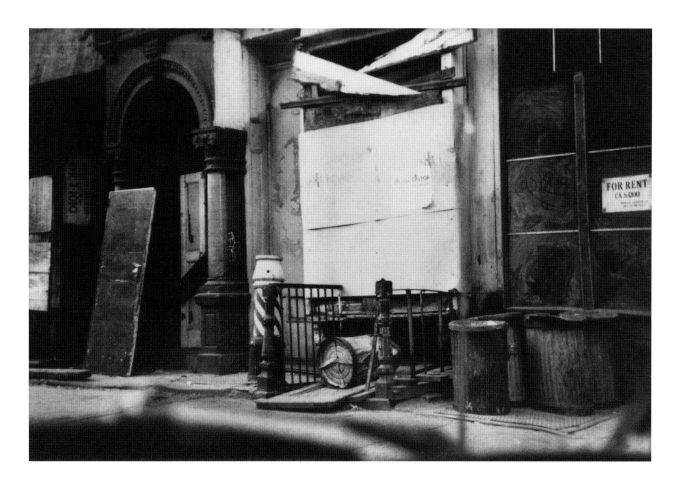

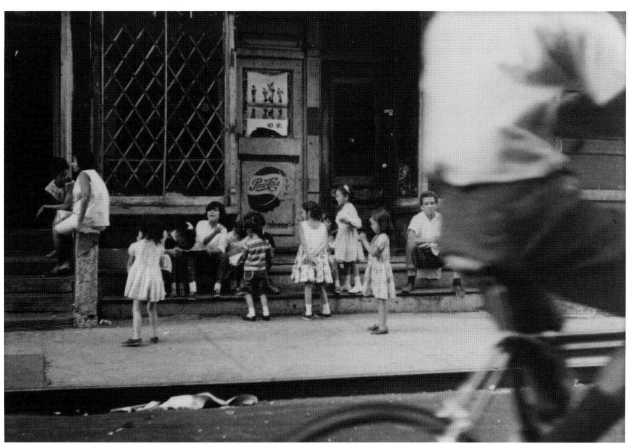

FIG. 54. Martha Rosler, *Untitled*, 1964.
FIG. 55. Martha Rosler, *Untitled*, 1964.

Film and Photo League (later known as the Photo League), Robert Frank, Lee Friedlander, Helen Levitt, Danny Lyon, the New York School photographers of the 1930s through the 1950s, and Garry Winogrand.[8]

In examining even this small sampling of Rosler's comments on documentary photography and street photography, two things are apparent. First, those photographers whose work she considers to embody street photography are virtually identical to those whose practice she identifies as embodying documentary photography.[9] Second, although she locates her origins as a photographer in an appreciation of such "street photography," her conception of the genre proves ineffectual and undifferentiated from documentary photography. Instead, she has written of street photography as an encapsulation of the essence of all photography ("what photography does—say, street photography[—is]: the representation of bodies in space ... with direct reference to time and place");[10] or as the most particular and most egregious of all documentary practices ("There is a long-standing documentary subgenre, namely 'street photography,' filling [the] niche of 'nonresponsibility' to the subject");[11] or as informative but bereft of social utility ("Despite its often acute revelations of social power differentials ... , street photography does not incline toward a calculus of rectification");[12] or, most quizzically, as "allied with war photography."[13] Based on the cumulative incommensurability of her specific references to street photography, it is my contention that Rosler has never fully addressed or considered the defining role of the city street in her critique of documentary photography, as her epigraph recommends. Had she done so, she would have found the street and street photography to be integrally linked with her most urgent critical arguments.

To create her critique of documentary—which relied on the urban nature of the practice and which, therefore, I will refer to as urban documentary photography, or "urban documentary"[14]—Rosler posed her fundamental questions and offered a starting point: "How can we deal with [urban] documentary photography itself as a photographic practice? What remains of it? We must begin with it as a historical phenomenon, a practice with a past."[15] That past contained a number of photographers whose work she wanted to engage with: Charles Sheeler, Paul Strand, Lisette Model, Aaron Siskind, Walter Rosenblum, Sol Libsohn, Ruth Orkin, Sid Grossman, Lou Seltzer, Arthur Leipzig, Bernard Cole, Bill Witt, Morris Engel, Lester Talkington, and Jerry Liebling, in addition to all those named above.[16] Taken together, the work of these photographers, she wrote, had "defined the medium in the twentieth century for Americans, especially New Yorkers," such as herself.[17] She argued that these mostly New York–based photographers had gained little from an examination of European photographic history, however much Buchloh might disagree.[18] She studied these New York–based practices as an act of historical archaeology (or genealogy) but even more so as a revelation of their assumptions (e.g., their right to depict the impoverished subject),

representational faults (e.g., transforming the individual urban poor into mere representations), and theoretical potholes (e.g., modernist self-absorption). This perspective enabled her to create a roadmap for future urban documentary practice, including her own. From this critical understanding, she advocated against photographers who abstract their specific subject matter, so often the poor urban neighborhoods of New York City and their residents. She challenged and unsettled common modes of framing those same subjects for viewers, resulting in her groundbreaking 1974–75 work of urban documentary photography, *The Bowery in Two Inadequate Descriptive Systems.*

PRECEDENTS IN URBAN DOCUMENTARY PHOTOGRAPHY

For Rosler, the history of urban documentary has included "the aggressive insistence on the tangible reality of generated poverty and despair" that would have, at a moment early in the twentieth century, been "newly elevated into consideration simply by *being photographed* and thus exemplified and made concrete."[19] Jacob Riis and Lewis Hine in particular photographed the living conditions of New York City's working and immigrant poor, who were concentrated on the Lower East Side in the late nineteenth and early twentieth centuries (fig. 56). Riis and Hine intended their images of families or children to have a humanizing effect on viewers of higher classes who were not otherwise inclined to face the realities of the urban poor. This effect relied on the public circulation of the pictures, as in Riis's book *How the Other Half Lives* (1890) or in the informational pamphlets that Hines distributed. Rosler describes such images as "victim photography" for their exploitation of a power differential that offers little agency to the subject: "In contrast to the pure sensationalism of much of the journalistic attention to working-class, immigrant, and slum life, the meliorism of Riis, Lewis Hine, and others involved in social-work propagandizing argued, through the presentation of images combined with other forms of discourse, for the rectification of wrongs. . . . Reformers like Riis . . . strongly appealed to the worry that the ravages of poverty—crime, immorality, prostitution, disease, radicalism—would threaten the health and security of polite society as well as to sympathy for the poor, and their appeals were often meant to awaken the self-interest of the privileged. The notion of charity fiercely argued for far outweighs any call for self-help."[20] Riis's desire to effect social and economic amelioration for the urban poor—by altering the consciences of the bourgeois class through his writings, lectures, and publications on the

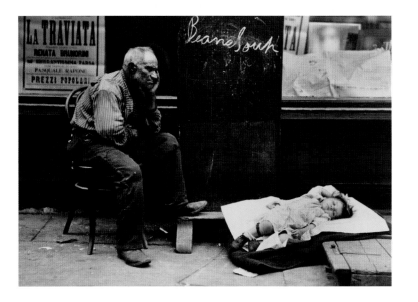

FIG. 56. Lewis Hine, *Fresh Air for the Baby, New York East Side,* c. 1910.

FIG. 57. Paul Strand, *Man,*
Five Points, New York, 1916.

topic of tenement reform—nevertheless bypassed the creation of any avenues of self-help in which the downtrodden could affect change themselves. Like Riis before him, Hine made photographs in which each person or family among the urban poor became a representation of social ills, a symptomatic embodiment of the shortcomings of mass immigration, poverty, and urban housing.[21]

This problem of picturing the urban poor led Rosler chronologically from Riis and Hine to a critique of the work of Paul Strand and certain photographers of the FSA. Rosler noted Strand's efforts "in establishing an iconography of the marginal that afforded them respect through full incorporation into the physiognomy of the human [fig. 57]. What Strand was after depended on the shock of confronting the viewing public with those considered unworthy of attention."[22] (That viewing public was the self-selected group of subscribers to Alfred Stieglitz's journal *Camera Work* or those visitors to his succession of New York City galleries.) FSA photographers found a more widespread audience for their photographs. In the early 1970s, when Rosler was formulating her critique of urban documentary, the FSA's history had just begun to be discussed and published.[23] Having already known the work of Walker Evans through his catalogue *American Photographs* (1938) and through his illustrations for James Agee's book *Let Us Now Praise Famous Men* (1941), Rosler knew Evans's photographs were deeply situated in their social context. While Evans and other FSA photographers made an effort to respectfully depict those hard hit by the Great Depression, the circulation of their images raised many questions for Rosler: What kind of exchange between photographer and subject did such photographs represent? How could these photographs claim to ameliorate when, decades later, their subjects were still living in relatively poor conditions? "Are photographic images, then, like civilization, made on the backs of the exploited?"[24]

Rosler's list of predecessors of urban documentary photography is overwhelmingly dominated by photographers affiliated with the Photo League of New York City and/or with what has since become known as the New York School.[25] Her connection to these photographic circles is practical: in the late 1960s she used the darkrooms at Brooklyn College, which were maintained by students of Walter Rosenblum, the league's de facto president from 1941 to 1951. The Photo League was at the forefront of advancing notions of urban documentary photography through its courses, programs, and exhibitions. Anne Tucker, the league's chief historian since her 1978 exhibition on

the group, notes that the league identified, taught, and displayed a type of photography that was just beginning to be appreciated and understood:[26] "The desire for social change and a belief in photography as an expressive medium that could mirror social problems and promote social change became the league's guiding principles."[27] The league thereby extended the legacy of social documentary with its belief that the photographic image could affect greater social change than the verbal arguments or published rhetoric that might surround those very images.

Given Rosler's oscillation between calling the Photo League photographers "documentary photographers" and "street photographers," it is particularly noteworthy that one historian and intimate of that group, Naomi Rosenblum, has made distinctions between the various terms. However, even she has admitted that by the late 1940s, the league had merged the two practices: "Photographers working on documentary projects often captured the random quality of street life, while the social scenes revealed in chance photographs can be said to constitute a documentation of particular aspects of human communion. . . . The desire to capture the flux of urban life . . . sometimes blended with the social documentary projects undertaken by government and private entities. Social documentation shares some of the characteristics of street photography, except that its purpose was and is reformative. . . . This genre had as its goal the revelation of social inequity or injustice."[28]

FIG. 58. Aaron Siskind, *Untitled*, from *Dead End: The Bowery*, 1937–38.

As a member of the league and one of its instructors, Aaron Siskind led his "Feature Group" in analyzing picture-magazine photo essays and then creating their own in particular locales in New York City: along the length of Park Avenue, among the tenements of the Lower East Side, and in Harlem. One such project was *Dead End: The Bowery* (1937–38) (fig. 58). Projects such as *Dead End* were the most visible aspect of the league; individual photographs were exhibited at the league and elsewhere in New York, and all of the Feature Group's finished photographs were kept on file at the league, readily available to publications ranging from *Look* to the *Daily Worker* to *Fortune*.[29] While such projects might, as Rosler characterizes Rosenblum's approach, "rescu[e] images of the down and out," they could not claim to have rescued the down and out themselves.[30] This discrepancy between image and action, she further argues, was partly because of the role of the photograph itself:

"The liberal [urban] documentary assuages any stirring of conscience in its viewers the way scratching relieves an itch and simultaneously reassures them about their relative wealth and social position. . . . One can handle imagery by leaving it behind. (It is them, not us.)"[31] Whatever compunction might have once stirred viewers was now transformed into nonrevolutionary moralism and diffuse humanism: "The exposé, the compassion and outrage, of [urban] documentary fueled by the dedication to reform has shaded over into combinations of exoticism, tourism, voyeurism, psychologism and metaphysics, trophy hunting—and careerism. . . . The liberal documentary, in which members of the ascendant classes are implored to have pity on and to rescue members of the oppressed, now belongs to the past."[32] This transformation was signaled even within the Photo League in the postwar years, as it focused more attention on photographs as expressions of individual creativity rather than as vehicles of social information.[33] In her critique of urban documentary, Rosler sought to understand and identify the factors contributing to this transformation of photographic import. However explicable in an era of Cold War accusations, the league's—and arguably also the New York School's—abandonment of its reformist goals in favor of greater individual expression nevertheless coincided with urban documentary's "aesthetic welcome by a more appreciative audience, that of art institutions."[34]

In 1966 Nathan Lyons curated an exhibition featuring a group of photographers who, he noted, might have been called "documentary" or "social realist" in an earlier time. Their pictures made him wonder, "what constitutes the meaning of reality in pictures?"[35] While this sounds like a question that could be applied to almost any photograph sharing the documentary impulse, it soon became clear that the photographers Lyons included, particularly Lee Friedlander and Garry Winogrand, were working in a fairly high modernist fashion, representing "ideas" through one of the "authentic photographic forms": the snapshot.[36] Conveniently, Lyons's group was a reticent one. Friedlander offered this insight into his choice of subject matter: "I'm interested in people and people things."[37] In his typically cryptic fashion, Winogrand commented on his creation of photographs and on their eventual viewing: "For me the true business of photography is to capture a bit of reality (whatever that is) on film . . . if, later, the reality means something to someone else, so much the better."[38] Lyons offered this elaboration: "The directness of their commentary of [sic] 'people and people things' is not an attempt to define but to clarify the meaning of the human condition. . . . The combined statement [of these photographers' pictures] is one of commentary, observation, aluminum, chrome, the automobile, people, objects, people in relation to things, questioning, ambiguity, humor, bitterness and affection."[39] These photographs were created from a personal sensibility that aspired to metaphysical commentary on everything from aluminum to affection. As curator John Szarkowski noted: "Photography has generally been defended on the ground that it is useful . . .

FIG. 59. Garry Winogrand, *New York*, 1968.

[however,] some of the very best photography is useful only as juggling, theology, or pure mathematics is useful—that is to say, useless, except as nourishment of the human spirit."[40] This commentary about Friedlander's photographs may date to 1973, but it reiterates Szarkowski's declarations in his landmark exhibition *New Documents*, held in 1967 at the Museum of Modern Art.

Featuring the images of Friedlander, Arbus, and Winogrand, *New Documents* opened with this text: "Most of those who were called documentary photographers a generation ago . . . made their pictures in the service of a social cause . . . to show what was wrong with the world, and to persuade their fellows to take action and make it right. . . . A new generation of photographers has directed the documentary approach toward more personal ends. Their aim has not been to reform life, but to know it. . . . What they hold in common is the belief that the commonplace is really worth looking at, and the courage to look at it with a minimum of theorizing."[41] Cutting off photography's connection to an experience of the world that might prompt social reform, and focusing instead on a visual knowledge of it, photographs by these three artists are aligned with modernist understandings of art as a personal, visual exercise distanced from temporality, social specificity, or narrative. Consider, for example, Winogrand's photograph of an older black man, with his hand outstretched toward the disembodied but also outstretched arm of another (seemingly white) man standing outside the frame (fig. 59). The relationship between the open palm and closed hand allows the viewer to surmise simultaneously the urban act of begging for and giving spare change; the severely tilted view may encourage the viewer to feel uneasy

or ungrounded; and the ability to perceive both the begging man's forward motion, as suggested by his bent knee, and the viewer's proximity to the charitable arm—visible in the composition because of Winogrand's wide-angle lens—heightens the sense that the viewer as much as the photographer (or the person just to his left) is being approached and solicited.

Disregarding such effects on viewers and in spite of the fact that Winogrand's photographs were shown in several exhibitions, Szarkowski's modernist understanding of Winogrand and others such as Arbus and Friedlander effectively consecrated urban photography for its formal accomplishments and purity of purpose.[42] Certainly these photographs were not taken with an aim to inform viewers about the particular character of the city or the social relations of the figures who appear in that city. Nevertheless, as Rosler notes in a commentary written the same year she completed *The Bowery*, "The transiency or mysteriousness of the relations in photos suggests the privatization of the photographic act. The result is an idiosyncratic aestheticization of formerly public and instrumental moves."[43] Thus urban documentary's extraction from the public, social sphere eased its transformation into merely an object of aesthetic admiration and art-market value.

Urban documentary's conflation with modernist formalism was deftly executed by Szarkowski in the exhibitions and publications program of urban documentary's stronghold, the Museum of Modern Art. As such, it created ripple effects in the understanding of the social context in which historical photographs had been made, as well as in the kind of audience those photographs, and their contemporary iterations, could access. Rosalyn Deutsche has characterized the interplay between these effects and the institutional space of their display: "Rosler analyzed the depoliticized messages about urban poverty that such photographs convey. These meanings, she suggested, do not emanate from the photographs alone but from their relations with viewers; they also depend on the institutional contexts within which photographic images circulate and which mediate between them and the public. The hierarchical relations of looking inscribed in the act of constituting bums as images—objects of vision—are heightened, Rosler concluded, when such pictures are made for exhibition in museums and galleries or when they are transferred to these spaces."[44]

In her Bowery project, Rosler confronted the "spatial contradictions" between urban documentary photographs of impoverishment and art-institutional contexts of the presumably elite.[45] Treating representations of destitution as art—as in the photographs Rosler examined—only serves to reinforce this polarity as a given. Hanging in the art or museum gallery, an urban documentary photograph is stripped of its context, and the audience is discouraged from considering who the original subjects were, why they were photographed, and what has become of them. Such specificities—and certainly any disruptive intentions—are eliminated as irrelevancies in the face of

artistic attention to forms, shadows, or composition. Potentially, and conversely, the audience becomes a point of nonconsideration for artists.

Certain photographers in the late 1960s and early 1970s searched for ways to complicate or overturn this trend. On the artistic heels of Pop art's ironic/critical quotation of mass-produced culture and Conceptualism's pursuit of seemingly "deskilled" or "low" art forms, Rosler and others considered and expanded art's social possibilities. This art—made during a time rife with cultural contestations about race relations, the Vietnam War, feminism, and sexual liberation—sought to demonstrate, as Deutsche has explained, "the *fluidity*, not the stability, of aesthetic meaning and institutions. Instead of inhering in self-contained and therefore transhistorical objects that exist in autonomous and neutral spaces, meaning was recognized as a contingent and constantly mutating process of cultural attribution."[46] Working from this premise, context, language, the use of multiple images, and the active interpellation of or accounting for the viewer flooded a new kind of urban documentary practice. It also, I contend, resulted in a new street photograph within that practice.

It was within this art context of the late 1960s and early 1970s that Rosler performed her "historical archaeology" (to borrow Buchloh's term) of urban documentary practice. The tools (not models) she uncovered offered the means by which she would envision a new photographic method, and which would result in *The Bowery*.[47] Furthermore, her conviction that *The Bowery* addressed urban documentary's newly enshrined and self-selected art audience allowed her to capitalize on that audience's awareness of the photographic legacy with which she took issue. It also gave Rosler an opportunity to reinsert and reevaluate the complicated messages street photographs had delivered and could deliver within the context of the art institution.

ROSLER'S PROCESS IN THE CITY

In December 1974 Rosler lived near the Bowery, in New York's East Village.[48] She walked along the street regularly and decided she would photograph it as part of her project critiquing urban documentary photography (figs. 60 and 61).[49] The resulting photographs from that month and from January 1975 indicate her pedestrian approach. Standing on the sidewalk, an anchoring element in almost all the photographs, Rosler turned to face the buildings, storefronts, and doorways that lined the Bowery. Most often she would neatly compose the image, so that her camera lens directly paralleled the facade, the corners of windows, stoops, and signs squarely placed in the photographic frame. Infrequently, the photographed scene mimics a less studied view, a downward glance at the detritus of a particular street or an oblique look at a specific building's signage (figs. 62 and 63). As Rosler wrote in her earliest description of the project, "The photos represent a walk down the Bowery seen as arena and living space, as a commercial district in which, after business hours, the derelict residents

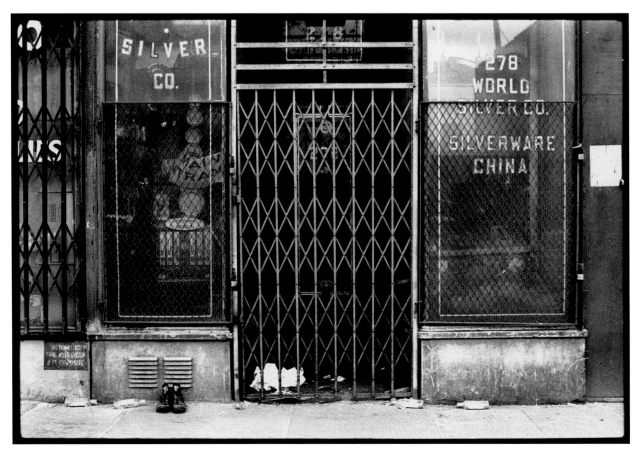

FIG. 60. Martha Rosler, *The Bowery in Two Inadequate Descriptive Systems* (detail 4a), 1974–75.
FIG. 61. Martha Rosler, *The Bowery in Two Inadequate Descriptive Systems* (detail 10a), 1974–75.

FIG. 62. Martha Rosler, *The Bowery in Two Inadequate Descriptive Systems* (detail 23b), 1974–75.
FIG. 63. Martha Rosler, *The Bowery in Two Inadequate Descriptive Systems* (detail 13a), 1974–75.

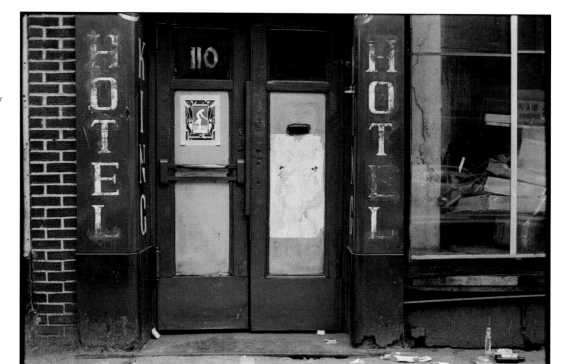

FIG. 64. Martha Rosler, *The Bowery in Two Inadequate Descriptive Systems* (detail 19b), 1974–75.

inhabit the small portal spaces between shop and street. . . . The photographs confront the shops squarely, and they supply familiar urban reports. . . . There is nothing new attempted in a photographic style that was constructed in the 1930s when the message itself was newly understood, differently embedded."[50] The 1930s style Rosler references is that of the FSA photographers as well as the New York Photo League. It is most particularly embodied, however, in the photographic conventions and urban approach of Walker Evans.

While it may be true that there are "no saints" in Rosler's critique, Evans's photographs contemplate the city as subject more frequently than do the works of his

FIG. 65. Walker Evans, *Waterfront Poolroom, New York*, 1933.

fellow FSA photographers.[51] Comparing Evans to Ben Shahn, who also photographed in cities, critic Max Kozloff has noted that "Evans had definite ideas about the city as a crucible of modern perception."[52] Straightforwardness, frontality, and detachment—qualities that Rosler utilized in her own Bowery project—characterize Evans's urban images (figs. 64 and 65). Moreover, Kozloff continues, Evans had a "much grander involvement with American storefronts, fire escapes, empty interiors, and door moldings."[53] This involvement yielded a photographic inventory of all sorts of buildings, but Evans's vision also lingered on liminal urban spaces, those that were neither building nor street: the suspended commercial signs, the corner-shop window, the stoop.

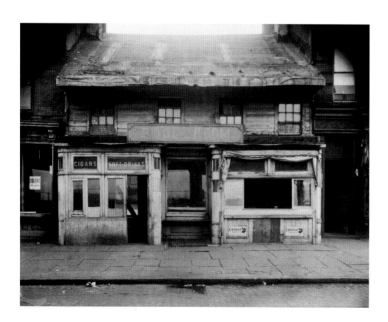

For Rosler, Evans "provided a certain revelation . . . [about] the urban." In fact, as she recently revealed for the first time, "a direct homage is visible in one of my Bowery photographs [fig. 66]: I was very struck by a picture Evans had taken of a store front with a bunch of hats piled up against a window. It seemed like a Bohemian inversion of the received discourse about the urban: for him the street was the safe and known place, and the shop interior is presented as a glimmering shadow, a semi-dangerous, unknown space."[54] In comparing Evans's photograph and Rosler's homage, certain differences are obvious. Rosler captures a wider view, encompassing, as usual, the sidewalk beneath her feet. While both images include glimpses of the doorjamb just to the right of the window, Rosler also pictures a grated doorway and a lone dark liquor bottle standing in front of it. More intriguing, however, are the nuances that surface in comparing the windows that each chose to photograph. Evans's window is piled high with recognizable, if not immaculately presented, commodities; Rosler's is filled with barrels, crates, boxes, and what look like broken chair legs, a space replete with the sense of chaos, uncertainty, and liminality that Rosler responded to in Evans's work.

Representational quotation requires the combined act of referencing and subsequent altering of the reference, as art historian Thomas Crow has pointed out in the context of a nonphotographic practice: "Any dissenting practice depends for its meaning on the existence—and the strength—of what it opposes. . . . The typical pop painting was formally organized sufficiently like contemporaneous abstract painting

FIG. 66. Martha Rosler, *The Bowery in Two Inadequate Descriptive Systems* (detail 17b), 1974–75.

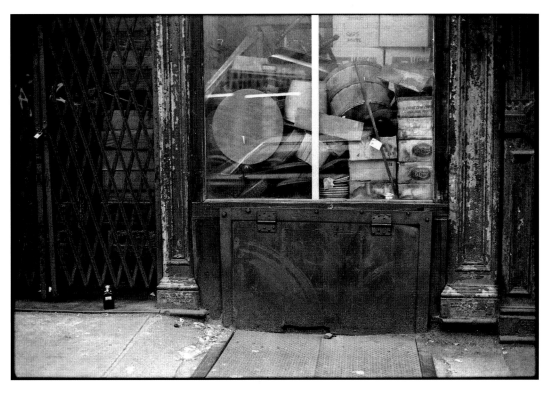

FIG. 67. Walker Evans,
South Street, New York, 1932.

to make the comparison count."[55] Buchloh has elaborated on this relationship, outlining the outcome of such quotational practices: "To the degree that the various sources and authors of quoted 'texts' are left intact and fully identifiable in truly contemporary montage, the viewer encounters a decentered text that completes itself through his or her reading and comparison of the original and subsequent layers of meaning that the text/image has acquired. . . . [In the case of Rosler's photographs of the Bowery,] these conventions are executed by Rosler rather than simply confiscated. . . . Rosler's crude attempts to try her photographic hand at mimicking the great urban 'documentarians' style is of course . . . thoroughly disappointing."[56] Rosler's photographs are disappointing, as any functioning quotation must be in order to toe the line between being completely "identifiable" in relation to their point of reference and being recognizable as "subsequent" to and "decentered" by that reference. The squared-off frontality of Rosler's pictures of building facades echoes Evans's style, even though Rosler never crossed the street to take her photographs.

This complex quality of quotation, Rosler has recounted, was initially lost on Buchloh, who was both horrified and fascinated by Rosler's use of Evans's approach: "[He] asked why would I do that? I was surprised: Did you think I was trying to be a great photographer? That intrigued him, but he still couldn't figure out why would anybody want to do unoriginal, even ugly, photos. I explain that they are quotes. Who are you quoting? You know, that's not the right question. I am quoting a mode of address."[57] By quoting "a mode of address," Rosler capitalized on the open-ended and mutually informing relationship between the quoting objects and those they quote. For those artists who use quotation or appropriation in this way, the representation of representation can demonstrate the construction and the contingency of meanings, objectivities, and truths in all contexts of image production. Consequently, Rosler's use of quotation posited photographs that could fail to provide authenticity, an original photographic aesthetic, and victimizing representations of their subjects: "[Evans] knew how to represent something about the ways in which the shop, the street, and people passing by form a unity. That allowed me to extract the people and still have the landscape of the city street, partly because the ghosts of the people are still there, if you will allow me. Partly because they are in Evans's photographs, but also because we already understand what a city street is and what the Bowery represents [fig. 67]."[58]

Rosler referred here to a pivotal component in her project and its relation to historical urban documentary: her photographs are devoid of their expected subjects—in this case, the Bowery's population of vagrant, homeless men associated with drunkenness. She allows only residual and metaphorical traces of their intentionally "ghosted" presence to remain: the abandoned liquor bottles, crumpled papers, disposable containers emptied of food, and inexplicably abandoned shoes (see figs. 60, 61, 63, and 66). These urban details alone imply the missing subjects. More accurately, her photographs of the setting attempt such a metonymic substitution while still implying that they represent something of "Bowery life," even if they do not. Rosler's refusal to figure a culturally coded human presence questions the supposed sufficiency of the photographic representational practices it dissents from. Moreover, her refusal illuminates how less critical photographs may be tied to—and even uphold—the dominant social power structure that often ensures and perpetuates class, gender, and race differences. In Rosler's hands, then, photography can be seen as "a system of representation, [one] that you bring to bear on other systems," like language.[59] For if her urban documentary project contests one of the basic components of traditional documentary (the presence of the human figure) it also invalidates another basic component (narrative), even when the words that accompany her photographs seem to perform the function of explanatory text.

Each of the twenty-one Bowery photographs Rosler selected for the project has a text-photograph pendant, which she typed, photographed, and printed with a filed out negative holder, "so you understand that you're looking at a photograph of typed words" (fig. 68).[60] Each pair of photographs (Bowery and text) was then

FIG. 68. Martha Rosler, *The Bowery in Two Inadequate Descriptive Systems* (detail 10b), 1974–75.

soaked	drenched
sodden	flying the ensign
steeped	over the bay
soused	half-seas-over
slôshed	decks awash
saturated	down with the fish

<table>
<tr><td>soaked</td><td>drenched</td></tr>
<tr><td>sodden</td><td>flying the ensign</td></tr>
<tr><td>steeped</td><td>over the bay</td></tr>
<tr><td>soused</td><td>half-seas-over</td></tr>
<tr><td>slóshed</td><td>decks awash</td></tr>
<tr><td>saturated</td><td>down with the fish</td></tr>
</table>

FIG. 69. Martha Rosler, *The Bowery in Two Inadequate Descriptive Systems* (detail 10a–b), 1974–75.

mounted to a black board approximately ten by twenty-two inches (fig. 69).[61] Rosler framed twenty-one of these mounted pendants, along with three additional boards that feature only text photographs. She then strategically sequenced the group of twenty-four boards in an order that is maintained whether the project is displayed as an installation on a gallery wall, as a slide show, or as a book.[62] (In order to maintain Rosler's pairing of images and their sequencing within *The Bowery*, I have assigned each element a number to indicate sequence and either "a" or "b" to indicate the left- and right-side elements of the pairs.) The construction and sequencing of the boards enacts and confounds, elicits and forecloses certain distinctions, readings, and meanings. The first three boards feature only text photographs, set on the right side of the mount with the left side empty (fig. 70). On the fourth to the sixteenth boards, each text photograph is joined to its left by a Bowery photograph (see fig. 69). On the seventeenth to twenty-third boards, the positions of text and image are reversed. The final board, which adheres to the layout of boards four to sixteen, features a text photograph with the name of the project: *The Bowery in Two Inadequate Descriptive Systems*. There are only a few instances in which the words of the text photographs seem to correspond directly with their pendant Bowery photograph (fig. 71). Far more often, the viewer is left to speculate on the connection between the text and Bowery photographs sharing a board, prompting the question that is at the heart of the project's title: if representation and language are inadequate systems, do adequate ones exist?[63]

The work's linguistic system, like the visual system it accompanies, follows a specific structure. For the first group of boards (one through sixteen), the typed words are all adjectives, drawn from the popular, shared lexicon that describes stages of drunkenness. Initially somewhat playful and lighthearted, the adjectives reference socially accepted states of tipsiness but gradually darken in tone, conjuring more chronically intoxicated states, as the first photographs of the Bowery appear.[64] On the seventeenth board, where the position of text and Bowery photographs reverses, nouns replace the adjectives, signaling a key shift: these nouns belong "firmly to the Bowery and [are] not shared with the world outside."[65] Rosler compiled her nouns and adjectives from research, both formal and informal, after she completed her Bowery photographs (fig. 72). The terms range in reference from food ("pie-eyed," "pickled") to industrial processes ("polluted," "steamed up"), from animals ("up to the gills," "owl-eyed") to the military ("soldiers," "marines"). In a project that enacts a historical critique of representation, Rosler also chose to include now-obsolete British slang terms, interspersing them throughout the more popular terms. She carefully calibrated the language to increase in seriousness, culminating in "commonly understood, blunt death imagery."[66] Taken together, these descriptive terms confound the Bowery photographs alongside them and reflect Rosler's "suspicion of language, which could

FIG. 70. Martha Rosler, *The Bowery in Two Inadequate Descriptive Systems* (detail 1), 1974–75.
FIG. 71. Martha Rosler, *The Bowery in Two Inadequate Descriptive Systems* (detail 23a–b), 1974–75.

not play the saint to photography's devil. The language in this work does not 'address' urban documentary problems; it is not an essay (any more than the photos constitute a photo essay), filled with suggestive, diagnostic, or prescriptive phrases."[67] Like the Bowery photographs, then, the texts toy with representations and meanings that remain just beyond reach, evocations never materialized. At the time of the project's conception, "linguistic theories had become central to artistic debates," and eventually these would focus on the relationship between language and photography.[68]

Much of the theoretical work addressing the narrative captions that typically accompany the kind of photography Rosler's project critiques also considers contemporary artists' uses of quotation and multiple images, strategies intended to fundamentally change the framework of the artwork.[69] Despite her critique of Evans's and others' traditional single-image revelations, Rosler found inspiration in Evans's sequencing of his photographs: "A strong aspect of Evans's *American Photographs* (and then later of [Robert] Frank's *Americans*) was its powerful sequencing—so much of the meaning of the work is in the interstices. . . . [Unlike the sequencing of Ed Ruscha's

FIG. 72. Martha Rosler's diary notes for *The Bowery in Two Inadequate Descriptive Systems*, 1975.

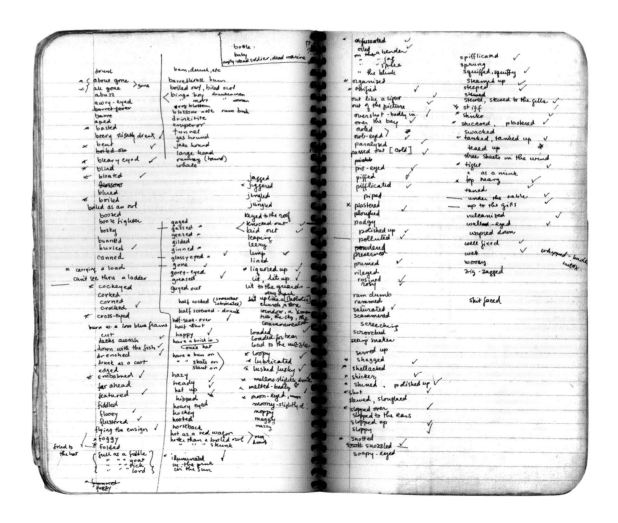

books, where it is one plus one plus one,] in Evans and Frank, it is one plus two plus three plus four, so the actual sequence and the content make a difference."[70] In Rosler's sequencing the cumulative effect fails to yield a specific signification; instead it invites critical reflection on meaning making. As viewers of the work try to "read" the sequence of images and words, they are prompted into self-awareness by the resulting disconnects. To borrow Rosler's earlier analogy, then, we might say that *The Bowery*'s sequence is one plus two minus three. The artist's foreclosure of transparent communication serves to foreground the role of the viewer, the social embeddedness of both art and its reception, and thus alters the social and political possibilities of art practice.

Rosler first became interested in the relationship between art and its audience in graduate school at the University of California, San Diego, where she had been enrolled for three years before beginning *The Bowery*.[71] Taking a lesson from Minimalism's engagement of viewers, she appreciated how such art demanded their attention and how viewers could make a variety of possible readings of a work. It was as though, she noted, the work declared, "'Look here now!' Don't look here in order to go somewhere else in your mind. . . . What does a person bring to looking? and what is the intention of the person that is asking you to look? I think it's the same problem with photography."[72] Photography offered Rosler greater possibilities than other media, because of the viewer's familiarity and identification with the medium. Her refusal to adequately represent her subject in either words or pictures also enacted her refusal of the standard relationship between an urban documentary photograph and its viewer, disrupting easy identification: "My work is a sketch, a line of thinking, a possibility."[73] From it, questions would arise and a conversation would ensue. *The Bowery* accommodates and even advances the viewer's reflection on the historic and current conditions of the experience of public space. For *The Bowery* is not merely a work incorporating photographic images of the street that is its namesake; it is also a critical representation of that particular street as a simultaneously social and political space, one long inseparable from the problems of urban poverty and homelessness.

POVERTY, HOMELESSNESS, AND GENTRIFICATION ON THE BOWERY

Increased awareness of poverty and class emerged in the 1960s on the heels of the economic boom and resulting widespread privilege that had characterized the preceding decade. As writer and activist Barbara Ehrenreich has described in her book *Fear of Falling: The Inner Life of the Middle Class*, "Living in what they took to be the final stage of material affluence—defined by cars, television, and backyard barbeque pits—they believed that this *was* America. Looking out through their picture windows, they saw only an endless suburb. . . . From this vantage point the jagged edges of inequality

seemed to have disappeared."[74] Michael Harrington's groundbreaking 1962 book, *The Other America*, challenged this narrow outlook, reclassifying poverty in America and bringing it to the forefront to such an extent that Lyndon B. Johnson's 1964 State of the Union address declared a nationwide "War on Poverty."[75] For the remainder of the decade, "poverty" was considered to encompass everything from blue-collar workers (or the working class) to homeless people.

Far from well defined, the poor were popularly perceived as ignorant, lazy, and childlike, fostering assumptions that any assistance would translate immediately into dependence. Rationalizing the poor in this way kept them psychologically as well as geographically distant from the middle-class populations ensconced by the suburbanization of major cities. "One could easily conclude," Ehrenreich wrote, "as the *New Republic* did in a 1964 editorial, that the goal was not so much to eliminate poverty as to eliminate the poor: 'they have to go if society is not to be poisoned.'"[76] It was, however, that selfsame society that had created this possible "poison" through rapid industrialization and urbanization, the very conditions that produced large-scale homelessness. New York City in the 1960s and 1970s was trapped in a vicious economic chicken-and-egg cycle: its middle class continued to flee to the suburbs, and businesses declined to invest or operate in the city, culminating in a recession that the local government was eager to reverse. Hard hit by recession, the city's homeless population numbered thirty thousand by 1967 and thirty-six thousand by the end of the decade.[77] Regardless of the precise numbers, one fact remained constant: homelessness constituted the "last stop" in the minority status of general American postwar prosperity. In New York City, this population's relegation to one particular area, the Bowery, rendered it increasingly invisible for all other urban dwellers.

Rosler's *The Bowery* addresses not just homelessness but drunkenness, and the decade prior to its creation saw radical changes to the laws and procedures involving both vagrancy and drunk and disorderly conduct, the more common charge for New York's homeless men.[78] A Supreme Court ruling decriminalized vagrancy in 1972, just three years after New York adopted a rigorous nonarrest policy toward its homeless populations.[79] Prior to that time, homeless men would have been arrested for being drunk and disorderly, or, if they were simply drunk, they would have been given "munie tickets" from the municipal department of social services, good for "three hots and a cot" (three meals and an overnight bunk at a Bowery "flophouse" hotel).[80] Part of the city's Operation Bowery, munie tickets represented wholesale "street cleaning" operations involving police roundups twice daily.[81] These roundups amounted to somewhere between forty thousand and sixty thousand arrests annually in the city. Beginning in 1969, the numbers declined markedly, as the city's nonarrest policy marked a fundamental shift in its treatment of homeless people: they were now either left alone by the police or taken to shelters rather than jail.[82]

The years immediately following the implementation of the nonarrest policy simultaneously witnessed a dramatic deconcentration of the city's homeless population and an important shift in the public lexicon away from the frequently deployed terms "derelicts," "bums," and "drunks."[83] The newly renamed "homeless" population had not necessarily diminished in numbers, but it had now "left the Bowery to frequent middle-class neighborhoods throughout the city," according to a *New York Times* article with a headline declaring, "Whole City Is Its 'Flophouse.'" The same article commented on the visual impact of the deconcentration, claiming that there "seem[ed] to be more of them than ever."[84] By the 1980s homelessness was common throughout the city but still widely misunderstood, most often traced to "severe social dysfunction, manifested as alienation, drug taking, or low self-esteem, thus classically substituting effects for causes."[85] The economic explanation was thus denied, a particularly cruel example being President Reagan's musing to an interviewer in December 1988 that people slept on grates in America's urban centers because they liked it; that same month the Centers for Disease Control reported a doubling since 1980 in deaths by exposure to freezing temperatures.[86]

Anthropologist Kim Hopper's extensive study of homelessness, particularly in New York City, demonstrates how consistently such misperceptions as those voiced by Reagan dominated the prevailing cultural attitudes of the 1960s and 1970s: "The alleged offense of the homeless poor (aside from the exhibit forced upon eyes that would prefer not to see) is their 'failure' to belong. . . . The social value of the home is to ensure that the organization of private life plays its appointed role in the reproduction of a given public order. Street people, in effect, reverse the order of priorities. . . . In the reigning sociological position at the time, the homeless man was bereft of social bearings. He observed no rules except the often ill-serving ones of apparent self-interest, was innocent of any sense of responsibility, professed no allegiances, and pursued a rootless and isolated life."[87] In the late capitalist economy of the day, only those who considered the homeless poor to be victims could accommodate them. This perception, however more grounded in the financial causes of homelessness, nevertheless fueled the notion that these individuals were "waste products": "Simultaneously worthless and (it isn't always clear how or why) dangerous, the homeless poor were a menace to be eliminated or contained."[88] A particularly choice indication of the notion of spatial "containment" is represented by the city's announcement of plans for its first rehabilitation center for "derelicts": North Brother Island, isolated in the East River.[89]

In her essay "In, Around, and Afterthoughts: On Documentary Photography," written to accompany the 1981 publication of *The Bowery*,[90] Rosler declared her awareness (and thus the project's intended address) of these contemporary economic currents: "The liberal New Deal State has been dismantled piece by piece. The War on Poverty has been called off."[91] Decades earlier, Walter Benjamin had posed the

question, "To whom do the streets 'belong'?" and formulated his response: "Streets are the dwelling place of the collective. The collective is an eternally restless, eternally moving essence that, among the facades of buildings, endures (*erlebt*), experiences (*erfährt*), learns and senses as much as individuals in the protection of their four walls."[92] Benjamin's assertion that urban space is variously, even triumphantly, engaged by an unhoused collective disputes the unity of such space (parallel to the effect of Rosler's multiplication of descriptive systems for the Bowery). Such refusal(s) prove crucial, as Deutsche pointed out, for preventing the perception of "conflicts— and social groups associated with conflict . . . as disturbances that enter space from the outside and [that] must be expelled to restore harmony." Rather, she continued, "social space is produced and structured by conflicts. With this recognition, a democratic spatial politics begins."[93] Rosler, coming of age in a decade of demonstrations, when the streets "belonged" to the people, similarly agonized that the street had become nearly an imaginary space: "Demoted to a site of surveillance and vehicular passage, the street is abandoned to maintenance services and the occasional spectacle. . . . Increasingly, the street is a waste space left to the socially fugitive and the unhoused— those unable to buy or to serve. . . . It is this 'empty' space, to which the destitute are relegated, that is increasingly identified with—or as—'the street.' The waste space resides where society used to stand."[94]

Rosler's concern about the vitality of city streets resonates with the seminal book on the topic, Jane Jacobs's *The Death and Life of Great American Cities*.[95] First published in 1961, this book, arguably more than any other in the twentieth century, issued a radical challenge to current urban thinking and city planning in New York City and, by extension, in all other American metropolises. Jacobs's study systematically explains that cities were kept interesting, strong, safe, and lively spaces because of the everyday complexity and mixed-use nature of their streets. These were also the very qualities modern planners sought to eliminate with the bulldozers and class-distinct housing so closely associated with gentrification. In turn, gentrification further impoverished other urban locations, ones not dissimilar to Rosler's Bowery of the 1970s.

Gentrification has been variously defined but generally indicates the transition of an urban space from a lower socioeconomic class to a higher one. Thus, from different viewpoints, it can be celebrated as a "renaissance" or decried as a geographic and ethnic "cleaning house." The term "gentrification," signaling the class motivations at work, also has an obscuring cousin, "revitalization." But, as Deutsche has pointed out, revitalization is "a word whose positive connotations reflect nothing other than 'the sort of middle-class ethnocentrism that views the replacement of low-status groups by middle-class groups as beneficial by definition.' 'Revitalization' conceals the existence of those inhabitants already living in the frequently vital neighborhoods targeted for renovation."[96] Moreover, gentrification plays a part in a broader "strategy

of impoverishment": "By creating neighborhoods and housing that only the white-collar labor force can afford," Deutsche and Cara Gendel Ryan argue, "the cities are systematically destroying the material conditions for the survival of millions of people."[97] In her recollection of the particular circumstances surrounding her Bowery project, Rosler has noted that gentrification is as tied to deliberate social and political state or municipal policy as it is to the fiscal cycles and crises that characterize (always urban) financial centers such as New York.[98] Again, Deutsche's writings on the matter prove exemplary and are worth quoting at length:

> To challenge the image of the homeless person as a disruption of the normal urban order, it is crucial to recognize that this "intrusive" figure points to the city's true character. Conflict is not something that befalls an originally, or potentially, harmonious urban space. Urban space is the product of conflict. . . . The perception of a coherent space cannot be separated from a sense of what threatens that space, of what it would like to exclude. . . . Urban space is produced by specific socioeconomic conflicts that should not simply be accepted, either wholeheartedly or regretfully, as evidence of the inevitability of conflict but, rather, politicized—open to contestation as social and therefore mutable relations of oppression.[99]

It is this understanding of homelessness, class relations, and urban space as sites of structural but undernoticed conflict that infuses Rosler's Bowery project. Removing the so-called "intrusive figure," as Rosler did, calls attention to the persistent absence of harmoniousness in the spaces that remained in the visual and linguistic representations.[100] Her particular critique of the conflicting and conflict-embodying representations of homelessness also confronts the notion of an urban "waste" population not worthy of concrete historical analysis.

An examination of the conditions that fostered and maintained homelessness in New York City exposes the long-standing nature of the problem and reveals how those conditions were tied to the specific geography of the Lower East Side, particularly the Bowery, which functioned as a major thoroughfare. In the latter half of the nineteenth century, three of the most densely populated areas—those with the most tenement buildings—bordered the Bowery: Chinatown to the south, Little Italy to the west (now NoHo), and New Israel to the east (now the East Village and a more reticulated "Lower East Side").[101] The clustering of overcrowded tenement buildings, as Benedict Giamo has noted, not only foreclosed the possibility of a geographic and therefore social mixture of the middle class with immigrant populations but also "blurred the boundaries of street, sidewalk, and residence" (something that Rosler would come to emphasize in her representation of the area).[102]

By the 1970s New York City's economy had become focused on maintaining corporate headquarters, financial markets, and international trade.[103] This fostered the professional or managerial class, as opposed to the blue-collar or manual-labor class—in which homeless men often found sporadic employment—that had dominated during the city's manufacturing heyday. The 1973 recession only exacerbated this trend, drawing more distinct lines between those who could afford the city and those who could not. These demographic shifts and economic upheavals inevitably changed the character of related urban spaces. The areas adjacent to the Lower East Side, home to the urban poor for more than a century and slowly gentrifying with artists paving the way for more elite residents, along with the Bowery, that long-standing and consolidated "dwelling place" of the city's homeless population, marked the epicenter of changes to the production of urban space.[104]

To be sure, Rosler explains the archaeological appeal of the Bowery location to her and contemporary documentarians: "The Bowery, in New York, is an archetypal skid row. It has been much photographed, in works veering between outraged moral sensitivity and sheer slumming spectacle. Why is the Bowery so magnetic to [urban] documentarians? It is no longer possible to evoke the camouflaging impulses to 'help' drunks and down-and-outers or 'expose' their dangerous existence. . . . We can reconstruct a past for [urban] documentary within which photographs of the Bowery might have been part of the aggressive insistence on the tangible reality of generalized poverty and despair—of enforced social marginality and finally outright social useless-ness."[105] The productive question to pose is not about the Bowery's magnetism for photographers, but rather about its social and historical role in the city's development such that it became an island of homelessness and despair. Etymologically, the Bowery is an adaptation of the Dutch term *De Bouwerie*,[106] meaning farm path, and it described the route from the settlement of New Amsterdam, where Pieter Stuyvesant worked, to his farmland and manor house, located at present-day Astor place. Geographically, this one-mile route has been constant since that time.[107] Amenities including hotels and taverns appeared along the route, and a town-like cluster around the Stuyvesant manor named Bowery Village boasted a population of about four hundred people by the early 1700s. By the start of the next century, the area had changed markedly and indicated certain urban disparities that would come to characterize the Bowery, even foreshadowing the gentrification and urban class struggles that took place from the 1960s to 1980s.[108]

The proliferation of cheap lodging along the Bowery and the shift in popularity from its haunts to the newer spectacles of Broadway enhanced the sense that the Bowery was becoming a "detached milieu."[109] According to Giamo, the Bowery's detachment was "not only evidenced in the form of housing conditions [e.g. tenements], but also in [its] vice and deviance, poverty and destitution, and commerce and entertainment.

These forms, which validated the process of segregation, instituted the divergent way of life that existed within the Bowery."[110] The homeless person embodied the most extreme "divergent" lifestyles on the Bowery, and some nine thousand homeless people sought shelter nightly in the Bowery's cheap lodging as early as the 1890s. Such a statistic cannot, of course, account for all those who found no shelter and instead slept on the street.[111] Slumming parties also ventured into this detached milieu to amuse themselves in saloons with names like Hell Hole, Inferno, and Plague, which capitalized on the influx of middle-class money.[112] Even such a limited sampling of the Bowery's pre-twentieth-century history indicates the extent to which, as an urban space, as a *street*, the Bowery has long embodied class struggles—including destitution and homelessness—as well as the social divisions, if not outright segregations, that are imposed because of them.

Estimations of the homeless population of the Bowery chart how, in the twentieth century, the area was said to have thoroughly "succumbed" to its skid-row status and "bequeathed" to the proverbial bums who lodged in missions or cheap hotels known as "flophouses."[113] Between the end of World War II and 1949, estimates range from nearly fourteen thousand to eighteen thousand homeless people in the Bowery.[114] Over the next twenty years, these numbers would decline dramatically and then plateau at a steady three thousand or four thousand from 1969 until the end of the 1970s.[115] During this period, articles and headlines from the *New York Times* alone—which frequently referred to the Bowery's homeless populations as drifters, derelicts, drunks, and bums—demonstrate that the very evocation of homelessness depended on the establishment of their figurative or rhetorical presence on the newspaper page. Such coverage in the largest-circulating local newspaper—an indicator of the collective public imagination—reinforced the idea of the Bowery as a detached and dangerous milieu. From 1970 to the beginning of Rosler's project four years later, the headings or taglines in the *New York Times* documented the Bowery as the often sensationalized site of serious crimes: police brutality, rape, murder by shooting and knifing, and a million-dollar burglary. This social and urban otherness of the Bowery had some sociological basis, according to Hopper, insofar as the population was isolated, their deviance explaining and simultaneously justifying their homeless state as well as their urban containment: "The Bowery was at once familiar and alien, a place where poverty, disengagement, and 'antisocial behavior patterns' intersected in a laboratory-like demonstration of what sociologists have commonly referred to as 'anomie,' in this case lack of adherence to norms held by society at large. For a population untrammeled by the usual ties that bind and reportedly immune to obligations that order, Bowery men were remarkably well behaved, seldom venturing beyond the confines of skid row."[116] While this explanation is behaviorally and culturally informative, it overlooks some practical reasons why this area functioned so consistently as an urban space for and of

the homeless and the destitute. Simply put, as Giamo notes, the Bowery was "an institutionalized skid row . . . a coordinated network of missions, flophouses, labor agencies, lunch counters, restaurants, used clothing outfits, cheap saloons, and pawnshops."[117] At the most basic level, the Bowery offered the necessities (cheap food and drink, shelter, and places for casual or sporadic employment) called for by the population so readily identified with it.

It is this specific sense of the Bowery as a "living space, as a commercial district," that Rosler had when she conceived of her project and on which she elaborated in her 1981 essay. She noted the range of shops, "from decrepitude to splendor, from the shabbiest of ancient restaurant-supply houses or even mere storage spaces to astonishing crystal grottoes" in the elaborate window displays of lighting fixture retailers.[118] Such businesses featured in Rosler's project not only because they shaped the urban landscape of the Bowery photographs but also because homeless men inhabited the doorways to these very shops after business hours. In this way, the figure of the homeless man retained its ability to "shock" the passerby, albeit here through his visual absence. In the 1970s Rosler was troubled by the sense that "none of this matters to the street" and, more important for the men of the Bowery, that "none of it changes the quality of the pavement, the shelter or lack of it offered by the doorways, many of which are spanned by inhospitable but visually discrete rows of iron teeth—meant to discourage sleep but generally serving only as peas under the mattress of a rolled-up jacket."[119] Her attention to this peripheral urban space—which marked the intersection of street and store, destitution and desire—enabled her to formulate another mode for "representing" homelessness, as well as an altogether reoriented form of street photographs.

In various texts and interviews for *The Bowery*, Rosler has consistently referenced not only historical urban documentary photographs but also contemporary images of the Bowery's homeless men. In a footnote to her 1981 essay, Rosler cites Michael Zettler's *The Bowery* (1975; fig. 73), noting that she saw it only after completing her project.[120] Zettler's project—in which his photographs of Bowery men are accompanied by their confessions such as "You must learn the art. The art of staying alive and staying drunk"[121]—seemed to Rosler the "perfect foil" (fig. 74).[122] Although she does not elaborate on her grievance with Zettler's use of quotations, her awareness of

FIG. 73. Michael Zettler, *The Bowery*, 1975.

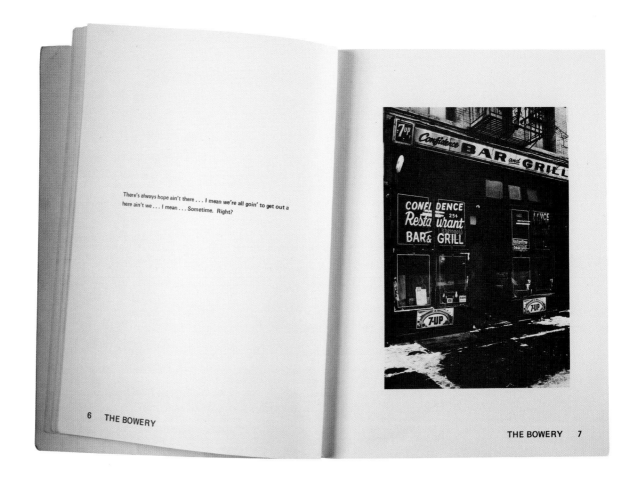

FIG. 74. Michael Zettler,
The Bowery, 1975.

There's always hope ain't there . . . I mean we're all goin' to get out a here ain't we . . . I mean . . . Sometime. Right?

CONFIDENCE BAR and GRILL

7up
Confidence

CONFI DENCE
254
Resta urant
BAR& GRILL

7UP 7UP

6 THE BOWERY

THE BOWERY 7

the project shows her keen concern for the relationship between image and text. This relationship is even more evident in the depictions of men on the Bowery that circulated more widely in the *New York Times*. In tandem with the accompanying captions, headlines, and story content that frequently called these men "tramps" and "derelicts," such press images created and upheld the common perception that "bums" were, as Rosler claimed, "judged as *vile*, people who deserve a kick for their miserable *choice*."[123]

The most immediate visual effect of the photographs made for the *New York Times* is the dramatic darkness produced by photographing the Bowery in the raking light of early morning or late afternoon. In a photograph by Neal Boenzi, the doorway of a building where a man lies prone, his leg thrust out into the sidewalk, recedes into impenetrable shadow (fig. 75). The series of recesses and elements projecting from the building certainly gives a more visually interesting sense of the facade than would have been possible in flat or overhead light. The photograph assumes all the drama, mystery, and even danger of the film noir aesthetic. The caption reads, "A typical Bowery drunk—so common, the casual passer-by pays little attention. But official aid is to start soon." While it may reference and conjure a passerby, no such person appears in the photograph. Instead, shot from a low angle, the sidewalk stretches vast and decidedly empty across the photograph's lowermost register. The article's title, "Two-Man Teams to Offer Help to Bowery Derelicts," may evoke pedestrian assistance for Bowery "derelicts," but the accompanying text instead suggests drama and despair for

Two-Man Teams to Offer Help to Bowery Derelicts

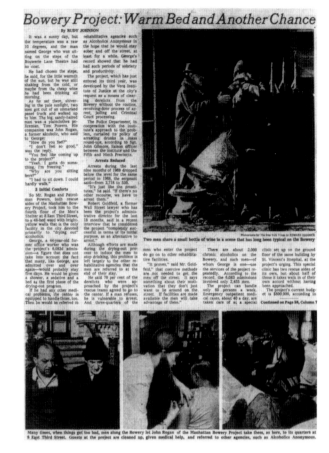

Bowery Project: Warm Bed and Another Chance

Continued on Page 58, Column 7

FIG. 75. David Burnham, "Two-Man Teams to Offer Help to Bowery Derelicts," *New York Times*, October 7, 1967, p. 31 (detail). Photographs by Neal Boenzi.

FIG. 76. Rudy Johnson, "Bowery Project: Warm Bed and Another Chance," *New York Times*, February 7, 1970, p. 31 (detail). Photographs by Edward Hausner.

passersby who are nonexistent in the lead photograph: "He lay on his back on the sidewalk, eyes closed, legs sprawled, hair matted, face scarred. The only signs of life were the trickle of blood from the gash on his forehead, and his lips, which every five or six seconds puffed out as he exhaled. Above his head, pasted to the streaked and dusty window of Betty's Tavern, Restaurant, Bar and Grill, was a small hand-lettered sign: 'Eye-Opener. Wine 15¢. 8 A.M. and 10 A.M.' The nameless, homeless, helpless drunk lying in the shattered glass bottles of the Bowery sidewalk on a recent warm October afternoon was ignored by the few pedestrians who scurried by."[124] In a similar turn, the secondary photograph of the assistance touted in the headline is utterly removed from the urban context, taken indoors, and diminished in scale to the more sinister image of the man lying in the doorway.

Another photograph, taken in 1970 by Edward Hausner and thus more contemporaneous to Rosler's project, displays the same high-contrast effect of raking light (fig. 76). The Bowery appears mostly dark, its two depicted inhabitants discernible by the highlights that fall on their hats, slivers of their faces, and the crooks of their garments. The "small bottle of wine" mentioned in the accompanying caption is visible nowhere (but is presumably obscured by the shadows). Nevertheless, this image of a "scene that has long been typical on the Bowery" dominates the other photographs on the page, which uncomplicatedly—and importantly for an article about the social services of the city's official Bowery project—depict men at the Bowery Men's Shelter

receiving medical aid and the "warm bed" promise of the article's headline. Exemplified by these two photographs featured in the *New York Times*, the circulating images of the Bowery did not address it as a specific urban space of homelessness.

Widely circulating images such as Boenzi's and Hausner's undoubtedly informed Rosler's project. "A lot of photographers made pictures of Bowery bums," she told an interviewer. "That upset me because I thought it was a false endeavor, that it involved a pretense that such photos were about the people when they were really about the sensibility of the photographers and the viewers. It's an illicit exchange about compassion and feeling and the bums are victims of this exchange between the photographer and the viewer. They provide the raw materials for a confirmation of class and privilege."[125] For Rosler, the viewing of a street photograph cannot be excluded from consideration in its making. This attentiveness to an eventual viewer takes on a more forceful presence when the photographs in question represent a collective social concern, such as the homeless men on the streets of the Bowery. If we do not explore the "exchange with the viewer" and ask "to what end?," we not only risk but also participate in the aestheticization of extreme poverty and suffering. To fail to consider the production *and* appearance of street photographs is generally to misunderstand their unique qualities; to do so with these particular street photographs would be to participate in the very photographic legacy that Rosler's *The Bowery* works to question and undermine.

HOW *THE BOWERY* APPEARED

Any description of a viewer's encounter with Rosler's project must account for its conception as a work for gallery walls (fig. 77), as well as its existence and circulation in other forms. *The Bowery* was, as Rosler has declared: "intended from the start to hang on the same walls as other photographic works, and from the mid-1970s on, it was shown in museums and noncommercial galleries in California and elsewhere."[126] Although she has no records of its first display in a museum or gallery following the work's completion in 1975, Rosler began presenting it in slide lecture format when she was asked to deliver talks. Allan Sekula offered perhaps the earliest critical consideration of the project in his 1978 essay "Dismantling Modernism, Reinventing Documentary (Notes on the Politics of Representation)."[127] Sekula's article situates *The Bowery* among a number of other works that he argued were "reinventing documentary," including projects by their mutual friends Fred Lonidier and Philip Steinmetz. Sekula wrote that Rosler's *Bowery* suggests "a walk downtown, from Houston toward Canal on the west side of the avenue" and, more to his point, represents the Bowery as "a socially mediated, ideological construction," with a title that calls out the "flawed, distorted character" of representation.[128]

Soon after Sekula's essay, Rosler was given an opportunity to publish the project in its entirety. After she presented a Bowery slide lecture at the Nova Scotia College

of Art and Design, then–faculty member Benjamin Buchloh expressed an interest in publishing her project, with one caveat. Rosler recalls that "Buchloh felt that a photographic practice not based on 'originality' would require some justification. I had wanted no introductory text: the work was itself a work of critique."[129] The resulting essay, "In, Around, Afterthoughts," was published as the third work in her 1981 spiral-bound monograph *Martha Rosler: 3 Works*. The essay—which immediately follows the section reproducing *The Bowery*—expresses the same criticism of documentary photography that had originally inspired the project. The sequencing was important to Rosler, who strategized the essay's placement after the reproduced *Bowery* project and envisioned that turning the book's pages would create the same temporal awareness as the experience of viewing the Bowery and text photographs on a gallery wall (see fig. 77).[130] This translation from installation to publication, Rosler has noted, came "at the expense of the 'all-at-onceness' of a grid, in which everything is available to the eye."[131] It also created the possibility that readers could approach the work with little, if any, awareness that a nonbook version had been displayed in art institutions. In spite of the multiple formats through which viewers have come to know and experience *The Bowery*, the crucial effects on its audience remained consistent: their readings of the text photographs, their projections onto street photographs of a public space emptied of its subjects, the foregrounding of economic disparity in the appearance of the work, and the reconception of urban documentary for an art-aware audience via the work's observation in art circles, whether as an installation, a slide lecture, or an artist's monograph.

Although figures do not appear in the "emptied" spaces of Rosler's *Bowery*, they are conjured and given form by the words in the text photographs: "heady," "bleary-eyed," "shit-faced," "bloated," "stinko," "paralyzed," "comatose," "embalmed," "buried." Using words so descriptive of bodily experience as to be aptly characterized as "somatic," Rosler called on the viewer's knowledge of a shared language.[132] Despite the archaic or Bowery-specific origins of some of the terms, her linguistic "descriptive system" maintains a fair amount of collective referents to drinking, the body, and the possibly dire consequences of one on the other as the words become more descriptive of physical incapacitation ("paralyzed," "comatose") and, eventually, of fatality ("embalmed," "buried"). Her shaping of the text, coupled with its activation by viewers, stalls assumptions that intoxication is either a "metaphoric state or an essential condition" of the Bowery men it seems to represent or describe.[133] Yet the viewer's reading of the text photographs, which allows the voicing of a physical subject, describes but simultaneously fails to adequately represent that subject. Just as with the Bowery photographs, Rosler's words offer meanings, but these meanings become relative to each other and to each viewer's interpretation of them over the course of his or her reading. Language may be a public or collective "descriptive system," but it

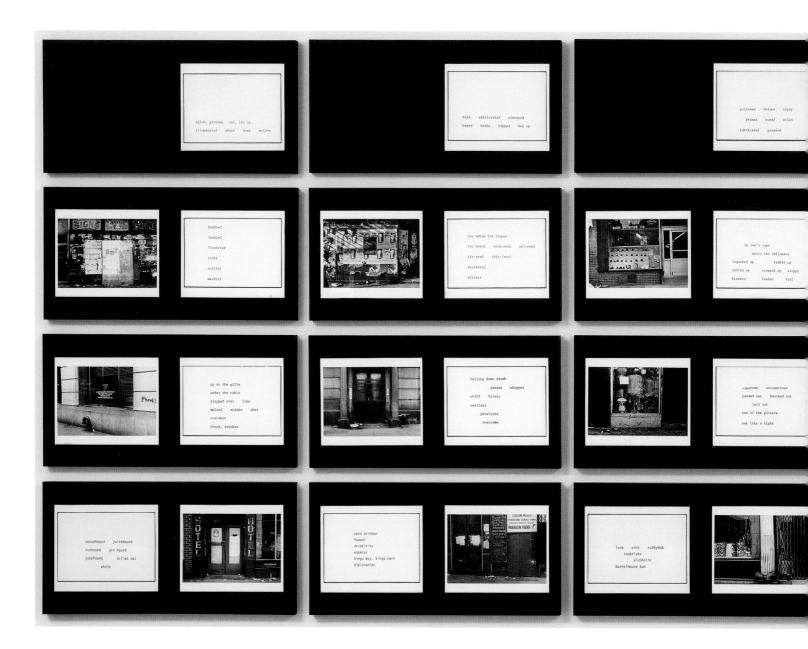

FIG. 77. Martha Rosler, *The Bowery in Two Inadequate Descriptive Systems*, 1974–75.

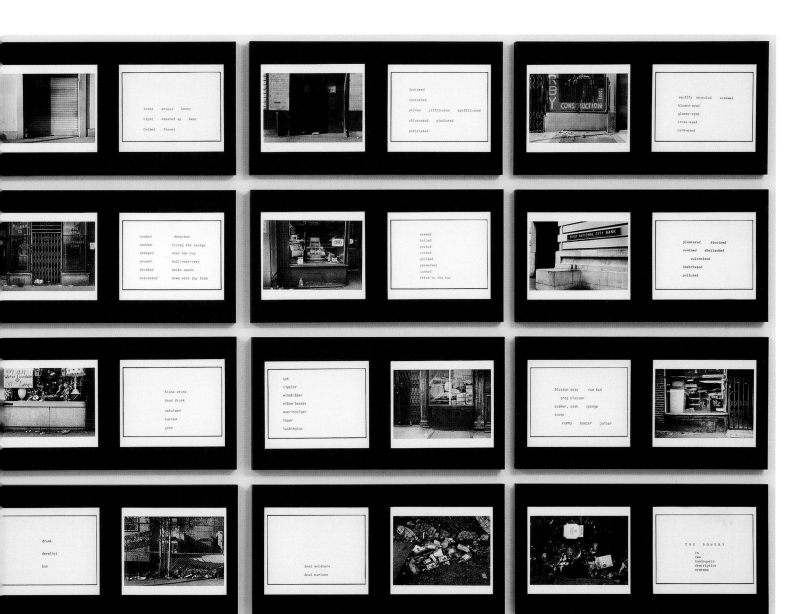

is every bit as unstable a system as representation. Rosler's interpellation of her viewers via the language of the text photographs may suggest that a completion, or reversal of the physical absence, of the Bowery photographs is possible. The viewer's reading of the language likely fails to do this satisfactorily and instead reinforces the words' susceptibility to interpretation, just as the Bowery photographs are susceptible to each viewer's projections about an urban space of poverty.

Insofar as Rosler always intended for *The Bowery* to approximate "a walk down the Bowery,"[134] she also meant for the representation of her experience in that urban space to invite viewers' recognition based on their experiences. Her use of her own viewpoint is an opening for an establishment of familiarity.[135] Her walk down the Bowery takes her viewers along the poverty-stricken street. When one of her photographs captures a sign in the window, it is from the vantage point of someone on the sidewalk, addressed by that sign; likewise, when she noticed the debris of intoxication or homelessness, she pivoted her camera down to indicate standing over empty and smashed liquor bottles. Pulled out of a passive position by the formal mechanisms of such Bowery photographs—a move only enhanced by the interpellation of text photographs—Rosler's viewers can confront these urban spaces as economically and socially constructed, while also negotiating their projections onto such spaces and onto the identities suggested to inhabit them.

If identity is shaped by representations and is thus constantly in process, then the mode of address of a work such as *The Bowery* can affect identity. Deutsche took up this proposition, offering a series of questions that lie at the heart of her scholarship: "How do images of public space create the public identities they seem merely to depict? How do they constitute the viewer into these identities? How, that is, do they invite viewers to take up a position that then defines them as public beings? How do these images create a 'we,' a public, and who do we imagine ourselves to be when we occupy the prescribed site?"[136] Most often, these identities and positions as experienced and occupied in relation to urban public space are characterized by difference, the act of seeing an "other" with whom there is no reason to identify or whose position merely serves to confirm the power of the viewer.[137] Photographic historians Peter Bacon Hales and Carol Squiers have in fact both argued that part of photography's initial function—its invention coinciding with massive urbanization in Europe and America—was "born out of a tremendous cultural need . . . to come to terms with the process of industrialization" and with the new experience of the street "characterized by noise and crowds, the continual proximity of people who were dissociated from one another."[138]

Addressing the experience of difference as a distinctly class-based one, Susan Buck-Morss has written of typical reactions to the *clochards* (tramps) of Paris (a ready parallel to the men of the Bowery): "They fascinate us the more their poverty, intoxi-

cation, dirt and idleness seem to come from defiance rather than hopelessness. It is their spitting in the eye of bourgeois decorum and their total disregard for its success values to which we, observing from the safe side, feel drawn. Yet to contemplate falling into their vulnerable state evokes a shudder, a fact which the authorities may count on, allowing these street-dwellers as a presence that constrains the rest of us."[139] In the case of Rosler's Bowery project, the "safe side" referenced by Buck-Morss is the art-going, culture-savvy professional middle class. This is the same class that Ehrenreich focused on in her aptly titled study *Fear of Falling*: "If this is an elite, then, it is an insecure and deeply anxious one. It is afraid, like any class below the most securely wealthy, of misfortunes that might lead to a downward slide."[140] Whether or not she was aware of Ehrenreich's insights, Rosler has aimed to prevent the typical reactions that either refuse to acknowledge common ground between "us" and 'them" or to use "them" to justify, reassure, and confirm our sense of "us." Considering her audience as one that shares the same community, Rosler has said that "I aim for the distancing effect that breaks the emotional identification with character and situation that naturalism implies, substituting for it, when it is effective, an emotional recognition coupled with a critical, intellectual understanding of the *systematic meaning* of the work, its meaning in relation to common issues."[141]

Rosler, then, aims to jettison a single, stable, or unified meaning that could be extracted from the viewer's interactions with her representations. Her work turns the viewer's attention to the quest for the photographic subject, that representational presence that might confirm one's own coherent identity. Her refusal to picture, and the simultaneous impulse to describe, her Bowery subjects focuses the audience's attention on its desire for identification or differentiation—and the possible failure to locate either reaction in the work. This turn also enacts an urban, photographic version of Bertolt Brecht's *Lehrstück* or "learning theater."[142] Buck-Morss has explained the class-oriented possibilities of this strategy: "It is one thing to create out of others allegorical figures for one's own fantasy-projections. It is quite another to see ourselves suddenly from the outside, as actors on a Brechtian stage, where the allegory we portray is the system of capital itself."[143] In creating a work that addresses the problem of homelessness—and its representation—Rosler uses a Brechtian approach to her viewers, in order to "move consciousness forward, or to move people toward . . . the idea of political action."[144] Her reconceived representation of the Bowery impedes, complicates, and throws into question not only the messages that the "two inadequate descriptive systems" would seem to deliver but also the viewer's reactions to the homeless subjects of the project.

Despite Rosler's declared intention for *The Bowery* to circulate within an art-world context, Buchloh expressed concern about its ability to respond adequately to that context as installation, book, and slide lecture. Within a year of *The Bowery*'s

publication in 1981, he wrote that "Rosler's position runs the risk of ignoring the structural specificities of the work's circulation form and distribution system, and of failing to integrate her work efficiently into the reception of current art practice, when the work's actual claim is in fact radical political awareness and change."[145] Taking up this matter in her recent interview with him, Rosler said, "It was meant as an art work, hanging on the wall—why else would I bother calling it 'inadequate'? Who cares about the inadequacy of representation? The general public doesn't care about inadequacy, the art world and artists care about adequacy of representational systems. The title showed that whatever other people might make of the work, the primary audience was the person interested in the production of meaning through art or language."[146] By analyzing the interaction between representations and their viewers and then by making that interaction unavoidably intrinsic to *The Bowery*, Rosler upset the modernist model of photographic vision as highly personal and contained within the photographic frame, as well as the urban documentary model of "victim photography" as exploitative and rarely socially rectifying. She also proposed an answer to the question "what does homelessness have to do with art?" that addressed, seemingly unknowingly, the specific historic and urban circumstances of street photographs.[147]

Rosler's critical understanding of *The Bowery*'s appearance to viewers did not at the time extend to an equally nuanced analysis of urban space and has never extended to a reckoning with street photography. This is made most clear in her interview with Buchloh, where both parties talk about the urban space of the street and the representational mechanisms of photography, but fail to allow them to intersect in a discussion of her street photographs. Buchloh states that *The Bowery* was mostly about photography and less obviously, "if at all, about urban space." To this, Rosler responds, "The Bowery photos . . . are . . . about the production of space in light of particular social forms. And they . . . use language to try to de-authorize photography while still not disclaiming it. They aren't about the people in the space but about the space itself as a production of a social system." Corrected further, Buchloh eventually proposes, "So 'inadequate' in that title also meant the inability to represent the actual underlying social structures of those spaces." Rosler replies that *The Bowery* "invokes social space. I didn't realize the degree to which that figured in it for me until somewhat later, but I think now it is quite clear."[148]

Bringing these two conversational threads together has been a tall order for most art-historical discourse, as Deutsche has articulated: "Viewing the two elements—art [here, photography] and the city—as fundamentally separate, mainstream art discourse [has] adopted an essentializing explanation of each individual element. By endowing the concepts of art and the city with intrinsic identities, art discourse ensured that they remained intact as distinct and separable entities."[149] While Rosler has failed to even approximate "an essentializing explanation" of street photography (the closest

and previously quoted effort being "the representation of bodies in space . . . with direct reference to time and place"[150]), she has written in more nuanced ways about the street in other art practices: "Some of the new quotational work exists in relation to 'the street.' 'The street' suggests metropolitan locales with deeply divided class structures and conflict, and perhaps where the impoverished and excluded are also ethnically different."[151]

If the street suggests these complicated urban locales, then surely street photographs should represent them in suitably complex, even if "inadequate," images. Synthesizing attention to artistic representation, urban poverty, and the sociology and politics of homelessness, Rosler's *Bowery* offers just such a conceptualization. These photographs analyze and problematize the relations shaping streets such as the Bowery, while exposing how such relations can also be structured through their representation. Thus reconceived, street photographs stand in for Rosler's hopes for urban documentary practice. By way of conclusion, I rework a closing passage from her 1981 essay on the project: *The Bowery in Two Inadequate Descriptive Systems* provides an example of street photographs that incorporates an explicit analysis of society and at least the beginning of a program for changing it.[152]

PHILIP-LORCA DICORCIA
ANALOGUES OF REALITY

I couldn't help but think of Giuliani and what he did to New York, the ethos that he established here. . . . Now, the city is a symbol and a real concentration of capitalist, globalized, mass culture. In some way, the people existing in Times Square seemed a reflection of that to me.
—PHILIP-LORCA DICORCIA

At the heart of this general circulation of signs, the modern individual is confronted with the image of reality rather than reality itself.
—GILLES MORA

New York (fig. 78), from Philip-Lorca diCorcia's *Streetwork* series, and *Heads #03* (fig. 79) offer two analogues of Times Square's particular and ever-changing reality as a streetscape shaped from the early 1990s to 2001 by commercial spectacle, architectural transformation, and social "revitalization." In *New York*, two men wearing business-tan overcoats walk down the street, briefcases in hand. The right sides of their bodies are obliquely lit in a manner that seems incongruous with the unremarkable light on the buildings surrounding them as well as the dull, pale gray sky above them. On the wide section of sidewalk where the camera has been trained, another coated figure, seen from behind and all but a silhouette, is preparing to pass them. Other pedestrians, alone or in groups of two, appear scattered on the sidewalks behind and across the street from the main figures, some of their dark vertical forms appearing all the more striking against an oddly brilliant patchwork of barred storefronts that line the street. Some of these buildings can be seen in their entirety, like the boarded building from which the "HAREM" theater marquee juts out over the sidewalk, its white letter boards blank. This contrasts with the marquee on the near sidewalk, just above the two businessmen's heads, which advertises "Fiona Shaw / The Waste Land / by T. S. Eliot / Directed by Deborah Warner / 212-279-4200." Despite the announcement of a seemingly current engagement at this theater, the play's title rhetorically reinforces the expanse of near-barren sidewalk and the disused storefronts.

FIG. 78. Philip-Lorca diCorcia, *New York*, 1997.

FIG. 79. Philip-Lorca diCorcia, *Heads* #03, 1999–2001.

Although visually quite different, *Heads #03* presents a streetscape no less specific to Times Square than the one depicted in *New York*. No buildings, marquees, or sidewalks are visible; a rich black subsumes most of the picture. In sharp focus, a man wearing sunglasses, a leather jacket, a driving cap, and headphones dominates the foreground. He is shown only from midchest up, and a strong raking light calls out his right cheekbone, lower lip, jacket seam stitching, and a triangle of white turtleneck. Behind him, facing the same direction, another man's torso and head appear out of focus and in deep shadow. We can make out his shirt, tie, jacket, and basic facial proportions, but little of what is behind him. There, despite the tight framing of this photograph, dappled blurs suggest as many as an additional five or six heads. These blurs and the proximity of the two men convey the compressed, compact social space of a busy city sidewalk filled with pedestrians who randomly must share that space.

Of the four artists considered in this book, only diCorcia has previously been discussed within the rubric of street photography. In diCorcia's first monograph, published by the Museum of Modern Art (MoMA) in 1995, Peter Galassi described the photographer as the heir to a long tradition of street photography: "For half a century—from Henri Cartier-Bresson to Robert Frank to Garry Winogrand—the open theater of the street has been a favored hunting ground for photography. The photographer's cloak of anonymity and freedom of action and the street's smorgasbord of character and incident together made an arena of seemingly endless artistic opportunity. After Winogrand's death in 1984, however, the arena was all but abandoned. . . . It is too early to know what diCorcia will make of this untended legacy, but photography has none more potent."[1] Galassi's catalogue debuted early examples of the *Streetwork* series, which diCorcia had begun to make on the streets of metropolises around the world.[2] In terms of subject, *Streetwork* invited comparisons to the traditional luminaries of street photography, and in the intervening years since Galassi's 1995 proclamation, the names of Walker Evans, Helen Levitt, and Harry Callahan have joined those of Cartier-Bresson, Frank, and Winogrand. The authors of such comparisons have resolutely identified two crucial differences between *Streetwork* and its street photography precedents: diCorcia's cinematic staging and lighting.[3] Much street photography has long been equated with the slice-of-life practice set forth in Cartier-Bresson's *The Decisive Moment;* with diCorcia, as critic Andy Grundberg has noted, one instead might "ask how much of a given work is staged to look real, and how much of it is truly (or merely) real."[4] DiCorcia's next body of work, debuting in 2001 and entitled *Heads*, extended this line of thinking. Although this chapter considers outlooks such as Grundberg's—as well as the role of the lighting and framing of the pictures—its main concern is both projects' photographic location in Times Square. From this site-oriented perspective, *Streetwork* and *Heads* more forcefully present a challenging contribution to the history of street photographs, one attendant to the social

FIG. 80. Walker Evans, *Girl in Fulton Street, New York*, 1929.

implications of dramatic urban change. When the urban street's appearance in general—and the commercial pedestrian spectacle of Times Square in particular—is transformed by a process of photographing atypical from that of canonical street photography, what can the resulting images tell us about the reality of that social space? Furthermore, *Heads* provokes contemplation of how much of the street must be visible in order to be considered a street photograph.

THE SOCIAL SPACE OF THE CITY: PRECEDENTS

New York and *Heads #03* have little of the decisive, momentary, or action-laden quality that has been essential in the dominant discourse on street photography, as exemplified by the quotations from Galassi and Grundberg. Certainly the most animated detail in either picture is likely the midstep stride of the main figures' feet in *New York*, but even this gesture appears steadied. (It is perhaps this more subdued representation, with an emphasis on what might be called "stasis," that has led some writers to call these images "street portraits.")[5] Nevertheless, a consideration of certain precedents for diCorcia's work can advance our understanding of the ways in which *Streetwork* and *Heads* reveal that more than cinematic staging or lighting has set him apart and resulted in street photographs that attend to and embody the specifics of Times Square.

DiCorcia came to photography in the 1970s, and like much of his generation, he was aware of and sought to react to an established artistic legacy. His practice seems particularly indebted to several of Walker Evans's photographic strategies. Evans's termed his earliest forays "snapshots." Made almost exclusively in the street, these photographs helped form Evans's characteristic photographic strategies (observation, handheld cameras) and subjects (social interaction, everyday life). Evans claimed, "I go to the street for the education of my eye and for the sustenance that the eye needs—the hungry eye, and my eye is hungry."[6] Three consecutive negatives from 1929 (fig. 80) indicate the combination of varied views and speed that mark Evans's photography of this period. He took multiple exposures of the same, usually unaware subject(s), while varying the formal composition or anticipating changed facial expressions from one frame to the next. His conviction that the street held the greatest of expressive possibilities grew from an appreciation of iconic literary modernists such as Gustave Flaubert, James Joyce,

and Charles Baudelaire, and it informed his decision to work only night jobs, which would leave him free to wander New York during daylight hours, making photographs such as *Girl in Fulton Street, New York* (see fig. 80, top).[7] Evans privileged being constantly a part of the mundane, everyday happenings of the city streets. With *Girl in Fulton Street*, he struck a balance between physical engagement and emotional distance, creating a crucial role for viewers of his photographs by directly taking up his place on the sidewalk. Evans's early street photographs, as Mora has posited, successfully portray "certain social relations . . . between signs and the environment . . . , [and] render the flux into which the city throws anyone penetrating it."[8] Informed by these early pedestrian experiences, Evans captured the social relations of the street in his Chicago street photographs of the late 1940s.[9]

Before discussing those images, it is necessary to pause at another body of work heavily referenced in the diCorcia bibliography: Evans's *Subway Portraits* (fig. 81). Taken while riding the New York subway between 1938 and 1941, Evans's portraits stand apart from his other work for their surreptitious quality.[10] With his Contax lens peering out between the buttons of his coat and a shutter release cable held discreetly in his hand, Evans made over six hundred exposures of fellow passengers on the bench directly opposite him in dimly lit subway cars. He exerted little or no control over the camera angle, compositional framing, lighting, or subjects.[11] The portraits capture the anonymity, respite, confrontation, and distraction of urban commutes. What

remains perplexing is the insistence of a number of scholars—especially among those addressing diCorcia's work—that the *Subway Portraits* are somehow defining examples of street photography or street portraiture. In his introduction to diCorcia's *Heads* catalogue, Luc Sante cited only two precedents for the work: Evans's *Subway Portraits* and "those professionals who prowled the streets of major cities roughly from the 1930s to the 1960s, photographing likely-looking pedestrians, primarily rubes and tourists, and offering to sell them prints."[12]

Setting aside momentarily the question of the street, such comparisons rest on the social typing of photographic subjects; the *Subway Portraits* in particular have thus consistently been seen as a collective portrait, a democratic cross-section, of New York City.[13] This emphasis on social variety—as read through skin tones, facial features, clothing, and grooming—allows a ready connection to diCorcia's *Heads*. But that very similarity is, I contend, reinforced in formal terms by the subjects' placement within the composition (only head, shoulders, and occasionally chest are visible) and their relative isolation (the backgrounds are dark or shadowy). In a caption for the small selection of *Subway Portraits* that appeared in the March 1962 *Harper's Bazaar*, Evans described his fellow riders: "The guard is down and the mask is off."[14] For Evans this sense of relaxation and invisibility, however slight or fugitive, seems to crucially distinguish the subway from the city street, which I would suggest demands vigilance, defensiveness, presence, and presentation. The subway also allows the city's inhabitants to disengage from the crowd. The city street, conversely, requires its pedestrians to almost constantly navigate the crowd in ways both bodily and visual. Given such pivotal differences between these two urban sites, Evans's *Subway Portraits* remain less convincing for this author as street photographs than his later *Chicago* series.

Evans made his *Chicago* photographs (fig. 82) in 1946 and 1947, and they seem to realize an intention he had declared as early as 1934: "[the] American city is what I'm after."[15] Metropolitan subjects, whether people in New York or Chicago, could function as representations of the city, especially when photographed in public and as part of the urban flux of city streets. Evans made no attempt to hide his camera while making street photographs in Chicago, though he did continue to use the fixed vantage point of his *Subway Portraits*. Presetting the exposure and focal distance enabled him to hold his Rolleiflex against his torso and not look through the viewfinder before releasing the shutter, thus keeping most passersby oblivious to his camera's activity. Taken during rush hours at an intersection in the heart of Chicago's downtown State Street shopping area, these pictures include some of the urban contextual information that had been so evocative in Evans's photographs from the 1930s. Lampposts, passing cars, street signs, store signs, and building facade clocks appear against the larger backdrop of a modestly scaled skyscraper, whose uppermost cornice is occasionally glimpsed due to the upward angle afforded by shooting from waist level. This urban

FIG. 82. Walker Evans, *Shoppers, Randolph Street*, 1946.

setting mattered greatly for a project that Evans summarized as photographs of "consumer women as they go about their business . . . [and an u]nappealing woman going by with materialism in their [*sic*] minds and their arms full of packages."[16] Evans wanted his photographs to record the increasing commercial spectacle of the city, as enacted by female shoppers and evidenced by the boxes and bags they carry. The shoppers of State Street may be seen from below, but they clearly occupy the same sidewalk as the photographer. Evans's vision of the city, which required him to engage quickly and regularly, created a place from which his viewer could also engage the city. This method influenced subsequent generations of photographers, and Evans's attention to the intense commercialism, spectacle, and social space of ever-changing urban streets resurfaces in the work of diCorcia.

FIG. 83. Harry Callahan,
contact sheet, 1950.

A selection of Evans's *Chicago* photographs was displayed at MoMA in 1948. The following year several were published in *U.S. Camera Annual.* Curator John Szarkowski noted that "they were among the most stimulating pictures of the period to the next-younger generation of American photographers."[17] Unaware of Evans's *Chicago* pictures, Harry Callahan in 1949 and 1950 made a series of close-range portraits on the same downtown Chicago streets (fig. 83).[18] He replicated aspects of Evans's street photographs but further emphasized the eye-level experience and social space of the street. An interview with Barbaralee Diamonstein addresses the evolution of Callahan's *Chicago* project as well as his parameters for the series:

[BD:] Well, in 1950 you had a very good idea. You knew a place where you wanted to be—on State Street in Chicago. You began a series of photographs of large, close-up views of the heads of passers-by on Chicago streets . . .

[HC:] I photographed them very close. A long time ago, I tried to photograph people walking down the street in Detroit. I couldn't think of any reason why; I just wanted to photograph them. I thought, I'd take pictures of them holding hands and with their arms around each other, shaking hands, or greeting each other. But it just didn't work for me. So I quit. Then later on I realized

FIG. 84. Soichi Sunami, installation view of Harry Callahan's *Chicago* series in the exhibition *Diogenes with a Camera I*, Museum of Modern Art, New York, June 1952.

that what I really wanted was the people walking down the street lost in thought. They had an entirely different kind of expression. And the way I could do this was to use the telephoto lens, walk myself, and photograph them by setting the camera at four feet with a long lens. When their heads filled up the viewfinder, I snapped the picture.[19]

In the resulting photographs, Callahan overcame technical difficulties and the constant upheavals of motion to yield strikingly immediate, high-contrast descriptions of the women's heads.[20] Demonstrably interested in transforming the familiar—namely, the experience of a bustling sidewalk—into something newly seen, he used a combination of exact repetition (the precise technical parameters he set himself) and spontaneous chance (the mobility of both himself and his subjects within the crowd), a process later paralleled by diCorcia. Whether squared within the frame, captured at an angle, or partially cut off by the composition, Callahan's women appear closely encountered, with little to no visual context of their urban setting.[21] Callahan's vision

of the city foregoes both the spatial celebration of skyscrapers and the expression of energy, instead lingering on a drab downtown of women shoppers whose only social interactions with each other or the surrounding space are as lone navigators. When the photographs were enlarged to 8-by-10-inch prints (or larger), the women's portrayed psychological distance was encountered by viewers as a physical, face-to-face proximity. In a 1952 MoMA installation, the *Chicago* series was hung in a long row on a gallery wall that was transparent above and below, allowing for sightlines to two life-size photographic enlargements of another artist's full-length views of female pedestrians (fig. 84). Without horizontal spacing between them and at the approximate height of a viewer's head, the installation underscored that visitors were meant to experience the photographs as though they were passing the women in quick succession on a densely populated city sidewalk.[22]

Throughout the 1950s and 1960s, Callahan continued to photograph urban scenes, occasionally in color, capitalizing on bright, saturated hues to emphasize the physical and psychological isolation sometimes fostered by pedestrian space. Another experiment with street photographs reveals Callahan's awareness of the growing mediatization—and mediation—of urban experiences. In the 1960s he superimposed some of his street pictures with photographs of advertisements or television screens (fig. 85). In *Providence*, for example, young female pedestrians pause on a street corner

FIG. 85. Harry Callahan, *Providence*, 1967.

while the ethereal image of a well-known male television host interviewing a female celebrity hovers over the pedestrians' heads in the upper right. Whether or not the two pedestrians are shoppers (like the women of Callahan's 1950 *Chicago* series), this picture aptly depicts a public sphere in which figures are constantly "bombarded by visual images" that dictate "how people should look, dress, think, and live."[23] *Providence* mimics the looming experience of billboards and other urban advertisements, and it anticipates the future spectacle of stories-high television screens, like those that appear in diCorcia's *Streetwork*. Considered alongside his photographs of female shoppers in Chicago, Callahan's superimposed street photographs attest to his desire to not merely reveal the subject of his photographs—his ongoing representation of the street as a site of commercialism and spectacle—but "to intensify it . . . to capture a moment that people can't always see."[24] Thus, one accomplishment of his consistent engagement with the representation of pedestrian experience is the suggestion that it could be rendered, not merely observed.

Ten years after Callahan made *Providence*, diCorcia was accepted into Yale University's graduate program in photography, which was then chaired by a Winogrand acolyte, Todd Papageorge. DiCorcia's Yale courses introduced him to modern documentary and street photographs, especially those by Evans and Winogrand.[25] Like many photographers of his generation, diCorcia initially turned resolutely away from this tradition. In his 2007 retrospective exhibition catalogue on diCorcia, curator Bennett Simpson notes, "This move can be seen in broad cultural terms that rhyme with the 'personal is the political' attitudes of the 1970s, a shirking of big gestures, abstract ideals, and the confidence that the meaning of America could be found by wandering its streets."[26]

In several interviews diCorcia has elaborated on his reaction to the then ubiquitous celebration of Winogrand's photographic process:

> The tradition of photography when I was [a] kid was an image that was supposed to epitomize the peak of the moment. It was about some transformative instant. A good photographer was one who was perceptive or fast enough to catch it. And I made a really conscious effort (for one, because I was never good at doing that) to develop a way of working where I wouldn't have to. I am not reacting to an instantaneous event. I am either making the event happen or choosing among one of many events that occur every day that are not that dramatic.[27]

> One reason I set up photographs is that I like to see the world as the world is. I don't want to see it as a photograph. I don't like to imagine the world as a photograph or a film. When I was in school [at Yale], they kind of forced you to do that, because you're forced to produce.[28]

I was gravitating toward film at that time, and it seemed to me that the power to affect people always involved some psychological engagement. I find it hard to have a psychological engagement with a conceptual joke illustrated by a photograph.[29]

The desire to psychologically engage viewers with his photographs plays a key role in the work diCorcia later made in Times Square. His instinct to control aspects of the picture-making process may seem like an opposition to his interest in everyday subject matter, but as Simpson encapsulates, "The pertinent questions to ask of diCorcia's photographs are thus not 'is that real?' or 'how did he do that?' but, in essence, 'what is being depicted—and why?' . . . What is the tenor of the reality these works depict?"[30] An understanding of diCorcia's complicating of street photographs through both his process and his engagement with the specifics of site enhances the answers to these vital questions.

DICORCIA'S PROCESS IN THE CITY

Two commentaries from 2001 regarding diCorcia's process on the *Heads* series are instructive and worth quoting at length. One was written to accompany their initial publication, while the other was a response to their first public exhibition, but both locate them within diCorcia's oeuvre and particularly in relation to *Streetwork*.

What began as a refreshing slap in the face of photographic realism (thanks, we needed that) has never lost its theatrical polish. But, as diCorcia's subjects gradually mutated from the intimate to the anonymous, from family and friends to Hollywood hustlers to passersby who rarely even notice that they have been photographed, his fictions improbably absorbed the weight and ambition of what some people still insist on describing as photography's more innocent documentary past. Improbably, but not unintentionally. Looking at these pictures, you might notice that Walker Evans and Harry Callahan have been here before. DiCorcia, who has a firm grasp of photographic history, noticed it too. He went ahead anyway, possibly because he was approaching the territory from a different direction and so figured that it might look different to him—and it does.[31]

This text, Galassi's introductory comments to a portfolio previewing *Heads* in the summer 2001 issue of *Artforum*, charts diCorcia's artistic developments across projects prior to *Heads* while also invoking some precedents. Galassi labeled diCorcia's photographs "fictions," but, unlike Grundberg, Galassi proposed their relationship to documentary realism as one more complex than simple refusal.

The other text, Michael Kimmelman's review of *Heads* at PaceWildenstein Gallery in Chelsea on September 14, 2001, provides a fairly typical, if more detailed, description of the series, comparing it by name to *Streetwork*:

> Since the mid-1990's Mr. diCorcia has helped to redefine the tradition of street photography (Walker Evans's subways pictures, etc.) Nearly a decade ago he began photographing strangers caught in his strobe light. The "Streetwork" series turned pedestrians into unsuspecting performers and the sidewalks along places like Sunset Boulevard, and in Tokyo and Paris, into ad-hoc movie sets, the strobes picking passers-by out of the crowds the way spotlights isolate actors onstage. The lights gave their gestures a sudden, baroque gravity and made everything around them seem contrived and weirdly portentous. For the new photographs a strobe was affixed to scaffolding in Times Square; Mr. diCorcia stood farther away than before, using a longer lens. The result: crisp and stark portraits picked out of murky blackness—just heads, no longer cityscapes, the surroundings now blocked by the scaffolding. They are simpler images and more intimate, the paradox of standing farther away being enhanced intimacy.[32]

As Kimmelman's review suggests, both *Streetwork* and *Heads* rely on diCorcia's already well-developed process of constraints: framing the scene, determining the elements of the composition, and planning well in advance of the moment of exposure how much of the final photograph would look. Leaving one element of the photographs to chance in *Streetwork*—the appearance of passersby—was a new departure from these constraints and became the dominant element in *Heads*.

DiCorcia's newfound openness to chance dates to 1993, when he made the earliest of his *Streetwork* photographs: "After many years of controlling every aspect of the shoot, of arranging the objects and even deciding which direction the subjects looked, I wanted to see what would happen when dealing with chaotic situations and subjects you can't control. . . . I was interested in the dramatic possibilities of chance."[33] Within these chaotic situations, diCorcia still maintained certain constraints or "givens," decisions that helped construct and compose—or, in the language of Ansel Adams, previsualize—what might occur in front of the camera. These advance decisions included camera placement and angle, additional lighting, and framing the view. (Of course, these decisions about a certain combination of photographic elements preceded another one: when to press the shutter release.) DiCorcia has claimed that "I created the circumstances, but after that, I was at the mercy of whoever passed by."[34] Indeed, the uncontrolled energy of city streets was what appealed to him: "Usually I have to focus on one central person or area and hopefully

other things fall into place even out of your view. There is a certain energy that exists on the street and you can tell when there is a lot of it and that is to your advantage."[35]

Knowing this, diCorcia located his camera in a propitious site for capitalizing on this energy, adjusting the point of view to include those aspects of the urban scene likely to provide the best context for the presence of his potential pedestrian subjects. Quite often, on or approaching street corners proved to be the most favorable location. In *Streetwork* this location is evident from the white stripes of a pedestrian crosswalk (fig. 86) or from the positioning of traffic signals and street signs (fig. 87). Though less immediately evident, the *Heads* photographs were also often taken near street corners. *Streetwork* and *Heads* mix direction and chance, fact and fiction, realism and drama, control and passivity; few commentators have embraced this admixture as street photography, thereby disregarding, as Luc Sante claimed, the genre's "ostensible promise"—"to serve up truth, unvarnished, unprocessed, and unpremeditated."[36]

Streetwork was diCorcia's first body of work made exclusively on city streets, and he has commented on the appeal of searching there for "unfamiliar realities."[37]

> When I was doing the street pictures, just being in those cities—Tokyo, Paris, Rio—finding a place within them that was usable, waiting, and trying to be unobtrusive—all things were out of my control. . . . That was something that brought me back to working on the streets. When I was just doing street pictures you could not quite concentrate on everything that was going around but you knew when something was happening. . . . If not (in this particular technique), people will just stare at you. One person or a couple see a man with lights and the camera will get the staring look. Whereas when things get chaotic nobody notices you. I almost had to have that. So it defined the places I could work and that project one way or another. I worked on it one way or another almost four years.[38]

Notably, in the same interview, diCorcia observed that "with the headshots you had no idea what was good."[39] This further uncertainty associated with *Heads* resulted from key shifts in his photographic "givens." *Heads* was shot in Times Square over the course of two years on a heavily trafficked stretch of sidewalk that was covered by industrial scaffolding.[40] DiCorcia planned the compositions with Polaroids, some of which have now been published and exhibited in their own right.[41] His camera, outfitted with a telephoto lens and mounted on a tripod, was positioned well out of view, twenty feet or more away from the framed spot. Every composition was limited to the darkened passageway—seemingly omitting all signs of the bustling city—and afforded no more than chest-up views of the passersby. DiCorcia's very restricted depth of field rendered in sharp focus only a particular portion of what was already a

FIG. 86. Philip-Lorca diCorcia, *New York*, 1998.

FIG. 87. Philip-Lorca diCorcia, *New York*, 1997.

155

limited slice of the pedestrian flow: "I was basically totally at the mercy of serendipity. There were so many things that could go wrong technically that would eliminate a good portion of the images. . . . [Passersby] had to be in a certain spot in a certain moment or it wouldn't work. I couldn't actually see them when I took the picture. (You can't look through the camera since people in Times Square passed too fast.) So I had a mark on the ground and I knew that if people were on that mark the flash would hit them. They might be too tall or too short but that's where they'd be in focus."[42] In front of or behind the calculated mark on the sidewalk, corresponding to the restricted focal plane, everyone and everything fell into soft focus and receded into the darkness of the scaffolding's shadows.[43] In *Heads #23*, a young man in a yellow shirt is only dimly visible behind two girls who have hit diCorcia's sidewalk mark walking shoulder to shoulder (fig. 88).

Lighting has too often been simplified as diCorcia's single, identifying modification of traditional street photography.[44] In both *Streetwork* and *Heads*, he hid electronic flashes or strobes—synched to his camera via a radio signal remote-control device known as a radio slave—by suspending them above city sidewalks. The light from these flashes appeared only for a fraction of a second, rhyming with the rapid shutter release of the camera. Few if any of the subjects in the *Heads* pictures ever knew a photograph had been taken. The intensity of the flash not only picked out certain elements or figures in the picture but also simultaneously enhanced or created strong shadows in other portions of the image. The highlighting of the lit elements or figures sometimes corresponds with a particularly saturated hue (e.g., the rich mustard and russet of a woman's jacket and backpack [see fig. 87]) or a refinement of detail (e.g., the legibility of the foreground figure's jacket seams [see fig. 79]), but it always sets those elements or figures apart from their surroundings. The combination of artificial and natural light can appear "somewhat irrational," as diCorcia has described it.[45] The direction of the light source and the location of shadows can quickly lay bare this irrationality, as when, for example, a prewar building facade is aglow with direct sunlight, the source of which must be to the right of the composition, but the highlights on the socks, backpack, and hair of the woman in the suede jacket indicate a light source directly overhead, one originating slightly to the left of the composition (see fig. 87). Likewise, in *Heads #23*, the lighting of the left sides of the two girls' faces is visually out of sync with the lighting of the right sides of the faces of those just behind them in the crowd (see fig. 88). DiCorcia's strobe lighting of the sidewalks also allows his subjects to take on the intense coloring and lighting displayed in the advertisements that surround them. A pedestrian's strobe-lit strawberry blond hair has the punch of a *Lion King* billboard (see fig. 86), and a spotlighting effect on an embracing couple competes with the hot white of a movie billboard, the uplights along its base clearly visible from this angle (see fig. 87).

FIG. 88. Philip-Lorca diCorcia, *Heads* #23, 1999–2001.

This irrationality of lighting in diCorcia's photographs has led some critics and scholars to invoke cinema.[46] Others have relied on fashion, and still others have referenced old master painting.[47] And many have discussed the overhead origin of the lighting in religious tones: "The lighting suggests organ or Theremin music, suggests thunder and lightning, suggests . . . the inspection tour of a deity."[48] (The artist himself remains uninterested in such interpretations, saying flatly that he does not consider his lighting "to be metaphorical.")[49] In spite of the emphasis placed on diCorcia's lighting, even among those who have labeled it "dramatic" or "theatrical,"[50] none has remarked on the very fact that the pictures were made in a theater district, specifically that of Times Square, perhaps the only section of New York City so identified with lighting as to have mandatory levels of it. I suggest that such particulars as diCorcia's chosen location inform his lighting and matter greatly to the resulting photographs. Indeed, the irrationality of his lighting seems to have a ready and proximate parallel in theater lighting, which balances spotlighting of individuals with more general stage illumination. To accomplish this, light sources are formulaically deployed to provide various intensities of light to top, back, front, and sides of all areas of a stage. Theatrical lighting systems yield shadows and highlights that would be contradictory or impossible in natural outdoor lighting, the same incongruity apparent in diCorcia's *Streetwork* but altogether unremarked upon in discussions of his lighting technique.

In so emphasizing the lighting or in declaring it diCorcia's visual "signature," critics and scholars have elided notable differences in the lighting's deployment and effect within the two projects. Most obviously, daylight suffuses the *Streetwork* photographs and disappears altogether in those from *Heads*. Conversely, the contractor's scaffolding that was responsible for the latter (and for housing the strobe lights) never factored in the creation of the earlier body of work. There, diCorcia's synched flashes went off "open-air" from their suspended positions on lampposts, traffic signal poles, and street signs. Significantly, then, in *Streetwork*, the lit pedestrians are given the emphasis that everywhere around them is also accorded to signs, glass, advertisements, corporate logos, and billboards. DiCorcia compels us to see a romantic couple on the corner even as Times Square itself visually surrenders the intersection to neon lights, billboards, and the Disney flagship store (the *EY* of its branded logo visible just above their heads) (see fig. 87). Likewise, the strobes highlight the gestures of those moving through the Times Square crowd, as well as the postures of those simply taking in the naturally lit chockablock signage lining the building facades; multistory advertisements are discernible as the street recedes in the composition. In contrast, the *Heads* photographs portray pedestrians moving through a space that initially reads as complete darkness, a void that has subsumed the urban structures and signage so evident in *Streetwork*. No billboards, neon logos, or even scaffolding emerge from the

shadowy blacks in *Heads*. The lighting in this series instead works against quick or easy recognition of the figures as passersby on a city sidewalk.

In both *Streetwork* and *Heads*, diCorcia planned and executed only horizontal compositions. (To be sure, his careful blocking out of elements within that horizontal frame is more legible in *Streetwork*, where the city's fixed horizons and the verticals of buildings' or billboards' edges are squared to the photographic frame.) The consistent horizontality of the pictures—particularly when coupled with the effects of his lighting—has, as mentioned, led to many an invocation of cinema's poise and drama. Indeed, diCorcia had once gravitated toward a career in film, and his graduate thesis analyzed two distinct styles of filmmaking.[51] Of the two styles, he was decidedly more influenced by the one that allowed the film's point of view to seem so omniscient as to minimize any sense of authorial presence. DiCorcia clearly prefers this nonauthorial point of view, and the absence of an eye-to-camera point of view (and thus an eye-to-eye relationship to the subject) sets him apart from most preceding street photographers. Perhaps more remarkable, diCorcia did not even look through his camera's viewfinder when taking the *Streetwork* and *Heads* photographs. Instead he watched possible subjects pass through the framed scene, always with his finger on the shutter release. This leaves little question that the planning of the edges of his frame were far more deliberate than whatever might fill its center, and far more constructed than the edges of point-and-shoot Winogrand photographs or even than those of Callahan's composed-by-chance shoppers. DiCorcia thus intended for the right edge of a *Lion King* billboard to nearly but not quite align with the right edge of the frame, and he also ensured that the buildings opposite the billboard have merely a sliver of presence at the left edge of his frame (see fig. 86). What he could not imagine was the way two male pedestrians in tan coats would move their arms simultaneously and so similarly. This pictorial echo is one of those "highly tangential incidents," as diCorcia calls them, of which he often "was not even aware" while watching the street from alongside his camera. In *Heads* both the cloak of the scaffolding and the slightly downward view of his camera allowed him to "kind of disappear."[52] DiCorcia has varied the presence of the figures within the photographic frame: in the former series, more of the composition is given over to the urban surroundings, and the figures occupy multiple places in the horizontal register; in the latter, they more fully fill the composition, and they more often appear horizontally centered within the frame.

Crucially, diCorcia never engaged any of the passersby he photographed. Without the cloak of scaffolding, he has said that most people pictured in *Streetwork* did not know they were being photographed so much as they knew he was taking a photograph.[53] In part, this assumption by passersby that diCorcia was photographing the surroundings accurately reflects the *Streetwork* pictures, which are dominated as much by the human subjects as by the built environment and sidewalks of Times

Square: "The sky, suggestive of an 'outside' appears jostled away by billboards and awnings competing for space on surrounding facades," observes Bennett Simpson. "Hulks of office buildings, clung to by fire escapes and scaffolds, interpose like giant ships" (see figs. 86 and 87).[54] I propose that *Heads*, too, reflects this balance between the subject and the highly specific urban context of Times Square, even when the latter is rendered more opaque. Times Square does not merely appear in both these projects; it fundamentally informs them. Always and already a culturally loaded urban site, Times Square was in fact undergoing radical changes at precisely the time that diCorcia was making *Streetwork* and *Heads*.

SPECTACULARS, SEX, AND REVITALIZATION IN TIMES SQUARE

Many people can conjure an image of Times Square, whether from television coverage of the New Year's Eve celebrations or tourist postcards or its iconic presence in so many films. It is arguably the preeminent, mythic American incarnation of urban experience, if a fairly extreme or spectacular one. It has drawn some of the largest historical public gatherings and has offered the kinds of entertainment that have long gone hand in hand with commercial entrepreneurship and consumer marketing in the United States. Always and already understood in symbolic terms, Times Square is thus entwined with fantasy, fostering dreams (or illusions) of fulfillment and freedom, community and anonymity, pleasure and consumption, deviance and familiarity. All this makes it exemplary of the negotiation between spectacular urban fantasies and a functioning urban space, which is never fixed or consistent. Both physical and semiotic changes in Times Square have resulted from complex political, social, and economical interactions—the subject of whole books—but some sense of this will prove useful in contextualizing diCorcia's New York street photographs, which were made both during and following a crucial push in the area's "revitalization." I do not maintain that previous versions of Times Square were better or worse than those photographed by diCorcia. (Writer James Traub has rightly noted some of the pitfalls of nostalgia for "a lost idea of urbanness, or of urbanity—for a time, before the advent of television and the suburbs, and before riots and drug wars, when everyone knew that city life was the best life of all.")[55] Instead, the versions of Times Square encountered in diCorcia's photographs are specific to that location, and as street photographs they comment on the social space of one of America's central urban sites.

Political scientist and cultural historian Marshall Berman writes that "ever since the opening of the Times Tower and the IRT subway . . . in the winter of 1904–05, Times Square has been a remarkable environment. With its huge crowds, multiple banks of light, layers of enormous signs, . . . it has taken one of the primal urban experiences—being in the midst of a physical and semiotic overflow, feeling the flow all over you—and concentrated it and focused it and sped it up and blown it up. The

signature experience of being there is being surrounded by too many in the midst of too much."[56] Formed by the intersection of 42nd Street on an east-west axis, Seventh Avenue on a north-south axis, and Broadway as the primary diagonal exception to the grid, Times Square has long played a critical role in the city's commercial and technological development, partly because Broadway's march from downtown to the Upper West Side is a key transportation route for navigating the city. Broadway was the first street to devote itself exclusively to commerce, eliminating residential buildings, and, likely for this reason, it was the first street to enjoy amenities such as gas and then electric lights.[57]

By 1904 the area boasted an ever-increasing number of theaters, restaurants, music halls, and other places of entertainment. The *New York Times*'s ambitious owner and publisher, Adolph Ochs, celebrated New Year's with a brilliant public relations stunt: an outdoor party with a fireworks show. An estimated 200,000 people crowded around the new Times Tower, transforming the square into the place for New Yorkers to gather for future celebrations, from election results to World Series victories.[58] As Traub notes, "those vast crowds were making Times Square radically different from any of its predecessors—more crowded, more turbulent and volatile, more democratic."[59] Outside New York City, the square was "rapidly becoming known as the crossroads of the world."[60] Moreover, its combination of urban geography, real estate investment, and public transit spawned a new visual environment.

FIG. 89. Photographer unknown, *New York: The Great White Way,* c. 1914.

"The Great White Way." New York.

The lighted sign came to Times Square in 1905, forever transforming an already lively, dense commercial landscape and quickly becoming the square's image to the world of "a city of night where the drumbeat of commerce never relents and the lights never go out."[61] In his treatise "Art and Advertising Joined by Electricity," O. J. Gude, the lighted sign's enthusiastic supporter, wrote, "Practically all other advertising media depend upon the willingness or even cooperation of the reader for the absorption of the advertiser's story, but the outdoor advertising sign asks no voluntary acquiescence from any reader."[62] Times Square's unique thoroughfare offered decidedly more viewers, and its triangular intersection created an ideal nexus for lighted signs, with sightlines unobstructed in multiple directions. Inventive in their design, enormous in their scale, and powerful in their luminosity, these signs commanded such a presence that Gude coined a new term to better describe them: "spectaculars."[63] By the 1910s, spectaculars had come to dominate the square's visual environment. Stacked atop one another on theater building facades and soaring up from the rooftops overhead, their commercial imagery, varied typefaces, and glowing colors created a new visual noise that mirrored the cacophony in the streets below (fig. 89). After nightfall, the square's

FIG. 90. Walker Evans, *Broadway Composition*, 1928–29.

FIG. 91. Alfred Eisenstaedt, *Times Square, V-J Day*, August 14, 1945.

blazing and flickering glow underscored its identity as a unique and unequaled urban gathering place.

In the following decade both New York City's and Times Square's centrality to American cultural and economic life was solidified by the widespread success of the Broadway musical.[64] If the spectaculars bespoke (and capitalized on) a mass audience, the Broadway musical and the increasing appeal of movies during the 1920s signaled decisively that mass entertainment reigned in Times Square. Both an early photographic postcard of the "Great White Way" (see fig. 89) and Walker Evans's *Broadway Composition* (fig. 90) respond to the predominant visual experience of the square: the glowing mediation of mass culture through the words and lights of commercialism. By 1929 this urban experience greeted over 250,000 people in Times Square nightly.[65] In 1937 the New Amsterdam Theater presented *Othello*, the last production of classical theater to open on Broadway for the next forty years.[66]

Times Square reasserted its identity as America's preeminent public square on V-J Day, August 14, 1945. That evening, news of Japan's eagerly anticipated surrender scrolled across the Times Tower, before which half a million people were waiting. Groups continued to flock to the square, and within three hours a mass of two million formed the largest crowd in Times Square history. Visually, that evening's celebration marked the first time in four years that the square's marquees and spectaculars had been illuminated. A newspaper reported the next day on the experience: "Men and women embraced—there were no strangers in New York yesterday."[67] Indeed, there is likely no image more iconic of Times Square, and certainly none that conveys so well the impact of the news and air of jubilation, than Alfred Eisenstaedt's photograph taken for *Life* magazine of a sailor kissing a nurse (fig. 91).[68] Beyond the embrace, this photograph highlights—especially to those not there—the crowds, the spectacle, and the celebration that had once again swirled in New York City's iconic public square.

A 1960 *New York Times* front-page article headlined "Life on W. 42d St.: A Study in Decay" is more characteristic of Times Square's representation in the decades following World War II.[69] Urban flight from the city to the suburbs, by residents and

businesses alike, affected many neighborhoods. Sex and drugs were visibly for sale in all parts of the square. Long the sex capital of the city, the square had by the 1960s also become the center of gay male prostitution, also known as hustling.[70] Its streets were lined with peep shows and strip clubs, stores for adult videos and sex magazines, massage parlors and porn theaters. Times Square was increasingly perceived as a crime-ridden twilight zone, most consistently populated by prostitutes, drug addicts, those seeking sex for hire, and alcoholics. Rhetoric about the deviant culture of the square intensified, and by 1981 the *Times* was quoting its inhabitants as saying they liked to rob people.[71] These and other claims fueled the city's plans to "clean up" the area, which chiefly meant replacing the sex industry with a more acceptable one. Times Square's revitalization hinged on its commercial redevelopment.

In 1978 the Ford Foundation commissioned a study on the square's revitalization, purposely charting the area's violence as well as its sex market and drug trade. The study concluded that rises in these three categories prefigured a decline in Times Square's other offerings, and it contended that "eliminating these businesses through changing the use of the street should cause the undesirable population to leave on its own."[72] The Ford Foundation's study focused on Times Square not only for its so-called decline but also for its symbolic status within the city. Four years earlier, the same impulse had informed Mayor Abraham Beame's 1974 choice of Times Square as his target site for fighting crime. He said at a press conference about this initiative, "I want the people of the City of New York to know that I have picked Times Square as a first target because of its high visibility and because of its role as a symbol of New York."[73] The first official plan for that transformation dates to the early 1970s, when "The City at 42nd Street"—a massive redevelopment proposal that began as a theme park and transformed into a more general real estate venture—was announced. Despite this plan's eventual failure (as well as that of subsequent plans), City at 42nd Street gave popular force to the concept that only dramatic change would produce the desired effects, as the Ford Foundation study concluded. The revitalization of Times Square became the subject of a series of debates and choices about the nature of that change and of New York City, coalescing in the 42nd Street Development Project of the 1990s.

At that time, along a two-block stretch of Seventh Avenue, Eighth Avenue between 44th and 51st Streets, and much of the same distance on Broadway, most of the theaters showed exclusively pornographic films or functioned as sex spaces. One such theater, the Adonis (located at the southwest corner of Eighth Avenue and 44th Street) came under particular scrutiny. Municipal health inspectors reported "high-risk sexual activities" among patrons of the gay pornographic movie house, without "any attempts to monitor or control them."[74] Forced to close its doors, the theater reopened in 1994 as the Playpen, a multifunctioning heterosexual sex

destination, the front of which served as a sex-toy and adult video store, the back rooms of which housed peep booths and "live girls."

The transformation of the Adonis into the Playpen coincided exactly with another transformation that was unfolding less than two blocks away. Located on 42nd Street between Seventh and Eighth Avenues, the New Amsterdam Theater was calculated to be the only theater large enough to ensure a profit once the costs of its renovation were taken into account by its would-be owner, Michael Eisner, CEO of the Walt Disney Company.[75] Eisner toured the theater as early as 1992, considering the venue for a newly conceived product line: Broadway musicals based on Disney's hit movies. *The Lion King* opened at the fully restored New Amsterdam in November 1997, but only after a lengthy negotiation between Eisner and representatives of the city.[76] The deal, signed on New Year's Eve 1994, brought together theater and real estate with the goal of reducing the sex trade's visibility. The city agreed to pay for the New Amsterdam's entire renovation, secure two major entertainment companies to lease a good portion of the same block of 42nd Street, and eliminate more than twenty sex shops in the immediate vicinity.[77] In anticipation of just such a deal, the 42nd Street Development Project had released a plan in 1993, declaring its desire to celebrate the "thrillingly unpredictable daily drama" of the area as much as its commercialism.[78] Traub elaborates: "The idea that there need be no contradiction between the drama of the streets and the ring of the cash register, between 'authenticity,' and the marketplace, was itself something of a revelation, at least in the debate over the future of 42nd Street."[79] To carry out this idea, the plan dictated the visual character of all new retail enterprises (e.g., mandatory square footage of lighted signage) as well as those enterprises' practical interface with pedestrians (e.g., retail hours extended well into the night). Noticeably absent from the 42nd Street Development Project's rhetoric and mandates was one of Eisner's three demands: the elimination of sex shops and porn theaters from Times Square.

Rudy Giuliani won his 1993 mayoral bid on a platform that was rich with rhetoric about enhancing the quality of life in New York City. This not only involved dramatically increasing the police force and enforcing minor infractions such as public drinking but also encompassed an offensive against pornography.[80] Times Square felt the impact, and Giuliani's policies ensured that the sex-related stipulations of Eisner's New Amsterdam deal would be met. Seen from one perspective, the "new zoning ordinances closed down and scattered the warren of X-rated video stores, movie theaters, and peep shows; aggressive policing cleared the sidewalks, side streets, and parking lots of most of the less seemly goings-on."[81] The mandate to carry 60 percent "family-friendly" video inventories made the already small business of running an adult video store so much less profitable that all these businesses were forced to sell to the developers waiting to buy.[82] This perspective counters generalist

historians' acknowledgment of the debates about Times Square's revitalization while leaving undiscussed the claims about its effect on gay men and others served by the sex and drug trade of the district.

Demolition of the targeted businesses began in 1995; in October of that year, those remaining were given one year to vacate their space.[83] As these stores closed, the 42nd Street Development Project painted the grates over former storefronts a rainbow of hues. Simultaneously, plans were finalized for the four major office towers that would be constructed in place of these businesses. (Even those that were not demolished were repurposed, so that restaurants appeared in former gay sex spaces like the Capri and Eros.)[84] With their initiation in 1995 and implementation over the next several years, these changes ensured a de facto abolition of gay culture in Times Square. Practices such as hustling and drug dealing, which are less bound to time spent in particular spaces than to transitory encounters in almost any possible location, proved harder to eliminate. Logistically, such momentary actions may never be able to be fully regulated or policed; these actions also cater to human desires that may never be fully restrained or, for that matter, fulfilled by the alluringly commercial displays in the shop windows of the new Times Square businesses. Regardless of the explanation, the purpose for and experience of the area shifted distinctly away from sex, fantasy, and private entertainment toward commercialism, consumption, and family activities.

New York City gave Disney, the first and most widely known leaseholder in the 42nd Street Development Project, its desired neighbors in the tourist shops, headquarters of global corporations, and musical theaters. The new office towers at 42nd and Broadway, the heart of Times Square, were anchored by leases from Reuters and Condé Nast; other corporate tenants soon filled buildings in the immediate area, including Warner Brothers, Viacom, Gap, and Barnes and Noble. Nearby theaters were restored, following the New Amsterdam's example. Not a part of the initial deal between Disney and the city, these leases were the result of market demand following the 42nd Street Development Project's plan for the main intersection. The street-level architectural elements of all new development in the area still had to comply with the project's determinations about what would maintain the "character" of Times Square. For example, requisite glass facades would ensure transparency and reflect the lights of the surrounding (also requisite) advertisements. Indeed, the illumination of advertising signs was mandatory, in deference to the spectaculars that had so defined the district. As Traub notes, "a block long building would thus have to provide at least 16,800 square feet of lighted signage, or about as much as already existed on Times Square's brightest blocks."[85] To quantify the light from such signage, readings were made from existing signs, dubbed "light unit Times Square" (LUTS), and they became the lowest permissible lighting level for the area. In many cases over the past dozen years, oversize video screens have helped meet the LUTS requirement. Digital imagery

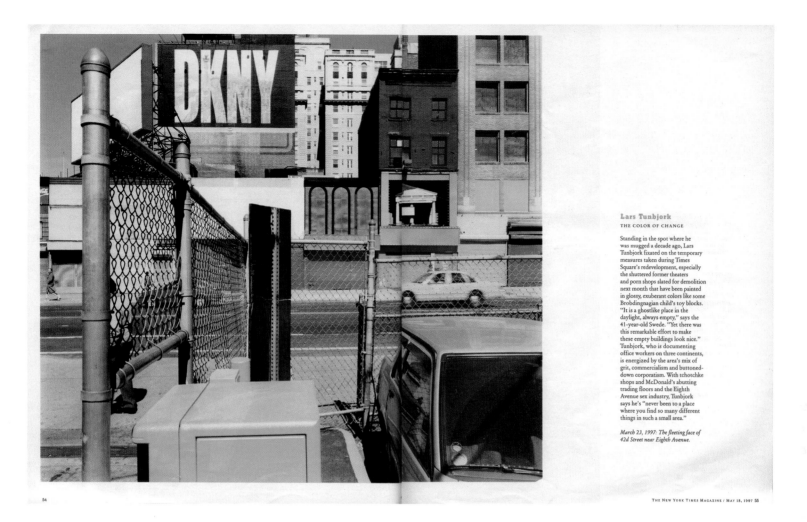

Lars Tunbjörk
THE COLOR OF CHANGE

Standing in the spot where he
was mugged a decade ago, Lars
Tunbjörk fixated on the temporary
measures taken during Times
Square's redevelopment, especially
the shuttered former theaters
and porn shops slated for demolition
next month that have been painted
in glossy, exuberant colors like some
Brobdingnagian child's toy blocks.
"It is a ghostlike place in the
daylight, always empty," says the
41-year-old Swede. "Yet there was
this remarkable effort to make
these empty buildings look nice."
Tunbjörk, who is documenting
office workers on three continents,
is energized by the area's mix of
grit, commercialism and buttoned-
down corporatism. With tchotchke
shops and McDonald's abutting
trading floors and the Eighth
Avenue sex industry, Tunbjörk
says he's "never been to a place
where you find so many different
things in such a small area."

*March 23, 1997: The fleeting face of
42d Street near Eighth Avenue.*

FIG. 92. "Assignment Times
Square," *New York Times
Magazine*, May 18, 1997, 54–55.
Photograph by Lars Tunbjörk.

and computer programming have allowed for more numerous, even competing, lighted
signs that could appear on the same screen, all of them fleeting and instantly replace-
able. Today these large screens, along with vinyl billboards, cover nearly every building
in Times Square whose surfaces are legible from the sidewalks below.

 In 1997, just a few years after the initial demolition of the porn theaters and
sex shops, Michael Kimmelman described Times Square as a nexus of simulacra: "In
the new Information-Age Times Square, where brand names and corporate logos are
rewriting the skyline, you can relax in an 'authentic' Irish pub before seeing your
portfolio on a multistory stock ticker or firing off a few rounds at a virtual-reality
shooting gallery. It's an eclectic, electric streetscape of intense simulation: a hyper-
reality."[86] This description of the early years of Times Square's revitalization comes
from a photo essay in the *New York Times Magazine*, commissioned from nineteen
contemporary photographers and dedicated to the "new" Times Square. One photog-
rapher, Lars Tunbjörk, returned to the location of his 1987 mugging and became
enthralled with the visual markers of the area's redevelopment (fig. 92). In particular,
Tunbjörk found the painting of the grated storefronts of former pornographic theaters
and sex shops a "remarkable effort to make these empty buildings look nice," despite

their imminent demolition.[87] Kimmelman characterized diCorcia's photograph *New York* (see fig. 87) as an update of the famous Eisenstaedt photograph (see fig. 91). Like Eisenstaedt's image, diCorcia's relies on a chance romantic occurrence that looked fake. More thoroughly than Kimmelman acknowledged or than subsequent authors ever realized, diCorcia's *New York* understood and accounted for the particularity of Times Square and the centrality of sex, desire, and fantasy—as well as the implications of revitalization—to its identity.

In 1996, three years before *Times Square Red, Times Square Blue*, Samuel R. Delany published "X-X-X Marks the Spot" in *Out*, a leading magazine of gay culture. Four diCorcia photographs accompanied the article. Like the picture that Tunbjörk would make the following year on assignment for the *New York Times Magazine*, diCorcia's photograph on the article's first page focuses on the bright, shuttered storefronts of Times Square (fig. 93). He framed the image so that a sequence of the colorful painted grates recedes, a seemingly endless row of shuttered storefronts matched by the broad but empty sidewalk that fills the foreground. In the upper right corner of the image, a shadowed overhang juts obliquely into view. That structure and the color pattern of the grated storefronts also appear in the background of diCorcia's *New York* (see fig. 78): the structure is clearly the marquee of the boarded-up Harem Theater on 42nd Street, and the grates are affirmed as a colorful front to a desolate urban area.[88] Other diCorcia photographs included in the Delany article portray people, such as male prostitutes, whose livelihood would soon be threatened by the changes to Times Square (fig. 94). Delany's text reports that hustler Darrell Deckard turned tricks for $40 or $50, far more than the $15 Delany and diCorcia paid him for the photograph.[89] This is notable insofar as it seems a reprise of diCorcia's 1990–92 *Hustlers* series, in which the photographer paid each subject his going rate for sex (fig. 95). DiCorcia's choice to photograph *Hustlers* exclusively within the culturally loaded site of Hollywood—picturing its eponymous Boulevard and Walk of Fame as well as its motels and fast-food drive-throughs—is a compelling parallel to his attention to Times Square at a time of the iconic area's upheaval and revitalization.

Delany's 1999 book *Times Square Red, Times Square Blue* features five previously unpublished diCorcia pictures, including views of pornographic theaters and their marquees, photographed as they would be seen, respectively, from across the street or the sidewalk below (fig. 96).[90] Like Delany's text, these photographs record the sex spaces used by men along 42nd Street in the years before revitalization. By the time of the book's publication, for example, some such spaces had been transformed into restaurants, so that diCorcia's circa 1996 photographs for Delany represent an urban landscape that had already ceased to exist.

Bennett Simpson is the only scholar who has indicated an awareness of diCorcia's other Times Square photographs during this period. He addressed Delany's publication

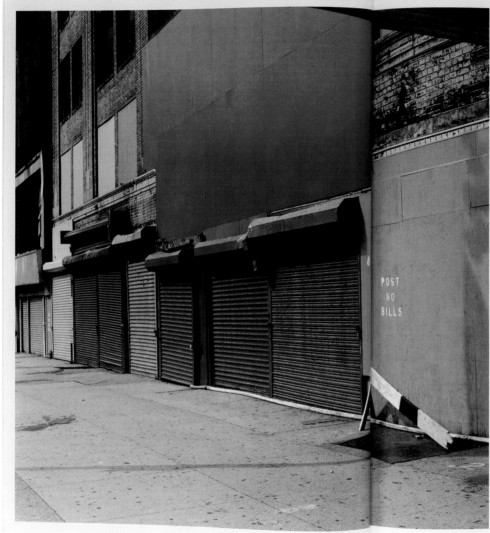

X-X-X Marks the Spot

Coast to coast, new laws are cordoning off sex-related businesses—even in New York's Times Square, the red lights are off and Disney and souvenir shops are in. Longtime denizen Samuel R. Delany wanders through the gay old neighborhood and remembers when.

AGAINST THE SUBWAY KIOSK AROUND the corner on 42nd Street and Eighth Avenue, A still sets up his shoeshine stand, cans of stain, his brushes, his cloths. A's come-on is much what it was when I first noticed him in the late '70s. To every third woman who walks by, with or without boyfriend, it's, "Hey there, beautiful!" or "*Mmmm!* Hi, sweetheart!" When woman or boyfriend turns, surprised, A—*so* faintly—shifts his tone: "You are a truly *fine* woman, and it's a pleasure to see you pass on the street!" or "Sir, you have a beautiful woman there. Respect her and treat her well!" Now, people smile. (Maybe one in five—the women in groups or some of the single ones—don't.) But it's harmless, even charming, isn't it? In his shorts and glasses, he's just this 70-plus-year-old black shoeshine man.

For all the years I've watched others smile and smiled with them, something bothers me in A's routine. It isn't A. Back and forth over the boundary between unacceptable harassments and sincere protestations of admiration, sometimes three or four times a minute, his agile leaps are a virtuoso performance by an

Photographs by Philip-Lorca diCorcia

FIG. 93. "X-X-X Marks the Spot," *Out*, December 1996/January 1997, pp. 114–15. Photograph by Philip-Lorca diCorcia.

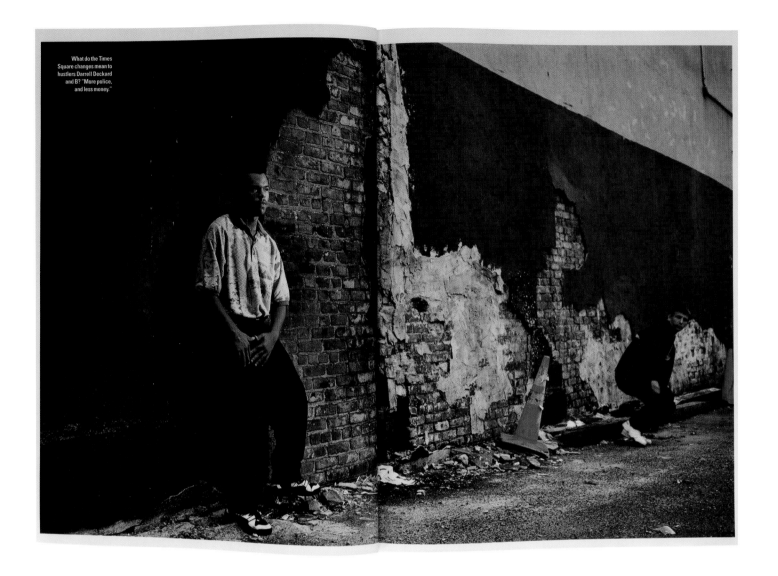

What do the Times
Square changes mean to
hustlers Darrell Deckard
and B? "More police,
and less money."

FIG. 94. "X-X-X Marks the Spot," *Out*, December 1996/January 1997, pp. 118–19. Photograph by Philip-Lorca diCorcia.

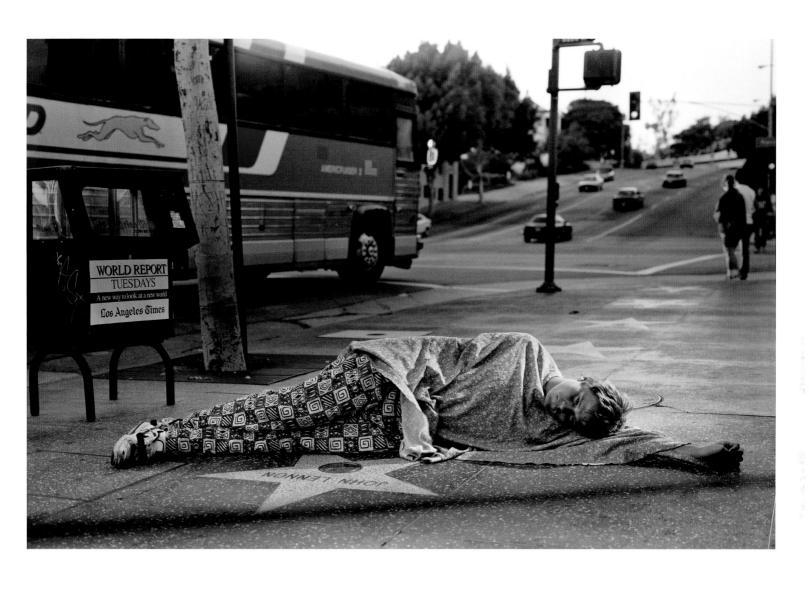

FIG. 95. Philip-Lorca diCorcia, *Major Tom; Kansas City, Kansas; $20*, 1990–92.

FIG. 96. Samuel R. Delany, *Times Square Red*, *Times Square Blue* (New York: New York University Press, 1999), cover. Photograph by Philip-Lorca diCorcia.

of these images: "In *Times Square Red*, *Times Square Blue*, Samuel Delany considers how entire episodes of sexual history are legible in the architectural and political fate of neighborhoods."[91] Simpson not only overlooked (or was unaware of) the earlier publication of diCorcia's photographs in "X-X-X Marks the Spot," but he mistakenly, if tellingly, cited *New York* (see fig. 78) as an example of the photographs diCorcia made for Delany. That image, however, appears in neither Delany's article nor his book. Simpson's miscategorization exemplifies how faint the separation is between diCorcia's *Streetwork* series and his photographs for Delany. I suggest a more forceful position regarding diCorcia's Times Square photographs, for both *Streetwork* and Delany: in those pictures, diCorcia visually recorded the reality that united sex, architecture, and urban change at a specific moment in Times Square's history. This chapter's close examination of diCorcia's choice of Times Square as both a location and a subject for his *Streetwork* and *Heads* projects makes that very argument.

As a final point, I am obliged to take account of Times Square on and after September 11, 2001, for three reasons: first, the square was and remains an icon of New York City; second, by 2001 the district's revitalization had arguably been completed; and, finally, the events of September 11 inadvertently but indelibly shaped the viewing of *Heads*, which diCorcia completed that year. In 2001, when the terrorist attacks of September 11 forever changed the history of Manhattan, Times Square once again functioned as a social nexus, a specific urban location by which one could gauge the city's—if not the nation's—priorities in the aftermath of the tragedy.[92]

In a *New York Post* article one month after the attacks, a Times Square street patrol cop described the district's revitalization in language that, except for its particular contemporary references, profoundly echoed that of the mid- and late 1990s: "[Hope] was in the cafés that used to be crime scenes and it was in the family from Wisconsin that brought their kids here to see *The Lion King*. Most of all it was in the New Yorkers, who had rallied together to reclaim a piece of stolen turf, and now came in droves to show the world they weren't about to hand it back to anyone, terrorists included. . . . Tough times are surely ahead, but all I need to do is walk down Broadway to know we're going to make it. New York City and Times Square: open for business, better and brighter than ever. Start spreadin' the news."[93] Business in Times Square had been hurt by the attacks, yet the municipal and state assistance offered to the district was in keeping with the square's iconic and historic

representation in the minds of New Yorkers and Americans. For example, New York City purchased fifty thousand tickets to Broadway theater productions at a cost of $2.5 million, while the state implemented a $1 million Broadway advertising campaign. A spokesperson for Broadway's theaters explained the logic behind the cash infusion: "As long as Broadway's stages were dark, the city itself would look dark to all the world."[94] Times Square's ability to bounce back to life (and light) became synonymous with the whole city's ability to recover. Mayor Giuliani made an even grander equation to a CNN reporter on New Year's Eve 2001: "Times Square is not just the city's celebration, it's the world's celebration."[95] As had been the case with the rhetoric surrounding early efforts to rid the square of crime and violence, Giuliani's statement emphasized Times Square's role as a symbol of New York: for New York, for the nation, and for the world.

By 2001 the revitalization of Times Square was largely complete, transforming the real experiences and imagined fantasies of that urban space. The intersection of Broadway and 42nd Street now housed corporate offices for Disney, Viacom, Reuters, and Condé Nast. In November the global giant of children's retail, Toys "R" Us, opened its flagship store, replete with magicians, music, videos, and a sixty-foot-tall Ferris wheel, whose spokes, predictably, were outlined in neon so as to be visible to passersby on the sidewalks outside the flagship's requisite transparent facade. To many at the time, Times Square seemed transformed into a corporate and marketing-driven simulacrum of its historical identity (albeit a sanitized, family-friendly rendering of that identity). This outlook, however, makes claims about a singular reality of Times Square that does not sit well with its complicated past as a place with multiple meanings (to say nothing of its comparison to other global hubs of advertising, commerce, and entertainment). Traub considered the question of the square as a simulation of itself in the early years of a new millennium:

> To say that Times Square has a "virtual" dimension is to say nothing more
> than that it is known through representations of itself as well as through direct
> experience and that, of course, has been true since people started sending
> postcards of the place. . . . But the production of images of itself is much more
> central to the new Times Square than it was to the old. When "the media"
> meant signs, songs, popular magazines and movies, one could say that the media
> played a central role in transmitting the life of Times Square to the world. But
> the media are now inextricable from that life. . . . What makes Times Square so
> powerful a place, at least in the calculation of global marketers, is that it is so
> intensely *there*—so dense with people, lights, buildings, history, emotion—while
> it is also one of the central nodes of the worldwide media network. It is Times
> Square's actuality that makes its virtuality possible.[96]

FIG. 97. Philip-Lorca diCorcia, *Heads* #20, 1999–2001.

Or, as historian William R. Taylor made clear in his introduction to the anthology *Inventing Times Square*, the square's image has always been contrived and determined.[97] Such historical awareness bears fruitfully upon this chapter's contextualized account of diCorcia's Times Square photographs, particularly the way the *Heads* series was viewed following its debut just days prior to September 11, 2001.

HOW *STREETWORK* AND *HEADS* APPEARED

In order to present his photographs either in book or exhibition form, diCorcia first reduces the number of his negatives under consideration. Drawing a parallel to how certain subjects are "picked out by the light" in his street photographs, he has said that "photography is an editing process. I don't think I go out looking for things and people who look alienated. I'm not trying to make that point. Perhaps in editing them they wind up that way."[98] Both projects were shaped by a mode of editing that has long been linked with the spontaneous handheld camera, the continual release of the shutter, and the totally unplanned urban scene. Although diCorcia employed only the second of these at times during the taking of *Heads*, his editing yielded not a single, stand-alone image but a definitive group of images. *Streetwork* and *Heads*

FIG. 98. Philip-Lorca diCorcia, *Heads* #20 (detail), 1999–2001.

both function as groups and, as such, the repetition of formal constraints among the component images of the group actually heightens the differences within each series. Most obviously, a *Streetwork* photograph made in Europe stands in contrast to the relative newness of one made in New York City, which highlights Times Square's very particular and unashamed embrace of commercialism and consumerism. More subtle differences arise in the *Heads* series, as demonstrated by comparing one subject's sunglasses (see fig. 79) and another's glasses (fig. 97). The latter image reveals the reflection of a pedestrian wearing a backpack and moving ahead of the main subject in the crowd (fig. 98).

In *Streetwork* diCorcia's embrace of an idea of street photographs as partly reliant on chance necessitated a more exacting mode of editing in order to attenuate the differences between images and to foreclose dull repetition among them. This explains, in part, the logistical appeal for diCorcia of crowded urban cities, including New York, for the project: the more populated the visual field before his camera, the more potential for capturing someone in an interesting moment or with a compelling expression. In an interview he described walking around "waiting for things to happen."[99] DiCorcia selects subjects who, within the chosen setting, represent the experience of the urban street generally and of a specific

street within Manhattan more particularly. These subjects from *Streetwork* continue to people diCorcia's photographs in the *Heads* series. In fact, the selection has attracted much commentary, since it seems to be a representative sampling of individuals within contemporary American society. Many critics found it difficult to write about the images in *Heads* without recourse to a laundry list of how the subjects indicate generic sociological categories: "[There is] an elderly bearded rabbi whose eyes are heavy with age; an amazingly clear-featured young woman who could easily be on her way to try out as a model . . . ; a grim-faced heavyset mailman; a bald middle-aged man whose dark glasses give him the inscrutable air of a Secret Service agent, and so on."[100] Such types (or archetypes, as some argued) became the emphasis of diCorcia's particular editing process with this body of work.[101] His months of shooting yielded more than four thousand negatives, and he edited these down to a final group of seventeen images.

DiCorcia recently published and exhibited a number of these "rejected" images, which underscores his claim that "the people themselves were not that interesting when you finally took their photographs, and then finding variety within that redundancy was difficult. (I could find a million pictures of people with dramatic lighting, but they all tended to look the same.)"[102] It was something that could not be discerned in the moment of the shutter's release, though of course selection was at work in that moment as well. Instead it required the later scrutiny of expressions (purpose, exhaustion, contemplation), dress (uniform, sportswear, suit), postures (self-contained, exposed, huddled), and miscellany (water bottle, gold crucifix pendant, map). This social range is shared by both *Streetwork* and *Heads* and results only in part from the diversity of subjects that most city streets provide. The social variety also represents and is specific to Times Square. Both projects present their viewers with a melee of strangers during the forced cohabitation of urban space, the intimacies of the social space of sidewalks. *Streetwork*'s edit depicts the down-and-out, businessmen, street performers, and tourists in that space. *Heads* kept the businessmen and tourists but replaced the down-and-out and the street performers with stylish youth, all seemingly and notably unaccompanied by adults. The strong presence of youth in *Heads*—they appear in five of the series' seventeen images—marks Times Square's transformation into the clean, safe, acceptable, family- and consumer-oriented space envisioned by the 42nd Street Development Project. This demographic shift matters as much as the democratic laundry list of types in either project, for it locates these pictures resolutely and exclusively in the Times Square of 1993 to 2001.

Although the results of diCorcia's editing can be noted in the widely distributed publications that both *Streetwork* and *Heads* enjoyed at the time of their debut, the differences within each series come to bear most forcefully in the moment of public display, when viewers can engage in the works' physical presentation. In the case of

Streetwork, portions were first shown in New York and in various European venues, and a full complement of images debuted in New York at PaceWildenstein/MacGill Gallery from November 18, 1998, to January 16, 1999.[103] These twenty-odd photographs, each printed to approximately 26 by 38 inches in size, depict a range of international metropolises.[104] Of the five shot in New York City, four were made in the vicinity of Times Square, and three unmistakably feature the square's theaters, advertisements, and pedestrians (see figs. 78, 86, and 87). This accounting matters not just because of the numerical privilege enjoyed by New York City–based *Streetwork*s (four are London-based, three are Paris-based, and so on, but no other city appears five times), but also because of the international audience for the project. Encountering five images entitled *New York*, European viewers were thus encouraged to see the city—and Times Square—as representative of America, just as Paris represented France.[105] Thus, diCorcia's *Streetwork* reinforces the popular equation of Times Square as the iconic American urban experience.

Heads debuted at Gagosian Gallery in London from May 2 to June 14, 2001. Printed from digital scans of medium-format negatives, the photographs measure four by five feet. Although some have called the figures in these prints "almost life-size," the subjects' heads appear at nearly twice the average size of a viewer's head.[106] The numbers included in each of the seventeen photographs' titles are neither continuous (e.g., *Heads* #20 in a series of seventeen photographs) nor do they reference the order of the images in their display or publication (e.g., *Heads* #01 is not the first photograph of the installations or catalogue). This titling and presentation reinforces diCorcia's assertion that "there's a dynamic among the pictures . . . [I] don't want them to be redundant, or able to be interchanged."[107] Following their display in London, the photographs opened PaceWildenstein's new Chelsea gallery in September 2001, and both the accompanying catalogue and critical reviews referred directly to the experience of standing before these images. Luc Sante, in his catalogue essay, remarked how the scale and presentation of the prints provided "the viewer with an opportunity for close inspection."[108] The isolated, chest-up view of the subjects in *Heads* mirrors what is visible to pedestrians on crowded urban sidewalks, where no full-figure, head-to-toe appraisal is possible because of the density of bodies in a confined space. This effect is at its most heightened in the gallery, where the sense of immediacy and proximity is enhanced by uninhibited looking, but it comes across on the pages of the book as well, mostly due to the shadowy but legible figures that often surround the main subject, pressing and compressing our sense of physical space as we contemplate the image. Observing these photographs, we can inspect and scrutinize diCorcia's selected sampling of passersby in ways that are more private and long-lasting than on the street itself. DiCorcia has said, "If anyone was there they could not see that—I don't even see that [while on site shooting]." Certainly this remark confirms photography's technical

ability to reveal information in the scrutiny of the final prints, but it also reflects the artist's privileging of the beholding of the prints.[109]

DiCorcia's emphasis on the viewer's encounter can be dated to his time at Yale. When contemplating filmmaking, he realized that "the power to affect people always involved some psychological engagement."[110] This kind of engagement seemed absent in the work of the conceptual artists he most admired—Vito Acconci, Robert Cummins, Ed Ruscha, and William Wegman—and often left him feeling that such work was a puzzle or joke. DiCorcia wanted viewers of his works to choose how to read a gesture or expression, just as he had chosen the framing and the illumination. As Galassi points out in diCorcia's first monograph, "the persuasiveness of documentary realism depends upon the viewer's assumptions that the subject is shown as it existed before the photographer came along. If the photographer is perceived to have broken this implied contract by tampering with the subject, the viewer rejects the picture as false."[111] DiCorcia, Galassi suggests, tampers with the subject minimally, so as to encourage the viewer to perceive the photograph as representative of a recognizable reality. For his part, diCorcia fully intends these photographs to prompt engagement and questioning for their viewers. His most forceful articulation of this aim appears in his text for the catalogue *Streetwork 1993–1997*:

> The world is too elusive to pin down in a photograph. The image has to create its own world, hopefully self contained, *an analogue of reality*, not a mirror of it. Issues raised in the images are part of their content. That there should be more questions than answers should surprise no one.
>
> Only the deeply deluded maintain that objective reality can define what is "real." I don't propose my work as an advanced definition of reality. I know as little as anyone about it. If the pictures stimulate interest, it is probably the subliminal recognition of the confusion we all face when confronting "reality." I am only sure that what we see in this world is deceptive, especially in the media. I work on the assumption that nothing is new and nothing is real. That skepticism underlines my strategies as much as the search for any objective truth.[112]

Assuming that the audience of *Streetwork* and *Heads* is largely urban, the emphatic role diCorcia gives the pictures as interpreters of reality can prompt a change in perception. Both Charles Wylie and Kimmelman indicated this possibility in their reviews, claiming that the photographs foster "an uncanny awareness [of the pedestrian subjects] that viewers may have taken with them as they left the gallery and reentered the streets of New York," and that "good art makes you see the world differently, as least for a while, and after seeing Mr. diCorcia's new 'Heads,' for the next few hours you won't pass another person on the street in the same absent way."[113] Engaging viewers in a possibly

ongoing awareness of their own urban experiences has as much to do with the pictures' relationship to reality as it does with their narrative quality. DiCorcia's images suggest fragments or single instances in a larger and longer narrative constructed by the viewer, whom he has called the "narrator" of his photographs.[114] "The more specific the interpretation suggested by a picture," diCorcia has said, "the less happy I am with it."[115]

The absence of a clear narrative pervades *New York* (fig. 99), in which a man—perhaps one of Times Square's dispossessed residents, overly dressed for the season and covered with blankets and scarves—puts forward his panhandler's basket for donations while turning his head and shrouded eyes to the sky. The reason or meaning of this combination of gesture and glance may be made more resonant with or more confounded by the immediate presence of a sidewalk preacher, who seems to be simultaneously addressing every passerby and no one in particular with his microphone. One reviewer of this work articulated the narrative in the following way: "A photograph of a homeless person moving along a crowded sidewalk, begging while wrapped in layers of shawls, powerfully conjures one kind of misery that can be experienced in a big city. The story hinted at in this image is set amid a topography of consumption comprising street signs, traffic lights, and advertising billboards."[116]

The viewer's ability to study diCorcia's pictures at length and in detail is also a surveillance opportunity. In his text for the Citigroup Private Bank Photography Prize 2002 catalogue, Dan Fox wrote of *Heads:* "Why else would one take time to look at these people if one encountered them on the street?—if they were attractive, maybe, or appeared threatening, perhaps. But diCorcia's *Heads* evoke an altogether more layered, ambivalent response, for the main part because they encompass facets of us all as we trail through the city streets, egos at the centre of no-one's attention but our own. The worried brows furrowed across nearly all these faces speak of stressful crosstown journeys—the anxiety to reach home, office, or a familiar face. . . . Uncannily familiar, they attract our curiosity, never our contempt."[117] The viewer's projections in relation to photographic surveillance are particularly relevant, considering that Fox's remarks—and the *Heads* photographs—appeared at a historical moment when surveillance in the United States had been given new import and license.

Kimmelman's initial review of the New York debut of *Heads*, quoted previously, suggests the behavioral application of surveillance after viewing diCorcia's work, which also makes us more aware of the means that produced it. The complete second half of Kimmelman's review reads, "Unaware of the camera, [diCorcia's subjects] are absorbed in thought or gaze absently; they are how we act most of the time, walking down the street, in a crowd, focused on something or nothing. But enlarged and isolated, their expressions become riddles, intensely melodramatic and strangely touching. Mr. diCorcia's pictures remind us, among other things, that we are each our own little universe of secrets, and vulnerable. Good art makes you see the world

FIG. 99. Philip-Lorca diCorcia, *New York*, 1993.

differently, as least for a while, and after seeing Mr. diCorcia's new 'Heads,' for the next few hours you won't pass another person on the street in the same absent way."[118] An understanding of social practices on New York City streets underlies these comments. Anonymously walking the streets of New York has been a part of urban experiences there for at least a century; it is the willful and conscious decision to remain unknown within urban crowds that is both more recent and a cultural imperative. Critic Ian Hunt has elaborated on this collaborative code of manners, reiterating the complicity required by what he terms the "contractuality of the eye" in city life: "A sense of collective safety is reinforced more by routinized avoidance of eye contact than by unexpected greetings and familiarity."[119] This contractuality means that pedestrians only take note in fragmentary ways of other pedestrians sharing urban space with them. The texture of a jacket, the sway of shoulders, or the color of hair on the person just ahead on the sidewalk may be the total visual information available to any pedestrian. Surely, this relates to the speed of movement on city streets, the hurry to leave or arrive somewhere, but it also reflects a collective agreement to barely or seemingly never look at other pedestrians. As diCorcia observes, "The street does not induce people to shed their self-awareness. They seem to withdraw into themselves. They become less aware of their surroundings, seemingly lost within themselves. Their image is the outward facing front belied by the inwardly gazing eyes."[120]

Walking city streets symbolizes both individual isolation and a kind of collective experience, but it is the latter that makes possible urban viewers' projection before diCorcia's street photographs—the *Heads* pictures in particular—whether on the gallery wall or in the catalogue. Viewers see the fragmentary details that would have caught their attention as they participated in the collective censoring of public looking, but they also observe the individual isolation that is part of that same experience of the streets. The darkened background in *Heads* accomplishes a visual isolation of subjects, while reinforcing the sense of a fragmentary view of the urban crowd. The subjects' compositional estrangement ensures and enables viewers' projection onto them, and diCorcia's lighting only furthers this effect. The same is true of his lighting of the key subjects in *Streetwork*, as when the beggar is "picked out" for our more sustained attention and scrutiny. DiCorcia's lighting, then, works against the non-authorial viewpoint. Insofar as his street photographs prompt viewers to scrutinize the passersby pictured yet simultaneously frustrate the eye-to-eye relationship, they are aligned with contemporary photographic surveillance. Indeed, the photographic liberty to make pictures of people without their consent in public spaces is the same one that allows for the monitoring of public passages with surveillance cameras or closed-circuit television.

DiCorcia encountered this ambiguity directly when the subject of *Heads #13*, Erno Nussenzweig, sued him for violation of privacy. A Hasidic follower, Nussenzweig

FIG. 100. Philip-Lorca diCorcia, *Heads #13*, 1999–2001.

argued that the resulting photograph "compromised his orthodox faith's prohibition against 'graven images'" (fig. 100).[121] This charge questioned the First Amendment's extension of the freedom of expression and freedom from consent laws into public spaces. As Bennett Simpson recently recounted, "After a lengthy trial in the New York State Supreme Court, the verdict sided with the defendant, affirming the protection street photographers have enjoyed since the birth of their medium. . . . The public realm would remain free ground for artists. This said, the landmark case raises numerous issues about the commerce of images that will undoubtedly persist as public space is increasingly surveilled."[122] Over a decade ago, the curators of the 1997 Whitney Biennial identified surveillance as a unifying preoccupation among many of the artists, including diCorcia, who had six *Streetwork* photographs on view. DiCorcia and other artists dealt less with the politics of surveillance than with "how you actually experience the process of observing."[123] Of course, the process of observing—as well as the permanent visibility to which it responds—informs what Geoffrey Batchen has called "surveillance-type images." Importantly, Batchen's writings on these photographers emphasize the role of the viewer's gaze in relation to that of the subject and to that of the photographer. At their best, such photographs can "function as alternately surveillance and *about* surveillance" in the moment of viewing.[124] After all, surveillance always and already implies a viewer, a viewer who will use the images gathered in some way. Neither the viewer-as-a-given nature of surveillance nor its prevalence in daily metropolitan life is new or specific to New York City.[125] But the surveillance diCorcia's photographs enable occurs off the street, lingering over the subjects in detail while standing in an art gallery or looking through a book; on the street, the same visual contracts apply.

Like so many street photographs, diCorcia's pictures respond to this urban dynamic when they are encountered by viewers, but they also respond to his viewers' familiarity with the particular location in which they were made. Times Square encompasses certain opposing qualities: it is at once real and imagined, it is a public site that can be inhabited privately, it can be experienced individually and collectively, and its specificity has, in recent years, come to coexist with a generic urbanness most associated with globalism. With foundations in fantasy and spectacle, Times Square has always reflected the dreams and desires of many—one could say it has been a simulacrum of those dreams and desires—and this continues to inform representations of it today. DiCorcia's photographs in particular reflect the square's commingling of history, spectacle, desire, reality, and experience. "While observing that people in public often hide their true character, DiCorcia also began wondering whether something similar was happening to New York itself. 'I couldn't help but think of Giuliani and what he did to New York, the ethos that he established here,' he says. 'The booming '80s were lurid, but there was still a sense of New York as a unique place in the

U.S. Now, the city is a symbol and a real concentration of capitalist, globalized, mass culture. In some way, the people existing in Times Square seemed a reflection of that to me.'"[126] This passage indicates diCorcia's ongoing awareness of Times Square, from its rundown character in the 1980s to Giuliani's revitalization program of the 1990s to its diminished specificity at the beginning of the twenty-first century. I contend that *Streetwork* negotiates the transition between the first two of these moments and *Heads* the transition between the latter two, with each project harkening forward or backward to the other.

Streetwork relies on details of architecture, sidewalk commercialism, advertisements, billboards, and traffic to signify New York City, to make it legible as the location of the photographs. Those photographs record Times Square's long-standing association with sex and desire, as well as the commerce of the square's "newly scrubbed face."[127] DiCorcia rendered this crucial coexistence, as it played out socially and architecturally. Socially, for example, *New York* reinforces the myriad people sharing Times Square's sidewalks—the beggar, the businessman, the preacher (see fig. 99). Architecturally, the series revels in the juxtaposition of theater marquees and brightly shuttered storefronts of the early to mid-1990s (see fig. 78); it captures the late 1990s cacophony of construction scaffolding that physically made possible the new requisite reflective and illuminated glass facades of a "revitalized" Times Square while also serving as yet another site for advertisements aimed at consumer desire (see fig. 86). Simpson has noted that diCorcia's settings are "loaded," "especially those he knows best such as Times Square or Hollywood."[128] To be sure, the sexual desire inherent to Times Square is not as declarative a marker of this project as it is for *Hustlers*, but the aim of this chapter has been to argue that this desire becomes legible once the specific history of Times Square has been considered. Even the repression of that desire following the square's revitalization can be located in *Heads*.

The metropolitan details of Times Square, so copious in *Streetwork*, have not entirely disappeared in the dark backgrounds of *Heads*, a point made more evident and legible by certain Polaroids recently published in diCorcia's book *Thousand*. In the picture reproduced on page 584 of that publication, for example, one of New York's signature yellow taxicabs passes behind a tangle of pedestrians (fig. 101). Even without the taxi, the tangle of pedestrians—though more varied in orientation than appears in *Heads*—is the element that enables viewers to read the site of the city. The proximity of subjects' bodies implies the density of dozens of fellow pedestrians that we, as viewers, cannot see; their presence in this social space is visually mapped by others (see figs. 79, 88, and 97). Skyscrapers and traffic are also implied, even in the blurred and darkened details of the backgrounds: in *Heads #13*, there is the unmistakable red glow of a traffic light (see fig. 100); and there remains the suggestion in form and color of a passing taxicab in several of the photographs (see fig. 88). Still, reducing

FIG. 101. Philip-Lorca diCorcia, *Untitled*, c. 1999–2001.

the city to such amorphous elements enabled diCorcia to present the square's pedestrians as reflections of this concentrated urban center of consumerist and globalized mass culture. *Streetwork* seems to have anticipated the more generic, less detailed metropolis of *Heads*, particularly if one considers an image made at the end of *Streetwork: New York* (see fig. 86). Here the urban environment matches the mandates of the 42nd Street Development Project: transparent-seeming buildings constructed of glass, bright electric illumination, and advertising as facade. Notably, the pedestrians in these recently mandated surroundings—the black man and two white women at the left edge of the composition, the man on crutches in the center, and the man whose profile is barely visible at the photograph's right edge—all look straight ahead. Their gazes are directed at the cacophony of signs before them (and us) or to the masses of people, like them, filling the streets of Times Square, appearing in jumbled proximity on this particular street corner.

By the 2001 debut of *Heads* in New York, the encroaching genericism of the city's streets was a burning topic of discussion, especially in relation to Times Square.[129] Writing the introduction to his history of the square just a few years later, Traub summarizes: "To its many critics, Times Square isn't a place, but a simulacrum of a place, an ingenious marketing device fostered by global entertainment firms . . .

[and] the symbol of the hollowing out of urban life, the decay of the particular in the merciless glare of globalization."[130] The timeliness of this sentiment resonated with diCorcia's *Heads*, and reviewers took note, especially those writing in foreign art periodicals for an overseas audience contemplating photographs made in one of the most iconic urban sites in the United States. For example, Italian curator Ilaria Bonacossa identified New York City as "*the* symbol of global capitalism" and Times Square as "the fulcrum of American-style spectacle culture."[131] Given that diCorcia earned a living partly through his commercial photography, he was well positioned to observe the characteristics of a society now inseparable from its consumerism, which will always be at its most concentrated and most visible in urban centers. There individuals find themselves amid swirls of advertisements, signs, and pictures intended to fuel consumer desire. Susan Buck-Morss has described this experience: "Images enter the psyche of the individual, but they are collectively perceived by the mass of passers-by. They 'speak' to those passing, and, in the inverted world of capitalism where things are related but people are not, they become the means through which the isolation of both individuals and generations is overcome."[132] Redirecting Buck-Morss's notion to the art world, where photographs are merely another "thing" through which isolation can be "overcome," it becomes possible to better contextualize the viewing of diCorcia's *Heads* in the aftermath of September 11.

In addition to being displayed at PaceWildenstein and being reproduced in numerous art periodicals during and after September 2001, no single *Heads* photograph likely experienced a larger viewing audience than when MoMA opened its exhibition *Life of the City* on February 28, 2002. *Heads #10* (fig. 102) was among the 156 photographs included in the exhibition, which was intended as "both a tribute to New York City and an exploration of photography's role in shaping a community."[133] The photographs were the most official and traditional component to what was effectively a three-part exhibition. The second part involved a changing display of anonymous tacked-up snapshots of New York, the results of an open call for submissions that would express individual relationships to the city. For the third and final part of the exhibition, MoMA collaborated with *Here Is New York: A Democracy of Photographs*, displaying a digital slide show of September 11 images on two monitors. MoMA saw *Here Is New York*'s accomplishment as an opportunity for New Yorkers to "come together in a time of distress."[134]

DiCorcia's *Heads #10*, joined by one of his early photographs as well as one of the few New York images from *Streetwork* not taken near Times Square, hung in that exhibition, surrounded by the photographers and photographs that informed it: Evans's *Girl on Fulton Street* (see fig. 80), Harry Callahan photographs, and other historical views of Times Square. The *New York Times* review of *Life of the City* concluded by posing a crucial question: "This is the new New York, the mourning,

FIG. 102. Philip-Lorca diCorcia, *Heads #10*, 1999–2001.

bewildered city, that people are getting to know. But how does it relate to old New York, the city that was before the city was attacked?"[135]

One answer to this question, the very premise of this book, proposes each street photograph as a visual nexus of the specific location of its making, the historical context of its moment, and its ongoing appearance to viewers. Thus, just as Times Square and New York City are of inescapable importance to diCorcia's *Heads*, so too is September 11, because of its effect on the images' reading, regardless of and in addition to diCorcia's original intentions.[136] For most street photographers' work, of course, the realization that historicization and viewing context are related has not come until long after the work's making. DiCorcia's *Heads* took far less than three decades to "become historical" and lay claim to 2001. Just one week after Kimmelman's September 14 review of the exhibition at PaceWildenstein, an editorial decision excluded a key phrase from the compressed text appearing on September 21. DiCorcia's photographs were still "reminders that we are each our own little universe of secrets," but no longer "reminders that we are each our own little universe of secrets, *and vulnerable.*"[137] Other reviewers tackled the appearance of the pictures more directly. In *Flash Art* that November, Bonacossa concluded: "Seeing this exhibition for the second time after the tragic events of September 11, I was struck by how these characters took on a more dramatic aura. Each Head seemed a testimony of the depth of sorrow shared by every individual, whatever her/his race or background in a deeply wounded city."[138] And so, revisiting the *New York Times* question about *Life of the City*, diCorcia's *Heads*—as street photographs specific to Times Square and the social space of its streets—have come to embody the relationship "between the new New York, the mourning, bewildered city" and the "old New York, the city that was before the city was attacked."

Given the extent to which New York City is understood as exemplary of American cities—and Times Square as the most iconic of American public squares—there is little surprise that a September 11 effect would affect all representations of that city and its square. Times Square is a place rife with symbolism and history—of its centrality to the city's identity, of its marriage of spectacle and consumerism, of its fulfillment of social (including sexual) desires, of its collective experience based on those individual desires, of its revitalization, and of its status as an indicator of the increasing presence of isolation, surveillance, and global genericism in American urban life. As Traub has written, today's "Times Square is every bit as true to its moment as the place was forty, sixty, eighty years ago—that whatever else it is, it's inevitable. . . . This place, too, is provisional and transitory. The last word on Times Square will never be written."[139] Times Square is ever changing, and much like diCorcia's "analogues of reality," the location prompts as many questions as it does answers.

For this reason, once the specifics of Times Square from 1993 to 2001 as the location of diCorcia's images—whether from *Streetwork* or *Heads*—have been

considered, the viewer confronts street photographs that unite the social and architectural dynamics of urban change that is Times Square. DiCorcia's purposeful engagement of the viewer relies on the calculation deployed in the making of his photographs as much as his final presentation of them. Both process and presentation rely on the conventions of realism, chance, and speed in order to transform the urban street's appearance in general and the commercial spectacle of Times Square in particular. DiCorcia's *Streetwork* and *Heads* photographs, made in that specific location, depict the street as a social space in transformation. They are analogues of Times Square's particular reality, and the issues of that location are a part of their content that should not be overlooked by their easy incorporation into the history of familiar street photography. DiCorcia's photographs posit that the best photographic representation of the experience of city streets may well be a framing of reality or a construction modeled after reality. The city streets are recognizable to us, primed to receive our projections, precisely because of what the photographer has done to frame or construct them for us in ways analogous to—not mirrors of—our experience of them.

AFTERWORD

When I set out to write this book, I wanted to kick-start a change in the conversation surrounding street photography by considering the street equally as site and subject. To my surprise, the very text that first named "street photography" over one hundred years ago proposes a category of street photographs that represents the specifics of the streets depicted. Osborne Yellott's article also embraces the photographs' appearance before viewers. Building on Yellott's proposition, this book has maintained that street photographs must be considered engagements with particular urban sites as cultural, political, economic, and social environments. Adequately representing the complex experiences of urban streets thus also involves addressing issues of gender, commerce, race, collectivity, class, dispossession, sexuality, and spectacle. This culturally and historically grounded approach to streets and their photographic representation has broad implications.

An expanded approach, one variously obliged to photo history, art history, sociology, literary studies, and urban studies, does not foreclose visual analysis of photographs, attention to the process of their making on the streets, or the response of the photographer to the specifics of the street. This approach also allows for a consideration of how these photographs first appeared to their viewers and the implication of those viewers in a certain kind of response, thereby recognizing that the manner in which a photograph is disseminated and received is a crucial factor in its public significance. At its best, this mode of inquiry emulates the complex interaction of place, object, and subject that constitutes "the street" as an urban experience.

The case studies in this book demonstrate the possibility that this approach can grapple with concerns both aesthetic and ideological. Avedon's photographs for *Harper's Bazaar* used the streets of Paris to achieve a better-than-real effect as part of a postwar effort to revitalize that city through commerce. Moore's Birmingham demonstration photographs attempted to implicate the viewer in this conflict and, as such, provided political momentum to the civil rights movement. Despite Rosler's activist and documentary-oriented rhetoric, her photo-text Bowery project functions as a critique of street photography and that genre's institutional canonization. DiCorcia's street photographs adopt the visual language of theatrical spectacle within the ever-gentrifying Times Square, an iconic American public space made retrospectively even more so following September 11.

Taken together, these street photographs span 1947 to 2001, a period in which postwar American cities underwent significant, often identity-shaping changes. The selected photographers intentionally include two who have been fully excluded from the existing street photography discourse (Avedon and Moore), one who has only recently been considered a maker of "street art" (Rosler), and one whose work was

enshrined among the canon even before the series considered in this book had been created (diCorcia). Their street photographs embody and convey a gendered consumption of the street (Avedon), a politics of demonstrations that take place on streets (Moore), an economic dispossession of a population living on the streets (Rosler), and a socially and sexually charged spectacle of streets (diCorcia). In short, Avedon, Moore, Rosler, and diCorcia each represent an important shift in the postwar history of street photographs, precisely because they have each addressed the street as a charged nexus of specific place, viewed object, and viewing subject. These four artists consider aspects of city streets so "unfamiliar" to the existing literature that I came to understand that they must necessarily change the very approach of their historical analysis. For some readers, the effort to historically situate these street photographs may seem a burden, perhaps even an unnecessary one. For others, I hope, the need for such contextualization will be clear. It is a challenge to undertake a historical analysis that attempts to match the complex series of forces that produced these street photographs. I hope this book's approach may also serve as a model, prompting future audiences and scholars to examine other kinds of photographic production in this fashion.

The photographs this book considers—as much as the approach it advocates, grounded in the historical particulars of the locations in which these street photographs were made—date to the brink of a new century. Increasingly globalized cities call into question the continued viability of the environmental and historical specificity posited by this book. Indeed, it is possible at this moment to imagine how photographs made during the coming fifty-odd years might render some streets in Paris indistinguishable from those in Birmingham, or New York's Bowery as homogenous with Times Square. Chronologically, this book also comes to a close on the cusp of an ever more digitized mode of making and sharing all photographs, to say nothing of the ease that digital technologies have brought to moving lens–based images. Do digital urban surveillance projects such as the Surveillance Camera Project of the New York Civil Liberties Union (1998–present) or works that have mourned the loss of a more historical urban experience, such as Zoe Leonard's *Analogue* (1999–2006), function as street photographs in the ways discussed here? What happens if the mode of historical analysis advocated in this book is applied to such projects?

Although this book has begun to chart a path for such inquiries, it is my intention and aspiration that it will serve as a generative model to others who aim to expand the conversation surrounding street photographs. Postwar American street photographs are every bit as true to the moment of their making as were street photographs from forty, sixty, or eighty years ago. The specific character of the streets—and of the photographs made on those streets—is provisional and transitory, open for continual reinterpretation by viewers. It is in the nature of urban streets both to be changed by and to change those who use and animate them. The last word on street photographs will never be written.

NOTES

INTRODUCTION

1. Although there are numerous articles from the turn of the twentieth century addressing the street as a site for making pictures, I have chosen to focus on the most sustained and extensive of these: Osborne I. Yellott, "Street Photography," *Photo-Miniature: A Magazine of Photographic Information* 2, no. 14 (May 1900): 49–88. Yellott concluded his article: "The use of the camera in the streets is a subject about which it would be easy to write a good-sized book. . . . There are no books published dealing exclusively with street photography, but the following contain useful information on the subject." Ibid., 88. Still, given the sheer quantity of periodicals devoted to popular photography in the late nineteenth century, it is possible that an earlier deployment of the term "street photography" awaits discovery. For late nineteenth-century articles and books that specifically address city streets, see John Thomson and Adolphe Smith, *Victorian London Street Life in Historic Photographs* (1877; repr., New York: Dover Publications, 1994); H. H. Williams, "Shooting in the Streets," *International Annual of Anthony's Photographic Bulletin and American Process* (New York: E. and H. T. Anthony, 1889), 281–82; and Alexander Black, *Photography Indoors and Out: A Book for Amateurs* (Boston: Houghton Mifflin/Cambridge, MA: Riverside Press, 1891). Although I discuss the earliest mention of the term "street photography," this book is not concerned with identifying the first street photograph or its origins in Paris or London. For such discussions, see Filippo Maggia, "Instant City," in *Instant City: Fotografia e metropoli* (Prato, Italy: Centro per l'Arte Contemporanea Luigi Pecci/Milan: Baldini and Castoldi, 2001), 22; and Carol Squiers, "The Stranger," in *Strangers: The First ICP Triennial of Photography and Video* (New York: International Center of Photography/ Göttingen, Germany: Steidl, 2003), 12.

2. Yellott, "Street Photography," 50.

3. Ibid., 50–51. Yellott offered an Alfred Stieglitz photograph—*Wet Day on the Boulevard*—as exemplary of the second category of street photography, since it left uncertain whether the city was New York, Paris, or Moscow. Stieglitz offered what may be the earliest tethering of photographs made in the street (though he did not use the term "street photography") to speed, spontaneity, and chance in his 1896 treatise, "The Hand Camera—Its Present Importance," in *The American Annual of Photography and Photographic Times Almanac for 1897*, ed. Walter E. Woodbury (New York: Scovill and Adams, 1896), 19–27. He reproduced *Winter— Fifth Avenue* in this article. For an illuminating interpretation of this particular photograph, see Christopher Mulvey and John Simons, "Citytext: A Theoretical Introduction," in *New York: City as Text* (London: Macmillan, 1990), 1–27, which gives substantial consideration to the specifics of locality.

4. There is only one published history of street photography covering the nineteenth century forward: Colin Westerbeck and Joel Meyerowitz, *Bystander: A History of Street Photography* (1994; rev. ed., Boston: Little, Brown, 2001). Other major accounts focus on the postwar era: Kerry Brougher and Russell Ferguson, *Open City: Street Photographs since 1950* (Oxford: Museum of Modern Art/ Ostfildern-Ruit, Germany: Hatje Cantz/New York: Distributed Art Publishers, 2001); and Lydia Yee and Whitney Rugg, eds., *Street Art, Street Life* (New York: Aperture, 2008).

5. Henri Cartier-Bresson, *The Decisive Moment: Photography by Henri Cartier-Bresson* (New York: Simon and Schuster, 1952). The term "decisive moment" is the accepted, albeit loose, translation of the title of the original French edition, *Images à la sauvette* (Paris: Verve, 1952). Major monographs on Winogrand include John Szarkowski, *Winogrand: Figments from the Real World* (New York: Museum of Modern Art, 1988); Garry Winogrand, *The Man in the Crowd: The Uneasy Streets of Garry Winogrand* (San Francisco: Fraenkel Gallery, in association with Distributed Art Publishers, 1999); and Garry Winogrand, *Garry Winogrand: El juego de la fotografía* [The game of photography] (Madrid: T. F. Editores, 2001).

6. Although there are exceptions, such as Helen Levitt, there is an overwhelming dominance of male photographers in the discourse on the genre. No texts have substantially addressed the role of gender in the practice of street photography, though a recent essay by Abigail Solomon-Godeau has made a similar point, emphasizing the "masculine" or "appropriative or aggressive attributes of this kind of photographic practice." Abigail Solomon-Godeau, "Harry Callahan, Street Photography, and the Alienating City," in *Harry Callahan: Variations on a Theme, The Archive*, no. 35 (Tucson: Center for Creative Photography, University of Arizona, 2007), 27.

7. Art history has a long tradition of city views, from detailed Dutch *vedute* prints to Hogarth's narrative scenes, from Currier and Ives popular illustrations to Ashcan school paintings. This book is concerned, as Yellott was in his text, in exploring the specifically photographic distinctions of street imagery captured by cameras.

8. To be clear, this shift can and does encompass city-based "architectural photography" and "urban photography," a term I deploy strategically in the chapter on Martha Rosler. For more on these two categories— though without reference to "street photography"—see Benjamin H. D. Buchloh, "Thomas Struth's Archive," in *Thomas Struth: Photographs* (Chicago: Renaissance Society at the University of Chicago, 1990), 5.

9. See Rosalyn Deutsche, "Alternative Space," in *If You Lived Here . . . The City in Art, Theory, and Social Activism*, DIA Art Foundation, Discussions in Contemporary Culture 6, ed. Brian Wallis (Seattle: Bay Press, 1991), 47, 58.

10. Solomon-Godeau made a similar demand of street photography in her 2007 article addressing the street photographs of Harry Callahan. She writes that "[we must] acknowledge those variously sociological, political, ideological, or even artistic motivations that contributed to their production. And once we have acknowledged that, the concept of street photography as a discrete genre is already destabilized." Solomon-Godeau, "Harry Callahan," 23. Her main emphasis, however, remains street photography's consistent representation of anonymous unaware individuals without their consent.

11. This approach allows for a range of photographic practices from seemingly straightforward documentation to fully constructed representations—all of which have the possibility of resonating with reality and experience. Such a possibility has been foreclosed in the existing discourse surrounding street photography. For helping me to articulate this position, I acknowledge Peter Bacon Hales's *Silver Cities: The Photography of American Urbanization, 1839–1915* (Philadelphia: Temple University Press, 1984).

12. See Westerbeck and Meyerowitz, *Bystander*, 34; and John Williams, "Double-take on Street Photography," *Photofile* [Sydney] (Winter 1983): 1, 5–6. My thanks to Geoffrey Batchen for bringing the latter to my attention.

13. Among the earliest such sources are Charles Baudelaire's writings on the *flâneur*, the quintessential and storied observer of city streets introduced in mid-nineteenth-century Paris. See Charles Baudelaire, "The Painter of Modern Life," in *The Painter of Modern Life and Other Essays*, trans. and ed. Jonathan Mayne (1863; repr., New York: Da Capo, 1986), 1–40. Philosopher and literary critic Walter Benjamin expanded on Baudelaire's *flâneur*, taking on the city as a source of observation. Crucial for this book, Benjamin's writings elucidate the experience of city streets as a collective one, informing my thesis that street photographs may well respond to and interact with such an experience. See "On Some Motifs in Baudelaire," "Paris, the Capital of the Nineteenth Century," and "The Paris of the Second Empire in Baudelaire," all in Walter Benjamin, *The Writer of Modern Life: Essays on Baudelaire*, ed. Michael W. Jennings (Cambridge, MA: Harvard University Press, 2006), 27–133; Walter Benjamin, "One Way Street" (1931), in *One-Way Street and Other Writings* (New York: Penguin, 2009), 46–115; Walter Benjamin, "Konvolut J: Baudelaire" in *The Arcades Project*, trans. Howard Eiland and Kevin McLaughlin (Cambridge, MA: Belknap Press of Harvard University Press, 2002), 228–387; Susan Buck-Morss, *The Dialectics of Seeing: Walter Benjamin and the Arcade Project* (Cambridge, MA: MIT Press, 1991); Graeme Gilloch, *Myth and Metropolis: Walter Benjamin and the City* (Cambridge: Polity Press, 1996); and Eduardo Cadava, *Words of Light: Theses on the Photography of History* (Princeton, NJ: Princeton University Press, 1997). Henri Lefebvre and Michel de Certeau are exemplary of efforts to arrive at a sociological understanding of the everyday urban experience. Such sociological examinations of urban experience represent a theoretical grappling with how cities are shaped as sites of consumer desire, political demonstration, economic dispossession, and social spectacle. See Michel de Certeau, *The Practice of Everyday Life* (Berkeley: University of California Press, 1984); Henri Lefebvre, *Critique of Everyday Life*, trans. John Moore (London: Verso, 1991); Henri Lefebvre, *The Production of Space*, trans. Donald Nicholson-Smith (Oxford: Blackwell, 1991); and Henri Lefebvre, *Everyday Life in the Modern World*, trans. Sacha Rabinovitch (New Brunswick, NJ: Transaction Books, 1984). One of the most popular, influential efforts to chronicle the interaction of people and city streets is Jane Jacobs's 1961 publication, *The Death and Life of Great American Cities*. This study affirmed urban density above all else in its research on everyday observations and occurrences in New York City, Philadelphia, Boston, San Francisco, St. Louis, and Washington, DC. Thus the workings of urban sidewalks revealed much about pedestrian contact, public safety, economic prosperity, and even (or especially, given the publication date) racial tolerance. Jane Jacobs, *The Death and Life of Great American Cities* (New York: Random House, 1961). See also David Frisby, "Straight or Crooked Streets? The Contested Rational Spirit of the Modern Metropolis," in *Modernism and the Spirit of the City*, ed. Ian Boyd Whyte (London: Routledge, 2003).

14. Deutsche categorized them as follows: "the city as subject matter for art; public art or art works in the city; the city itself as a work of art; and the urban environment as an influence exercised over the emotional or perceptual 'experience' of artists, an experience, in turn, 'expressed' or 'reflected' in works of art." Deutsche, "Alternative Space," 46.

15. Ibid., 46–47. One important model that has bridged the divide between art-historical and urban studies texts since Yellott is Peter Bacon Hales's *Silver Cities*, which considers photography's ability to structure the cities it depicts. Hales's writing provided a source of inspiration for my claim that street photographs correspond to the picture millions have of urban reality, as well as how the dissemination of these photographs informed the manner in which they are viewed.

16. Ibid., 47.

17. Deutsche has advocated this multiplicity, arguing that there is no single, fixed city, but her own scholarship remains closely tethered to New York.

18. Yellott, "Street Photography," 85.

19. The readings offered in the case studies do not necessarily foreclose other readings in their assumption that the urban-aware postwar viewer knew how to visually engage the street photographs by Avedon, Moore, Rosler, and diCorcia, however unfamiliar their images may have remained to both canon and discourse. Indeed, the readings of viewers' initial encounters with the work in each chapter will always be subject to revision, given changes in contextual and historical circumstances.

20. It has only recently been argued that Rosler's *The Bowery in Two Inadequate Descriptive Systems* should be considered in the context of (or at least proximate to) street photography. See Yee and Rugg, *Street Art*. The exhibition and publication *Street Art, Street Life* interprets canonical street photography as the springboard for later works of art in various media made in and on the street. See, in particular, Katherine A. Bussard, "Canon

and Context: Notes on American Street Photography," in Yee and Rugg, *Street Art*, 90–98; and Frazer Ward, "Shifting Ground: Street Art of the 1960s and '70s," in Yee and Rugg, *Street Art*, 99–104. Portions of my essay for that catalogue appear here in revised form.

21. Avedon has not been discussed in any history of street photography, though Jane Livingston did include some of Avedon's New York street photographs from 1946 in her survey *The New York School*. She claimed that Avedon was practicing "street photography in a manner just as intense, and just as wildly inventive, as any of his colleagues in the New York School," though she never articulated street photography as a shared interest of this loose group of photographers. Instead she privileged documentary, thereby replicating the Szarkowski's omission of urban content and context a quarter-century earlier in his *New Documents* exhibition. Jane Livingston, *New York School: Photographs, 1936–1963* (New York: Stewart, Tabori and Chang, 1992), 339.

22. The photographs considered in the Richard Avedon chapter were made between 1947 and 1952. During those years, approximately 60–64 percent of Americans lived in urban areas, and *Harper's Bazaar* targeted a readership based largely within those urban populations. (For more on the circulation of *Harper's Bazaar*, see page 51, note 95.)

23. Jacobs, *Death and Life*, 71.

24. Among these three, newspapers frequently maintained an audience larger than that of the other two media combined. See James L. Baughman, "Who Read *Life*? The Circulation of America's Favorite Magazine," in *Looking at "Life" Magazine*, ed. Erika Doss (Washington, DC: Smithsonian Institution Press, 2001), 43.

25. A complication of Cartier-Bresson's practice precedes this quotation: "Actually taking a photograph usually involves acting so quickly that there is rarely time to wait for the '*decisive moment*' or consider in advance the details of the situation. The requirements of *spontaneity* and *intuition* mean that the people taking the pictures not only respond to the event to be photographed, but also reproduce the images already stored in their mind." Jörg Huber, "Reading—Seeing—Understanding: In Praise of Illegibility," in *Covering the Real: Kunst und Pressebild von Warhol bis Tillmans* [Art and the press picture from Warhol to Tillmans], ed. Hartwig Fischer (Cologne: DuMont, 2005), 349–50 (emphases added).

26. Quoted in Arthur M. Schlesinger Jr., *A Thousand Days: John F. Kennedy in the White House* (Boston: Houghton Mifflin/Cambridge, MA: Riverside Press, 1965), 975.

27. Rosalyn Deutsche, "Introduction," in *Evictions: Art and Spatial Politics* (Chicago: Graham Foundation for Advanced Studies in the Fine Arts/Cambridge, MA: MIT Press, 1996), xxiv.

28. Stanford Anderson, preface to *On Streets*, ed. Stanford Anderson (Cambridge, MA: MIT Press, 1978), vii. A *Life* article fifteen years earlier addresses the recent programs of rapid industrialization and urbanization adopted in many American cities—not coincidentally, the same conditions that produced large-scale urban homelessness: "The very questions that explore this larger story have an ugly ring to them: Why, really, are white people abandoning their big cities?" Theodore H. White, "Racial Collision in the Big Cities," *Life* 55, no. 21 (November 22, 1963): 104.

29. Barbara Ehrenreich, *Fear of Falling: The Inner Life of the Middle Class* (New York: Pantheon, 1989), 46–47. Ehrenreich elaborated, "In all the debate and discussion that surrounded the beginning of the War on Poverty—and later, in the endless evaluations of it—the poor had no voice. In fact, their principal virtue, as opposed to the black insurgency, was that they were so agreeably silent." Ibid., 56.

30. Martha Rosler, "Notes on Quotes," in *Decoys and Disruptions: Selected Writings, 1975–2001* (Cambridge, MA: MIT Press/New York: International Center of Photography, 2004), 145.

31. Florian Ebner, "Urban Characters, Imaginary Cities," in Ute Eskildsen, ed., *Street and Studio: An Urban History of Photography* (London: Tate, 2008), 192.

32. In 1960 Claes Oldenburg created an installation environment called *The Street: A Metaphoric Mural*. Its poetic manifest read, in part: "I am for an art that is political—erotical—mystical, that does something / other than sit on its ass in a museum. . . . I am for an art that tells you the time of day, or where such and such a street is. / I am for an art that helps old ladies across the street." Quoted in Ric Burns, James Sanders, and Lisa Ades, *New York: An Illustrated History* (New York: Alfred A. Knopf, 1999), 540–41. Bennett Simpson has noted that "this move can be seen in broad cultural terms that rhyme with the 'personal is the political' attitudes of the 1970s, a shirking of big gestures, abstract ideals, and the confidence that the meaning of America could be found by wandering its streets." Bennett Simpson et al., *Philip-Lorca diCorcia* (Göttingen, Germany: Steidl/Boston: Institute of Contemporary Art, 2007), 14–16.

33. Of course, diCorcia's use of color photography marks a notable difference from the canon and from this book's other case studies. See Peter Galassi, "Photography Is a Foreign Language," in *Philip-Lorca diCorcia* (New York: Museum of Modern Art/Harry N. Abrams, 1995), 14. See also Thomas Weski, "Contemplation, Pleasure, Understanding," in Philip-Lorca diCorcia and Thomas Weski, *Streetwork* (Hanover, Germany: Sprengel Museum Hanover, 2000), n.p.

34. This sentence is a rewording of Graeme Gilloch's enumeration of the critical models Walter Benjamin outlined as responses to the city. See Gilloch, *Myth and Metropolis*, 13.

35. Rosalyn Deutsche, "Agoraphobia," in *Evictions*, 325. For an updated consideration on the uses of sidewalks from the perspective of urban studies, see Anastasia Loukaitou-Sideris and Renia Ehrenfeucht, *Sidewalks: Conflict and Negotiation over Public Space* (Cambridge, MA: MIT Press, 2009). *Sidewalks* takes inspiration from Jacobs and Deutsche alike, calling them "an undervalued element of the urban form. . . . A commercial terrain for merchants and vendors, a place of leisure for flâneurs, a refuge for homeless residents, a place for day-to-day survival for panhandlers, a space for debate and protest for political activists, an urban forest for environmentalists: U.S. sidewalks have hosted a wealth of social, economic, and political uses and have been integral to a contested democracy." Loukaitou-Sideris and Ehrenfeucht, *Sidewalks*, 3.

RICHARD AVEDON
BETTER THAN REAL

Carmel Snow, "Notes from Paris by Carmel Snow," *Harper's Bazaar*, May 1946, 124, 126.

Roberta Smith, "Eyes of Richard Avedon," *Art in America* 67 (January–February 1979): 135.

1. Although Avedon continued to work on location in Paris, the 1950s found him increasingly moving indoors—first to the decidedly Parisian interiors of cafés, theaters, and restaurants, and, mid-decade, more often to his Paris studio (though nothing about the studio signified its location in Paris). Avedon's transition from the streets of Paris to his studio seems to have been prompted by a desire for greater control over lighting and atmosphere. See Richard Avedon, *Made in France: Richard Avedon* (San Francisco: Fraenkel Gallery, 2001), n.p.

2. Rosalind Krauss, "A Note on Photography and the Simulacral," *October* 31 (Winter 1984): 65. I have taken the liberty of redirecting this quote to Avedon's fashion photographs rather than Irving Penn's still-life photographs for the cosmetics brand Clinique, which are among Krauss's subjects in this essay.

3. Photographs were first copied by engravers for *Document photographique de la Maison Reutlinger* around 1881, then printed with the newly refined halftone process in *La mode pratique*, and by 1901 the periodical *Les modes* could rely almost exclusively on photographic illustration. See Nancy Hall-Duncan, *The History of Fashion Photography* (New York: Alpine Book, 1977), 22, 26.

4. Avedon remarked on this formula, saying that by 1947 "fashion had become a business, and . . . the days of court portraitists like [George Hoyningen-Huene (1900–1968)], Baron de Meyer, and Cecil Beaton, who belonged to the same *gratin* as their subjects—aristocrats modeling their own clothes—were finished." Quoted in Judith Thurman, "Hidden Women," in Avedon, *Made in France*, n.p.

5. Susan Kismaric and Eva Respini, "Fashioning Fiction in Photography," in *Fashioning Fiction in Photography since 1990* (New York: Museum of Modern Art, 2004), 12.

The apogee of this approach can be found in Irving Penn's best-known work from this period.

6. Thurman, "Hidden Women," n.p.

7. Although he has been mistakenly linked to the photographers reveling in the technical development of 35 mm roll film, Munkacsi remained devoted to medium- and large-format cameras throughout his career. For more on both his shooting and cropping practices, see Martin Munkacsi, "Think While You Shoot," *Harper's Bazaar*, November 1935, 92, 152.

8. Carmel Snow, *The World of Carmel Snow* (New York: McGraw-Hill, 1962), 88.

9. It is also worth noting the reach of magazines such as *BIZ*, the most widely read picture magazine in the world, with a circulation of two million in the late 1920s. Munkacsi seems to have inherently understood the impact of picture-driven magazines so well that he was one of two men responsible for the maquette of what would become *Life* magazine. For more details, see Martin Munkacsi, *Martin Munkacsi* (New York: Aperture, 1992), 50.

10. Quoted in Kismaric and Respini, "Fashioning Fiction," 13.

11. Hall-Duncan, *History of Fashion*, 72, 78.

12. Richard Avedon, "Munkacsi," *Harper's Bazaar*, June 1964, 64. In this same tribute, Avedon noted that he had never met Munkacsi.

13. Hall-Duncan, *History of Fashion*, 136. Avedon himself noted in 1949 that "real people move, they bear with them the element of time—not time in the sense of aging, but time in the sense of motion." Richard Avedon, "Time for Motion . . . the Fourth Dimension," *Commercial Camera Magazine* 2, no. 2 (1949): 9. For more on Avedon's 1940s experimentation with motion, see Carol Squiers, "'Let's Call It Fashion': Richard Avedon at *Harper's Bazaar*," in *Avedon Fashion: 1944–2000*, ed. Carol Squiers and Vince Aletti (New York: Harry N. Abrams, 2009), 159–61, 168–69.

14. Helen Levitt's solo exhibition was on view there from March 10 to April 18, 1943.

15. Jane Livingston, "The Art of Richard Avedon," in Richard Avedon, *Evidence,*

1944–1994 (New York: Random House, 1994), 37. Likely the best examples of Avedon's struggle to conform to street photographs more in keeping with those of Levitt are the pictures he made in 1949 on assignment for *Life* magazine. Retracted by Avedon at the time because they looked like imitations, these photographs were eventually published in Livingston's *New York School* and subsequently in both Avedon's *An Autobiography* and *Evidence, 1944–1994*.

16. Quoted in Winthrop Sargeant, "Profiles: A Woman Entering a Taxi in the Rain," *New Yorker*, November 8, 1958, 80, 82. For more on Avedon's 1940s experimentation with variable focus, see Squiers, "Let's Call It Fashion," 158–59, 168–69. This statement dates to three decades before Avedon's discussion of street photography with Jane Livingston. In 1993 Avedon said to Livingston, "I wanted to get away from everyone else's subject matter, the man on the street, and deal with things I understood better. . . . It wasn't that I didn't know about people in the street. It's that I knew something different from what Helen Levitt knew." Livingston, "Art of Avedon," 38.

17. The opening credits devote one screen to Avedon's role and to a smaller note of thanks to *Harper's Bazaar*, likely as a nod to both Avedon's participation and for that magazine's clear inspiration of the film's fictional one, *Quality*. *Funny Face*, 1957, produced by Paramount Pictures, directed by Stanley Donen and written by Leonard Gershe.

18. See Sargeant, "Profiles," 54, 71–72, 80, 82–83; and Thurman, "Hidden Women," n.p.

19. This second, practical directive of Avery's may have doubled as a tribute to Munkacsi. See Munkacsi, *Martin Munkacsi*, 50. "Run!" was also a frequent command overheard in Avedon's studio. See Stephen Birmingham, "Richard Avedon: Photographer of Beauty," *Cosmopolitan*, June 1961, 48.

20. *Harper's Bazaar* did publish color photographs from 1947 to 1954, most dramatically and most often on its cover.

21. In the years between 1947 and 1954, Louise Dahl-Wolfe was the only other photographer assigned to the Paris collections. A widely accepted anecdote involves Avedon

being secretly sent to Paris by Snow, instructed to keep out of sight of Dahl-Wolfe, and spending his time on the streets rather than in the studio of *Harper's Bazaar*. See Snow, *World*, 204; and Squiers, "Let's Call It Fashion," 162, 164–65.

22. Livingston, "Art of Avedon," 88.

23. Quoted in Thurman, "Hidden Women," n.p. The "troupe of acrobats" performed for his camera in the Marais, possibly at the site of a guillotine (though it is unclear which "Marquis" Avedon is referencing). He may be assigning to the Marais courtyard the history of the Place de la Concorde, the location of the guillotine that killed Louis XVI, where Avedon photographed more than once.

24. Model Dorian Leigh has explained that editors did not simply choose which designs they liked best from a couturier's collection for photographic coverage in their magazines: "She [an editor] had to select those designs that were going to be available in the United States, either as originals or copies, so that the women reading the magazine could go out and buy what they saw and liked." Dorian Leigh, *The Girl Who Had Everything: The Story of "The Fire and Ice Girl"* (Garden City, NY: Doubleday, 1980), 78.

25. Ibid., 79–80.

26. Livingston suggested that the Rolleiflex 2¼ was Avedon's primary camera until 1969, but the move from street to studio in the late 1950s also paralleled a move to the 8 × 10 camera. Livingston, "Art of Avedon," 59.

27. Ibid., 36.

28. Adam Gopnik, "The Light Writer," in Avedon, *Evidence*, 103.

29. Leigh, *Girl Who Had Everything*, 75.

30. Sunny Harnett dominated Avedon's work from 1955 to 1956. Suzy Parker and a new string of ever more iconic and famous models working with Avedon ushered in an era of fame and household familiarity for models in the 1960s.

31. Sargeant, "Profiles," 82. Sargeant wrongly dated the Dorian Leigh photo to 1950; it appeared in the October 1949 issue of *Harper's Bazaar*.

32. Smith, "Eyes," 135.

33. Although *Harper's Bazaar* articles on Dior's collection did not use the phrase "new look," Carmel Snow is credited with creating this now famous nickname. See Squiers, "Let's Call It Fashion," 161–63, 188n37.

34. The *Paris* portfolio was made on the occasion of Avedon's retrospective exhibition at the Metropolitan Museum in 1978. The press release for that exhibition notes that "most of the photographs [in the exhibition and portfolio] were taken during assignments for *Harper's Bazaar* and *Vogue*, but some have not been published or exhibited before." Center for Creative Photography, Avedon Archive Material (box 23, section II), press release for the exhibition *Richard Avedon: Photographs 1974–77*, Metropolitan Museum of Art, New York, n.p.

35. These kiosks were created by their namesake, Morris, at the end of the nineteenth century. To this day in Paris, their rounded surfaces display posters of upcoming events.

36. The list includes several nonpublic locations such as Maxim's, the Casino at Le Touquet, Helena Rubinstein's apartment on the Île Saint-Louis, the interior of the Café des Beaux Arts, the open-air dining room at the Pré Catelan in the Bois de Boulogne, and backstage at the Folies Bergère. See, for example, the Paris collection coverage in the October 1949 and September 1954 issues of *Harper's Bazaar*.

37. Snow, "Notes," 200.

38. Rosamond Bernier, "Richard Avedon," in *Richard Avedon, 1947–1977* (New York: Farrar, Straus, and Giroux, 1978), n.p.

39. See ibid.; Livingston, "Art of Avedon," 50; and Sargeant, "Profiles," 72.

40. The Marais contains some of Paris's oldest architecture and reflects its early urban plan, making it one of the city's most historical arrondissements.

41. Sargeant, "Profiles," 72. "Fashion photographs are ostensibly as transitory as last year's style or this month's magazine issue." Hall-Duncan, *History of Fashion*, 10.

42. Serge Guilbaut, *How New York Stole the Idea of Modern Art: Abstract Expressionism, Freedom, and the Cold War*, trans. Arthur Goldhammer (Chicago: University of Chicago Press, 1983), 49.

43. Julian Stallabrass has emphasized that street photography was not practiced easily or lightly during the occupation; permits from the German authorities were required. Julian Stallabrass, *Paris Pictured* (London: Royal Academy of Arts, 2002), n.p. Thus those street photographs taken for publication by those with permits represent restricted views of Paris.

44. Guy Debord, *The Society of the Spectacle*, trans. Donald Nicholson-Smith (New York: Zone Books, 1995), 12.

45. Long understood as a hallmark of modern industrial society, leisure time is deeply enmeshed in and even defined by its consumption of spectacles. See ibid., 13, 22.

46. Don Slater, "Photography and Modern Vision," in *Visual Culture*, ed. Chris Jenks (London: Routledge, 1995), 223, 232.

47. In his article for the *New Yorker*, Sargeant compared Avedon's Paris photographs to the realism found in theater. See Sargeant, "Profiles," 77. More direct is Livingston's phrase "cinema verité" to describe Avedon's technique; see Livingston, "Art of Avedon," 48–50. Semantically, "realism" describes the resulting photograph and "cinema verité" describes the making of that photograph, but the term "reality effect" intentionally references the act of viewing that photograph and its effect on reception.

48. Nancy J. Troy, *Couture Culture: A Study in Modern Art and Fashion* (Cambridge, MA: MIT Press, 2003), 18.

49. Valerie Steele uses the same term as Guilbaut on the opening page of her insightful history of Paris's domination of the fashion industry from the fourteenth through twentieth centuries. See Valerie Steele, *Paris Fashion: A Cultural History* (New York: Oxford University Press, 1988), 5. The tier of haute couture is widely acknowledged to have emerged in the 1860s in the fashion capital. See Troy, *Couture Culture*, 18–19.

50. Within haute couture, there are two official classes—Couture and Couture-Création—each with their own subdivisions. Every fashion house's status within a class and subdivision is evaluated annually by a jury of Chambre syndicale members. For more, see Alexandra Palmer, *Couture and Commerce: The Transatlantic Fashion Trade in the 1950s* (Vancouver: University of British Columbia Press, 2001), 15–16.

51. The Nazis had initially intended to relocate the entire industry to Berlin or Vienna. The president of the Chambre syndicale de la couture parisienne, Lucien Lelong, argued strongly against this, thereby keeping the French houses intact, if weakened. See Steele, *Paris Fashion*, 266; and Palmer, *Couture and Commerce*, 16. Not incidentally, the war years saw the first widespread success of ready-to-wear apparel by American designers. See Hall-Duncan, *History of Fashion*, 136; and Kismaric and Respini, "Fashioning Fiction," 13.

52. Hall-Duncan, *History of Fashion*, 130.

53. For more, see Edmonde Charles-Roux et al., *Théâtre de la mode*, photographs by David Seidner, edited by Susan Train with Eugène Clarence Braun-Munk (New York: Rizzoli, 1991).

54. *Le théâtre de la mode* (New York: American Relief for France, under the auspices of l'Association française d'action artistique, 1945), n.p.

55. See Steele, *Paris Fashion*, 272.

56. *Harper's Bazaar*, June 1946, 80–83. See also Steele, *Paris Fashion*, 272.

57. In her catalogue essay on Avedon's fashion photographs, Bernier suggests that Avedon first traveled to Paris in late 1946, just months prior to Dior's February 1947 collection that debuted the New Look: "When the French fashion houses began to open up again in 1946–47, American magazines thought it worth while to send people over to report on them. One of these people was Richard Avedon." Bernier, "Richard Avedon," n.p. Based on the published coverage, none of which includes Avedon's Paris pictures until late 1947, I believe Bernier is mistaken. The exhibition's press release also touts Avedon's presence at the February debut of Dior's New Look, likely based on misinformation from Bernier. See Center for Creative Photography, Avedon Archive Material, press release, n.p. Squiers firmly dates Avedon's arrival in Paris to the summer of 1947; Squiers, "Let's Call It Fashion," 162. For more first-hand accounts of the New Look, see Steele, *Paris Fashion*, 272–75.

58. See Steele, *Paris Fashion*, 271; and Palmer, *Couture and Commerce*, 40. For a lengthier treatment of this topic, see Dominique Veillon, *Fashion under the Occupation* (New York: Berg, 2002), originally published as *La mode sous l'Occupation* (Paris: Éditions Payot, 1990).

59. Palmer, *Couture and Commerce*, 40. Avedon himself recalled that "five girls came out through the doors with long, full, pleated skirts. I am sure you remember that during the war there wasn't fabric so that all skirts were way above the knee. These skirts were down to the ankles. And the five girls swirled at the same time and the skirts rose as they swirled; it knocked over the standing ashtrays, and people were weeping." Center for Creative Photography, Avedon Archive Material (box 23, section II), transcript of and information about acoustiguide for Avedon retrospective, 1948–80, University Art Museum, Berkeley, recorded Feb. 11, 1980, 6.

60. Christian Dior, *Christian Dior and I* (New York: E. P. Dutton, 1957), 35. Both Steele and Snow have pointed out that the essence of the New Look shapes and silhouettes were apparent as early as 1939. See Steele, *Paris Fashion*, 272–74; and Snow, *World*, 158–59.

61. Palmer, *Couture and Commerce*, 20.

62. Christian Dior, *Talking about Fashion* (New York: G. P. Putnam's Sons, 1954), 23. Snow declared that "Dior saved Paris." See Snow, *World*, 158.

63. Hall-Duncan, *History of Fashion*, 135.

64. Snow, "Notes," 124, 126, 190, 198. The November 1944 issue of *Harper's Bazaar* was the first to feature French fashions, with minor exceptions, since the 1940 occupation. The editors honored "the thousands of French girls who are the backbone of the couture . . . who resisted, and worked, and fought in the streets in the hours of liberation. Without them Paris could not live. These pages belong to them." "Pages from Paris," *Harper's Bazaar*, November 1944, 59.

65. Kristin Ross's superb study on the fixations of postwar French consumers and the country's intensified modernization during those years cites several such descriptions of "hunger." Kristin Ross, *Fast Cars, Clean Bodies: Decolonization and the Reordering of French Culture* (Cambridge, MA: MIT Press, 1995), 71–73. See also 4–5, as well as the rest of the chapter in which these descriptions are quoted: "Hygiene and Modernization," ibid., 71–122.

66. Indeed, Snow's efforts on behalf of France's national economy and the Parisian couture industry were acknowledged in 1949 when France awarded her the Knight's Cross of the Legion of Honor. See Snow, *World*, 168–69. For more on Americans' general desire for a newly and "uniformly prosperous France, surging forward into American-style patterns of consumption and mass culture," see Ross, *Fast Cars*, 9–10, 13.

67. Quoted in Candia McWilliam, "From Wasp-Waists to Tubular Belles—*Appearances: Fashion Photography Since 1945*," Times Literary Supplement, March 29, 1991, 14. One explicitly political photograph might be Avedon's 1948 image of designer Coco Chanel against a wall painted with "Pourquoi Hitler n'a pas eu sa bomb?" and "Liberté, Égalité, Fraternité," which Avedon said was intended "meaningfully." Though not necessarily referencing Chanel's Nazi sympathies, it nevertheless bordered on the subversive. Understandably, *Harper's Bazaar* never ran the image. When Avedon did publish it in his book *Observations*, Chanel was furious but only, he claimed, because it did not flatter her throat. See Gopnik, "The Light Writer," 109; and Thurman, "Hidden Women," n.p. For more on Avedon's shoot with Chanel, see Squiers, "Let's Call It Fashion," 166–67.

68. The visual spectacles of major Hollywood box-office hits provide some indication of this mood: *An American in Paris* (1951), *Sabrina* (1954), the aforementioned *Funny Face* (1957), and *Gigi* (1958).

69. Debord, *Society of the Spectacle*, 12.

70. Center for Creative Photography, Avedon Archive Material, transcript of and information about acoustiguide for Avedon retrospective, 1948–80, 6–7.

71. Center for Creative Photography, Avedon Archive Material (box 44), WNET *American Masters* interview with Richard Avedon, January 27, 1995, tapes 261–66, tape 261 side A, transcript page 15 and tape 262 side A, transcript page 7, respectively. Elsewhere, Avedon had said: "We as journalists went over with very full hearts trying to bring back to world consciousness—particularly to

American consciousness—the glamour of Paris and the beauty of Paris [sic] clothes and style. But Paris was a very sad place at that time. There was no food. There was no gas for the cars." Center for Creative Photography, Avedon Archive Material, transcript of and information about acoustiguide for Avedon retrospective, 1948–80, 6.

72. Snow edited the magazine from 1932 to 1957. She came to *Harper's Bazaar* from *Vogue*, where art director Mehemed Fehmy Agha had taught her to appreciate a more modernist vision and innovative style. Vreeland began her column for the magazine in 1936 and was quickly promoted to fashion editor. Avedon claimed that Vreeland "invented the fashion editor. Before her it was society ladies who put hats on other society ladies." See Richard Avedon, "In Memoriam: Diana Vreeland 1903–1989," *Vanity Fair*, January 1990, 158. Vreeland left *Harper's Bazaar* in 1962 to become the fashion editor of *Vogue*. Brodovitch was hired by Snow in 1934; his tenure lasted until the year following her departure. Avedon dedicated *Made in France* to this "trinity."

73. As already noted, *Harper's Bazaar* was widely considered the most reputable and compelling women's fashion magazine throughout the 1940s and 1950s. For more, see Andy Grundberg, *Alexey Brodovitch, 1898–1971* (New York: Harry N. Abrams, 1989), 59; Hall-Duncan, *History of Fashion*, 68; and Munkacsi, *Martin Munkacsi*, 47.

74. Quoted in Sargeant, "Profiles," 49.

75. Quoted in Hollis Alpert, "The Ambiguities of Suzy Parker," *Esquire*, March 1959, 76.

76. By far the most eloquent of these tributes is Truman Capote's. Quoted in Richard Avedon, *Observations* (New York: Simon and Schuster, 1959), 150.

77. Brodovitch's informal critique-based gatherings, the "Design Laboratory," inspired a generation of photographers to appreciate what strong design could accomplish. Affiliated with the New School for Social Research in New York, the Design Laboratory would regularly gather an ever-changing group of photographers and designers who would present, discuss, and critique each other's work.

From 1947 on, Design Laboratory sessions most often took place in Avedon's studio. Although *Harper's Bazaar* was "by no means the only U.S. magazine supporting innovative photography in the postwar period, the magazine had proved singularly hospitable on a long-term basis to a certain kind of photographer. By the 1940s, besides Munkacsi, Louise Dahl-Wolfe, and Avedon, photographers such as Lisette Model, Bill Brandt, Brassaï, Cartier-Bresson, and André Kertész had begun to appear in the magazine with some regularity." Livingston, "Art of Avedon," 34.

78. For a complete assessment of Avedon's two decades under Brodovitch at *Harper's Bazaar*, see Squiers, "Let's Call It Fashion," 156–91.

79. Quoted in Livingston, "Art of Avedon," 90, in reference to a 1967 interview with Avedon about his photo-collages. Perhaps accordingly, Avedon did not restrict his photographs based on the original format of the negative, the size of photographic papers, or the belief that a particular image required a certain scale. For more, see ibid., 44, 88.

80. He later said that dark or gray tones "allowed the romance of a face coming out of the dark." Richard Avedon, "Borrowed Dogs," *Grand Street* 7, no. 1 (Autumn 1987): 58.

81. Thurman, "Hidden Women," n.p.

82. Time and again, Avedon photographed the most extravagant, luxurious couture in indoor private or exclusive locations, not public outdoor spaces. For more details, see Troy, *Couture Culture*; and Palmer, *Couture and Commerce*. Models wearing these clothes were depicted either arriving by car (never as the driver but in the back of a taxi or chauffeured car) or already indoors, in the semiprivate spaces of socially elite restaurants and clubs: Maxim's, the Pré Catalan, and the casino at the resort of Le Touquet. This was not simply a matter of evening wear being more lavish than day wear, because Avedon took photographs at night that present dressy but believable fashions for someone stopping on an amorous evening walk to linger on one of the Seine's many bridges, to cite one example.

83. Palmer, *Couture and Commerce*, 18.

84. Roland Barthes, *The Fashion System*, trans. Matthew Ward and Richard Howard (Berkeley: University of California Press, 1990), 252–53.

85. Roland Barthes, *Camera Lucida*, trans. Richard Howard (New York: Hill and Wang, 1981), 5.

86. This contrasts sharply, for example, with the dominant mode of advertising images in the 1980s, which sought to *equate* the consumer and the product ("The product is you"). See Maud Lavin, *Clean New World: Culture, Politics, and Graphic Design* (Cambridge, MA: MIT Press, 2001), 70–75, 77.

87. Hall-Duncan, *History of Fashion*, 10.

88. John Berger, *Ways of Seeing* (London: Penguin, 1972), 130.

89. Ibid., 139, 146.

90. The book was originally published in 1967. It encompasses every issue of *Elle* and *Le jardin des modes* as well as forays into others such as *Vogue* for the period from June 1958 to June 1959. As Barthes explained in the foreword, his "structural analysis of women's clothing as currently described by Fashion magazines" chose to analyze the "written system" rather than the "real (or visual) system." Barthes, *Fashion System*, ix.

91. Ibid., 12, 301, 303. Earlier in his study, Barthes enumerated two communicative classes in "written clothing," one where "*clothing° world*" with explicit signifieds, and another where "*clothing° Fashion*" with implicit signifieds. Ibid., 33–39.

92. Ibid., 246–47.

93. Other questions (and the relationships they propose) as recounted by Barthes are what? (transitivity), when? (temporality), and who? (personality). Ibid., 249–57.

94. Ibid., 251–52.

95. I have been unable to attain circulation or demographic statistics from the Hearst Corporation. Neither can I locate comparison figures from *Harper's Bazaar*'s most avid competitor at the time, *Vogue*. In France, however, *Elle* claimed a readership of one in six French women by 1955. See Ross, *Fast Cars*, 209n14.

96. Ibid., 1. It should be noted that Ross is specifically referencing the ideal reader of *Elle*, not of *Harper's Bazaar*.

97. Lavin, *Clean New World*, 74.

98. See, for example, Ross's analysis of this function of magazines and of women as consumers. Ross, *Fast Cars*, 71–105, esp. 77–79, 81.

99. Ibid., 77.

100. Snow, *World*, 171–72.

101. Kismaric and Respini, "Fashioning Fiction," 15.

102. Slater, "Photography and Modern Vision," 233.

CHARLES MOORE
TO BE INVOLVED

Quoted in Steven Kasher, *The Civil Rights Movement: A Photographic History, 1954–68* (New York: Abbeville Press, 1996), 98.

Wendy Kozol, "Gazing at Race in the Pages of *Life*: Picturing Segregation through Theory and History," in *Looking at "Life" Magazine*, ed. Erika Doss (Washington, DC: Smithsonian Institution Press, 2001), 162.

1. Quoted in Anne Wagner, "Warhol Paints History, or Race in America," *Representations* 55 (Summer 1996): 110.

2. Ibid., 104–5.

3. I have chosen to use the word "black" throughout this chapter in my own prose but have maintained the use of "Negro" or "nigger" in all quotations. Kasher has pointed out that, historically, "debates over appropriate labels were heating up in the summer of 1963. 'Negro' was used almost exclusively in the March [on Washington] speeches; only John Lewis referred to 'black people' and 'the black masses.'" Kasher, *Civil Rights*, 118.

4. For the purposes of this chapter, I use the term "1960s" to refer to the actual decade from 1960 through 1969. That said, I recognize that many scholars consider the 1960s to have come to a close in 1973 when the US Army made its final withdrawal of forces from Vietnam. See, for example, Terry H. Anderson, *The Movement and the Sixties* (New York: Oxford University Press, 1995), xiii.

5. Like Anderson, I do not use the word "movement" to refer to specific "organizations, leaders, or ideology" but to refer to more widespread, cumulative activism in this era. Unlike Anderson's text, however, I use "movement" as shorthand for the civil rights movement, the first of the decade's numerous social and political movements. See ibid., xiv–xv.

6. Matthias Reiss, introduction to *The Street as Stage: Protest Marches and Public Rallies since the Nineteenth Century* (London: German Historical Institute/Oxford: Oxford University Press, 2007), 4. On urban sidewalks as sites of contestation, see Loukaitou-Sideris and Ehrenfeucht, *Sidewalks*, esp. chap. 6, 97–121.

7. "In 1953 45% of American households had televisions; just three years later the number had jumped to over 83%. The Telstar I communications satellite began to enable worldwide television linkups in 1962; the March on Washington for Jobs and Freedom of 1963, the largest political demonstration in the United States to date, was one of the first events to be broadcast live around the world." Kasher, *Civil Rights*, 12.

8. Ibid., 13.

9. For a rhetorical analysis of Moore's images from the field of communication studies, see Davi Johnson, "Martin Luther King Jr.'s 1963 Birmingham Campaign as Image Event," *Rhetoric & Public Affairs* 10, no. 1 (Spring 2007): 1–25. Our research was conducted simultaneously, and we reached some of the same conclusions, but some aspects of Johnson's conclusions differ dramatically from those of this chapter.

10. For recent (and perhaps the only) examples, see Katherine A. Bussard, "Canon and Context: Notes on American Street Photography," in *Street Art, Street Life*, ed. Lydia Yee and Whitney Rugg (New York: Aperture, 2008), 90–98; and Frazer Ward, "Shifting Ground: Street Art of the 1960s and '70s," in Yee and Rugg, *Street Art*, 99–104.

11. Kasher, *Civil Rights*, 165; and Gene Roberts and Hank Klibanoff, *The Race Beat: The Press, the Civil Rights Struggles, and the Awakening of a Nation* (New York: Alfred A. Knopf, 2006), 384.

12. Steven Kasher, *Appeal to This Age: Photography of the Civil Rights Movement, 1954–1968* (New York: Howard Greenberg Gallery, 1994), n.p.

13. Michael L. Carlebach, *American Photojournalism Comes of Age* (Washington, DC: Smithsonian Institution Press, 1997), 184.

14. Szarkowski, *Winogrand*, 12.

15. Some continued to argue that such sources offered only a facile, uneducated version of the news. See Carlebach, *American Photojournalism*, 145–46.

16. Yves Michaud, "Critique of Credulity: The Relationship between Images and Reality," in Fischer, *Covering the Real*, 307.

17. Ibid., 309.

18. Howard Chapnick, *Truth Needs No Ally: Inside Photojournalism* (Columbia: University of Missouri Press, 1994), 7.

19. The discourse surrounding street photography has ignored the historical role played by photojournalism, an omission that is not exclusive to the 1960s. Representations of urban demonstrations were not unknown prior to that era. For more, see Carlebach, *American Photojournalism*, 147.

20. Quoted in Doss, introduction to *Looking at "Life,"* 2.

21. Ibid., 15.

22. Ibid., 4.

23. One survey in the late 1930s indicated that fourteen people read each issue; another in July 1938 boasted a pass-along factor of 17.3. See Baughman, "Who Read *Life*?," 42.

24. By the late 1940s, *Life* maintained three times the circulation of *Time*, reaching one in five Americans over the age of ten. For example, the February 1960 issue boasted a circulation of 6.5 million on its front cover; one month later, that number had increased by 200,000. Even in 1970, two years before its dissolution as a weekly magazine, *Life*'s circulation was strong at eight million, with an estimated pass-along rate of four to five people. Ibid., 41–51; see also Doss, introduction, 1–4.

25. Doss indicates that in the postwar era *Reader's Digest* and *TV Guide* exceeded *Life*'s estimated circulation. Doss, introduction, 3.

26. Baughman, "Who Read *Life*?," 48. He cautions scholars against overstating the magazine's impact and against their own delight in studying *Life* in comparison to other historical news media.

27. Doss, introduction, 13.

28. Ibid., 3.

29. Such hiring out also explains the many Black Star photographers who would become *Life* staff photographers. See Lili Corbus Bezner, *Photography and Politics in America: From the New Deal into the Cold War* (Baltimore: Johns Hopkins University Press, 1999), 142.

30. See Doss, introduction, 18.

31. This includes *Ebony*, the black-owned general interest magazine aimed at the black middle class. From 1955 to 1965 *Ebony* inexplicably offered almost zero coverage of the civil rights struggles. Regarding *Ebony*'s failure to mention the Birmingham demonstrations in its spring 1963 issues, Wagner has posited: "It was a lifestyle magazine imaging black success and upward mobility: racial demonstrations were definitely out of place." Wagner, "Warhol Paints History," 119n27. This compelling explanation suggests that street activism and street demonstrations could be construed as antagonistic to idealism, and implies an increased nuance to *Life*'s idealism, since its weekly issues consistently covered such struggles.

32. "'The White Devil's Day Is Almost Over,'" *Life* 54, no. 22 (May 31, 1963): 22–30; Gordon Parks, "'What Their Cry Means to Me'—A Negro's Own Evaluation," *Life* 54, no. 22 (May 31, 1963): 31–33, 78–79.

33. Gordon Parks, "How It Feels to Be Black," *Life* 55, no. 7 (August 16, 1963): 72–79; Gordon Parks, "The Long Search for Pride," *Life* 55, no. 7 (August 16, 1963): 80–84, 87.

34. Parks, "Long Search," 80.

35. Ibid.

36. Parks, "'What Their Cry Means to Me,'" 78.

37. Erika Doss, "Visualizing Black America: Gordon Parks at *Life*, 1948–1971," in *Looking at "Life,"* 236. Yet despite Parks's integrationist outlook, his personal, intimate interior photographs for the spreads in *Life*, unlike those by other staff photographers, do not picture a white or integrated presence in the struggle.

38. Ibid.

39. Moore's photographs of King's arrest were his first to be published by the magazine and were widely distributed on the Associated Press wires.

40. Ken Lassiter, "Charles Moore: Fighting Back with His Camera," *Photographer's Forum* 29, no. 4 (2007): 19.

41. Michael S. Durham, "The Civil Rights Photography of Charles Moore," in *Powerful Days: The Civil Rights Photography of Charles Moore* (New York: Stewart, Tabori and Chang/Rochester, NY: Professional Photography Division, Eastman Kodak, 1991), 24; Kasher, *Civil Rights*, 82; and Manuel Rodriguez, "Charles Moore: Civil Rights Photography," *Photographer's Forum* 14, no. 3 (May 1992): 37. Rodriguez indicated that the image was also reproduced in *Life*, though I have not located it in any of the magazine's issues from 1960.

42. Durham, "Civil Rights Photography," 25.

43. Sunday's *Advertiser* also reported that the police had not intervened in the attack. See Kasher, *Civil Rights*, 82.

44. Durham, "Civil Rights Photography," 25. See also Roberts and Klibanoff, *Race Beat*, 326. As for Moore's death threats, he has said that one came from the vigilante himself, to which Moore responded, "I told him he should be ashamed of himself, since I knew his family." Rodriguez, "Charles Moore," 37.

45. Lassiter, "Charles Moore," 19.

46. Kasher, *Appeal to This Age*, n.p.

47. Rodriguez, "Charles Moore," 37. See also Durham, "Civil Rights Photography," 23.

48. Danny Lyon, *Memories of the Southern Civil Rights Movement* (Chapel Hill, NC: University of North Carolina Press, 1992), 70–71.

49. Exceptions to this strict segregation of access based on skin color are rare, rely on "passing," and fall outside the scope of this chapter. For one magnificently subversive example, however, see "Civil Rights: 'The Awful Roar'; The March in Washington," *Time* (August 30, 1963): 10–11. Ruses such as that employed by Lyon were also implemented by white news reporters covering the movement. There was, for example, the so-called Claude Sitton notebook, after the *New York Times* civil rights correspondent, created by cutting a steno pad in half vertically. One such notebook in the reporter's breast pocket remained undetectable by racist mobs; two stacked in the breast pocket bulged like a gun in a shoulder holster, suggesting that he or she was an FBI agent rather than a reporter and encouraging hesitation among mobs that might otherwise be poised to attack. "Or you could go the other way: dress like a white heckler and cram the notebook under your belt beneath a flapping shirttail, and blend in with the mob." See Roberts and Klibanoff, *Race Beat*, 377. As activist Julian Bond stated, "The cameras of reporters, their pads and pens, were seen by segregationists as an invitation to brutality." John Lewis, afterword to *Road to Freedom: Photographs of the Civil Rights Movement, 1956–1968* (Atlanta: High Museum of Art, 2008), 146. For more, see the chapter entitled "New Eyes on the Old South" in Roberts and Klibanoff, *Race Beat*, 184–207.

50. Chapnick, *Truth Needs No Ally*, 154–55. See also Durham, "Civil Rights Photography," 25.

51. John Kaplan, "Charles Moore's *Life* Magazine Coverage of the Civil Rights Movement, 1958–1965," lecture delivered at the annual meeting of the Association for Education in Journalism and Mass Communication (New Orleans, August 3–8, 1999), 9. Roberts and Klibanoff have identified a "Southern War Correspondents Club"—which may or may not be the same as SCREW—whose mock membership cards read "'Integrated' on one side and 'Segregated' on the other side, so they could flip the card to fit whatever situation they faced." Roberts and Klibanoff, *Race Beat*, 329.

52. Quoted in Kaplan, "Charles Moore's *Life*," 13–14.

53. Durham, "Civil Rights Photography," 16.

54. Kasher, *Civil Rights*, 11–12.

55. Durham, "Civil Rights Photography," 32–33.

56. Ibid., 34. This quote is preceded by: "That thought came to me *after* I'd taken the picture. But at the moment I wasn't thinking, 'Boy, I'm shooting something that's history.' I wasn't thinking about the civil rights movement or politics. Instead, I was focusing my attention on a dramatic situation."

57. My description is based on accounts in the following sources: ibid., 26–27; Kasher, *Civil Rights*, 107; Roberts and Klibanoff, *Race Beat*, 316–17; and Kaplan, "Charles Moore's *Life*," 10. Kasher claimed the water pressure was 200 pounds per square inch; see Kasher, *Appeal to This Age*, n.p.

58. Roberts and Klibanoff, *Race Beat*, 316.

59. Quoted in Kaplan, "Charles Moore's *Life*," 10.

60. Roberts and Klibanoff do not publish or give details on the photographs in which Moore appears. They noted that still photographers and television crews populated the area, but most stood at a distance. Roberts and Klibanoff, *Race Beat*, 316.

61. Julian Cox, "Bearing Witness: Photography and the Civil Rights Movement," in *Road to Freedom*, 25.

62. Durham, "Civil Rights Photography," 28 (emphasis added).

63. Prior to 1960, photojournalists' camera of choice was the Graflex Speed Graphic, whose 4-by-5-inch negatives made for wonderful photographic detail but whose size also necessitated a visibly noticeable photographic mode. See Cox, "Bearing Witness," 23. For a detailed history of photographic and press equipment, see Carlebach, *American Photojournalism*, 157–62, 166–67.

64. Moore stated that his photographs of the dog attacks were taken with his 28 mm lens; see Rodriguez, "Charles Moore," 39. Moore also specified that he had used a 28 mm wide-angle lens to photograph the baseball bat attack in downtown Montgomery. Chapnick, "Civil Rights Movement in Stills: Charles Moore and Benedict Fernandez," videotaped lecture at the JFK Library and Museum of the John F. Kennedy Library Foundation (January 19, 2004), 8:28, http://forum.wgbh.org/wgbh/forum.php?lecture_id=1407 (accessed October 6, 2008), 51:59.

65. He also remarked on the absence of a motor drive in his camera that would have automatically advanced his film and allowed for more continuous shooting. Rodriguez, "Charles Moore," 34.

66. Chapnick, "Civil Rights Movement in Stills," 57:54.

67. Moore and Bill Hudson made their photographs of the dog attacks on May 3, 1963; see Cox, "Bearing Witness," 36. In various sources, however, Moore referred to his photographs having been taken the following day while simultaneously acknowledging that the dogs were reinforcements to the water hoses and an overwhelmed police force. See Durham, "Civil Rights Photography," 28; Lassiter, "Charles Moore," 22.

68. Cox, "Bearing Witness," 20.

69. Roberts and Klibanoff, *Race Beat*, 318.

70. Michaud, "Critique of Credulity," 311.

71. Huber, "Reading–Seeing," 347.

72. Ibid., 349–50.

73. Cartier-Bresson was also acutely aware of the presentation or framing of his photographs. Indeed, a sizable portion of *The Decisive Moment* is devoted to what he calls the "picture-story," or photo essay. Entitled "The Customers," that section establishes the objective of the photo essay as "to depict the content of some event which is in the process of unfolding, and to communicate impressions." That is, a commingling of practice and original viewing context. Cartier-Bresson explained the importance of picture magazines' ability to either convey or distort photographers' intentions to their audience via the photo essay. Editing the photographs and making decisions about their layout for publication were done with readers' interest in mind, so that the more important or interesting a photo essay, the more pages it was allocated within the magazine. See Cartier-Bresson, *Decisive Moment*, 74.

74. Durham, "Civil Rights Photography," 28. As late as 2007, Moore continued to emphasize the dog attacks' impact on him: "When I saw the snarling dogs tearing people's clothes and attacking them, I knew I had to show the world just how bad things had become." Quoted in Lassiter, "Charles Moore," 22.

75. Durham, "Civil Rights Photography," 29. *Life* posted Moore and Durham's bail, but the magazine's lawyers anticipated a six-month sentence if they kept their court appointment for May 8, and so they advised the pair to leave the state as fugitives. It would be nearly a year before Moore could return to the state in which his family lived.

76. Ibid., 31, 35; Kaplan, "Charles Moore's *Life*," 16, 18.

77. Rodriguez, "Charles Moore," 39.

78. Quoted in Kasher, *Civil Rights*, 88. Alabama had successfully squelched any NAACP chapters in the state since 1956. See also Anderson, *Movement*, 70.

79. "They Fight a Fire That Won't Go Out," *Life* 54, no. 20 (May 17, 1963): 30, 36.

80. Kennedy, quoted in Roberts and Klibanoff, *Race Beat*, 320; King, quoted in Anderson, *Movement*, 70. Statistics in this paragraph were compiled from multiple sources: "They Fight a Fire That Won't Go Out"; "Races: Freedom—Now," *Time* 81, no. 20 (May 17, 1963): 23; "Beyond Rights to the Issue of Human Dignity," *Life* 54, no. 21 (May 24, 1963): 4; "Civil Rights: The Sunday School Bombing; Where the Stars Fell," *Time* 82, no. 13 (September 27, 1963): 18; "Man of the Year," *Time* 83, no. 1 (January 3, 1964): 16; Roberts and Klibanoff, *Race Beat*, 320; Kasher, *Civil Rights*, 88; Anderson, *Movement*, 70; and Juan Williams, *Eyes on the Prize: America's Civil Rights Years, 1954–1965* (New York: Viking, 1987), 179.

81. Cox, "Bearing Witness," 37. Connor was not the first segregationist to use fire hoses against civil rights marchers. In *Time* magazine alone, their use (or threatened use) was noted in South Carolina, Texas, and Alabama as early as 1960. See "The South: Youth Will Be Served," *Time* 75, no. 12 (March 21, 1960): 21; "The South: Freeze and Thaw," *Time* 75, no. 13 (March 28, 1960): 24; and "The Sympathizers," *Time* 75, no. 15 (April 11, 1960): 64.

82. Kasher, *Civil Rights*, 95.

83. "The South: Dogs, Kids and Clubs," *Time* 81, no. 19 (May 10, 1963): 19.

84. Roberts and Klibanoff, *Race Beat*, 315.

85. Regarding previous uses of dogs on civil rights demonstrators, see "A Look at the World's Week," *Life* 50, no. 14 (April 7, 1961): 30; and Kasher, *Civil Rights*, 138.

86. Upon seeing the *Post*, President Kennedy said the Hudson photograph "made him sick." Quoted in Kasher, *Civil Rights*, 8. Others have said he found the situation "'intolerable'" and stated, "I think it's terrible, the picture in the paper." Quoted in Roberts and Klibanoff, *Race Beat*, 319–20. Whatever his exact words, it is clear the photograph had an immediate effect and changed the agenda of at least one policy meeting that day to the topic of Birmingham. The Hudson photograph also appeared in *Time* on May 10 and in *Newsweek* on May 13.

87. Cox, "Bearing Witness," 36. Not surprisingly, Southern daily newspapers did not reproduce the dog attack photographs on their front pages. For the first days of the Birmingham demonstrations, in fact, their coverage focused on the "restraint" demonstrated and injuries sustained by law enforcement officers, but such distortions could not

be maintained in the wake of national television coverage. See Roberts and Klibanoff, *Race Beat*, 320–21; and Cox, "Bearing Witness," 37.

88. Quoted in Kasher, *Civil Rights*, 90. For more on European reactions in particular, see C. Eric Lincoln, "The Race Problem and International Relations," in *Racial Influences on American Foreign Policy*, ed. George W. Shepherd Jr. (New York: Basic Books, 1970), 39–59.

89. "Races: Freedom—Now," 24. See also Kasher, *Civil Rights*, 97.

90. Kasher, *Civil Rights*, 97. The segregated jail cells still had room for whites, whether segregationists or press like Moore.

91. Durham recounts that they were arrested while Moore photographed a woman skidding down the pavement. Durham, "Civil Rights Photography," 29. Roberts and Klibanoff indicate that the arrest happened immediately after the photograph of three protestors pinned to a storefront by a water hose (see fig. 44). Roberts and Klibanoff, *Race Beat*, 322.

92. "They Fight a Fire That Won't Go Out," 29.

93. "Beyond Rights," 4.

94. "Civil Rights: 'The Awful Roar,'" 12.

95. Kasher, *Civil Rights*, 114. Anderson specifies nearly two hundred Birmingham-inspired demonstrations that took place in Southern cities alone; Anderson, *Movement*, 71.

96. Quoted in Kasher, *Civil Rights*, 98. See also Schlesinger, *A Thousand Days*, 966.

97. Quoted in Parks, "'What Their Cry Means to Me,'" 78.

98. Theodore H. White, "Power Structure, Integration, Militancy, Freedom Now!" *Life* 55, no. 22 (November 29, 1963): 78. "We Shall Overcome" was a historical song that had served labor movements earlier in the century, but it became the particular anthem of the early civil rights era.

99. For a summary of this shift, see Manning Marable, *Freedom: A Photographic History of the African American Struggle* (London: Phaidon, 2002), 254.

100. Such movements include the antiwar movement, women's rights, farm workers' movement, and gay liberation. Additionally, as

Kasher has noted, "its vision and its methods continue to inspire and instruct struggles for justice around the world," so that the anthem of the early 1960s demonstrations, "We Shall Overcome," was sung in Tiananmen Square and Johannesburg. Kasher, *Civil Rights*, 17. For more on the "ripple effect" of the early civil rights movement demonstrations and actions on other 1960s movements, see ibid., 139–42; Lyon, *Memories*; Alexander Bloom and Wini Breines, eds., *"Takin' It to the Streets": A Sixties Reader*, 2nd ed. (New York: Oxford University Press, 2003), 10; and Charles Johnson, introduction to *Road to Freedom*, 17. For more on the intersections of the civil rights movement and the Vietnam War, see Kasher, *Civil Rights*, 142; Lyon, *Memories*, 173; Harold R. Isaacs, "Race and Color in World Affairs," in Shepherd, *Racial Influences*, 36–38; and Paul Seabury, "Racial Problems and American Foreign Policy," in Shepherd, *Racial Influences*, 60–78.

101. "More Law, Plus Leadership," *Life* 54, no. 24 (June 14, 1963): 4.

102. Roberts and Klibanoff, *Race Beat*, 322.

103. The editors' subtitle admits the sensational quality of the feature: "The Spectacle of Racial Turbulence in Birmingham."

104. Kozol, "Gazing," 160, 178.

105. Durham claims that *Life*'s editors had laid out most of the eleven pages by the time he and Moore arrived in New York following their arrest on May 10. Durham, "Civil Rights Photography," 30. Journalism scholar and photographer John Kaplan has indicated that Moore was "allowed to supervise" the layout. Kaplan, "Charles Moore's *Life*," 12.

106. Roberts and Klibanoff, *Race Beat*, 322.

107. Durham, "Civil Rights Photography," 28.

108. Kozol, "Gazing," 160.

109. "They Fight a Fire That Won't Go Out," 29.

110. Ibid.

111. Ibid.

112. In his *Race Riot* paintings, Warhol also maintained the original sequence of the photographs, although, like *Life*, he sometimes cropped them. Wagner has emphasized Warhol's preservation of the narrative sequence. See Wagner, "Warhol Paints History," 106–9.

113. "They Fight a Fire That Won't Go Out," 30.

114. This stands in contrast to other scenarios. AP photographers routinely captioned their own pictures or annotated their versos as an "integral element in the evaluation of the image for publication by newsroom editors." Cox, "Bearing Witness," 23.

115. Kasher, *Civil Rights*, 96.

116. Kaplan, "Charles Moore's *Life*," 1. Roberts and Klibanoff provide another example of a more complicated analysis, stating that headlines "did not misrepresent the significance of the Birmingham developments. What King had done was 'provocation,' and what Connor had done was 'reprisal.'" Roberts and Klibanoff, *Race Beat*, 322.

117. Roberts and Klibanoff, *Race Beat*, 324.

118. "They Fight a Fire That Won't Go Out," 30.

119. Ibid., 36.

120. Roberts and Klibanoff, *Race Beat*, 321.

121. I am indebted to Huber's text for encouraging such a pertinent and illuminating way of thinking about illegibility. "What is meant here by illegibility, then, is not the opposite of legibility, but something that infiltrates legibility, disrupting it, interrupting it and pushing it to its limits." Huber, "Reading–Seeing," 352.

122. Cox, "Bearing Witness," 35. In the decades since, Moore's Birmingham photographs have remained "among the best-selling of all time at Black Star." Kaplan, "Charles Moore's *Life*," 12.

123. The photographic community celebrated and recognized Moore for his accomplishment and the impact of his Birmingham photographs, both at the time and since. In 1964 he won a special award from the American Society of Magazine Photographers. In 1989 he won the first Kodak Crystal Eagle Award for Impact in Photojournalism, honoring "'documentation of a vital social issue [that] has changed the way people live or what they believe.'" Rodriguez, "Charles Moore," 27.

124. See Kasher, *Appeal to This Age*, n.p.; and Roberts and Klibanoff, *Race Beat*, 315, 320.

125. Forty thousand of these collages were sold for one dollar each. Kasher, *Civil Rights*, 116; and Kaplan, "Charles Moore's *Life*," 16. For their assistance with images, I am grateful to Mark Choate, Special Collections, and Aaron

Lisec, manuscripts researcher, at Southern Illinois University Library—whose library is one of only two in the United States that houses the portfolio. No text I consulted names the artist of the collages, but the signature on each portfolio image as well as the portfolio cover seems to read "Lo Monaco." Finally, although my illustrative figures appear in black and white, the actual collages incorporate the colors red and blue.

126. Sara Blair, *Harlem Crossroads: Black Writers and the Photograph in the Twentieth Century* (Princeton, NJ: Princeton University Press, 2007), 198.

127. Doss, introduction, 3; and Kasher, *Appeal to This Age*, n.p., respectively.

128. Rodriguez, "Charles Moore," 38.

129. See John Lewis, foreword to *Time of Change: Civil Rights Photographs, 1961–1965* (Los Angeles: St. Ann's Press, 2002), n.p, for one such example. Another compelling response (in this case to televised images of the 1965 attacks in Selma) was George B. Leonard's "Midnight Plane to Alabama," *Nation* 200 (March 10, 1965), 502–5.

130. "More Law," 4.

131. Baughman, "Who Read *Life*?," 43.

132. Ibid., 44.

MARTHA ROSLER
A WALK DOWN THE BOWERY

Martha Rosler, "Fragments of a Metropolitan Viewpoint," in *If You Lived Here*, 32.

Rosalyn Deutsche, "Alternative Space," 52–53.

1. Martha Rosler, "Lookers, Buyers, Dealers, and Makers: Thoughts on Audience," in Martha Rosler, *Decoys and Disruptions: Selected Writings, 1975–2001* (Cambridge, MA: MIT Press/New York: International Center of Photography, 2004), 42. It must be noted that Rosler is a remarkably prolific and astute writer on art practice, her own and that of others, both historical and contemporaneous. Moreover, the commentary surrounding the Rosler's *Bowery* is ample and strong. For an excellent recent contribution to this literature, see Steve Edwards, *Martha Rosler: The Bowery in Two Inadequate Descriptive Systems* (London: Afterall, 2012).

2. Martha Rosler, "Post-Documentary, Post-Photography?" in *Decoys and Disruptions*, 217.

3. This definition continues: "(though its tools are somewhat more diverse and include the 'artless' control motives of police record keeping and surveillance)." Rosler also notes that documentary photography has had "well-articulated ties to social-democratic politics." Martha Rosler, "In, Around, and Afterthoughts: On Documentary Photography," in *Decoys and Disruptions*, 176.

4. Ibid., 180.

5. Benjamin H. D. Buchloh, "A Conversation with Martha Rosler," in *Martha Rosler: Positions in the Life World*, ed. Catherine de Zegher (Birmingham, UK: Ikon Gallery/Vienna: Generali Foundation/Cambridge, MA: MIT Press, 1998), 24.

6. "Martha Rosler in Conversation with Molly Nesbit and Hans Ulrich Obrist," in *Martha Rosler: Passionate Signals*, ed. Inka Schube (Ostfildern-Ruit, Germany: Hatje Cantz/Hannover, Germany: Sprengel Museum Hannover/New York: Distributed Art Publishers, 2005), 12.

7. Ibid., 14.

8. See Rosler, "In, Around," 180; "Martha Rosler in Conversation," 12, 24; Buchloh, "A Conversation," 23, 29, 43.

9. Those who appear strictly on the roster of documentary and are never mentioned by Rosler in the context of street photography are few by comparison: Larry Burrows, Robert Capa, Larry Clark, August Sander, W. Eugene Smith, Erich Salomon, and Weegee. Clearly, however, at least two of these, Sander and Weegee, are quite well known for the photographs they made in the streets of New York and Berlin. Aware of the intricacies of categorization, Rosler, in her first explanatory footnote to the term "documentary," relates that, in the postwar era, documentarians are "locating themselves, actively or passively, as privatists (Dorothea Lange), aestheticians (Walker Evans, Helen Levitt), scientists (Berenice Abbott), surrealists (Henri Cartier-Bresson), social historians (just about everyone, especially photojournalists like Alfred Eisenstaedt), and just plain 'lovers of life' (Arthur Rothstein)." She further notes another subsidiary of documentary,

"concerned photography," as emblematic of "the weakest possible idea of (or substitution for) social engagement, namely, compassion." Rosler, "In, Around," 175n.

10. Buchloh, "A Conversation," 29.

11. Rosler, "Post-Documentary," 226.

12. Ibid., 226.

13. Ibid., 225n.

14. I use "urban documentary" chiefly to linguistically permeate Rosler's category of critique in ways that "street photographs" cannot.

15. Rosler, "In, Around," 175–76.

16. These names are compiled from Rosler, "In, Around"; "Martha Rosler in Conversation," 12, 24; and Buchloh, "A Conversation," 23, 29, 43.

17. "Martha Rosler in Conversation," 24.

18. Buchloh has suggested for nearly twenty-five years that Rosler might have engaged more productively with the political collages of Dada, perhaps best exemplified by John Heartfield. See Buchloh, "A Conversation," 42–44; and Benjamin H. D. Buchloh, "Appropriation and Montage in Contemporary Art," *Artforum* 21, no. 1 (September 1982): 50.

19. Rosler, "In, Around," 176.

20. Ibid., 177.

21. Max Kozloff, *New York: Capital of Photography* (New York: Jewish Museum/New Haven, CT: Yale University Press, 2002), 15–16.

22. Rosler, "Post-Documentary," 221.

23. Rosler cited William Stott's *Documentary Expression and Thirties America* (New York: Oxford University Press, 1973); F. Jack Hurley's *Portrait of a Decade: Roy Stryker and the Development of Documentary Photography in the Thirties* (Baton Rouge: Louisiana State University Press, 1972); and Roy Stryker's *In This Proud Land: America, 1935–1943, as Seen in FSA Photographs* (Greenwich, CT: New York Graphic Society, 1973).

24. Rosler, "In, Around," 185 and 185n.

25. For more on these not mutually exclusive groups, see Anne Tucker, Claire Cass, and Stephen Daiter, *This Was the Photo League: Compassion and the Camera from the Depression to the Cold War* (Chicago: Stephen Daiter Gallery/Houston: John Cleary Gallery, 2001); and Livingston, *New York School*.

26. The league's courses, exhibitions, and programs fastidiously addressed the concept of documentary years before Beaumont Newhall would include a reference to it in his historical survey of photography. Tucker made clear just how unusual and important the activities of the league were in a city where there were so few places to see original photographs or even reproductions and before the comprehensive publications. Tucker, Cass, and Daiter, *This Was the Photo League*, 10, 14.

27. Ibid., 9.

28. Naomi Rosenblum, "The Photo League: A Humanist Approach," in *Photo League: New York 1936–1951*, ed. Enrica Viganò (Trieste, Italy: Il Ramo d'Oro, 2001), 11.

29. Anne Tucker, "Photographic Crossroads: The Photo League," *National Gallery of Canada Journal* 25 (April 1978): 7. See also Aaron Siskind, "The Feature Group" (1940), in *Aaron Siskind: Toward a Personal Vision, 1935–55*, ed. Deborah Martin Kao and Charles A. Meyer (Chestnut Hill, MA: Boston College Museum of Art, 1994), 27–28; Deborah Martin Kao, "Personal Vision in Aaron Siskind's Documentary Practice," in Kao and Meyer, *Aaron Siskind*, 15; and Carl Chiarenza, *Aaron Siskind: Pleasures and Terrors* (Boston: Little, Brown, 1982), 27.

30. Buchloh, "A Conversation," 43.

31. Rosler, "In, Around," 178–79.

32. Ibid., 178, 195.

33. Tucker, "Photographic Crossroads," 7. This shift was signaled by the Photo League's 1947 declaration to become a "Center of American Photography," in a move away from its documentary origins. See Tucker, Cass, and Daiter, *This Was the Photo League*, 17.

34. Martha Rosler, "Afterword: A History," in *Martha Rosler, 3 Works* (Halifax: Press of the Nova Scotia College of Art and Design, 2006), 97.

35. Nathan Lyons, ed., *Toward a Social Landscape: Bruce Davidson, Lee Friedlander, Garry Winogrand, Danny Lyon, Duane Michals* (New York: Horizon Press, 1966), 5.

36. Ibid., 5–6. Rosler has contended that such works should not be considered as snapshots because they refuse one of its signature qualities: the commemoration of an event, person, or moment.

37. Ibid., 7.

38. Mary Orovan, "Garry Winogrand," *U.S. Camera* 29, no. 2 (February 1966): n.p. Quoted in Lyons, *Toward a Social Landscape*, 7.

39. Lyons, *Toward a Social Landscape*, 7.

40. John Szarkowski, *Looking at Photographs: 100 Pictures from the Collection of the Museum of Modern Art* (New York: Museum of Modern Art, 1973), 204.

41. Quoted in Rosler, "In, Around," 189. Rosler notes here that this triumvirate's most relevant aesthetic predecessors are not, as Szarkowski suggested, the social documentarians of the 1930s but rather what she deems the "bohemian photographers," such as Brassaï, Kertész, and Cartier-Bresson.

42. Szarkowski claimed that, from 1960 on, Winogrand did not take his pictures for his audience but rather for himself: "Without any clear idea of where, or if, a broader audience might exist. . . . [Winogrand's] essential, supportive audience was often small enough to gather around a café table." In such a statement, Szarkowski disallowed an audience external to the artistic process of creating photographs. See Szarkowski, *Winogrand*, 130.

43. Martha Rosler, "Lee Friedlander, an Exemplary Modern Photographer," in *Decoys and Disruptions*, 128, 123, respectively.

44. Deutsche, "Alternative Space," 61. See also Deutsche, introduction to *Evictions*, xvii.

45. Rosler wanted to work within both documentary and art institutions in order to try and change them. Rosler, "Afterword: A History," 99.

46. Deutsche, "Alternative Space," 52.

47. Buchloh, "A Conversation," 38. Rosler's archaeology was not intended to dismiss or discount urban documentary practice, which is a common misreading of her essay "In, Around, and Afterthoughts." In the years since its initial publication, she has taken more than one opportunity to point out that any message of abandonment found there is the reader's interpretation, not hers. See Rosler, "Afterword: A History," 100; Rosler, "Post-Documentary," 236; Buchloh, "A Conversation," 45; and "Martha Rosler in Conversation," 26, 28.

48. In her 2006 "Afterword," Rosler included the following footnote next to this information: "A native New Yorker, I was in the midst of a decade of living and studying in San Diego county, with a few breaks of varying length back in New York; this one lasted eight or nine months." Rosler, "Afterword: A History," 94. She lived at the northernmost end of the Bowery; in 1973 her address was 109 St. Mark's Place.

49. She took the photographs over the course of "a couple of days" but printed and edited them six months later, once she was back in California. Ibid.

50. Rosler, "In, Around," 194–95.

51. When asked about how self-conscious her relationship to Evans's work was while making her own photographs of the Bowery, Rosler has said that Evans proved "the least Norman Rockwell–like because least small-town oriented." Buchloh, "A Conversation," 39.

52. Kozloff, *New York*, 24.

53. Ibid., 25.

54. Buchloh, "A Conversation," 38.

55. Thomas Crow, "These Collectors, They Talk about Baudrillard Now," in *Art and the Public Sphere*, DIA Art Foundation, Discussions in Contemporary Culture 6, ed. Hal Foster (Seattle: Bay Press, 1987), 1.

56. Buchloh, "Appropriation and Montage," 52–53.

57. "Martha Rosler in Conversation," 24.

58. Buchloh, "A Conversation," 44.

59. Ibid., 33.

60. Craig Owens, "On Art and Artists: Martha Rosler," *Profile* (Chicago: Video Data Bank, School of Art Institute of Chicago) 5, no. 2 (Spring 1986): 30.

61. Alexander Alberro has suggested that the backing boards make the "words appear not as captions floating on a page but rather as bounded images, just like the photographs." Alexander Alberro, "The Dialectics of Everyday Life: Martha Rosler and the Strategy of the Decoy," in de Zegher, *Martha Rosler: Positions*, 99–100. Bound they may be, but such a characterization only reinforces the sense that the textual component is nonphotographic.

62. When installed on a wall, the sequence unfolds left to right and top to bottom across rows of a grid of variable layouts (6 boards ×

4 boards, 4 × 6, or 5 × 5 with a blank position at the end). Rosler, "Afterword: A History," 95.

63. Rosler has revealed that there was a second title under consideration during the work's creation, in which "insufficient" took the place of "inadequate." See Rosler, "Afterword: A History," 69n.

64. Rosler, "In, Around," 194; Rosler, "Afterword: A History," 96.

65. Rosler, "In, Around," 194.

66. Rosler, "Afterword: A History," 96.

67. Ibid., 95.

68. Ibid., 94.

69. Rosler was aware of the critical discourse on photographic sequencing through her readings of Barthes's structural analyses; Benjamin's reflections on captions (his "Short History" in particular); Brecht's analysis of realism; and the Birmingham cultural studies authors. See Buchloh, "Appropriation and Montage," 53; Buchloh, "A Conversation," 33; Silvia Eiblmayr, "Martha Rosler's Characters," in de Zegher, *Martha Rosler: Positions*, 155; and Alberro, "Dialectics," 75, 86.

70. Buchloh, "A Conversation," 37.

71. In graduate school, Rosler found peers in Fred Lonidier, Alan Sekula, and Phil Steinmetz. She studied with Alan Kaprow and David and Eleanor Antin, and her group of peers interacted with students of Frederic Jameson and Herbert Marcuse. See Buchloh, "A Conversation," 32–33; and Owens, "On Art," 17–22.

72. Buchloh, "A Conversation," 28.

73. Ibid., 31. For more, see "Martha Rosler in Conversation," 32.

74. Ehrenreich, *Fear of Falling*, 17–18.

75. See ibid., 8, 27, 29, 42, 47.

76. Ibid., 53.

77. David Burnham, "Two-Man Teams to Offer Help to Bowery Derelicts," *New York Times*, October 7, 1967, 31. Rosalyn Deutsche, "Krysztof Wodiczko's *Homeless Projection* and *The Site of Urban 'Revitalization,'*" in *Evictions*, 47. Unfortunately, all estimates of the homeless population, whether nationwide or particular to New York City, are variable and unreliable. As historian Kim Hopper has pointed out, they are "subject to wild discrepancy depending on methods of estimation used, sources relied on, the season of year,

and . . . the intended purpose of the count." Kim Hopper, *Reckoning with Homelessness* (Ithaca, NY: Cornell University Press, 2003), 69. For statistics prior to 1967, see Benedict Giamo, *On the Bowery: Confronting Homelessness in American Society* (Iowa City: University of Iowa Press, 1989), 14–15.

78. While there are contemporary references to some homeless women and children, all sources consulted for this chapter agree that the problem of homelessness in New York predominantly affected white men over the age of fifty. Regarding drunkenness among these men, a 1969 study found that more than one-third of those on the Bowery were "heavy drinkers," in comparison with one-eighth of the control sample ("a low-income, racially mixed neighborhood in Brooklyn"). Francis X. Clines, "Study Finds Bowery Losing Derelicts," *New York Times*, January 27, 1969, 21.

79. See Hopper, *Reckoning with Homelessness*, 6–7.

80. "Self-Help Is the Goal of a Skid-Row Project," *New York Times*, July 10, 1973, 33; Dena Kleman, "Remember the Neediest—Share Blessings with Others: Many Poor Who Have Despaired of Hope Are Helped by 2 Agencies," *New York Times*, December 14, 1975, 46.

81. Quoted in Burnham, "Two-Man Teams," 31. These roundups, permissible under New York's public intoxication laws, were the basis for the slang phrases still in use today: "on the wagon" or "off the wagon."

82. Pranay Gupte, "The Derelict Population Is Declining, but the Whole City Is Its 'Flophouse': Derelict Population Here Is Declining," *New York Times*, October 23, 1973, 58; Sydney H. Schanberg, "City to Dry Out Bowery Drunks: Voluntary Center Will Open Downtown in a Month," *New York Times*, November 22, 1966, 29.

83. Hopper, *Reckoning with Homelessness*, 7, 63.

84. Gupte, "The Derelict Population," 58. Crucially, the "decline" in the New York City homeless population also referenced in the article's heading stands for a decline since World War II–era statistics. In fact, the article says there may have been as many as 75,000 homeless people, one of the highest numbers in the range for this period.

85. Rosler, "Fragments," 21.

86. Ibid.

87. Hopper, *Reckoning with Homelessness*, 62. The "sociological position" refers to her 1979 study.

88. Ibid., 63.

89. "Center for Derelicts to Be Built by City: Center for Derelicts to Be Built by City on Island in East River," *New York Times*, October 14, 1965, 1, 31.

90. To be clear, this essay is not considered a part of *The Bowery*.

91. Rosler, "In, Around," 178. See also her 2006 description of that period in Rosler, "Afterword: A History," 94. If *The Bowery* project accomplished the tethering of urban documentary practices to class concerns, then Rosler's later project *If You Lived Here . . .* (1987–89) fully synthesized an understanding of urban space—particularly that of city streets—and homelessness. With a title taken from the "back-to-the-city" movement of the 1970s and 1980s and focused specifically on New York City, the project included three discrete thematic exhibitions in 1989: *Home Front*, which addressed housing issues; *Homeless: The Street and Other Venues*, which explored the problem of homelessness in the city; and *City: Visions and Revisions*, which considered architectural schemes, strategies, and utopias. Devised at the invitation of the Dia Foundation, the three-part project coincided with a corresponding forum on each topic, as well as one on artists' housing, and an outgrowth publication in 1991. For more, see Deutsche, "Alternative Space," 62–65; and Alberro, "Dialectics," 110.

92. Quoted in Susan Buck-Morss, "The Flâneur, the Sandwichman, and the Whore: The Politics of Loitering," *New German Critique* 39 (Fall 1986): 114. Buck-Morss dated this formulation to 1927–29 and noted that in the later 1929 published version of this statement the term is changed from "collective" to "masses."

93. Deutsche, introduction to *Evictions*, xxiv.

94. Rosler, "Fragments," 19.

95. Jane Jacobs, *The Death and Life of Great American Cities* (New York: Random House, 1961).

96. Deutsche, "Krysztof Wodiczko," 12–13. Deutsche is quoting from Bruce London and J. John Palen, "Introduction: Some Theoretical and Practical Issues Regarding Inner-City Revitalization," in *Gentrification, Displacement and Neighborhood Revitalization*, ed. J. John Palen and Bruce London (Albany: State University of New York Press, 1984), 10.

97. Rosalyn Deutsche and Cara Gendel Ryan, "The Fine Art of Gentrification," *October* 31 (Winter 1984): 96.

98. See Rosler, "Fragments," 25; and Rosler, "Afterword: A History," 94. Demographically, both Rosler and Deutsche have acknowledged the far more ambiguous and overlooked role of artists in such dramatic reorientations of urban space. See Rosler, "Fragments," 31; and Deutsche and Ryan, "Fine Art of Gentrification," 91–92. Rosler was not the only artist who lived near the Bowery; by the mid-1960s, Robert Indiana, Jasper Johns, Robert Rauschenberg, Mark Rothko, Robert Ryman, and Tom Wesselman, among others, had already taken up residence there. Most were drawn by the plentiful sunlight afforded by the lack of high-rises and "dirt-cheap" rents for home and studio. See, for example: Bernard Weinraub, "The Bowery Blossoms with Artists' Studios: Area Is 'Hogarthian,' but Has Low Rent and Big Rooms," *New York Times*, January 2, 1965, 21, 22; Lawrence O'Kane, "The Bowery Awakens to an Upbeat Trend, The New Bowery: An Era of Change, Shops, Theaters and Artists Drift Down the Street," *New York Times*, October 16, 1966, 1, 12; and Thomas W. Ennis, "Bowery Hotel Where Derelicts Slept Being Converted to Artist Studios: Derelicts' Homes Becoming Studios," *New York Times*, August 6, 1967, 1, 6. More recently, see Joy Press, "The Last Days of Loserville: Once Home to Hustlers, Drunks, and Bohemians, America's Slummiest Street Has Turned into a New Millionaire's Row," *Village Voice*, February 22, 2005, http://www.villagevoice.com/2005-02-22/nyc-life/the-last-days-of-loserville/ (accessed February 26, 2012).

99. Deutsche, "Agoraphobia," 278.

100. For the "intrusive figure," see Christopher Phillips, "The Uses of Strangers," in *Strangers: The First ICP Triennial*, 60.

101. Giamo, *On the Bowery*, 16.

102. Ibid., 16, 18. On urban sidewalks and homelessness, see Loukaitou-Sideris and Ehrenfeucht, *Sidewalks*, esp. chap. 8, 157–87.

103. In the twentieth century, the class composition of New York City shifted dramatically; the percentage of the labor force made up of blue-collar workers dropped steadily, from 59 percent in 1929 to 47 percent in 1957 to a mere 33 percent in 1980. Deutsche and Ryan, "Fine Art of Gentrification," 94–95.

104. See Ennis, "Bowery Hotel"; O'Kane, "The Bowery Awakens"; and Weinraub, "The Bowery Blossoms." Press's 2005 eulogy for the Bowery in the *Village Voice* concluded: "Once upon a time, this wasn't just a city of winners: The Bowery is proof that New York had a place for life's losers too." Press, "Last Days," n.p.

105. Rosler, "In, Around," 175–76.

106. Other sources list the term as *"bouwerij."* "Siren Song of the Bowery Is Muffled," *New York Times*, October 23, 1973, 76.

107. The Bowery originates in Chatham Square and continues one mile north to Cooper Square, where it splits into Third and Fourth Avenues. An offshoot street at Chatham Square was once named "New Bowery" but was changed to St. James Place to confer more respectability. Luc Sante also notes that the stereotypical New York accent originated in the area surrounding the Bowery. Luc Sante, *Low Life: Lures and Snares of Old New York* (New York: Farrar, Straus and Giroux, 1991), 14 and xiii, respectively.

108. For more, see Giamo, *On the Bowery*, 6–7. For a sense of popular depictions of the Bowery in literary, filmic, and musical theater works from the late nineteenth century through the 1970s, see Edwards, *Martha Rosler*, 14–15.

109. Giamo, *On the Bowery*, xiv.

110. Ibid., 19.

111. Ibid., 25. The estimated total homeless population in New York City at this time was sixty thousand.

112. Ibid., 22. This tradition continued in modified form as late as 2003. See Hopper, *Reckoning with Homelessness*, 6.

113. By the early 1900s, the Bowery's population numbered some twenty-five thousand men. The numbers of homeless on the Bowery only increased in the 1920s,

following World War I and the widespread unemployment caused by the Great Depression. Up until 1940, unemployment had so direct a causal relationship to homelessness that "occupancy in the Bowery's Men's Shelter . . . [provided] a reliable index of the rate of unemployment in the [city's] manufacturing industry." Ibid., 26–28.

114. See Giamo, *On the Bowery*, 29; and "Siren Song," 76.

115. Hopper cites a legislative report's estimate of four thousand Bowery homeless from 1969 to 1975. By 1978 the aforementioned citywide dispersal is evidenced by her estimate of thirty-six thousand homeless people throughout New York City. See Hopper, *Reckoning with Homelessness*, 61. Giamo refers to three thousand in 1971; Giamo, *On the Bowery*, 29. This same number appears throughout 1970s newspaper coverage of the issue. By 1980 estimates were down to two thousand; Giamo, *On the Bowery*, 29. By the century's end they were down to one thousand; see David Isay and Stacy Abramson, *Flophouse: Life on the Bowery* (New York: Random House, 2000), n.p. This sharp decline had strong links to housing legislation (in 1955, municipal law forbade all construction of single-room occupancy or SRO hotels), to gentrification (existing SROs were increasingly zoned for residential conversion into lofts, often explicitly for artists, throughout the 1960s), and, more broadly, to the gradual dispersion of the homeless population throughout the city.

116. Hopper, *Reckoning with Homelessness*, 6.

117. Giamo, *On the Bowery*, 28.

118. Rosler, "In, Around," 194.

119. Ibid., 195. The liminality of this doorway zone—as a vulnerable public space affording a modicum of privacy—is perhaps best expressed by the fact that it motivated teenage boys from the neighborhood to perpetrate a particularly heinous crime. Just eight years before Rosler began her project, on September 16, 1966, "gasoline was splashed on the men, Bowery derelicts, as they slept in doorways. Then lighted matches were thrown on them." Six days later, one of the men, Leonard Benton, died from his second- and third-degree burns. Maurice Carroll,

"No-Arrest Policy Is Hailed on Bowery," *New York Times*, September 22, 1966, 43.

120. Michael Zettler, *The Bowery* (New York: Drake Publishers, 1975).

121. Ibid., 24.

122. Rosler, "In, Around," 191.

123. Ibid.

124. Burnham, "Two-Man Teams," 31.

125. Martha Gever, "An Interview with Martha Rosler," *Afterimage* 9, no. 3 (October 1981): 15.

126. Rosler, "Afterword: A History," 94. In a recent interview with Rosler, Buchloh asked her exactly where the work had been displayed during the time between its creation and its publication. She responded, "I don't keep such records, but perhaps at the 1975 show 'Information,' at the San Francisco Art Institute or the 1977 show there called 'Social Criticism and Art Practice.' Possibly late in '75 at the Whitney Museum Downtown. Certainly at the Long Beach Museum in '77, in a solo show David Ross gave me when he was the director there, and in a solo show at and/or in Seattle in '78. I showed it at A-Space in Toronto. And I think I showed it at Véhicule Art in Montreal. It may have been shown at one or two other places in the 70s, and it was shown at the Vienna Secession in 1981 around the time the book you published came out." See Buchloh, "A Conversation," 44–45. Although Rosler was included in a Whitney Downtown exhibition, its title alone, "Autogeography: An Exploration of the Self through Film, Objects, Performance, and Videos," suggests that *The Bowery* would have been a highly unlikely inclusion. Far more likely is her 1977 video performance work *Vital Statistics of a Citizen Simply Obtained*. As for the other locations listed in the interview with Buchloh, I have found no records confirming *The Bowery*'s display there, nor have I found any substantiation of Edwards's claim that *The Bowery* was on view in a museum or gallery between 1975 and 1977 (see Edwards, *Martha Rosler*, 1). In the same interview with Buchloh, Rosler made it clear that *The Bowery* was never for sale from 1975 until 1982; Buchloh, "A Conversation," 44–45. See also Rosler, "Afterword: A History," 99, and Gever, "An Interview," 15.

127. Allan Sekula, "Dismantling Modernism, Reinventing Documentary (Notes on the Politics of Representation)," *Massachusetts Review* 19 (Winter 1978): 859–83.

128. Ibid., 867.

129. Rosler, "Afterword: A History," 97. In another recent recollection of the publication's discussion, Rosler has explained her decision to take charge of her own work's interpretation: "As to the Bowery essay, I had neither the desire nor the intention to write something about documentary, but Benjamin Buchloh all but demanded it for my book. He said the Bowery work needed an essay or introduction. I resisted, saying, I've done the work, why repeat it in another form? What he said amounted to 'If I didn't get it, no one will. You have to tell us what this work is about.'" "Martha Rosler in Conversation," 38.

130. The work, displayed in thin black frames, appears in grid formation on a single gallery wall. As Edwards notes, it was shown in documenta 12 in 2007 across the right angle of two walls. Edwards, *Martha Rosler*, 4.

131. Rosler, "Afterword: A History," 96.

132. Buchloh, "A Conversation," 42.

133. Rosler, "Afterword: A History," 95.

134. Ibid., 96.

135. This contrasts with a part of Rosler's critique of Friedlander's street photography, which "is not a stand-in for our presence in the real-world moment referred to by the photo but an appropriation of it." Rosler, "Lee Friedlander," 123. In part, Rosler can expect a recognition of her individual walk down the Bowery as a more collective one because, to borrow from Deutsche, public space exceeds the individual but is not necessarily outside the individual. See Deutsche, "Agoraphobia," 302–9.

136. Deutsche, "Agoraphobia," 286.

137. As Brian Wallis has reminded us, by way of Franz Fanon, all public identities are necessarily unfixed, temporal, and relational, shaped by power relations, external projections, internal anxieties, cultural encounters, and more. See Brian Wallis, "Ethnographies of Everyday Life," in *Strangers: The First ICP Triennial*, 178. See also Phillips, "Uses of Strangers," 60; and Deutsche, "Agoraphobia," 325–26.

138. Peter Bacon Hales, *Silver Cities: The Photography of American Urbanization, 1839–1915* (Philadelphia: Temple University Press, 1984), 280; Carol Squiers, "The Stranger," 13, respectively.

139. Buck-Morss, "The Flâneur," 114.

140. Ehrenreich, *Fear of Falling*, 15.

141. Martha Rosler, "For an Art against the Mythology of Everyday Life," in *Decoys and Disruptions*, 8.

142. Rosler has acknowledged Brecht's role in her critical thinking about art: "As readers of Brecht, we wanted to use obviously theatrical or dramatized sequences or performance elements together with more traditional documentary strategies, to use text, irony, absurdity, mixed forms of all types." Buchloh, "A Conversation," 33, 55. See also Owens, "On Art," 19–21, but for the most detailed analysis of Rosler's relationship to Brecht, see Philip Glahn's chapter, "Martha Rosler: Refusal, Documentation, and Realism," from his "Estrangement and Politicization: Bertolt Brecht and American Art, 1967–79" (PhD diss., City University of New York, 2007), 48–128.

143. Buck-Morss, "The Flâneur," 128.

144. Owens, "On Art," 22.

145. Buchloh, "Appropriation and Montage," 50. In this article, Buchloh also notes the importance of Rosler's own position outside the institutional framework and distribution system. Ibid., 56. See also Alberro, "Dialectics," 79.

146. Buchloh, "A Conversation," 45.

147. I borrow this question from Deutsche. Deutsche, "Alternative Space," 61.

148. Buchloh, "A Conversation," 50–51. In two publications since this interview with Buchloh, Rosler has again, if somewhat retroactively, advocated for *The Bowery* as an urban study of the street as a social space: "The Bowery project thus becomes a work about territory, habitation, and representation. . . . I have said from the beginning that this Bowery project is a walk down the street called the Bowery, and thus a walk in the heart of the city, with its social relations laid bare." "Martha Rosler in Conversation," 22, 24.

149. Deutsche, "Alternative Space," 47.

150. "Martha Rosler in Conversation," 29.

151. Rosler, "Notes on Quotes," 145.

152. Based on Rosler, "In, Around," 195.

PHILIP-LORCA DICORCIA
ANALOGUES OF REALITY

Quoted in Tim Griffin, "Private Eye," *Time Out New York*, September 6–13, 2001, 113.

Gilles Mora, "Havana, 1933: A Seminal Work," in Walker Evans, *Walker Evans: Havana 1933* (London: Thames and Hudson, 1989), 17–18.

1. Peter Galassi, "Photography Is a Foreign Language," in *Philip-Lorca diCorcia* (New York: Museum of Modern Art/Harry N. Abrams, 1995), 14.

2. The street was not the first productive location for diCorcia, nor has it remained an exclusive one. Domestic interiors, populated by friends and family members, are the setting for what he now recognizes as his earliest serious work. A recent body of photographs, *Lucky 13*, captures strippers midroutine amid the dark veneers and mirrored surfaces of strip clubs. Philip-Lorca diCorcia, *Lucky Thirteen: Philip-Lorca diCorcia* (New York: PaceWildenstein, 2005).

3. Several critics besides Galassi have reinforced this artistic legacy. See Weski, "Contemplation," n.p.; Yilmaz Dziewior, "Philip-Lorca diCorcia," *Artforum* 36, no. 6 (February 1998): 101; and Andy Grundberg, "Street Fare: The Photography of Philip-Lorca diCorcia," *Artforum* 37, no. 6 (February 1999): 80–83.

4. Grundberg, "Street Fare," 81–82.

5. "Philip-Lorca diCorcia: *Heads*," PaceWildenstein gallery press release (2001), n.p. See also Sante, *Low Life*, 14; Michael Kimmelman, "Art in Review: Philip-Lorca diCorcia, 'Heads,'" *New York Times*, September 14, 2001, E26; and Dziewior, "Philip-Lorca diCorcia," 101.

6. Gilles Mora and John T. Hill, *Walker Evans: The Hungry Eye* (New York: Harry N. Abrams, 1993), 8.

7. Ibid., 34.

8. Mora, "Havana, 1933," 11.

9. Evans also made street photographs in Havana. For details on those photographs, see ibid., 12, 16, 18; Walker Evans, *Walker Evans at Work: 745 Photographs Together with Documents Selected from Letters, Memoranda, Interviews, Notes* (New York: Harper and Row, 1982), 10, 13.

10. The final edited group was not published until 1966. For more on the chronology of the project and its publication, see Jeff L. Rosenheim, afterword to Walker Evans, *Many Are Called* (New Haven, CT: Yale University Press, 2004), 199–200, 202–4. See also Luc Sante, foreword to *Many Are Called*, 11. For a complete selection of Evans's writing about the *Subway Portraits*, see Evans, *Walker Evans at Work*, 160.

11. Rosenheim, afterword to *Many Are Called*, 197; John Szarkowski, introduction to *Walker Evans* (New York: Museum of Modern Art, 1971), 18.

12. Luc Sante, "The Planets," in *Philip-Lorca DiCorcia: Heads* (Göttingen, Germany: Steidl, 2001), n.p.

13. See James Agee, introduction to *Many Are Called*, 15. See also Sante, foreword to *Many Are Called*, 14.

14. Evans, *Walker Evans at Work*, 152.

15. Belinda Rathbone, "Walker Evans: Lost and Found," in *The Lost Work* (Santa Fe, NM: Arena Editions, 2000), 254.

16. Quoted from a 1973 interview in Mora and Hill, *Walker Evans*, 270. See Walker Evans, "Chicago—A Camera Exploration of the Huge, Energetic Urban Sprawl of the Midlands," *Fortune*, February 1947, 118.

17. Szarkowski, introduction to *Walker Evans*, 19. See also Mora and Hill, *Walker Evans*, 12, 34, 270; and Peter Galassi, *Walker Evans and Company* (New York: Museum of Modern Art, 2000), 27–29.

18. Britt Salvesen has proposed that Callahan may have begun making photographs on the street after viewing published street photography. Britt Salvesen, *Harry Callahan: The Photographer at Work* (Tucson: Center for Creative Photography/New Haven, CT: Yale University Press, 2006), 28. Callahan's awareness of Evans is not supported by Sarah Greenough; see her "The Art of Seeing," in *Harry Callahan* (Washington, DC: National Gallery of Art, 1996), 55n55.

19. Barbaralee Diamonstein, "Harry Callahan," in *Visions and Images: American Photographers on Photography* (New York: Rizzoli, 1982), 15. Callahan explained this project in consistently similar terms. See Sally Stein, *Harry Callahan: Photographs in Color,*

The Years 1946–1978 (Tucson: Center for Creative Photography, University of Arizona, 1980), 7–8; and "Harry Callahan: A Life in Photography," interview in *Harry Callahan Photographs: An Exhibition from the Hallmark Photographic Collection*, ed. Keith F. Davis (New York: Hallmark Cards, 1981), 54, 60.

20. For technical details, see John Szarkowski, introduction to *Callahan* (Millerton, NY: Aperture, 1976), 20–21; and "Harry Callahan: A Life in Photography," 54.

21. Importantly, Abigail Solomon-Godeau has noted that "Callahan's vision of the metropolis requires the suppression of those aspects of the city that are communal, interactive, and productive of social space and social relations." Abigail Solomon-Godeau, "Harry Callahan, Street Photography, and the Alienating City," in *Harry Callahan: Variations on a Theme*, The Archive, no. 35 (Tucson: Center for Creative Photography, University of Arizona, 2007), 27.

22. While it is uncertain whether Callahan helped design this installation, he would certainly have approved it. This experience for viewers approximated the aesthetic of his two brief experiments with moving images in 1948–49. Entitled *Motions* and *People Walking on State Street*, these projects were more successful in Callahan's opinion because "it was just the people walking—walking towards me and across the frame." "Harry Callahan: A Life in Photography," 58.

23. Callahan simultaneously produced another group of superimposed pictures that merge erotic images of women with photographs of building facades "to address the huge gulf between our desires and our reality." Greenough, "Art of Seeing," 52.

24. Szarkowski, introduction to *Callahan*, 14.

25. Notably, when diCorcia arrived in 1978, Evans had just recently stepped down as head of the program.

26. Bennett Simpson, "Philip-Lorca diCorcia: The Exploded View," in Simpson et al., *Philip-Lorca diCorcia*, 14, 16.

27. This interview also contains diCorcia's description of his early attempt at Conceptual art. Nan Richardson, "Philip-Lorca diCorcia

Speaks with Nan Richardson," in *Conversations with Contemporary Photographers: Joan Fontcuberta, Graciela Iturbide, Max Pam, Duane Michals, Miguel Rio Branco, Philip-Lorca diCorcia, Alex Webb, Bernard Plossu, Javier Vallhonrat* (New York: Umbrage Editions, 2005), 176–77. (Though published in 2005, Richardson conducted her interviews with diCorcia on May 8 and May 18, 2003.)

28. Lynne Tillman, "Interview with Philip-Lorca diCorcia," in Simpson et al., *Philip-Lorca diCorcia*, 103. DiCorcia's statement—"I like to see the world as the world is. I don't want to see it as a photograph"—directly references a frequently invoked Winogrand quote about photographing to see what things will look like as photographs. Elsewhere, diCorcia has said that it took him years to appreciate how "difficult it was to make a Winogrand." Galassi, "Photography Is," 10.

29. Tillman, "Interview," 94–95.

30. Simpson, "Exploded View," 12–13.

31. Peter Galassi, "Philip-Lorca diCorcia," *Artforum* 39, no. 10 (Summer 2001): 169.

32. Kimmelman, "Art in Review," E26.

33. Denis Angus, "Philip-Lorca diCorcia: Faire le trottoir" [Putting a gloss off things], trans. Angus and Sandra Petch, *Art Press* 297 (January 2004): 45.

34. Griffin, "Private Eye," 113.

35. Richardson, "Philip-Lorca diCorcia Speaks," 174.

36. Sante, "The Planets," n.p. See also Galassi, "Photography Is," 14.

37. This phrase was used to describe the portion of an earlier body of photographs, *Hustlers*, which he made in the urban landscape of Los Angeles. "Philip-Lorca diCorcia: *Strangers*," Museum of Modern Art press release (March 1993), 1.

38. Richardson, "Philip-Lorca diCorcia Speaks," 173–74.

39. Ibid., 173.

40. This technique was deployed in Times Square in "two places mostly." See Tillman, "Interview," 94. One source says the pictures were taken at rush hour, further enhancing the density of the pedestrian traffic. Ilaria Bonacossa, "Philip-Lorca diCorcia," *Flash Art* 34, no. 221 (November/December, 2001): 93. DiCorcia himself has only said, "It was a busy

city street and people were crossing back and forth." Richardson, "Philip-Lorca diCorcia Speaks," 173.

41. Tillman, "Interview," 94. Some of these Polaroids have recently been published in *Thousand* (Göttingen, Germany: Steidl, 2007) and were exhibited at the Los Angeles County Museum of Art from May 23 to September 14, 2008.

42. Richardson, "Philip-Lorca diCorcia Speaks," 173.

43. "'A lot of people think there was a trigger and that people [on the street] activated their own picture, but it's not true,' [diCorcia] reveals. 'I did it with the shutter. The thing with working with this very long lens is that you can't really look through it: people pass through it too quickly. So, I had to establish a certain height, a certain frame and a certain point of focus, and the only way that I could tell anyone was there was by looking at a mark that I put on the ground. When someone would hit that mark and I wanted to take their picture I would. And very often they were out of focus because it was really a matter of inches, the depth of field was tiny.'" Quoted in Simon Bainbridge, "Everyday Life," *British Journal of Photography* 150, no. 7436 (July 2, 2003): 33.

44. For specific passages, see Sante, "The Planets," n.p.; Dziewior, "Philip-Lorca diCorcia," 101; and Bainbridge, "Everyday Life," 31. Certainly these comments have been made with an awareness of diCorcia's earlier emphasis on lighting; for a technical discussion, see Steve Herne, "'Download': 'Postcards Home'—Contemporary Art and New Technology in the Primary School," *International Journal of Art and Design Education* 24, no. 1 (2005): 8.

45. DiCorcia elaborates: "It is pretty conventional lighting, it is just that to find it there is unusual." Quoted in Bainbridge, "Everyday Life," 33.

46. See, for example, Grundberg, "Street Fare," 80–81; "Philip-Lorca diCorcia," *Guardian Unlimited*, January 30, 2002, http://www.guardian.co.uk/culture/2002/jan/30/artsfeatures4 (accessed January 20, 2012).

47. See, for example, Barry Schwabsky, "Philip-Lorca diCorcia," *Contemporary* 67 (2004): 27.

48. Sante, "The Planets," n.p. See also Kimmelman, "Art in Review," E26.

49. Quoted in Bainbridge, "Everyday Life," 33.

50. This is not to be confused with "theatricality" in art historian Michael Fried's use of the term, referring to a theatrical relationship between an artwork and its viewer.

51. In the framing of a scene, one style recognizes all that extends unseen in the world outside the frame (as in the work of François Truffaut), while the other presents a more sealed-off vision, in which the camera's point of view dominates and even overpowers (as in the work of Alfred Hitchcock). Galassi, "Photography Is," 7.

52. Tillman, "Interview," 94.

53. See Josefina Ayerza, "Philip-Lorca diCorcia," *Lacanian Ink* 14, www.lacan.com/frameXIV9.htm (accessed January 20, 2012).

54. Simpson, "Exploded View," 19.

55. James Traub, "Common of Earthly Delights," *New York Times Magazine* (March 14, 2004), 48.

56. Marshall Berman, *On the Town: One Hundred Years of Spectacle in Times Square* (New York: Random House, 2006), xxi. As the Berman quotation indicates, two events in 1904 pivotally transformed what had, until that year, been known as Longacre Square: the *New York Times* completed its office building on the triangular island just north of the square's intersection, effecting the rechristening of the area as Times Square; and the subway system opened its first branch with a stop at Times Square that would soon serve as a convergence point in an expanding network.

57. Gas lights came to Broadway in 1825; electric in 1882. Sante, *Low Life*, 10.

58. James Traub, *The Devil's Playground: A Century of Pleasure and Profit in Times Square* (New York: Random House, 2004), 21.

59. Ibid., 22. The electric streetlights lining Broadway had partially laid the foundation for such transitory crowds, having encouraged pedestrian presence along Broadway at all hours since the mid-1890s, particularly in the stretch between 28th and 42nd Streets. Ibid., 14.

60. Burns, Sanders, and Ades, *New York*, 293.

61. William R. Taylor, *Inventing Times Square: Commerce and Culture at the Crossroads of the World* (New York: Russell Sage Foundation, 1991), xi–xii.

62. Quoted in Traub, *Devil's Playground*, 45.

63. Times Square was so overtaken by spectaculars that regulations were eventually imposed, effectively zoning the square as the only city district that could be lit in this way.

64. While not limited to the theaters of Broadway, the musical found no shortage of venues there, with sixty-six theaters in operation showcasing more than two hundred different productions in 1926 alone. Burns, Sanders, and Ades, *New York*, 299, 346–47, 350.

65. Ibid., 351.

66. The New Amsterdam had resisted the 1930s trend of theaters being repurposed as movie houses and burlesque halls, but by the advent of World War II even these latter venues struggled to survive in large numbers, and the area became less exclusively associated with crowds seeking mass entertainment. See ibid., 449; and Traub, *Devil's Playground*, 91.

67. Quoted in Traub, *Devil's Playground*, 100. See also Burns, Sanders, and Ades, *New York*, 478.

68. Michael Kimmelman, "Assignment Times Square," *New York Times Magazine*, May 18, 1997, 43.

69. Milton Bracker, "Life on W. 42d St.: A Study in Decay," *New York Times*, March 14, 1960, 1, 26.

70. Brothels had long ago followed the theaters to this district, so that by early 1900s Times Square was the sex capital of Manhattan. See Taylor, *Inventing Times Square*, xxii–xxv; Traub, *Devil's Playground*, 30, 117; and Bracker, "Life on W. 42d St.," 26.

71. See Traub, *Devil's Playground*, 124.

72. Quoted in ibid., 126.

73. Quoted in Daniel Makagan, *Where the Ball Drops: Days and Nights in Times Square* (Minneapolis: University of Minnesota Press, 2004), xiii.

74. Quoted in David W. Dunlap, "A Seedy Eighth Avenue Landmark, Gone Dark," *New York Times*, CityRoom blog, September 7, 2007, http://cityroom.blogs.nytimes.com/2007/09/07/a-seedy-eighth-avenue-landmark-gone-dark/?hp (accessed January 20, 2012).

75. Traub, *Devil's Playground*, 168.

76. The first Disney musical presented in the theater was actually *Beauty and the Beast*; however, this show opened before restoration was complete at the New Amsterdam.

77. Traub, *Devil's Playground*, 169. The two companies that signed were Madame Tussaud's and AMC Entertainment.

78. Quoted in ibid., 165.

79. Ibid.

80. For more on Giuliani, see ibid., 208–9; and Burns, Sanders, and Ades, *New York*, 547.

81. Burns, Sanders, and Ades, *New York*, 553.

82. Samuel R. Delany, *Times Square Red, Times Square Blue* (New York: New York University Press, 1999), xvii.

83. See ibid., xi; Samuel R. Delany, "X-X-X Marks the Spot," *Out* (December 1996/January 1997), 172.

84. Delany, *Times Square Red*, xv.

85. This was the first time in New York history that zoning regulations had been used to require, rather than prohibit, excessive lighting. Traub, *Devil's Playground*, 159.

86. Kimmelman, "Assignment Times Square," 47. The three sections of Kimmelman's article were titled: "Hyperreal," "Surreal," and "Real."

87. Quoted in ibid., 55.

88. Incidentally, the stretch of storefront grates to the left of diCorcia's photograph for Delany's article (fig. 93) is the very same area depicted toward the right edge of Tunbjörk's image (fig. 92).

89. Delany, "X-X-X Marks the Spot," 172.

90. Delany's book also reproduced one of diCorcia's photographs published in "X-X-X Marks the Spot," as well as two unpublished frames related to fig. 94. In the book's acknowledgments, Delany thanked diCorcia for "photographs that did not appear with the original article," making it clear that they were all taken c. 1996. Delany, *Times Square Red*, ix.

91. Simpson, "Exploded View," 20.

92. See Makagan, *Where the Ball Drops*, 196–99.

93. Bernard B. Kerik, quoted in ibid., 200–1.

94. Quoted in ibid., 200.

95. Quoted in ibid., 196.

96. Traub, *Devil's Playground*, 280–81.

97. Taylor, *Inventing Times Square*, xi–xii.

98. Richardson, "Philip-Lorca diCorcia Speaks," 175.

99. Ayerza, "Philip-Lorca diCorcia."

100. Schwabsky, "Philip-Lorca diCorcia," 29.

101. Among all the writing on *Heads*, Galassi's text appeared first and was the earliest to label the selected subjects "archetypes," using capitalization to emphasize a representative of a classifiable category: "the Mailman, the Young Blonde, the Rabbi, the Black Executive, the White Teenager, and so on. . . ." Galassi, "Philip-Lorca diCorcia," 169.

102. Richardson, "Philip-Lorca diCorcia Speaks," 173.

103. Prior to this, of course, seven of the photographic prints from the series had debuted in his 1995 monographic catalogue by MoMA. Those seven represent his earliest efforts from 1993, the year just after the *Hustlers* series was completed, to 1995.

104. Twenty-four photographs were reproduced in the accompanying catalogue, though a handful of *Streetwork* images were made during or after this exhibition and thus do not appear in this catalogue. Some do appear in the different *Streetwork* catalogue accompanying an exhibition in Germany from January 12 to March 12, 2000.

105. Los Angeles appears minimally, only in two works, one of which is not identifiable as Los Angeles.

106. Simpson, "Exploded View," 21; and Katherine A. Bussard, "Tête-à-Tête: The Social Vision in Philip-Lorca diCorcia's *Heads*," lecture delivered at the Critical Studies Symposium of the Independent Study Program, Whitney Museum of American Art, New York, May 28, 2003. I thank Jennifer González for correcting my scale assessment in her response to my paper that evening.

107. Tillman, "Interview," 97.

108. Sante, "The Planets," n.p.

109. Charles Wylie, "Streets of Paradox: The Photographs of Philip-Lorca diCorcia," *Art on Paper* 3, no. 4 (March/April 1999): 44.

110. Tillman, "Interview," 94. See also Richardson, "Philip-Lorca diCorcia Speaks," 175.

111. Galassi, "Photography Is," 12.

112. Philip-Lorca diCorcia, "Reflections on Streetwork," in *Philip-Lorca diCorcia: Streetwork 1993–1997* (Salamanca: Ediciones Universidad de Salamanca, 1998), 14 and 12, respectively (emphasis added).

113. Wylie, "Streets of Paradox," 44; and Kimmelman, "Art in Review," E26, respectively.

114. "There is a third person's point of view, sure. There is a narrator who is the viewer." Ayerza, "Philip-Lorca diCorcia."

115. Galassi, "Photography Is," 6. For more, see Simpson, "Exploded View," 26n14; Michael Fried, "Absorbed in the Action," *Artforum* 45, no. 1 (September 2006): 335; and Weski, "Contemplation," n.p.

116. Dziewior, "Philip-Lorca diCorcia," 101.

117. Dan Fox, "Philip-Lorca diCorcia," in *The Citigroup Private Bank Photography Prize 2002: Roger Ballen, Elina Brotherus, Philip-Lorca diCorcia, Thomas Ruff, Shirana Shahbazi* (London: Photographers' Gallery, 2002), 59.

118. Kimmelman, "Art in Review," E26. In later weeks, this review would become a pared-down "Art Guide" listing. That listing, consistent in language, appeared once more alongside a reproduction of *Head #01* on September 28. See Michael Kimmelman, "Art Guide: Philip-Lorca diCorcia, 'Heads,'" *New York Times*, September 21, 2001, E32; Michael Kimmelman, "Art Guide: Philip-Lorca diCorcia, 'Heads,'" *New York Times*, September 28, 2001, E36; and Michael Kimmelman, "Art Guide: Philip-Lorca diCorcia, 'Heads,'" *New York Times*, October 5, 2001, E32.

119. Ian Hunt, "Contractualities of the Eye," in *Face On: Photography as Social Exchange* (London: Black Dog Publishing, 2000), 57. See also William Stover, "At a Remove," *Photography Quarterly* 80 (2001): 4.

120. DiCorcia, "Reflections on Streetwork," 12.

121. Simpson, "Exploded View," 21.

122. Ibid., 22. At the time of Simpson's catalogue text, the case was still up for review by the New York appellate court, but this appeal by the plaintiff met with the same verdict. The appellate court's decision can be read in its entirety online at: http://www.docstoc.com/docs/431133/NY-State-Court-of-Appeals-2007-Erno-Nussenzweig-very-Philip-Lorca-diCorcia (accessed February 27, 2012).

123. Lisa Phillips and Louise Neri, "Inside-Out: A Conversation between Lisa Phillips and Louise Neri," in *1997 Biennial Exhibition* (New York: Whitney Museum of American Art, 1997), 47.

124. Geoffrey Batchen, "Guilty Pleasures," in *Ctrl Space: Rhetorics of Surveillance from Bentham to Big Brother*, ed. Thomas Y. Levin, Ursula Frohne, and Peter Weibel (Karlsruhe, Germany: ZKM Center for Art and Media/ Cambridge, MA: MIT Press, 2002), 448, 457.

125. As long ago as the 1930s, one New York daily paper would occasionally print an aerial surveillance photograph of the pedestrians and award five dollars to anyone who could locate themselves in the crowd. Sante, foreword to Evans, *Many Are Called*, 11.

126. Griffin, "Private Eye," 113. This argument is not the same as the contention that "Philip-Lorca diCorcia is not concerned with national peculiarities, for his choices of location—the world's metropolises—have universal validity." See Weski, "Contemplation," n.p. *Hustlers* and *Streetwork* both demonstrate how very attuned he is to the specific identifying elements of the urban environments in which he is photographing, perhaps most especially in Los Angeles and New York City.

127. Kimmelman, "Assignment: Times Square," 44.

128. Simpson, "Exploded View," 20.

129. See Burns, Sanders, and Ades, *New York*, 533. These concerns were also understood as having national implications. See, for example, Mark Gottdiener, *The Theming of America: Dreams, Media Fantasies, and Themed Environments* (Boulder, CO: Westview Press, 2001).

130. Traub, *Devil's Playground*, xiv.

131. Bonacossa, "Philip-Lorca diCorcia," 93.

132. Buck-Morss, "The Flâneur," 133.

133. The works, on view until May 21, 2002, represented ninety-three artists and were selected by the Department of Photography.

"Photographic Celebration of New York City on View at the Museum of Modern Art," MoMA exhibition press release (February 2002), 1. This text appeared in slightly altered form in the exhibition brochure: "*Life of the City* is a celebration of New York, a diverse cross section of modern photography, and an experiment in exploring the ways that photographs help to make a community." *Life of the City*, MoMA exhibition brochure and wall text (2002), n.p.

134. *Life of the City*, n.p.

135. Sarah Boxer, "Prayerfully and Powerfully, New York City Before and After," *New York Times*, March 6, 2002, E1, E3.

136. To be clear, diCorcia has never denied the impact of September 11 on *Heads*; rather, he has described it as something with effects both practical and artistic moving *forward* from that moment. See Richardson, "Philip-Lorca diCorcia Speaks," 169–71.

137. Kimmelman, "Art in Review," E26; and Kimmelman, "Art Guide," September 21, 2001, E32, respectively (emphasis added).

138. Bonacossa, "Philip-Lorca diCorcia," 93. *Heads* is discussed and illustrated in commentaries on the finalists for the 2002 Citigroup prize in multiple art periodicals. For those with the most extensive commentary on diCorcia, see Francis Hodgson, "City Slickers," *Art Review* 53 (March 2002): 72–73; Melissa Denes, "Snap Happy," *Guardian Unlimited*, February 2, 2002, 24–28. Perhaps one of the most strenuous of the post–September 11 readings of *Heads* occurs in the pages of the *Citigroup Private Bank Photography Prize 2002* catalogue, which commemorates the five finalists named in March that year. (DiCorcia was both a finalist and the winner of the prize, largely on account of *Heads*.) Describing the unself-consciousness of the subjects, Dan Fox claimed that, with this work, diCorcia "recasts it as a moment of epic *heroism*." Fox, "Philip-Lorca diCorcia," 57 (emphasis added).

139. Traub, "Common of Earthly Delights," 51.

INDEX

Page numbers in *italics* refer to illustrations.

Paris, 3, 7, 11, 13–53, 134, 177, 191; Avedon's street photographs of, 3, 7, 13, *14*, 15, 17, *18*, 19, 20, 21–24, 25–27, 28, *29*, 30–53, *40–49*; Café de Flore, 28; Champs-Élysées, 28, *44*, 48; couture industry, 33–35, 46, 196*n*50, 198*n*82; Eiffel Tower, 17, *18*, 19, 28; fashion photography of, 13–53; Gare du Nord, 28; Grand Palais, 28; Louvre, 22; Marais, 30, *45*, 48, 196*n*23, 196*n*40; Montmartre, 28, *29*; "Notes from Paris," 35–36, *36*, 37, 52; Palais Garnier, 22; Petit Palais, 28; Place de la Concorde, *26*, *27*, 28, 196*n*23; Place du Trocadéro, 17, *18*, 19, *19*, 28, *40*; Pont Alexandre III, 28, *47*, 48; postwar fashion and nostalgia, 13–15, 22, 31–38, 50–52; Seine, 22, 28; Tuileries Garden, 22, *22*; Universal Exposition (1900), 28; wartime occupation, 31–34, 196*n*43, 197*n*51

Parks, Gordon, 64–68, *69*, 70, 73, 85, 200*n*37; *The Learning Tree*, 65; *Life* photographs, 64–69, *65–67*; "The Long Search for Pride," 65, 67, *67*; "What Their Cry Means to Me'— A Negro's Own Evaluation," 65, 67–68, 85; "The White Devil's Day Is Almost Over," 65, *65–66*

Paulette, *49*

pedestrians, 3, 17, 19, 38, 82, 109, 128, 145, 149, 150, 152; Birmingham, 82; New York, 109, 128, *129*, 139–89; Paris, 13, 17, 19, 27, 28, 38, 39, 42, 48

Penn, Irving, 195*n*2, 195*n*5

Perugia, *18*, 39, *40*

photo essay, 8, 64, 65, 86, 94, 119, 2013*n*73; Moore's "They Fight a Fire That Won't Out" in *Life* magazine, 55, 80, *81*, 86–87, *88–92*, *92–97*

photojournalism, 3, 8, 11, 55–97, 199*n*19; captions, 87–95; framing and movement in, 74–77, 86–95; *Life* magazine and precedents, 62–68; Moore's civil rights photographs, 3, 8, 9, 55–62, *57–60*, 68–70, *69–70*, 71–73, *73*, 74–84, *81–84*, 85–87, *88–92*, *92–97*; Park's *Life* essays, 64–68, *65–67*

Photo League, 102, 104–6, 112–13, 203*n*25, *204n26*, 204*n*33

Playpen, 164–65

Polaroids, 153, 184, 185

Police-Dog Attacks and Photographers (Photographer unknown), 56, *61*, 74

politics, 2–5, 7–9, 11, 76, 120, 135, 150, 190, 191; civil rights photography and, 55–97; of surveillance, 179–84

Pop art, 109, 113

pornography, 164, 165, 167, 168

postmodernism, 9–10

postwar consumerism, 3, 7, 50, 51–52, 64, 163–64, 190

postwar nostalgia, 31–38, 50–52

poverty, 3, 9–10, 100, 103; on the Bowery, 120–30; urban documentary photography of, 100–37

privacy, 181–83

prostitution, 103, 164, 168, 210*n*70

"publicity" images, 50

Q

quotation, 109, 113–14, 119, 137

R

racism, 2, 7, 8–9, 11, 55–97, 109, 190; Moore's civil rights photographs, 3, 8, 9, 55–62, *57–60*, 68–70, *69–70*, 71–73, *73*, 74–84, *81–84*, 85–87, *88–92*, *92–97*; Parks's photographs of, 64–68, *65–67*

radio slave, 156

Randolph, A. Philip, 8

Rauschenberg, Robert, 96, 206*n*98

Ray, Man, fashion photography by, 39

Reagan, Ronald, 122

realism, 196*n*47; diCorcia's New York photographs and, 139–89; in fashion photography, 16–17

Reiss, Matthias, 56

Renée, *26*, 27, 30, *41*

Respini, Eva, 15–16, 52

Reuters, 166, 173

Riis, Jacob, 103–4; *How the Other Half Lives*, 103

Roberts, Gene, 74, 76, 79, 86, 87, 94, 95, 201*n*60

Rodino, Peter, 80

Rolleiflex camera, 22, 23, 33, 145, 196*n*26

Rosenblum, Naomi, 105

Rosenblum, Walter, 102, 104

Roser, Maud, 29

Rosler, Martha, 3, 5, 6, 7, 9–10, 11, 99–137, 190, 191; *The Bowery in Two Inadequate Descriptive Systems*, 3, 9–10, 11, 103, 108–20, *110–19*, 121–31, *132–33*, 134–37, 193*n*20; *City: Visions and Revisions*, 205*n*91; diary notes for *the Bowery*, 117, *119*; *Home Front*, 205*n*91; *Homeless: The Street and Other Venues*, 205*n*91; *If You Lived Here . . .*, 205*n*91; "In, Around, and Afterthoughts: On Documentary Photography," 122, 127, 131; *Martha Rosler: 3 Works*, 131; New York street photographs, 3, 9–10, 11, 103, 108–20, *110–19*, 121–31, *132–33*, 134–37; process in the city, 109–20; text used by, 115–20, 131–34, 204*n*61; *Untitled*, 100, *101*

Ross, Kristin, 52

Rothko, Mark, 206*n*98

Ruscha, Ed, 120, 178

Ryan, Cara Gendel, 124

Ryman, Robert, 206*n*98

S

Salomon, Erich, 203*n*9

Sander, August, 203*n*9

San Francisco Chronicle, 79

Sante, Luc, 145, 153, 177

Scale of photographic prints, 5, 6, 39, 86, 87, 92, 177

Schiaparelli, 34, *36*, 49

segregation, 7, 55–97, 126

Sekula, Allan, "Dismantling Modernism, Reinventing Documentary (Notes on the Politics of Representation)," 130

Seltzer, Lou, 102

September 11 terrorist attacks, 10, 172, 175, 186, 188, 190, 211*n*136

sequencing, 117–20; in urban documentary photography, 109–20, 204*nn*61–62, 204*n*69

sex, 10, 11, 190; Times Square and, 164–72, 184, 188

Seymour, David, *Richard Avedon and Fred Astaire (as Dick Avery), Tuileries, Paris*, 22, *22*

Shahn, Ben, 112

Shakespeare, William, *Othello*, 163

Sheeler, Charles, 102

Shuttlesworth, Fred, 78, 79, 80

sidewalks, 7, 11, 48, 56, 80, 82, 100, 109, 113, 139, 149, 156, 176, 177, 194*n*35

ILLUSTRATION CREDITS